THE **SOVEREIGN SELF**

THE

TO THE AVANT-

SOVEREIGN SELF

AESTHETIC AUTONOMY FROM THE ENLIGHTENMENT GARDE

GRANT H. KESTER

DUKE UNIVERSITY PRESS
Durham and London 2023

© 2023 DUKE UNIVERSITY PRESS
All rights reserved
Designed by A. Mattson Gallagher
Typeset in Untitled Serif and Helvetica Rounded LT Std
by Westchester Publishing Services

Library of Congress Cataloging-in-Publication Data
Names: Kester, Grant H., author.
Title: The sovereign self : aesthetic autonomy from the
Enlightenment to the avant-garde / Grant H. Kester.
Description: Durham : Duke University Press, 2023. | Includes
bibliographical references and index.
Identifiers: LCCN 2022045551 (print)
LCCN 2022045552 (ebook)
ISBN 9781478020424 (paperback)
ISBN 9781478019961 (hardcover)
ISBN 9781478024552 (ebook)
Subjects: LCSH: Art—Philosophy. | Art criticism. | Autonomy
(Psychology) in art. | Subjectivity in art. | Avant-garde (Aesthetics)—
History—20th century. | Art, Modern—Political aspects. | Art and
society—History—20th century. | BISAC: ART / Criticism & Theory |
ART / History / Contemporary (1945–)
Classification: LCC N7476 .K47 2023 (print) | LCC N7476 (ebook) |
DDC 701—dc23/eng/20230216
LC record available at https://lccn.loc.gov/2022045551
LC ebook record available at https://lccn.loc.gov/2022045552

The creation of this book coincided with the early years of my son's life, and it was inspired in many ways by the complex labor involved in helping his unique spirit negotiate the tension between autonomy and dialogical interdependence that defines the human condition. I would like to dedicate this book to Elliott, and to Samira, whose wisdom and compassion are my constant guide. I also want to extend my gratitude to Ken Wissoker, who remained committed to this book, and its vision, despite formidable obstacles.

CONTENTS

1 Introduction

I. FROM BEAUTY TO DISSENSUS

1
19 Freedom and Sovereignty

2
48 Communism and the Aesthetic State

II. NEGATION AND PERFORMATIVITY

3
85 From Vanguard to Avant-Garde

4
108 Activism and Autonomy in the 1960s

III. AUTONOMY SINCE THE 1980S

5
145 The Rise of the Neo-Avant-Garde

6
180 The Hirschhorn Monument
Autonomy as Brand and Alibi

212 Conclusion
Aesthetics beyond Semblance

219 Notes
243 Works Cited
259 Index

INTRODUCTION

With the political artist things are very different indeed. For him Man is at once the material on which he works and the goal towards which he strives.
—Friedrich Schiller, *Letters on the Aesthetic Education of Man* (1794)

The concept of autonomy has emerged over the past fifteen years as a key locus of debate and theorization in contemporary art. In 2010, a consortium of European cultural institutions convened the Autonomy Project, an ambitious, two-year-long series of symposia, summer schools, and publications that featured many of the leading thinkers in the contemporary art world (Tania Bruguera, Boris Groys, Thomas Hirschhorn, Peter Osborne, Jacques Rancière, Hito Steyerl, etc.).[1] As the organizers acknowledge, the concept of autonomy has traditionally been associated with the outmoded image of the "isolated artist" laboring in their studio and "unaffected by the sociopolitical world."[2] However, as they also note, autonomy has acquired a growing relevance in recent years as contemporary art has been increasingly

instrumentalized by both the market and the demands of neoliberal cultural institutions. The return to autonomy thus represents an attempt to discover new ways in which art might "reenergize" its emancipatory potential.[3] Critic Sven Lütticken, in an essay for the Autonomy Project newspaper, advocates a new "performative autonomy," in which artists turn "performances back into acts" through their individual decision to refuse complicity with the neoliberal order.[4] And artist Thomas Hirschhorn, during one of the symposia, boldly declared that "art must be something completely autonomous . . . and autonomous could be another word for the Absolute or for Beauty."[5] Autonomy also plays a central role in the work of Jacques Rancière, who has argued that the paradigm of aesthetic autonomy developed by philosopher Friedrich Schiller provides the crucial analytic frame necessary to understand the unique forms of insight generated by contemporary artistic practice.[6] This same desire is evident in the recent revival of interest in Frankfurt School theorist Theodor Adorno, whose writing on aesthetic autonomy, according to John Roberts, still possesses "exemplary dialectical value."[7] And Nicholas Brown, in *Autonomy: The Social Ontology of Art under Capitalism*, defines the work of art as a "self-legislating" entity that can only preserve its critical power through its recursive "intervention" in the "institution of art" itself. Art that seeks "to confront capitalism directly," beyond the protective enclosure of the art world, as Brown writes, "turns instead into a consumable sign of opposition."[8]

These examples suggest the wide-ranging influence that the concept of autonomy continues to exercise in contemporary art theory and practice. Autonomy is consistently understood in terms of the relationship between the work of art and the surrounding social and political world, which serves as either the target of the artwork's transgressive criticality or the engine of its inevitable appropriation. Thus, autonomy is associated with the defensive segregation of the artwork from an environment that is seen as fraught with both risk and transformative potential. While this research has shed important light on the complex relationship between aesthetic and political meaning in contemporary art, it has also been characterized by a central aporia. Thus, no matter how much the conventions of autonomy might be probed, expanded, or revised, the conviction remains that autonomy as such is the only possible form that art's relationship to the social and political world might take. The essential task in the current moment is simply to recover the lapsed potential of aesthetic autonomy, even as its underlying ontological structure remains unquestioned. It is this underlying structure—the division between interior and exterior, purity

and impurity, authentic criticality and degraded complicity—that will be my concern here. It is, as I discuss in this book, a discursive structure that has remained remarkably consistent over the past two centuries. There is a great deal at stake in the recent turn to autonomy, as we seek to understand the nature and potential of both historical and contemporary art. It has, as well, significant implications for our understanding of cultural politics more generally. My goal in this book is to offer an alternative genealogy of the aesthetic that can help clarify those stakes, and also point to an often-subterranean tradition of artistic production that allows us to think the aesthetic beyond autonomy.

I use the term "aesthetic" in two related ways in this book. First, I use it to refer to the knowledge that is produced through the interaction between cognitive self-reflection and our sensory experience of the external world. I also use the "aesthetic" to refer to the specific ways in which this form of knowledge is constructed in philosophical and theoretical discourse, which is concerned with the potential emergence of a harmonious social order that might challenge the fragmenting forces of modernity. As I argue, aesthetic experience became a key site of speculative engagement during the Enlightenment because it promised to disclose a crucial human capacity to reconcile the individual self with a larger social body during a period of growing political uncertainty. In each context the aesthetic carries a utopian potential. There is, of course, a complex interrelationship between these two usages, as individual philosophers sought to mobilize the concept of the aesthetic on behalf of a specific emancipatory project (enlightenment or revolution). However, in many of the cases I examine here, the discursive staging of aesthetic knowledge was structured through an explicit hierarchy in which emancipation can only be secured through a process in which physical or sensual experience is subordinated to mental or cognitive supervision. In a key historical transposition, this same epistemological opposition is often projected onto entire classes of people (the proletariat, women, colonized subjects) who are seen as incapable of self-regulation. My own understanding of aesthetic knowledge follows a different trajectory. Here the discourse of the aesthetic does not seek to subordinate one of these terms to the other, but attends, instead, to their dialogical interdependence. I provide examples of forms of cultural and theoretical production that illustrate this alternative understanding at various points in this book. My primary focus, however, will be on what I will identify as the dominant interpretation of the aesthetic in the European tradition, which understands the cognitive as exercising a regulatory control over the physical in the formation of aesthetic knowledge.

At the center of the concept of aesthetic autonomy stands the sovereign personality of the artist, which is understood to transcend the complex, dialectical tensions that accompany the work of art itself on its perilous journey from the isolated studio to the social and political world beyond its doors. Thus, while the integrity of the artwork as a vehicle of emancipatory insight might occasionally be called into question, the authority of the artist as the originary source of this insight is never in doubt. Here the "internal" cognitive space of artistic creativity is essentially pure and uncorrupt, and the mechanisms of complicity or instrumentalization associated with the "external" world only accrue to the artwork after it has left the benign consciousness of the artist. As a result, we find a wide-ranging normalization of conventional forms of authorship throughout many of these debates, from Rancière's valorization of a canon of white, male auteurs (in *Aisthesis* alone he discusses Whitman, Emerson, Balzac, Mallarmé, Ibsen, Rodin, Chaplin, Stieglitz, Vertov, and Agee), to Thomas Hirschhorn's insistence on his own untrammeled "form giving" authority as an artist, to critic Claire Bishop's conviction that the autonomous "authorship" exercised by the contemporary artist is the very precondition for "provocative art and thinking."[9]

The belief that the utopian potential of aesthetic experience can only be fully expressed through conventional forms of authorial sovereignty has remained a central tenet of the modernist tradition for the past two hundred years. And certainly, art today faces a unique set of forces that threaten to diminish its transformative and transgressive power. However, before we rush to embrace autonomy once again, I would argue that we need a clearer understanding of its multivalent nature and of its constraints as well as its potential. In this book I will explore the complex history of artistic subjectivity and the principle of autonomy that it exemplifies. As I will suggest, the modern artistic self, which first takes coherent shape in the Enlightenment, is the ur-form for a whole series of subsequent institutional and discursive enclosures that are understood to be uniquely free from the forms of ideological domination that constrain all other modes of cultural production. Moreover, as I will also argue, the question of aesthetic autonomy has ramifications that extend well beyond art to a larger constellation of issues associated with the nature of political transformation, including the complex imbrication of the artistic avant-garde and the revolutionary vanguard, and forms of anticolonial resistance that challenge the Eurocentric concept of "Man" on which the aesthetic itself so often depends. In order to explore these issues, I will be examining the evolving discourse of aesthetic autonomy over a long historical arc, from its origins in Enlightenment aesthetic

philosophy, through the initial emergence of avant-garde art movements in the nineteenth century, to its more contemporary manifestation in what critic Hal Foster has termed a "neo-avant-garde," beginning in the 1970s.

Autonomy and the Avant-Garde

The emergence of the modern avant-garde is associated with the transition to an aesthetic paradigm based on a concept of critical negation rather than redemptive beauty. This principle of negation would be embodied in the personality of the avant-garde artist, whose unique expressive freedom, manifested in an ongoing assault on normative social values, became the primary vehicle for preserving a form of autonomous criticality that was assumed to be otherwise absent in society due to the rise of an increasingly hegemonic system of political domination. We typically view the avant-garde as a repudiation of the concept of aesthetic transcendence that was central to the Enlightenment aesthetic. It was, of course, precisely the principle of autonomy, and the artist's defensive separation from the chaotic social and political world, that avant-garde artists sought to overturn by challenging conventional notions of beauty and distanced aesthetic contemplation with provocative images of expiring stonebreakers and working-class barmaids. In fact, as I will argue here, there is a complex interconnection between the Enlightenment notion of aesthetic autonomy and the forms of radical negation that are typical of the avant-garde tradition. Thus, while the epistemological modality of the avant-garde will shift (from a concern with the virtual reconciliation of self and other in the experience of beauty to the strategic denial of this reconciliation through some form of cognitive assault), the underlying discursive structure of aesthetic autonomy (which governs the roles assigned to the artist, the viewer, and the work of art within a broader social network) remains largely unchanged.

The concept of the avant-garde has remained central to our understanding of modern art for more than a century and a half. While it has taken varying forms over the years, it has consistently emerged in conjunction with calls to revitalize art's lapsed political potential. This is evident in a number of more recent publications, including Marc James Léger's *Brave New Avant-Garde*, Mikkel Bolt Rasmussen's *After the Great Refusal: Essays on Contemporary Art*, and John Roberts's *Revolutionary Time and the Avant-Garde*.[10] This resurgence has been paralleled by various efforts in the realm of critical theory to resuscitate Leninism and the concept of a political vanguard.[11] Slavoj Žižek has even argued that the global hegemony of neoliberal capitalism will

only be arrested with the emergence of a new Leninist "master," willing to take a decisive "leap" into the void through an unsparing commitment to revolutionary political violence.[12] The parallel here with the rhetoric of artistic experimentation (one thinks of Yves Klein's *Leap into the Unknown* of 1960) is symptomatic. In fact, Alain Badiou identifies Lenin and Marcel Duchamp as twin exemplars of a new form of revolutionary thought unique to the twentieth century.[13] As Badiou's example suggests, the avant-garde artist and the vanguard leader have always been intimately linked. They share a common rhetorical orientation and a common set of beliefs about social change, violence, and the decisive role played by revolutionary and artistic elites.

In Badiou we encounter the symptomatic correlation between avant-garde art and revolutionary theory as radically autonomous modes of expression that bear a privileged relationship to political emancipation. In this view, the totalizing ideological control exercised by contemporary capitalism necessitates a complete break with all existing systems of thought. Philosopher Daniel Bensaïd has reflected on Badiou's particular fascination with the concept of an absolute sovereignty: "Emerging out of nothing, the sovereign subject, like eventual truth, provides its own norm. It is represented only by itself. Hence the worrying refusal of relations and alliances, of confrontations and contradictions. Badiou invariably prefers an absolute configuration over one that is relative: the absolute sovereignty of truth and the subject, which begins, in desolate solitude, where the turmoil of public opinion ends. [Peter] Hallward rightly sees in this philosophy of politics an 'absolutist logic' that leaves little space for multiple subjectivities, shuns the democratic experience, and condemns the sophist to a sort of exile."[14] As we will see, the "desolate solitude" of the sovereign self that refuses "relations and alliances" and "provides its own norms" is evident in the traditions of both the artistic avant-garde and the political vanguard.

The resurgence of the vanguard/avant-garde matrix must be understood in the context of the perceived inevitability of contemporary neoliberalism. Faced with the ongoing failure of Marxist political discourse to catalyze broad public opposition to capitalism, there is an active search among left intellectuals for new or rearticulated forms of anticapitalist ideology that can both explain this resistance and provide the foundation for a more compelling political narrative. Renewed interest in the avant-garde is also linked to the growing monetization of contemporary art and, in particular, its formalization as a financial instrument (including the emergence of investment funds linked to its market performance).[15] While modern art

has often been integrated with the market, the remarkable expansion of this interdependence over the past two decades has put increasing pressure on the ideological rationales that are typically employed to legitimate art's critical or oppositional role within contemporary society. In the past, contemporary art was considered among the riskiest sectors of the art market due to the unpredictability of the long-term value accrued by a given work through the slow and uncertain processes of historical validation. However, with the dramatically increased levels of capital available for investment, the pressure to rapidly monetize this work and to accelerate, or simply bypass, the conventional mechanisms of critical and art historical evaluation has been irresistible. In this context, contemporary art, far from challenging the imperatives of bourgeois capitalism, has emerged as one of the single most reliable sites of capital investment.[16] We might say, then, that the avant-garde, or some version of it, is a necessary corollary to the dramatically expanded market for contemporary art, providing the frisson of transgression necessary to keep the "brand," as New York art dealer David Zwirner describes it, fresh and exciting to wealthy consumers who prefer high-yield investments that carry a whiff of cordite.[17] Notwithstanding the cynicism of the art-world nomenklatura, the desire for a renewed concept of the avant-garde, like the desire for a "reenergized" notion of autonomy, also reflects a genuine interest among critics and artists in understanding the complex interconnection between political resistance and cultural production today. As a result, ongoing efforts to develop a coherent theory of avant-garde art can reveal a great deal to us about contemporary artistic production more generally and, in particular, about the potential for *any* form of art that can resist the overwhelming appropriative powers of the market.

Here I will be approaching the avant-garde as both a discursive system (defined by a specific model of political change and subjectivity, and a set of interrelated cognitive mechanisms) and as a performative matrix involving the deployment of objects and actors with assigned roles, in which these mechanisms are acted out. The dispositif of the avant-garde is organized around a dual structure. On the one hand, it is defined by an outwardly oriented gesture of pure negation, directed against the reified structures of daily life. On the other hand, this gesture is incubated within the consciousness of an artist who is impervious to any "external" influence or determination. Here autonomy is produced through the conjunction of a unique, autopoietic creative activity (art) that sets itself decisively apart from other forms of knowledge production, and a specific form of subjectivity, embodied in the artistic personality, which is endowed with unique forms of cognition

and agency.[18] The autonomy of the artistic personality is founded on their capacity to transcend systematic forms of social domination and semantic convention to which others unconsciously submit. As I noted above, this entails a process through which forms of either critical or habitual consciousness are spatialized, via metaphors of "inside" and "outside." The artist is understood as existing outside a given hegemonic system and is therefore able to reveal the hidden structural determinants of individual experience to those who remain trapped within that same system. While the artist possesses a unique rhetorical power over the consciousness of others, this capacity remains unilateral rather than reciprocal, as any external determination of the artist's own subjectivity (to be constrained or acted on by others) would entail an unacceptable violation of their creative freedom. How did this defensive, immunological model of the self originate? And what are the political and aesthetic consequences of identifying emancipatory thought so fully with a form of consciousness that seeks to "abstract itself from all particularity," as Badiou writes?[19]

Overview and Chapter Summaries

Given the breadth of this study, it will necessarily sacrifice a great deal of historical specificity. I hope to compensate for this loss by providing some sense of the continuity of aesthetic autonomy as a broader discursive system that is integral to the experience of modernity. This continuity can be traced through three distinct but interrelated phases. In the first phase, autonomy emerges in conjunction with a European bourgeoisie eager to assert its political independence from existing forms of absolutist rule. In the second phase, autonomy reemerges in vanguard artistic and political discourse during the nineteenth and early twentieth centuries to ensure the integrity and purity of revolutionary struggle against what was seen as an irredeemably corrupt capitalist system. And in the final phase, autonomy in contemporary art practice seeks to preserve a mnemonic trace of a now moribund revolutionary consciousness for some future moment of political transformation. As this outline suggests, aesthetic autonomy bears a complex and shifting relationship to concepts of resistance and emancipation across the past two centuries.

While a significant part of this study will be devoted to a historical analysis of aesthetic theory and artistic subjectivity, it is also concerned with issues that remain central to artistic practice to the present day. I will contend that many of the core evaluative tensions that define contemporary art (the relationship between art and adjacent areas of cultural production, the capacity

of the artwork to convey some form of meaningful social or political critique, and the institutional complicity, or independence, of the art world itself) are rooted in the discursive system of modern aesthetic autonomy. My inquiry is centered on the particular forms of subjectivity and consciousness mobilized by the experience of modern art, and through the personality of the modern artist. As I discuss below, modern art will define itself in opposition to the instrumentalizing forms of identity associated with the rise of capitalism, in which the world is reduced to a set of resources to be exploited and consumed. At the same time, in seeking to challenge the appropriative autonomy of the bourgeois self, we will find artists claiming a form of creative subjectivity that makes its own demands for absolute sovereignty. Thus, the untrammeled freedom enjoyed by the artist is necessary precisely because they possess a unique capacity to transcend the ideological constraints of the existing capitalist system and envision its utopic reinvention.

In his *Letters on the Aesthetic Education of Man*, Friedrich Schiller provides one of the most cogent early diagnoses of European society in thrall to the "economic self-interest" inculcated by the rise of the market system.[20] As a result of this dehumanizing system, "whole classes of men uphold their capacities only in part," as Schiller writes, "while the rest of their faculties scarcely show a germ of activity."[21] Schiller's prescience is notable. Even in the context of the rudimentary forms of modernization evident in late eighteenth-century Germany, he was able to detect the tectonic shifts that would transform Europe during the coming century as society was increasingly driven by utilitarian calculations of profit and loss. Moreover, Schiller helps us recognize the damaging effects that this transformation will have on human interrelationships as we come to view others not as our equals deserving respect and compassion, but rather as a kind of raw material. In the state of crisis that defines modern life, as Schiller writes, "every man seeks for nothing more than to save his wretched property from the general destruction, as it were from some great conflagration."[22] Echoes of this original critique will resonate throughout the history of modern art. Thus André Breton, writing more than a century later, will contend that "wherever Western civilization is dominant, all human contact has disappeared, except contact from which money can be made."[23] For Schiller, the solution to this crisis entails a comprehensive reinvention of the human self, which will be accomplished by our therapeutic exposure to beautiful works of art. Through this process of "aesthetic education," we will move from a predatory form of subjectivity to one in which we experience, and feel, our underlying kinship with other selves.

If modern political life is defined by the struggle over how the individual relates to the social in the face of incipient capitalism, the philosophical discourse of the aesthetic is concerned with how we come to both feel and think this relationship, and how we come to imagine new forms of connection to other selves, capable of transcending this banal, materialistic enclosure. The concept of the aesthetic, I will argue, provides us with a unique vantage point from which to identify, and challenge, the deleterious effects of modern capitalism on the human personality. In this respect it shares certain essential features with evolving forms of Marxist theory in the nineteenth and twentieth centuries. In the following chapters I will trace the relationship between these two discursive systems: between artistic production and political action, between the artistic avant-garde and the political vanguard, and between the realms of aesthetic philosophy and Marxist theory. We encounter formative critiques of the capitalist system, and its associated modes of bourgeois selfhood, in both the modern avant-garde and in Marxist theory. Each of these traditions, as we shall see, also seeks to transcend this system, whether through the incremental reformation of individual viewers or through the revolutionary overthrow of the capitalist system. And each is defined by the desire to usher in a new social order in which self-interest would be replaced by a noninstrumentalizing openness to others. What unique forms of subjectivity and critical knowledge are generated across these two domains? And what are the key points of disjunction, displacement, and differentiation between them?

There is a rich intellectual tradition devoted to the relationship between avant-garde art and revolutionary transformation in the areas of aesthetic philosophy and critical theory.[24] Fredric Jameson's *The Political Unconscious* helped to inaugurate a renewed interest in these questions during the 1980s. In his book Jameson argued that modernist literary texts constitute "a revolt against . . . reification and a symbolic act which involves a whole Utopian compensation for increasing dehumanization on the level of daily life."[25] This emancipatory potential is not openly thematized at the level of literary content. Rather, it is carried in the complex formal structures of the works themselves, in a manner that is often inaccessible to the average reader. It requires, then, the intervention of the critic to reveal this "political unconscious" and to bring it into our conscious awareness through a process of ideological "decipherment." There are a number of themes here that will be important for my subsequent analysis of the avant-garde, including the compensatory relationship between artistic production and revolutionary change, the central role played by formal mediation in preserving the art-

work's political meaning, and the underlying bifurcation between the reader and the critic. Jameson's book exemplifies a diverse body of scholarship in which the literary text, or the physical artwork, expresses a form of revolutionary political consciousness that cannot yet be realized through practical action. This perception will be evident in a number of thinkers discussed in the following study, especially in the work of Theodor Adorno. This remains a valuable and illuminating tradition. However, I will offer a somewhat different path through this familiar terrain. In particular, while I will occasionally discuss specific works of art, my primary concern is not with the artwork qua object and its associated hermeneutic conventions. Rather, I am interested in tracing what I term the "social architecture" of the aesthetic. By social architecture I refer to the ways in which the concept of the aesthetic has been constituted historically around a set of a priori subject positions (of artist and viewer, movement and public), defined by specific forms of cognitive agency and interpretive competence. In this sense I am less concerned with the ontology of the work of art than I am with the ontology of the artist. I will be concerned, as well, with the relationship between artistic production and the forms of revolutionary praxis that, in Jameson's account, it symbolically preserves.

These questions will bring us once again to the concept of autonomy, which plays a central role in the traditions of both Marxist and aesthetic thought. As we know, aesthetic discourse during the Enlightenment undergoes a fundamental reorientation. Rather than art serving to provide a form of moral instruction (*docere et delectare* in Horace's maxim), the work of art will become entirely autonomous and "complete in itself," as Karl Moritz contends. In this view, art's significance does not derive from its practical effect on the world, or the viewer, but from the fact that art as such has no outwardly directed purpose at all.[26] Here the "utility" of the instructive artwork becomes a surrogate expression of the relentless utilitarianism of the nascent bourgeoisie.[27] In this capacity the autonomous artwork comes to symbolize a condition of individual freedom that mirrors the aspirations of the modern political subject, finally freed from external coercion by god and king. By the same token, it comes to symbolize a resistance to the means-end rationality of the capitalist system that is gradually displacing these sacral authorities. Of course, as we see in Schiller, the autonomous work of art does seek to "instruct." It simply approaches this task through a different set of cognitive protocols, entailing the transformation of the underlying structures of human consciousness. Thus, it is precisely by abjuring any ostensibly "external" validation that the autonomous work of art gains the

capacity to awaken in the viewer an intuition of our fundamental connection to other selves (through a prefigurative sensus communis, which can overcome the rampant self-interest promulgated by the market system).

In the following chapters I will explore the translation of this paradigm of aesthetic autonomy into the mid-nineteenth century, where it will be renewed in the radical sovereignty of the avant-garde artist. "I alone," as Courbet claimed, "have the power to represent and translate in an original way both my personality and my society."[28] Here the expressive freedom of the avant-garde artist serves to anticipate the utopian forms of selfhood that will one day be universally available, when society is finally liberated from capitalist domination. We encounter a variant expression of this form of autonomous subjectivity in the personality of the vanguard leader who sustains the as-yet unrealized insurrectional potential of the masses in the form of revolutionary theory, while possessing a singular ability to penetrate the veils of ideological mystification that otherwise confound the benumbed victims of capitalist exploitation. These are, of course, highly complex, internally differentiated discursive systems; it will be the work of the coming chapters to more fully describe their tangled interrelationship. However, they are united at a broader level by a similar structure. In each case, in the figure of the avant-garde artist and the vanguard revolutionary, we encounter a spatial paradigm defined by an enclosed domain of contemplative purity, and an "external" world of corruption and political disorder from which this reflective consciousness must remain fundamentally separate and over which it is destined to exercise a transcendent cognitive mastery.

To be autonomous means to be self-governing or to give oneself norms. But norms are, by definition, shared social constructs. How, then, does the autonomous subject engage in the consensual creation of norms rather than simply imposing their self-generated values onto others? Here we encounter a characteristic tension between autonomy as marking the individual's freedom from external coercion and a form of autonomy that enables that same individual's sovereignty over other selves. In the first part of the book, I explore the tension between autonomy as freedom and autonomy as mastery through the work of Kant, Schiller, and Hegel, exploring the crucial linkage between the autonomous concept of the self developed in the Enlightenment and the ontology of European colonialism. I then explore the ways in which this tension is both challenged and reinforced in the emergence of a concept of the aesthetic, outlining a composite model of aesthetic autonomy in which the actual moment of reconciliation (of self and other) that is prefigured in the aesthetic encounter is both deferred, until a future moment of utopian

social emancipation, and displaced into the formal and representational matrix of the artwork. In this view, any attempt to transform the existing social order now will be premature, as evidenced by the revolutionary Terror in France (a sign for Schiller and Hegel of humanity's political immaturity). Next, I will outline a four-part structure that describes the key features of aesthetic autonomy as a discursive system. This structure is carried through the book as a touchstone to gauge the ways in which aesthetic autonomy is both sustained, and transformed, over time. I then explore the relationship between the Enlightenment concept of aesthetic autonomy and the new modes of autonomy that emerged in the nineteenth century through the rapprochement between vanguard politics and avant-garde art. Rather than seeing the avant-garde discourse that emerges at this time as a repudiation of the Enlightenment aesthetic, I examine the underlying continuities between the two discursive traditions. These are organized around the central value assigned to art, and the artistic persona, as the vessels for an entirely unique form of critical and prefigurative insight. Here the anticipatory reconciliation of self and other evoked by the experience of beauty is replaced by a deliberate undermining of transcendence, in the avant-garde assault on the viewer's consciousness, even as the sovereignty of art and the artistic persona remains paramount. The perceived cognitive incapacity of the public, evident in Schiller's critique of the French Revolution, finds its corollary in the perception that the proletariat is incapable of revolutionary transformation and requires the oversight of a vanguard party.

In the second part of the book I examine the reciprocal influence between Bolshevism and avant-garde artistic production during the early twentieth century. In particular, I focus on the diffraction patterns that are produced in the overlap between the avant-garde artist and the revolutionary theorist. Each of these figures claims a transcendent power to comprehend the complex totality of capitalist domination and cultural production, and each can be seen as modifying, and carrying forward, certain key features associated with the discourse of autonomy outlined in the first section. In particular, they reflect the symptomatic tension between autonomy as freedom from constraint by the world that exists beyond the domain of the self, and autonomy as sovereignty over that same external world, which is at the core of philosophical aesthetics. Precisely in order to precipitate a new political order capable of nurturing a genuine form of social harmony, the vanguard leader takes on a merciless and unilateral authority, seeking to destroy an existing system of government through unrestrained violence and revolutionary terror. The modern avant-garde is structured around a similar

disjunction. Here the artist, in seeking to challenge a bourgeois culture defined by the arrogant mastery of the natural world and other human selves, nonetheless takes on an appropriative relationship to the individual viewer, whose subordinated consciousness will be subjected to a violent, transformative assault. In this manner the prefigurative dimension of the artist's expressive freedom reveals its necessarily instrumentalizing corollary, evident in Schiller's description of the "political artist," who takes humanity as a passive "material" onto which to impose his redemptive will.[29] We find this paradigm reiterated in Maxim Gorky's poignant observation in 1917 that "the working class is for Lenin what iron ore is for a metal worker."[30] The discourse of the avant-garde will thus normalize a form of sovereign authority (in assigning to the artist, or revolutionary theorist, certain exemplary modes of transformative agency and self-actualization), while simultaneously gesturing beyond sovereignty to a mode of being in which the very "self" that is naturalized in the avant-garde personality is called into question. I link these traditions with a revised concept of aesthetic autonomy in the work of Theodor Adorno during the 1960s and contrast his approach with an alternative aesthetic paradigm developed by C. L. R. James, rooted in the experience of anticolonial resistance and the complex imbrication of race and class. I then outline a series of projects, from the "Prolekult" movement and the struggle for Indian independence during the 1920s and 1930s, to artistic practices developed in conjunction with new social movements during the 1960s, that exemplify this alternative paradigm.

In the third part of the book, I explore the interconnection between Adorno's aesthetic and the concept of a neo-avant-garde that was introduced during the 1990s, associated with the academic art criticism published in the journal *October*. Critics such as Hal Foster and Benjamin Buchloh came to identify the forms of conceptual and minimalist art that emerged in the 1960s and 1970s as a displaced expression of the radical energies created by the Russian Revolution of 1917 (after which the journal is indirectly named). This paradigm will be subsequently renewed in the work of critic and historian John Roberts, who develops a concept of aesthetic autonomy for the contemporary moment inspired by the legacy of Adorno. As Roberts argues, art demonstrates its authenticity by refusing any direct contact with processes of social or political change and focusing its critical powers instead on the reified institutional and ideological structures of the art world itself. I then examine the practical expression of this neo-avant-garde paradigm in the work of Swiss artist Thomas Hirschhorn, focusing on his acclaimed

Gramsci Monument, which was staged at a New York City public housing project in the summer of 2013. Here many of the core themes associated with an avant-garde paradigm of aesthetic autonomy take on exemplary physical and institutional form. In *Gramsci Monument*, Hirschhorn sought to effect a utopian transcendence of class and racial difference, even while employing the lives and daily interactions of the public housing residents as a compositional material intended for consumption by an international art world defined precisely by class and racial privilege. In the conclusion I reflect on the implications the discourse of avant-garde aesthetic autonomy has for our understanding of the potentials and the constraints of contemporary art more generally.

As I suggested above, contemporary efforts to revive a concept of aesthetic autonomy are motivated by the fear that art's unique, critical potential is in danger of being subsumed by the inexorable appropriative powers of neoliberal capitalism. This sense of impending crisis is, of course, entirely familiar. Art's emancipatory potential has always been at risk, from the market, from the vicissitudes of popular culture, and from the instrumental demands of social and political change. In fact, we might say that the very function of the modern avant-garde is to symbolically enact an embattled and (and ultimately futile) resistance against the implacable forces of ideological domination. Alana Jelinek captures this mythos in her insistence that "Art is not political action. Art is not education. Art does not exist to make the world a better place. Art disrupts and resists the status quo, and if it fails in this prime objective it only serves to deaden a disenfranchised society further."[31] Of course, art must fail; it cannot avoid failure because the task assigned to it in the avant-garde tradition (to "disrupt" the status quo) is impossibly abstract. The fragility of art's emancipatory potential is not an unfortunate side effect. It is, rather, essential to the ontology of art itself; to evoke some absolute and inviolable form of resistance that cannot be realized in the current moment. The meaning of art, in these terms, never lies in the forms of criticality that it can generate here and now but rather, in its meta-performativity over time, acting out an incipient radicality, its inevitable co-option, and its eventual rebirth, which are seen as symbolizing an irrepressible human desire for utopian change. This entails, in turn, the necessary autonomy of art itself from the very social mechanisms necessary to produce the change it claims to embody ("political action," "education"). In this manner, autonomy understood as a capacity for critical distance from the ideological norms on which political domination depends is collapsed

into the institutionalized separation of artistic production *from* the world in which those norms are generated. This is the slender thread that links the aesthetic paradigm introduced in the Enlightenment with the most recent manifestation of neo-avant-garde artistic practice. My goal in this study is to understand how a paradigm of aesthetic autonomy that originated more than two centuries ago continues to exercise such a decisive influence on the ways in which we envision the potential of art today.

I

**FROM
BEAUTY**
 **TO
DISSENSUS**

FREEDOM
AND SOVEREIGNTY

The Origins of Aesthetic Autonomy

The emergence of autonomy as a central category in European thought coincided with the gradual decline of established forms of religious and political authority following the Reformation. This decline entailed the erosion of many of the societal norms and constraints that had patterned European life for centuries. It also led to the realization, both disturbing and liberating, that these foundational values were contingent and potentially open to reconstruction. As a result, there was a pressing need to identify a new model of human cognitive agency capable of generating the normative values that would be necessary in a postabsolutist era. What kind of person was best suited to create these values? And how would these values, once established, exercise any behavioral influence in the absence of the coercive external pressure that had been relied on by absolutist forms of political rule? As J. B. Schneewind has observed, previous concepts of morality were

based on the principle of subordination (to God or to God's agents on earth) rather than self-governance.[1] If the socially and institutionally hardened concept of obedience evolved over centuries of human practice, autonomy as self-governance suggested that this reified shell of custom could, at least potentially, be reconfigured by any single actor or group of actors. We encounter in this tradition a human subject freed from the accumulated weight of past tradition and better able to access the core of "natural" reason buried in the recesses of the individual consciousness, which will provide an unerring compass in imaging more just systems of government. Autonomy thus marks an open, essentially content-less, space within modernity that refers to the (as-yet-unrealized) potential of humankind to create more egalitarian forms of social organization: to learn from both the past and from current practices of political transformation in a pragmatic and self-reflexive manner. In this sense, it is an intrinsically generative concept: offering a space in which shared values can be envisioned. It retains, as well, an implicit commitment to an intersubjective ethos capable of supporting the consensual generation of these new values.

As this outline suggests, the debate over autonomy raised a set of foundational questions about the nature of the self and the human capacity to reinvent existing social and political structures. It marked the opening of a unique historical space, in which new modes of social being could come into existence. The fact that this process was framed in the specific context of the struggle against absolutism would have a significant effect on the ways in which the category of the self was reinvented at this time. In particular, it led to a symptomatic tension between the idea of a dialogical self, open to a reciprocally transformative relationship to the other, and a defensive self, closely guarding its integrity against external influence. This second approach would come to influence subsequent political theory, leading to a model of subjectivity in which those influences that come from "outside" the internal sphere of the subject were perceived as hostile or threatening; proxies for the coercive forms of absolutist power against which these theories first contended. As a result, the "self" capable of resisting these external forces must, by necessity, be inviolable. In this model the autonomous subject is impervious to external force or compulsion; free to act upon the world, but resistant to being acted upon by it in return. This defensive orientation was informed by the fact that early paradigms of political autonomy were rooted in the ontological structures of the emerging bourgeoisie. Here the open space of autonomy is given a more active orientation through its linkage to nascent concepts of property and possessive individualism.[2] The bourgeois

self was not simply resistant to external pressure but capable of advancing its own appropriative project. We find a key expression of this shift in the writing of Thomas Hobbes, whose political theory replaced the network of reciprocal moral obligations characteristic of feudal society with a privatized concept of the subject, reduced to an isolated, individual will.[3] The "natural law" tradition, associated with Hobbes, Locke, Grotius, and Pufendorf, provided a complex philosophical justification for the individual's ability to possess independent things in the world, beyond the physical boundaries of the self. It was precisely in expanding the domain of the self, and in accumulating the material resources necessary to sustain personal existence, that the autonomy of the subject from external determinants (embodied in institutions such as the church or the court) could be secured.

The act of possession was not simply an expression of self-interest; it also provided the foundation for a new, emancipatory social order in which freedom was universalized. Property-based models of the autonomous subject held out the promise that anyone who was willing to invest the labor necessary to cultivate nature, and achieve economic independence, was entitled to full political representation. In this sense, property-based social systems were intended to be radically egalitarian in comparison to the static principles of consanguinity that determined one's political status under feudal systems. Moreover, the expansion of the self entailed by possession also endowed the property owner with a transcendent, quasi-cosmopolitan perspective.[4] The propertied subject does not exist in sublime isolation from the world, but rather enjoys an active, transformative relationship to it. Thus, to the autonomous self that sees all other subjects as potential threats to be repelled, we can add a second permutation: the self that views those same others as a potential resource to be consumed. In fact, the autonomous subject is dependent on the world, and the resistant experience of otherness presented by objects not yet possessed, for the maintenance of its own ontological boundaries. In this new configuration autonomy does not simply imply separation *from* others, but rather a form of nonreciprocal agency in which the autonomous subject alone is able to exercise a transformative power *over* others. This appropriative paradigm would easily enough be used to rationalize European colonial expansion in the early modern period, when settler-colonists sought to justify the occupation of other lands, and the subjugation of other peoples, as the necessary response to societies that failed to make sufficiently productive use of nature's bounty. It reaches its apotheosis in the Atlantic slave trade, in which the body of the other was literally appropriated, bought, and sold.

While the discourse of political autonomy claimed to have identified an innate human capacity for freedom, it nonetheless depended on an implicit hierarchical system in which humanity as such is divided between those who are deserving of freedom and those who are not, between those who are destined to exercise a transcendent mastery over the natural world and those who are consigned to the status of property. In this manner, the ostensible universality of the human self inaugurated in the wake of desacralization was betrayed by the class-specific paradigm of possessive individualism on which it was based. And this paradigm was based, in turn, on a more fundamental discursive structure, rooted in the sixteenth-century theological division between the "elect," who are destined for salvation, and the sinful, who are enslaved by their bodily appetites and consigned to hell. As Sylvia Wynter has argued, this set of beliefs emerged out of the historical event of European colonial expansion as the Spanish and Portuguese encountered indigenous, non-Christian peoples in the New World. This complex encounter, across boundaries of race, culture, and ethnicity, exercised a decisive influence on the new, secularized concept of man that emerged during the Renaissance. As Wynter contends, a theological model of the human self did not end with the process of desacralization. Rather, it was recoded through a new set of hierarchies based on the relative capacity for rational thought. "This was the relation," as Wynter writes, "between the European settlers classified as by nature a people of reason and the non-European population groups, 'Indians' and 'Negroes,' classified as 'brute peoples without reason' who were no less naturally determined to be so."[5] This tension is evident in Kant's writing, in which he claims to have identified a universal human propensity for reason, while simultaneously dividing the category of the human itself into a series of racist divisions in which Africans are destined to remain cognitive inferiors to Europeans, capable of "no feeling that rises above the trifling."[6]

The emancipatory potential of reason lay precisely in the claim that it constituted a universal human attribute that could provide the foundation for a political system based on shared, consensual decision-making, rather than the imposed hierarchies of absolutist governments that cast their subjects as childlike dependents. And yet, as Wynter demonstrates, the very concept of man on which this new discursive system was based renewed the previous hierarchical divisions associated with Christian theology, in the relationship between the civilized European and non-European peoples who were unable to transcend their barbaric and animal-like nature. In this view,

the non-European other constructed through the experience of colonization serves as the "constitutive outside," in Derridean terms, which structures the fundamental ontology of secular, humanist man. This set of oppositions, of spirit and flesh, mind and body, human and animal, will provide the template for a series of subsequent ontological divisions, including those that were presumed to exist between the bourgeois and the working-class subject. As Wynter observes, "if internally, the servants and alms-takers category represented lack of reason in relation to the middle class then at the global level, it was non-Western cultures and peoples that represented varying degrees of the lack of reason."[7]

The initial version of secular humanism that comes into existence following the Renaissance would provide a key ontological foundation for Enlightenment thought. During the nineteenth century, it underwent a further modification in conjunction with the theory of evolution, which placed human and animal in a clearly ordered hierarchy. Here the Darwinian notion of evolutionary adaptation provided the quasi-scientific imprimatur for a further refinement of bourgeois possessive individualism, in which one's identity is secured in the act of transforming the natural world. Now the hierarchical ordering of human selves is dictated by the objective power of evolution itself via a process of "natural selection" that places non-Europeans in closer proximity to apes and animals. By extension, it leads to a discourse of racial purity associated with the privileging of whiteness that persists to the present day in the politics of white supremacy. This broader discursive system will, as Wynter writes, be "empirically institutionalized" in the "colonizer/colonized relation" between the West and "the islands of the Caribbean and, later, on the mainlands of the Americas," through the nineteenth and twentieth centuries.[8]

The scandal of autonomy in the Enlightenment is associated with the revolutionary claim that one could, in fact, claim independence from such long-established institutions as the church and the monarchy. But autonomy is also Janus faced. Its obverse entails a reconstitution of authority through a form of selfhood premised on the act of instrumentalizing not simply the natural world, but also those human subjects who are defined as nature like themselves. One becomes autonomous from an existing external power by inverting that subordinate position and adopting the same position of external authority relative to another subject (the worker, women as chattel, the colonized native), who becomes the raw material necessary to establish the fixed contours of a newly empowered identity. This mimetic inversion

thus leaves intact the notion that human consciousness as such is intrinsically appropriative and that society as a whole exists as a domain of competing, self-interested individuals contending over a limited pool of natural resources and set decisively apart from a subaltern class of dependent human selves who are incapable of autonomous freedom. While this is, in fact, an accurate description of aspects of the emerging bourgeois worldview, it also forecloses, at the speculative level, the possibility of a different model for how the self might relate to the other within modern society; one that does not simply reproduce the prevailing appropriative model. At the same time, by treating any force or agency external to the self as either a threat to be repelled or a resource to be consumed, the concept of autonomy valorizes the monological individual as the singular origin of all critical insight (e.g., the questioning of existing norms) and creative agency (e.g., the transformation of the self, the development of new norms). In each case, the relation of this monadic self to others is characterized by a process of negation, in which the unique agency of the other is devalued or entirely effaced. It is this last characteristic that will link the bourgeois concept of autonomy to its subsequent rearticulation in the discourse of the avant-garde.

On the one hand, the discourse of autonomy opened up the dizzying prospect of a world turned upside down and reinvented in accordance with nascent liberal principles of justice and equality, rather than the arbitrary will of a monarch. On the other hand, the fact that this new world was as yet only hypothetical led to an anxious search for new principles of social cohesion, and an underlying concern about the "true" nature of humanity, once released from the bonds of sacral authority. What collective beliefs and values would hold this incipient society of newly liberated subjects together and help to mitigate the instrumentalizing self-interest that is the potential concomitant of the turn toward autonomy (especially under the influence of emerging forms of capitalism)? This question touches on a key point of tension within the discourse of autonomy. To be autonomous means that I alone determine the principles by which I regulate my own conduct, but this ignores the fact that the actions that I take, on the basis of my self-generated normative values, might harm another, equally autonomous, self. It assumes, as well, the status of the "I" as a fixed point of ontological stability on which static norms can be founded, even as the process of consensual will formation entails a necessary erosion of the defensive boundaries of the self. The very concept of autonomy is predicated on this contradiction. The answers to these questions take us into the domain of aesthetic theory itself.

The Aesthetic as Alibi and Prefiguration

On the wings of taste ... the fetters of serfdom fall away from the lifeless and the living alike. In the Aesthetic State everything—even the tool which serves—is a free citizen, having equal rights with the noblest.
—Friedrich Schiller, *Letters on the Aesthetic Education of Man* (1794)

The discourse of autonomy presents us with one of modernity's central contradictions. How do we reconcile a model of the self premised on the negation of otherness (and driven by the instrumentalizing logic of the market) with the desire, equally central to the postabsolutist moment, for a new social system based on universalized principles of justice and the reciprocal openness of self to other? This contradiction is all the more glaring because of the ongoing persistence of structural economic inequality in modern society, even after absolutist forms of political power had begun to wither. As a result, the bourgeois subject was confronted by the cognitive dissonance between their commitment to autonomy and freedom for themselves, and their dependence on an economic structure in which this same freedom is denied to others. It is the *systematicity* of this difference that must be denied: the fact that it is the inevitable consequence of the existing economic system from which they materially benefit. This new form of autonomous subjectivity had to justify its political legitimacy in a historical context in which truth claims could now be challenged through public debate. It was also forced to contend with the direct opposition of subaltern subjects (workers, slaves, rebellious colonial subjects, etc.), who understood quite clearly the ways in which the universalization of freedom and independence promised by liberal political philosophy was blocked by entrenched forms of economic domination.[9]

We might consider the evolution of bourgeois political thought as a series of dialectical movements. The first movement combined the negation of absolutist domination with the assertion of a new social formation predicated on possessive individualism and the independent ownership of property. The self that was previously consigned to a fixed position within the hierarchy of the great chain of being was now able to exercise new forms of agency that allowed for its creative reinvention through the transformation of nature. The second movement occurred as the limitations of possessive individualism became evident; specifically, the impossibility of its universalization under the constraints imposed by a market-based economic system. This took place through the direct contestation of bourgeois political authority in the public sphere. By the late eighteenth century we can observe the emergence of a

strand of thought within liberal political philosophy (and in Romanticism more generally) that was directly critical of the market system.[10] The result was a second cycle of negation, as the principles of capitalism embodied in the personality of the bourgeois individual were repudiated through the ideal of a disinterested subjectivity that encourages, rather than circumvents, the harmonious interaction of self and other.

This therapeutic reconciliation of self and other is, of course, exemplified by the discourse of the aesthetic. It is worth recalling the extent to which both Kant and Schiller advanced overt critiques of proto-capitalist social values. We need only consider the frequent references to the perils of rampant "self-interest" in Kant's ethical philosophy. Self-interest for Kant involves an often-insular appeal to our personal appetites and needs, in which a privileged class "keep the majority in a state of oppression, hard labor, and little enjoyment."[11] It will be challenged by a cosmopolitan aesthetic disinterest in which we attend to objects not because they can satisfy some individual desire, but because they elicit a genuine transcendence of the self. Schiller, as I noted earlier, attacks the dominance of "economic self-interest" in contemporary society and the "fragmentation" that reduces each individual to a cog in a larger machine of modernist efficiency.[12] And in 1825 Saint-Simon, the progenitor of the modern concept of the avant-garde, would encourage the contemporary artist to exercise a "true priestly function" over "individualistic egoism," that "bastard fruit of civilization."[13] We are now in a better position to appreciate the significance of the aesthetic in Enlightenment thought. The value of aesthetic philosophy resided in its claim to have identified a core propensity toward social harmony; a new binding principle that no longer relied on external coercion but was immanent, albeit dormant, in the human personality itself. Crucially, this capacity was manifested at the most individual and intimate level of the self, in our bodily experience. Under the tutelage of an aesthetic encounter, we will be brought to a deeper appreciation for the other, not through the abstract diktats of reason, but through the subjective pleasure set in motion by the experience of beauty, exemplified most fully in our experience of art.

The autonomy of aesthetic experience can be more accurately understood as a reflection of the autonomy of the modern subject, who is increasingly free to question societal norms and engage in his or her own acts of judgment. In this respect it is dependent on the principle of political autonomy that precedes it, to the extent that the subject of aesthetic experience shares a capacity for critical self-reflection. At the same time, the process of aesthetic self-transformation promises to preserve the unique specificity of the

other, rather than reducing them to an instrumentalized resource (in effect, retaining the core of ethical intersubjectivity that had been sacrificed with the appropriation of political autonomy to the project of possessive individualism). The political implications of this capacity for a mutually enriching intersubjective encounter are profound. It expresses the ontological openness necessary to develop new forms of social organization through reciprocal interaction rather than monological decree. In aesthetic perception, the instrumentalizing gap—between subject and object, self and other, and humankind and resistant nature—is at least virtually transcended, and we recognize the possibility of an intersubjective harmony that might transform the world as a whole and our appropriative relationship to it. Far from being alienated from the world "outside" the self, onto which we must violently project our possessive appetites, the aesthetic reveals a previously unrecognized capacity for intersubjective openness that rejects the capitalist reduction of nature to raw material and other subjects to the fixed categories of enemy, competition, or chattel.

This capacity was not yet widely manifest in actual human conduct. Rather, it represented a potential, awaiting activation by the appropriate aesthetic stimulus (hence, the frequent recourse in early aesthetic philosophy to the division between a small circle of advanced savants and the philistine masses awaiting enlightenment). As Kant warns in "What Is Enlightenment?" (1784), "Laziness and cowardice are the reasons why such a large proportion of men . . . gladly remain immature for life. For the same reasons, it is all too easy for others to set themselves up as their guardians. It is so convenient to be immature!"[14] If the public, in its current state, is incapable of freeing itself from the oversight of external "guardians," then the aesthetic will take on an essentially custodial function, carrying forward the possibility of our eventual emancipation from a self-imposed "tutelage." In the Enlightenment aesthetic, the promise of a harmonious social order is projected into the future, in the form of an anticipatory sensus communis. "In the realm of Aesthetic Semblance," as Schiller writes, "we find the ideal of equality fulfilled which the Enthusiast would fain see realized in substance."[15] As a result, aesthetic experience is characterized by a central tension between the speculative generation of new norms and their material embodiment or realization in daily life. On the one hand, it provides a necessary space of prefigurative experimentation in which new modes of reality can be imagined, while on the other, it can operate as a principle of delay or deferral. Here bourgeois liberalism can point to the partial, symbolic fulfillment of its utopian promise, in the segregated realm

of fine art, to defuse calls for its more immediate and universal realization. The prefigurative quality of aesthetic experience was only ever intended to awaken in us a pressing desire for a more harmonious and equitable social order here and now, and to initiate the forms of consciousness necessary to bring it into practical existence. So long as the transcendent experience of art, and the leisure time necessary to enjoy it, remains the singular privilege of the upper class, this projective quality is all too easily subsumed in an exculpatory defense of the status quo.

Building the Aesthetically Tempered Man

Since it is a good thing to know how to use men as they are, it is even better to make them in the way one needs them to be.
—Jean-Jacques Rousseau, "Discourse on Political Economy" (1758)

For Kant, the realization of a harmonious social order was assumed to be possible through a gradual process of collective education. And while aesthetic experience might play a role in this process, it was hardly unique, being no more important than the broader circulation of Enlightenment ideals in the form of books, commerce, and formal education. Both of these beliefs are challenged by Schiller. First, Schiller identified art, specifically, as the singular agent of a renewed consciousness, superior to all other cultural modes. In particular, he has in mind more populist forms of literature, which were the by-product of expanding literacy in Germany during the late eighteenth century. Here an aesthetic sensus communis would be acted out through forms of drama and poetry, which transcended the class differences between an elite coterie of court-based artists and the broader public. Thus, Gottfried August Bürger, one of the most popular writers of the Sturm und Drang movement, called for a reform of literature, in order to make it more broadly accessible. "Get to know the people," Bürger urged his fellow poets in 1776, "eavesdrop on the ballads and popular songs under the linden in the village, in the bleach-yard, and in the spinning room."[16] Following his early commercial success, Friedrich Schiller shared Bürger's enthusiasm for populist art. However, after his subsequent plays failed to attract an audience, he struggled to survive as a writer. He was rescued from the vicissitudes of the market through his timely employment by the Duke of Augustenburg. It was under the Duke's patronage that he wrote his famous *Letters on the Aesthetic Education of Man*, in which he argues that the artist must transcend the "degraded" tastes of the masses. "The

first, essential condition for the perfection of a poem," Schiller observes, "is that it possess an absolute intrinsic value that is entirely independent of the powers of comprehension of its readers."[17] He would later chastise Bürger for "mingling with the people, to whom he ought merely to condescend, and instead of elevating them to himself jokingly and playfully, he is often pleased to make himself their equal."[18]

Second, in Schiller's work the concept of temporal deferral (the period of time required for the broader diffusion of a redemptive aesthetic consciousness, necessary to transform the world) is given a much more specific historical articulation. Thus, where Kant would contend that aesthetic experience can help "guide" (*Geleitet*) the new forms of moral consciousness necessary for the practical creation of postabsolutist political systems, Schiller will make the more radical argument that *any* attempt to transform existing political institutions is premature until humanity as a whole has undergone an "aesthetic modulation of the psyche."[19] "We must continue to regard every attempt at political reform as untimely," as Schiller writes, "so long as the split within man is not healed, and his nature restored to wholeness."[20] This position is the result of Schiller's pessimistic assessment of the French Revolution, which represents for him the tragic evidence that humankind is not yet prepared to be free from the yoke of external repression.[21] As we shall see, the perception that humanity is incapable of engaging in substantive political change without some custodial oversight will become a key motif in the discourse of the avant-garde as well.

Schiller's work demonstrates the important causal linkage between the temporally deferred realization of an aesthetically grounded process of social reconciliation (due to the generic limitations of existing human nature) and a spatial displacement, in which the cognitive insight necessary to visualize this reconciliation is partitioned off from the forms of social and political practice necessary to produce it in reality. Schiller's inspiration here, of course, is Kant's account of aesthetic experience in the *Critique of Judgment*. At the core of Kant's aesthetic is the uncoerced "harmony" of the faculties. The faculties include reason, the seat of the restless drive to expand human knowledge, the understanding, which supervises the "material" labor of cognition, and the imagination, which is closest to our immediate experience of the world and organizes sensory experience. In normal acts of cognition, the imagination delivers a "manifold" of sensory data to the understanding, which then seeks to match those data with an existing set of empirical concepts. It is the strenuous cognitive labor of squeezing experiential reality into the procrustean bed of a given concept that is suspended

in an aesthetic encounter. Rather than being "forced" into agreement with the concepts provided by the understanding, in aesthetic experience, the imagination, of its own accord, organizes sensory experience in such a way that it becomes effortlessly cognizable to the understanding.[22] We might think of the harmony of the faculties as rehearsing, at a cognitive level, the reconciliation of the individual self (embodied by the imagination) and the social (embodied in the normative, law-giving power of the understanding).[23] To the extent that the imagination can be identified as the seat of our most individualistic and creative sense of self, where we literally "feel" ourselves as discrete subjects, aesthetic experience reassures us that we are, at our core, predisposed to what Kant would term "lawfulness," embodied in the imagination's capacity for self-regulation. Here the fear that humanity's natural impulses, unleashed from the regulatory control of a coercive external power, would devolve into a destructive social antagonism, is assuaged by the anticipatory harmony of the faculties in aesthetic perception.

Aesthetic experience, understood in these terms, helps us intuit our underlying connectedness to others, but only by detaching us from any direct interaction with the world as we withdraw into a contemplative "apperception" of our own cognitive powers. Here the system of political autonomy outlined earlier in this chapter is recoded in aesthetic form. Both models depend on a concept of the subject defined by a radical division between self and other, inside and outside. The core self, the self that must be transformed in order for substantive political change to occur, is formed *prior* to any social or intersubjective experience and must be re-formed at that same, presocial level through aesthetic experience. The only generative space is the space of an internal consciousness, closed off from external influence, and the only generative process entails a privatized act of self-reflection. This same dynamic is reproduced by Schiller. For Schiller, the impasse created by humanity's violent and selfish nature will only be resolved by the cultivation of a new form of subjectivity, embodied in his concept of the "aesthetically tempered man."[24] The creation of the aesthetically tempered man involves the facilitation of a strategic regression, where we exist "free of all [external] determination."[25] The work of art, in order to produce this regression, must itself be withdrawn from any connection to the prosaic world of daily life or practical existence.[26] The movement away from the experiential world into semblance also implies a movement away from the body, and its sensuously mediated connection to that world, into a realm of pure, mental contemplation.

Schiller's corollary to Kant's harmony of the faculties involves a process of "free play" between the "form-giving drive" of reason and the "sensuous

drive" of feeling and emotion. The "form-giving" or "rational" drive, according to Schiller, is "awakened with our experience of the law" and the "sensuous" drive "awakens with . . . the beginning of our individuality."[27] For Schiller, the reconciliation of the individual self and the normative social world evident in the harmony of the faculties is now rooted in historically specific subjectivities. Thus, the form-giving drive is associated with the "enervated" aristocratic classes ("civilized man"), who are incapable of emotional attachment due to their overreliance on reason, while the "sensuous drive" is associated with the "passionate" working class ("natural man"), who can feel strong emotions but are incapable of subordination to rational law. In aesthetic experience, these two subjectivities will be reconciled through a "play drive" that selectively "tenses" and "relaxes" the form-giving and sensuous drives in the virtual space of semblance. Here class difference is transcended through the aesthetic encounter. While this experience can evoke for us "the most perfect of all works of art—the establishment and structure of true political freedom," it can contribute nothing to the practical realization of that freedom without sacrificing the very autonomous purity that allows it to be envisioned in the first place. "It is in the world of semblance alone," as Schiller writes, that the artist possesses a "sovereign right . . . and he possesses it there only as long as he scrupulously refrains from predicating the real existence of it in theory, and as long as he renounces all idea of imparting real existence through it in practice."[28] From this perspective, the aesthetic can be understood as the reactive inversion of a repressive system of absolute, external power. If that system allows for no individual freedom and impinges on our most intimate thoughts and actions, then its overcoming can only be affected by a discursive system predicated on an equally absolute and inviolable subjective autonomy, through which we will discover the "Supreme Reality" of the human spirit.[29]

 Schiller seeks to resolve the disjunction between a paradigm of political autonomy based on an instrumentalizing and "cold hearted" mastery of the world and the forms of intersubjective openness necessary to engage in consensual will formation that might be produced through an aesthetic encounter. In fact, the very balancing of our "animal" and "spiritual" natures outlined in his concept of aesthetic play implies a retuning of the self, now open to the transformative experience of otherness through a form of autopoiesis. At the same time, Schiller's response to this situation entails the naturalization of a paradigm of subjective autonomy that bears the imprint of the very ontology it sought to unsettle. Thus, the emancipated self evoked in *Aesthetic Education*, defined by an absolute cognitive freedom, can only be

established against the grain of a subject defined by subordination and dependence (the masses driven by their "coarse, lawless impulses"). Of course, Schiller is also critical of the calculating "egoism" of the "refined classes," but the final paradigm of the self toward which his theory aspires clearly privileges spirit over animal and mind over body. Schiller does not simply dismiss the importance of bodily experience. As he writes, "The wisest of purposes is served by the power exerted by animal sensations on the sensitivity of our soul." Without this plangent reminder of the material world, we would abandon ourselves entirely to the dematerialized realm of pure thought. Thus, the body provides the material grounding necessary to keep our consciousness mindfully rooted in experiential reality. However, beyond this supplementary role, "the domination of the body ends": "Otherwise it is the soul's slothful companion . . . whose assaults sever the thread of the most profound speculation and snatch the spirit from its clearest and most lucid ideas, plunging it into physical chaos. Its desires carry most of our fellow-beings far from their lofty origin and debase them to the level of brutes."[30] The body, then, is ultimately a pernicious and arbitrary force, which must be held in check by the supervisory wisdom of a speculative consciousness. As Nicholas Germana has noted, the division between reason and emotion, and between mind and body, which structures the relationship between the bourgeoisie and the working class in Enlightenment aesthetic thought, is linked with a whole series of subaltern others, including women, children, and "oriental" subjects whose "childlike immaturity and dependence" served as the contrast necessary to "define an ideal of freedom that took as its foundation the historical maturation of the human race toward rational, moral perfection."[31] Here we encounter a symptomatic ideological chain in which lawlessness, excessive emotion, and an incapacity for reason are mapped onto both working-class and non-European subjects, who enter the European imagination through the process of colonial expansion referenced above.

Aesthetics from Below

We who are interested in alternative Development propose an ab-use (not abuse) of the Enlightenment (understood in shorthand as "the public use of reason"), a use from below.
—Gayatri Chakravorty Spivak, "1996: Foucault and Najibullah" (2003)

The concept of an aesthetic state in Schiller's writing holds out the hope that societal norms and values can be generated in a democratic and consensual manner, rather than being unilaterally imposed by a sovereign power. But it

also assumes a symptomatic hierarchical division between the author or savant, who enunciates this promise, and the public, consigned to the "slavery of the animal state," who are destined to fulfill it.[32] For Schiller, the public, in its current form, is incapable of exercising this freedom without impinging on the freedom of others. Thus, aesthetic experience is the essential supplement to political autonomy in the European tradition. Its role is to facilitate the transformation of human consciousness necessary to prepare the public for its eventual emancipation. Since the members of the public still exist in a condition of cognitive and moral servitude, this transformation must be undertaken by an external authority who already possesses this capacity (the artist, the philosopher). As a result, the modern aesthetic always carries along with it the assumption of the viewer or public's fundamental incapacity to engage in social interaction without resorting to intersubjective violence. This system is meant to resolve the symptomatic slippage between autonomy as freedom *from* externally imposed coercion and autonomy as sovereignty *over* the external world. Thus, it seeks to avoid the danger of a newly autonomous subject simply imposing their self-generated values onto others by awakening within us a recognition of our shared humanity, but in doing so it effectively reproduces a variant of the same instrumentalizing relationship it initially pledges itself against (the enlightened artist or theorist taking on a quasi-parental relationship to the "immature" public). It is this a priori cognitive and moral deficiency that necessitates the virtualized forms of social interaction made available by aesthetic experience, which can only operate in the realm of semblance (the pages of a novel, the painted canvas). In this view, one can achieve critical insight into the constitution of the self (and the imbrication of the self and the social) only in isolation from other selves, through contemplative self-reflection. Here we can identify the epistemological foundation for a series of beliefs that continue to define our understanding of art to the present day.

Notwithstanding these constraints, the discourse of the aesthetic captures, in its very contradictions and displacements, a set of core problematics that remain central to our understanding of creativity and political change to the present day. While the Enlightenment concept of the aesthetic clearly bears the traces of its bourgeois origins, it is also the source of one of the most strenuous philosophical challenges to the principles of possessive individualism. The unfolding discourse of the aesthetic constitutes an important space in which we might still envision and enact new modalities of the political. As Kandice Chuh argues in *The Difference Aesthetics Makes*, "aesthetic inquiry emphasizes the link between what is held to be reasonable and what

is viscerally experienced. In that way, it brings forward the doubled meaning of sensibility... and the sensus communis as a key domain of political struggle."[33] The career of the Caribbean intellectual and activist C. L. R. James exemplifies the complex nature of this legacy. "I denounce European colonialism," as he wrote in 1980, "but I respect the learning and profound discoveries of Western civilization."[34] In a similar manner we find Léopold Senghor proposing an aesthetic paradigm based on the principle of Négritude, in which "the West's own humanist ideals were more fully realized than in the alienated societies of modern Europe," as Gary Wilder observed.[35] Where Schiller will discover his aesthetic ideal in ancient Greece, Senghor will define the art of Africa as a "gift" that would "link flesh to spirit, and man to his fellow man." Rather than one culture subsuming the other, he describes a process of cultural hybridity (*métis*) in which the qualities of each are combined.[36]

Instead of simply rejecting the traditions of Enlightenment thought in their entirety (which extend, of course, to the insights of Marxism itself), we must, as Gayatri Spivak describes it, "ab-use" them, recovering and reinventing a potential that has been lost or not yet realized. In *Enlightenment against Empire*, Sankar Muthu urges us to "pluralize" our understanding of the Enlightenment and to recognize that it holds within itself a range of often conflicting beliefs and values, reflective of its time.[37] While it is certainly possible to identify a central strand of Enlightenment thought that was used to justify the cruelty of colonial domination, there is also a robust, anti-imperialist tradition associated with figures such as Rousseau, Montaigne, Diderot, and Herder. This tradition is exemplified by Diderot, who writes, in *Histoire des deux Indes* (1772):

> Beyond the Equator a man is neither English, Dutch, French, Spanish, nor Portuguese. He retains only those principles and prejudices of his native country which justify or excuse his conduct. He crawls when he is weak; he is violent when strong; he is in a hurry to enjoy, and capable of every crime which will lead him most quickly to his goals. He is a domestic tiger returning to the forest; the thirst of blood takes hold of him once more. This is how all the Europeans, every one of them, indistinctly, have appeared in the countries of the New World. There they have assumed a common frenzy.[38]

Diderot predicts the eventual emergence of a "Black Spartacus," who will lead the subjugated peoples of the New World and Africa in an uprising against European colonial power—a prediction, as Muthu notes, that would go on to

inspire Toussaint L'Ouverture. Rather than viewing Europe as the idealized expression of an evolved humanity, we find these thinkers openly attacking the corruption, violence, and materialism of their own culture, and holding up the societies of the New World as exemplifying a morally superior form of civilization. They have retained "alive and vigorous," as Montaigne wrote, "their genuine, most useful and natural virtues and properties, which we have debased . . . in adapting them to gratify our corrupted tastes."[39] As the French writer Louis-Armand de Lom d'Arce observed in 1703, following his encounters with indigenous societies in North America, "the name of savages that we bestow among them would fit ourselves better."[40] Herder, for his part, openly rejects the hierarchical discourse prevalent during the late eighteenth century, which casts non-European societies as the barbaric antithesis of civilized Europe. As he argues in his *Letters on the Advancement of Humanity*, "There is no such thing as a specially favored nation on earth. . . . Least of all must we think of European culture as a universal standard of human values. The culture of *man* is not the culture of the *European*; it manifests itself according to place and time in *every* people."[41]

As Muthu notes, in its early stages, anti-imperialist sentiment often succumbed to the ethos of the "noble savage," which simply inverts the binary structure of Eurocentrism. Now, the childlike purity of non-European societies (whether from Africa, Asia, or the New World) serves primarily as a device to attack the "decrepitude" and corruption of existing European society. In this process the cultures in question were reduced to reified artifacts, incapable of growth, complexity, or contradiction. However, the infantilization of the noble savage was displaced by a more thoughtful analysis, evident in Diderot and Herder, who reject the belief that non-European societies exist in some eternally arrested primordial state. Instead, Diderot and Herder introduce a key differentiation in which the human subject is not defined by the possession of some fixed and unchanging essence (to be variously nurtured or corrupted), but rather is produced through an ongoing process of cultural exchange and co-creation, which is specific to each region of the globe. In this view, as Mutha contends, Diderot understands the human subject first and foremost as a "cultural agent" who is "shaped by and situated within cultural contexts, yet also able to consciously and freely transform themselves and their surroundings."[42] In this context Herder describes the "human being . . . as a pupil of the ear, which first teaches him gradually to understand the language of the eye. The difference of things must be imprinted on his mind by the voice of another; and then he learns to impart his own thoughts."[43]

While we may be endowed with an innate capacity for reason, as Herder continues, "we are not capable of possessing or acquiring it by our own power." Here human subjectivity is not the expression of an innate condition (of reason or irrationality, of spirit or flesh), but rather is relational and changing. It is produced dialogically, in the interstices between self and other, and between one culture and another, through a process of self-invention that clearly has aesthetic overtones. Here cultural difference is not pathologized, but instead becomes the very precondition for an evolving form of selfhood. I will return to this paradigm of a relational self later in this book. Here I simply want to note the contrast that is already evident between Schiller and Herder. Of particular importance here is Herder's image of human beings as agents, capable of coherent and creative action, which stands in contrast to Schiller's image of the public defined by incapacity or incompletion, worthy only of being acted upon by a benign, civilizing influence. Where Schiller disparaged the culture of the "bleaching yard" and insisted on the primacy of classical aesthetic sources for the poet or playwright, Herder was an early collector of European folk songs. Finally, his aesthetic theory was centered on a notion of cultural pluralism rather than cultural hierarchy.[44] Key to this set of beliefs was a capacity for empathy or *Einfühling*, a term invented by Herder to describe the forms of human perception necessary to comprehend experiences outside the boundaries of our own subjectivity or culture. However, as Muthu notes, for Herder, empathy alone is insufficient unless it is joined with a commitment to a standard of justice that would apply equally to self and other, European and African.[45]

Here it is necessary to preserve an understanding of the aesthetic as a discourse that is both with and against the Enlightenment. As I have suggested above, the concept of the aesthetic functions as a placeholder, subject to the vicissitudes of history, whose potential is not yet exhausted. But this space must be continuously reoccupied, this potential reinvented, with each historical moment, each shift in the strategic deployment of hegemonic power and practical resistance. By the early nineteenth century, what we might think of as the discursive structure of aesthetic autonomy was well established. It will, of course, undergo further modification later in the nineteenth century and throughout the twentieth century, but the primary components will remain remarkably consistent. I outline the most salient aspects of this structure in the following section. They revolve around a series of monological enclosures, between our "internal" cognitive apparatus and external reality, between aesthetic contemplation and action in the world,

between the body and the mind, between self and other, and between art and culture more generally. These are framed by a set of two interconnected claims. The first claim is that the experience of modernity (specifically, the materialistic self-interest promulgated by the capitalist system and colonial exploitation) has been deeply corrosive to the human personality, leading to the atrophy of our ability to treat others with respect and compassion. As a result of this quasi-pathological condition, we have been rendered incapable of engaging in the modes of free political association and creative reinvention made possible by the decline of absolutist systems of rule. As a further consequence, any direct action on our part to transform or ameliorate the deleterious aspects of unfolding modernity will end in failure unless we first engage in a process of individual self-reformation that will cultivate a capacity for social harmony that is innate but currently moribund. Given the extreme degradation of the human personality, this reformation requires a new mode of somatic conditioning capable of awakening our dormant sense of humanity and intervening in the constitution of the self at the deepest level. This leads to the second key claim. Aesthetic experience alone provides this new mode of conditioning. Art possesses a unique capacity, relative to all other forms of cultural production, to repair the damaged human personality. It does so by offering the recipient a prefigurative experience of reconciliation (of self with other), which lays the groundwork for our eventual participation in actual forms of political transformation. Due to the proscription against any direct attempt to bring about political change, this experience must, by necessity, unfold entirely within the consciousness of the individual viewer or reader via regression to a presocial state where the true self is located. A process of aesthetically driven self-reflection is the point of origin for all subsequent forms of political insight. Each of these claims carries a set of implicit assumptions about the nature of modernity, the potential for, or the impossibility of, substantive political change, and the role of art that will be carried over and reformulated in the discourse of the avant-garde.

Hegel and the Prehistory of the Avant-Garde

This multitude, who are capable of judging things only by their sensations, had been easily persuaded to make a comparison that goes something like this: What were we under royal domination, what are we under the Republic? The answer was entirely to the detriment of the latter.

—François-Noël Babeuf, "Babeuf's Defense"[46]

As I outlined above, the principle of autonomy that begins with resistance to absolutism (necessitating the defensive partitioning of the self as a bulwark against the intrusion of external religious or political authority) undergoes a crucial shift in its translation into a specifically aesthetic idiom. No longer concerned with simply preserving a generic concept of individual freedom against a monolithic external power, it takes on the more ambitious goal of transforming subjectivity itself, or rather of awakening an as-yet dormant mode of subjectivity, in order to resolve the incipient class tensions introduced by early capitalism. Now, the autonomization of the self is both protective and ontologically generative. It allows for the emergence of a new form of selfhood, better able to handle the intersubjective freedom made possible by desacralization, without lapsing into barbarism. As I have already noted, this rearticulated concept of autonomy retains the initial division between an authentic mode of being and an external principle of instrumentalizing control that threatens to corrupt it. Thus, the discourse of aesthetic autonomy hinges on the opposition between the interiorized domain of the self (experienced through reflection on the cognitive operations of individual consciousness) and an external reality characterized by rampant materialism, cultural degradation, and lurking social disorder, evoked by Schiller.

For Kant, as we have seen, the self was certainly affected by external reality, through the reciprocal loop created as the concepts of the understanding were modified by the new experiential data provided by the imagination, but the generative processes all occurred *within* the mind of the bounded and self-contained subject (for whom the datum of the world served merely as a cognitive raw material). Hegel, for his part, was profoundly dissatisfied with the modesty of Kant's ambitions (Kant was "too tender for things," as he famously observed), arguing that reason could, in fact, fully comprehend the essence of the world. This was possible precisely because external reality, far from being something external to the self, is, in fact, constitutive of subjectivity itself. The self does not simply come into being autochthonously, from within the confines of the individual consciousness. In fact, there is no (bounded) "self" to engage in acts of self-reflection prior to our exposure to, and immersion in, the world around us and, in particular, to other selves. Hegel thus sought to challenge the monological closure of the self that was characteristic of Kant's "mentalist paradigm." By contrast, the Hegelian self is defined by an openness to other selves and other loci of subjective experience. Hegel's effort to "de-transcendentalize the knowing subject," as Jürgen Habermas writes, draws our attention to the necessarily dialogical structure

of subjectivity more generally.[47] In this manner Herder's notion of the self, produced through the "voice of another," was refined and carried forward.

For Hegel, the familiar dualities of Kantian thought—self and other, subject and object, phenomena and noumena—are the artifacts of an incomplete understanding that fails to grasp their necessarily dialectical interconnection. The resolution of this incomplete understanding will be found in the philosophical interpretation of Geist ("mind" or "spirit"), a device that will be variously embodied by classical Greece, Christianity, the French Revolution, Napoleon, the modern Germanic state, and speculative thought itself. Geist represents the conative energy of reason, slowly coming to consciousness of its own multivalent nature and overcoming its fragmented incompletion through a process of dialectical rediscovery that concludes with the full realization of a "World Spirit" or Absolute Idea. In this homecoming of consciousness we come to recognize our fundamentally interdependent nature as human selves. Here we can understand humanity as a kind of collective "self," which completes the journey toward the Absolute as the complex composite of all the individual moments of dialectical insight that preceded its final apotheosis. As Joseph Chytry has noted, Hegel will contend that the ideal intersubjective encounters experienced only virtually in Kant's aesthetic have already begun to take concrete form in a series of interconnected historical stages.[48] Taken in the aggregate, they constitute the practical, experiential space in which the dialectical relationship between self and other is negotiated. Thus, what is only prefigured in the Kantian aesthetic encounter, our desire for a world in which we retain our unique nature while also discovering a harmonious common ground with others, becomes for Hegel the very engine of human progress.

This suggests the affinity between Hegel's Geist and the aesthetic sensus communis of Kant and Schiller.[49] This congruence is first evident in Hegel's Jena-period writing, where he employs Schiller's concept of an "aesthetic state" to describe the manifestation of Geist in classical Greece.[50] In Greece's "schöne Demokratie," as Hegel writes, all citizens lived in a state of free coexistence in a society dedicated to the cultivation of beauty.[51] The Athenian state was seen as exemplary not simply because it supported remarkable works of art, but because this cultural patronage was linked with a system of government that was committed to individual autonomy and democracy. The centrifugal force of personal political freedom, which might otherwise reduce society to an "agglomeration of atomic individuals" (as he writes in *Philosophy of Right*), was compensated for by the centripetal force of a

shared culture of beauty, in which art served as a literalized sensus communis, uniting individual Greek citizens in a common ethical community or *Sittlichkeit*.[52] As this outline suggests, Hegel will argue that the work of art possesses a privileged relationship to the unfolding revelation of Geist. In his *Lectures on Aesthetics*, he will describe art's ability to facilitate the sensuous expression of freedom in a way that makes it uniquely available to us. If the true, relational nature of the self has been hidden away within us, if we have learned to deny our own agency and to project it onto some externalized deity, art allows us to reclaim this agency through the authored manifestation of the self in the concrete form of an artwork. Thus, "the universal need for art," according to Hegel, "is man's rational need to lift the inner and outer world into his spiritual consciousness as an object in which he recognizes again his own self."[53] If the Kantian aesthetic is intuited wholly within the confines of the singular consciousness as it attends to the uncoerced harmony of the faculties, Hegel's aesthetic experience is produced through the artist's direct interaction with the materiality of the world. The "self" is extruded, so to speak, in the physical form of the artwork, in order that it can be recognized.

Philosophy, Art, and the Incompletion of the State

To know what one wills, and still more to know what . . . reason wills, is the fruit of profound apprehension and insight, precisely the things which are not popular.
—G. W. F. Hegel, *Philosophy of Right* (1820)

Hegel will eventually reject the Hellenistic nostalgia of Hölderlin and Schelling, pointing in the *Phenomenology of Spirit* to the dependence of Athens's beautiful democracy on the institution of slavery. Thus, the longed-for reconciliation of political freedom and creative community, symbolized by the age of Pericles, was ultimately failed. We are left instead with the elegiac image of an aesthetic state that could never be brought into practical existence.[54] It would take the unfolding of millennia of human history, through the decline of Greece, the transition to Roman order, and the eventual emergence of Protestantism, before this reconciliation would achieve its proper form in the modern Prussian state.[55] As he argues, "the development of the state to constitutional monarchy is the achievement of the modern world, a world in which the substantial Idea has won the infinite form [of subjectivity]. . . . The history of this genuine formation of ethical life is the content of the whole course of world history."[56] If aesthetic experience, for Kant and Schiller,

has as its telos the eventual reconciliation of the self and the other, the particular and the universal, in a new sensus communis, for Hegel, the Prussian state represents the practical realization of that goal.[57] In this manner both the coercive binding force of absolutism and the fragmenting force of the market would be overcome through the necessary unity of the political and the aesthetic in modern-day Germany. If aesthetic experience offered an exemplary model for the modern state, then the poet was its necessary legislator. Only the poet, as Schelling writes, possesses the "aesthetic force" necessary to make the concept of the ideal aesthetic state "accessible" and compelling to the general public.[58]

Here we encounter a symptomatic shift in Hegel's political thought. Democracy, which was so central to the integrity of the Hellenic state, takes on a much more attenuated role in his analysis of contemporary Germany. Rather, Hegel will contend that the growing scale and complexity of modern life (in particular the division of society into separate "estates," each with its own interests) has necessitated a new paradigm of governance in which the decision-making burdens imposed by a democratic system are transferred to the state and to the personality of the monarch.[59] Only the monarch, as a "sovereignty which contains all differences in itself," is capable of the "articulation of the whole" that is the necessary task of the Absolute.[60] Here the material processes of political negotiation between individual and collective interests that are at the root of democratic systems of government are displaced to a new transcendent authority as Geist becomes re-privatized in the consciousness of the monarch. The sovereignty that was a central feature of the absolutist system thus returns in modified form. It is a sovereignty constrained by the countervailing influence of the estates, but a sovereignty nonetheless.[61] Even the constitution, which is intended to impose some limits on the arbitrary rule of the monarch, must be treated "as divine ... and so as exalted above the sphere of things that are made."[62] As a result, the crucial linkage between the ideal of social harmony and its practical realization through collective political action (prefigured in aesthetic experience) was decisively loosened.

How do we account for this shift? It can be traced, in part, to Hegel's ambivalent response to the French Revolution.[63] While Hegel was more balanced than Schiller in his assessment of the revolution, he nonetheless felt that it revealed humanity's general level of political immaturity. The French people, driven by an unreflective and abstract concept of freedom, were incapable of tempering their desire for an absolute social transformation, even when it devolved into terror. As a result, the frustrated negating power of a free

will that refuses any negotiation with the concrete particularity of existing reality descended into a "fury of destruction."[64] Hegel would become increasingly skeptical about the political capacities of the "people," describing them in the *Philosophy of Right* as a "formless mass," too mired in "sentiment" to fully grasp the Absolute.[65] The consciousness of the "people," as produced in the form of "public opinion," constitutes a realm of "ignorance and perversity," which threatens to "infect" the reasoning of the state.[66] Notably, these are precisely the terms that Schiller used in questioning the degraded tastes of the German reading public, seduced by mere sensation and resistant to the appeals of suitably ennobling artistic practices.[67] As a result of this view, Hegel would reject as hopelessly naive the principle that "every single person should share in deliberating and deciding on political matters of general concern on the ground that . . . what is done should be done with their knowledge and volition."[68]

But surely, the telos of Hegel's system would imply an end point at which humanity in its entirety would experience a collective realization of its own freedom and creative agency, rather than a system in which this autonomy is simply delegated to the monarch on its behalf. Instead, we encounter here a transposition in which the aesthetic paradigm of uneducated masses and men of delicate taste, between those who are capable of aesthetic discrimination and those who are not, is given an overtly political form. We might say, in fact, that this division, initially centered around aesthetic experience, precedes and informs the subsequent political division between the "people" (incapable of reason and lawfulness) and the monarch or, as Hegel will argue, the philosopher himself. Here sensate knowledge is a signifier of the individual body, subordinate to the higher power of the intellect, while also being linked to the diminished mental capacities of the poor or working class, who are enslaved by their physical appetites. For Kant, the senses are like the "common people," who "gladly submit to their superior, [the] understanding."[69] The people, in this view, become a collective body dependent on the reason commanded by the monarch, who transcends his particularity and speaks for the public in general.

It would appear, then, that Geist is not *yet* fully materialized in the modern state, as we still require the mediation of an externalized "sensuous" container for its expression (in the person of the monarch). There is, moreover, a second level at which we might say that Hegel's identification of the modern state as the final realization of the Absolute is premature. This involves the persistence of forms of structural inequality produced by the operations of the estates themselves (the agricultural class, the business

class, and civil servants).[70] The estates, the same social institutions that are intended to forestall the diffusion of individual subjects into atomized particularity, also have the effect of producing economic inequalities that the state is unable to resolve. Thus, while Hegel praises the modern Prussian state as the "ethical whole and actualization of freedom," it is, at the same time, riven by a fundamental inequality. The "unimpeded activity" of (capitalist) civil society leads to the "amassing of wealth," on the one hand, and the "creation of a penurious rabble," on the other, which threatens to destabilize the entire social order.[71] As he writes in the *Philosophy of Right*, "The important question of how poverty is to be abolished is one of the most disturbing problems which agitate modern society."[72] In fact, Hegel will identify colonial expansion as the necessary solution to growing class tensions in Europe, as superfluous workers are shipped off to overseas colonies.[73] If, for Hegel, the course of world historical development culminated in modern Europe, then it was axiomatic that the cultures of Africa, Asia, and the New World were little more than way stations on the evolving flight of Spirit, or safety valves whose primary function was to alleviate class tensions within European society itself.[74]

The racial and class divisions of the modern European state threaten to reproduce the same contradiction that Hegel identified in his analysis of ancient Greece, in which a systematic form of repression (capitalism in the case of modern Germany) prevents the full "actualization of freedom" associated with the realization of Geist, leaving the hollow shell of a "beautiful" state enclosing a social order predicated on inequality and injustice. This insight will, of course, form the basis of Marx's critique of Hegel. We might say, then, that the modern Prussian state for Hegel possesses the proper final *form* of Spirit, but that it is still marked by incompletion. In fact, Hegel states clearly that the modern state is, precisely, *not* a "work of art" and cannot hope to achieve "the happy equilibrium which is the soul of Beauty and the condition of humanity" that was associated with the ideal (if not the reality) of Athenian democracy.[75] Modern society still requires, then, a mode of critical awareness that is external to the general public (understood as cognitively deficient), which can act in a custodial capacity to guide and correct it on its journey to self-realization. This autonomous intelligence would have the capacity to hold society accountable for the disjunction between its ideal form (defined by the universalization of freedom) and its concrete reality (a society based on class difference), while facilitating the ongoing enlightenment of the public. While the monarch functions to unify the disparate components of the state, his role is as much symbolic and functionalist

as it is cognitive.[76] Art and religion had previously served to hold up to humanity an aspirational embodiment of its own unrealized potential. Art, in its evolution from the physical opacity of the Symbolic, "in which an inner meaning rests concealed," to Classical sculpture, in which God first takes human form, to the Romantic era, in which art begins to forsake sensuous embodiment for the opticality of painting, marks the gradual progression of Spirit, finally freed from materiality and able to recognize itself as pure thought.[77] However, in the modern era, as Hegel would famously argue, art, as well as religion, had been superseded by philosophy, in the form of "speculative reason."[78]

Philosophy forms the necessary supplement to the modern state, which is defined by an as-yet unresolved contradiction between the possessive individualism cultivated by the capitalist system and the forms of reciprocal openness necessary to sustain a democratic system of government. Philosophy will keep before us the utopian potential of a sensus communis that can, as yet, only be anticipated in the virtual realm of speculative thought. This is how Hegel resolves the impasse between the scalar complexity of modern society, which inevitably produces conflicts that it cannot resolve, and the teleological drive of Geist, which constantly tries to push society beyond its present limitations. His response is to displace this teleological consciousness onto a special cadre of advanced thinkers, separated from society as a whole, who are able to preserve and sustain it. Finally, then, the capacity for a "profound apprehension," capable of grasping the totality of society and urging it toward its destiny, rests with neither the people nor their rulers, but with the philosopher, who acts as their surrogate. The philosopher is furthest from the practical exigencies of the political process, but most conversant with the dematerialized currency of "ideas" in their purest form (toward which this process aspires). For Hegel, the philosopher is the singularly privileged agent of an advanced form of critical consciousness within modern society. Like aesthetic experience itself, he is both catalyst and prefiguration. Only the philosopher is able to fully comprehend the essential nature of the modern social order as it struggles to reconcile the Absolute and concrete particularity. As he writes in the *Lectures on Fine Art*, "If general culture has run into such a contradiction (between 'inner freedom' and the 'necessity of external nature'), it becomes the task of philosophy to supersede the oppositions, i.e. to show that neither the one alternative in its abstraction, nor the other in the like one-sidedness, possesses truth."[79]

Here, in embryonic form, we find the idealized self-image of the theorist (or the avant-garde artist) seeking to correct the false consciousness,

and awaken the unrealized potential, of the people. We encounter, as well, a reiteration of the specular paradigm that was implicit in the work of both Schiller and Kant. In Hegel's version of this paradigm, there exists an occulted truth as yet inaccessible to the majority of people—a heretofore secret knowledge that holds the key to their emancipation but which they are too mired in sentiment to grasp. This truth cannot be acquired through practice or experience, but only via a kind of epiphanic revelation brought from outside their conscious reality. The philosopher alone bears witness to this truth and will reveal it to the public. Once shown this truth, the people will ascend to a higher cognitive level. This experience unfolds in two registers as the cognitive shift induced by exposure to speculative thought also produces an ontological transformation, in which the recipient learns to disavow sentiment and to judge from a transcendent perspective, becoming in the process a more fully evolved person. The philosopher, as Fichte argued, is the "Priest of Truth."[80] This phrase conveys the necessary detachment of the intellectual, who withdraws into an autonomous space of analytic contemplation. For his part, Hegel would define philosophy as "an isolated sanctuary," with its "servants" forming "an isolated priesthood, which ought not to consort with the world, and [from this sanctuary] has to protect the possession of truth."[81] In Hegel, then, the principle of autonomy, which we have tracked through aesthetic experience (in Kant) and the work of art (in Schiller), finds a new resting place, in the privatized consciousness of the philosopher, as the retranscendentalized manifestation of Geist.

The Discursive Structure of Aesthetic Autonomy

Hegel believed that the gradual progression of Spirit in its journey toward self-actualization had reached a sufficiently advanced stage that it no longer required the sensuous container of art to facilitate its ongoing movement. It was now able to dispense with physical embodiment entirely and take the dematerialized form of thought itself. The transposition of "art" and "philosophy" articulated by Hegel will emerge as a key feature of the modernist avant-garde. For the moment, I am less concerned with the interchangeability of art and philosophy than I am with the nature of the underlying discursive structure within which both are produced, which remains largely unchanged in Hegel's account. As discussed in the preceding section, this broader structure emerges as the composite of a range of ideas about aesthetic autonomy initially developed during the Enlightenment and effectively synthesized and extended by Hegel in the early nineteenth century. Here I

want to review some of the key features of this structure, which will be reproduced and modified in the transition to an avant-garde mode of artistic practice later in the nineteenth century.

The discursive structure of aesthetic autonomy is organized on two levels. The first level concerns what I will term the social imaginary of aesthetic philosophy. That is, it concerns the particular model of social reality implicit in the concept of aesthetic autonomy, and against which an aesthetic experience is presumed to unfold. This would include a paradigm of social or political transformation, as well as the ideal political system toward which this transformation aspires. It also includes a concept of human psychological development necessary to facilitate this transformation (i.e., a model of the kind of self that is produced by current social and cultural conditions, as well as a model of the transformed version of that self which will result from an aesthetic encounter). Two features of this level are particularly important for my analysis here. The first concerns the perceived incapacity of the masses. From Schiller's disdain for the "the childish understanding" of German readers to Hegel's assault on the "ignorance and perversity" of public opinion, the general population is perceived as incapable of higher forms of reasoning and self-reflection, and marked by a level of cognitive immaturity that renders them unfit for forms of political action intended to challenge the existing distribution of power (or even for full participation in democratic forms of government).[82]

For Hegel and Schiller, this incapacity is demonstrated by the perceived failure of the French Enragés during the 1789 Revolution (as they sought to "force" the transition to an ideal aesthetic state prematurely, before human nature was prepared for the freedom that this transition entails). "The masses," as Goethe wrote, "are respectable hands at fighting, but miserable hands at judging."[83] As a result of this incapacity, any form of practical, collective action, guided by the consciousness of the general public, and drawing on their own experience of political action, will fail. Praxis, in this view, is always premature. For Schiller, we must first undergo a process of aesthetic education, while for Hegel we still require the tutelage of the philosopher to resolve conceptual impasses. It is for this reason that the modern (Prussian) state had to deploy a complex set of bureaucratic systems designed to diffuse the autonomous decision-making power of the people (via the monarch, the estates, etc.). These mechanisms are intended, as Hegel writes, to "prevent individuals from having the appearance of a mass or an aggregate, and so from acquiring an unorganized opinion and volition and from crystallizing into a powerful bloc in opposition to the state."[84]

If the first level of this discursive structure is concerned with general assumptions about the nature of the self and of political transformation that frame the concept of aesthetic autonomy, the second level concerns the specific epistemological claims made on behalf of the work of art, and aesthetic experience more generally, in advancing this emancipatory vision. Because aesthetic experience operates at the level of individual somatic experience, it is uniquely equipped to transform the consciousness of the broad public, which is defined by its dependence on sensation rather than intellect. The idea that art alone is capable of this ontological reprogramming stems from the growing bifurcation between "fine art" and new forms of popular culture, identified by figures such as Schiller and Karl Philipp Moritz as early as the 1780s.[85] The result is an apophatic model of fine art that is defined by its differentiation from, and superiority to, all other forms of cultural production. In addition, the cognitive immaturity of the masses outlined above requires that the capacity for critical self-reflection that lies at the core of the aesthetics' redemptive power must be off-loaded to a surrogate (the artist or philosopher), who will carry this advanced form of consciousness on their behalf, engaging in the gradual propagation of an aesthetically augmented enlightenment.

While the aesthetic may reach us initially through our senses, its ultimate goal is a form of cognitive transformation that can only occur though a strategic rehabilitation of the core self, to what philosophers imagined was its originary state, prior to any external determination. To facilitate this ontological regression, it was necessary that aesthetic experience be produced through the individual viewer's self-reflective awareness of the operations of their own consciousness. In this privatized space, social interaction is acted out in our apperceptive awareness of the harmony of the faculties or the "free play" of the form-giving and sensuous drives. These are, in each case, psychic corollaries for actual forms of social reconciliation (the sensuous drive of the masses synchronized with the form-giving drive of the ruling class; the subjective realm of the imagination harmonizing with the socially normative realm of the understanding). The goal in each case is a form of self-transcendence that occurs through the prefigurative reconciliation of self and other in the aesthetic encounter. A key corollary assumption here is that all subsequent forms of intersubjective experience are simply the by-product of a deeper form of self-transformation that can only occur in isolation from the social.

2

COMMUNISM AND
THE AESTHETIC STATE

The Two Avant-Gardes

The idea of a new order of society must first have seeped through into people's minds.
—Jean Jaurès, "Yesterday and Tomorrow" (1907)

In this chapter I examine the ways in which the discourse of aesthetic autonomy outlined in the previous chapter was rearticulated in the nineteenth and early twentieth centuries, in conjunction with the emergence of an artistic avant-garde. I will also explore the complex interrelationship between the figure of the avant-garde artist and the vanguard revolutionary during this same period. In my discussion of the artistic avant-garde I refer not simply to individual works or artists, but to a broader discursive system consisting of formal movements, manifestos, journals, and new rhetorical and performative modes that, taken in the aggregate, reflect a significant change in the relationship between art, the state, and the public. Before I discuss some of the underlying continuities between Enlightenment and avant-garde modes

of aesthetic autonomy, I first need to address the clear differences. These are, of course, quite familiar to us. After all, the emergence of an avant-garde, associated in the French tradition with figures such as Courbet, Rimbaud, Baudelaire, and Manet, is typically seen as marking a profound overturning of the conventions of traditional aesthetic autonomy. The avant-garde artist vehemently rejects the idea that art constitutes a world apart from the exigencies of everyday life and (in some cases) the vicissitudes of actual political struggle. From Millet's images of the rural poor to Courbet's central role in the Commune to Pissarro's *Turpitudes Sociales*, we find ample evidence that the Olympian heights occupied by Schiller and Novalis have been abandoned for a direct engagement (or at least identification) with the vernacular culture and political interests of the poor and working class.

This thematic shift is consistent with the avant-garde rejection of the belief that art's primary mission is to "civilize" the viewer through exposure to ideal aesthetic forms associated with the experience of beauty. As early as 1845 we find the Fourierist Gabriel-Désiré Laverdant urging the contemporary artist "to lay bare with a brutal brush all the brutalities, all the filth, which are at the base of our society."[1] The goal of this revelatory act is a form of ontological disruption that inverts the aesthetics of the beautiful. Instead of inculcating a sense of social harmony through the experience of an anticipatory sensus communis, the artist will now force viewers to acknowledge their own contingent position as members of the bourgeoisie—the same class that has refused to universalize the freedom promised by aesthetic experience itself. By the late 1840s it was increasingly clear that the presumed linkage between the new modes of social consciousness engendered by aesthetic experience and the subsequent forms of practical action necessary to reconstruct the world in the image of the aesthetic state had been decisively broken. The experience of beauty (as evidenced by the academic painting that filled the salons of mid-to-late nineteenth-century Europe) had come to function as little more than a virtual escape for the middle class, eager to imagine that its own economic privilege was the result of an authentic struggle for individual autonomy rather than the by-product of a corrupt economic system. Here the beautiful artwork, far from holding out an ideal toward which society as a whole might aspire, simply mirrors back to bourgeois viewers the idealized perfection of their own sequestered existence. The avant-garde response to this shift is epitomized by Richard Hulsenbeck's famous manifesto *En avant Dada* (1920): "The Dadaist considers it necessary to come out against art, because he has seen through its fraud as a moral safety valve.... In this war the Germans... strove to justify

themselves at home and abroad with Goethe and Schiller.... Dada is German bolshevism. The bourgeois must be deprived of the opportunity to buy up art for his justification."[2]

As Hulsenbeck's reference to German Bolshevism indicates, one of the most decisive factors in the transition to an avant-garde mode of artistic production was the influence of Marxism. With the emergence in the late 1840s of a Marxist theoretical discourse and new forms of working-class political agitation, the culturalist model of social progress evident in the German Romantic tradition was transformed. The appeal to "universal" modes of reason was decisively challenged by a new body of theory that sought to expose the previously repressed class contingency of Enlightenment political and aesthetic thought. Schiller anticipates this new consciousness of social and economic division in his analysis of the distinct cognitive itineraries of the masses (passionate but immune to reason) and the aristocratic ruling class (rational but unfeeling). But Schiller's play drive is concerned with reconciling these two subjective modes, which for him represent the divided halves of a formerly integral self. The Marxist tradition, for its part, will identify each class with an ethical imperative; the parasitic ruling class (now bourgeois rather than aristocratic) will be utterly destroyed by the nascent proletariat, which contains within itself the emancipatory potential of the entire human race.

This valorization of violent destruction is characteristic of the avant-garde drive to assign primary creative value to the moment of negation in the dialectic rather than the subsequent moment of synthesis. Marx argued that Hegel's identification of contemporary Prussia as the realization of Geist was premature for the same reasons I identified above (the persistence of structural inequality). In doing so Hegel had, in Marx's view, attempted to immunize the (bourgeois) state from the political and intellectual pressure necessary to propel it toward its final, ideal form. "Hegel," as Marx writes, "has accomplished the feat of deducing the hereditary peerage, landed estates, etc. ... from the absolute Idea."[3] For Marx, the aesthetic state had not yet been attained because the promise of freedom carried by the concept of the aesthetic had not yet been fully universalized. And it would not be universalized until one last spasm of negative violence had ended the eon-long cycle of the dialectic in a final grand synthesis, leading to the emergence of the first truly classless society. Until that time, until the proletarian revolution, the primary modality of thought necessary to move society forward and sustain critical awareness of its unfulfilled potential was no longer focused on ideal forms or virtual harmonies, but on the relentless subversion and

negation of existing systems of power (a tendency that reaches its apogee in Leninism). As we shall see, a permanently sustained mode of negation (deliberately suspending any final reconciliation) will be central to traditions of the avant-garde as well.

While Marx disputed Hegel's claim that the Prussian state represented the fulfillment of the utopian promise of Geist, his image of life after a Communist revolution bears a striking resemblance to the ideal model of social harmony that originates with the Romantic concept of the aesthetic state. Following the violent interregnum of the dictatorship of the proletariat, society will enter into a new phase of existence in which individuals are able to create social bonds that are entirely free of instrumentalization. As theorist Bertell Ollman notes, Marx compares the new social reality that would follow a proletarian revolution to a musical orchestra. Here "people's activities are no longer organized by external forces, with the exception of productive work where such organization still exists but in the manner of an orchestra leader who directs a willing orchestra."[4] Consistent with the larger traditions of autonomy, it is precisely the fear of a coercive "external force" that defines this utopia. Here, then, is yet another iteration of the ethos of autonomy: absolute and unconstrained freedom to determine one's own actions, combined with the awakening of a previously repressed recognition of our common "species being," which binds us willingly together in our independence. In this fully realized sensus communis we come to acknowledge that our essential nature is social rather than individual and privatized. In a society based on "Full Communism," as Marx writes, "I . . . have the joy of having been the mediator between you and the human species [and] therefore of being recognized and experienced by you yourself as a complement of your own nature and as a necessary part of your being, therefore of knowing myself affirmed in your thoughts as in your love."[5]

We find a symptomatic expression of this utopic state in anarchist Paul Signac's *In the Time of Harmony* (1896; see figure 2.1), which portrays the range of activities undertaken by the citizens of a truly liberated society. Now that the plenitude made possible by industrialization is equitably shared rather than being horded by a plutocratic elite, everyone is free to engage in their own creative self-actualization. "Art" is no longer a specialized endeavor allowed to only a handful of privileged agents (whose task is to prefigure the leisure and creativity we may someday all enjoy) but is now universalized. We are finally free to pursue our own unique interests, from painting to dance to lawn bowling.

FIGURE 2.1. Paul Signac, *In the Time of Harmony* (1896).

In the presence of this new form of harmonious coexistence, the state itself will wither and die, its role in adjudicating between individual and collective interests in a complex social system no longer necessary now that the unnatural pathology of bourgeois self-interest has been expunged from the human personality.[6] Conflicts between self and other will vanish in this new order because all such conflicts are, at root, merely the epiphenomenal expression of the single causal, ur-form of all intersubjective violence, which is class. Even crime will cease to exist, as the bourgeois self that made the concept of crime possible will disappear.[7] Since intersubjective violence is carried, virus-like, by a single, clearly differentiated class, as a kind of ontogenetic legacy, the dissolution of this class (which is the work of the dictatorship of the proletariat) will permanently remove self-interest from the repertoire of human emotions and from society as a whole.[8]

While Marx's account of life under Full Communism might share certain generic features with the preexisting concept of an aesthetic state, his proposals for how to achieve this new social order mark a decisive break with the quietist traditions of the Enlightenment. Where Hegel argued that the philosopher must maintain a carefully calibrated distance from the exigencies

of political change, Marx will seek to engage directly with the process of social and political transformation through his development of the Communist League, the German Worker's Educational Association, the International Working Men's Association, and other early working-class political organizations. But even as Marx endorses direct intervention, he also retains something of Hegel's ambivalence regarding the cognitive capacities of the masses. While the philosopher for Marx may not be an isolated priest, he does retain a privileged access to the truth of historical development by virtue of his distinctly bourgeois command of the abstract, technical language of theoretical analysis. Thus, it is the task of alienated factions within the "ruling class" to "supply the proletariat with its own elements of political and general education . . . [and] with fresh elements of enlightenment and progress," as Marx writes in the *Communist Manifesto*.[9]

The Bricks of Socialism

Just as philosophy finds its *material* weapons in the proletariat, so the proletariat finds its *intellectual* weapons in philosophy; and once the lightning of thought has struck deeply into this virgin soil of the people, emancipation will transform the *Germans* into *men*.
—Karl Marx, "Critique of Hegel's Philosophy of Right" (1843–1844)

The principle of autonomy is not abandoned in the Marxist tradition of direct action. Rather, as with Hegel, it remains housed within the consciousness of the radical philosopher who, alone among the bourgeoisie, is able to transcend the psychological limitations of their own class and grasp the totality of the social order, which is hidden from the mass of society. Here the bourgeois concept of autonomy, predicated on the ability to comprehend society in its totality in order to exercise a transformative will over its subsequent development, is reoriented toward revolutionary change. Thus, while he no longer stands apart from the mechanisms of social or political transformation, the Marxist philosopher nonetheless retains a crucial cognitive sovereignty. As a result, the division between manual and intellectual labor, which will cease to exist under the conditions of Full Communism, remains a central feature of the revolutionary struggle itself. The masses, the working class, exist as a potential or a set of physical capacities (for insurrectionary action) awaiting mobilization and direction. They are the "material weapons" that will be employed by philosophy, which provides the "intellectual weapons" in the struggle for emancipation. "Philosophy is the head of this emancipation," as Marx writes, "and the proletariat is its heart."[10]

We encounter here a rearticulation of the aesthetic division (evident in Schiller) between the masses, driven by passion and sentiment, and the ruling class, capable of advanced forms of abstract thought.[11] This is not to say that the proletariat has no cognitive capacity whatsoever. Rather, it is limited to achieving a basal level of self-awareness in which the workers recognize their own identity and coherence as a class and their destiny in the broader evolution of human freedom (a destiny that the philosopher has already divined through scientific analysis). But the achievement of this proletarian sensus communis produces no operational theoretical insight through which to orient revolutionary practice itself. The annealing together of the working class is the necessary precondition for revolutionary struggle, but only the philosopher is able to "thoroughly comprehend the historical conditions and the very nature" of the universal emancipation of which the proletariat will be the agent, or the specific manner in which it will be delivered. As Engels contends, this knowledge, encoded in the "theoretical expression of scientific socialism," can only be "imparted" to the proletariat by the philosopher.[12]

The proletariat, like the bourgeoisie, exists as an ontologically fixed entity, defined by an intrinsic set of characteristics that cannot be fundamentally altered and which predetermine, in large part, their respective social and political trajectories. As a result, Marx has little interest in what actual members of the working class might think; they are not distinguished by their own conscious, volitional thought processes, but by a greater ontological destiny that stands outside of their cognitive reach.[13] "It is not a question of what this or that proletarian, or even the whole proletariat, at the moment *regards* as its aim," as Marx writes. "It is a question of *what the proletariat is*, and what, in accordance with this *being*, it will historically be compelled to do."[14] This destiny can only be fully grasped by the "theoretical Communist" rather than by the workers themselves ("practical Communists"), who remain largely at the mercy of a Marxist cunning of reason.[15] This displacement of critical consciousness is, as we have already seen, a key feature of the tradition of aesthetic autonomy in which "absolute objectivity is given to art alone" (as Schelling wrote), as well as Hegel's celebration of the "profound apprehension and insight" that is the unique province of the speculative thinker. As I discuss below, in the evolution of the Marxist tradition, this mobile critical consciousness will eventually be lodged in the Communist Party itself. More than a century after the publication of the *Communist Manifesto* we find Sartre's description of the relationship of the French Communist Party to the working class expressed in similar terms:

> You claim that the masses *do not demand* a single Party? You are right: the masses demand nothing at all, for they are only dispersion. It is the Party which demands of the masses that they come together into a class under its direction. . . . In a word, the Party *is* the very movement which unites the workers by carrying them along towards the taking of power. How then can you expect the working class to repudiate the C.P.? It is true that the C.P. is nothing outside of the class; but let it disappear and the working class falls back into dust particles.[16]

While individual "workers" exist, they only come into coherence as a class, capable of exercising collective political agency, through the mechanism of the party, which orients and "directs" their actions.[17]

Autonomy, as I noted earlier, marks an open space within the experience of modernity in which new forms of social life might be envisioned and the limitations of existing forms evaluated and critiqued. More accurately, we might think of autonomy as describing a specific human capacity for independent, critical thought (the ability to step back from our un-self-conscious immersion in the world as it exists, in order to imagine what it might become). In the transition I have sketched thus far, from Schiller to Hegel to Marx, we can observe various permutations of the same core principle, in which the poet, the philosopher, or the theoretical Communist come to embody, and mediate, this new, visionary capacity. In each case this insight has to be transmitted to a larger public or mass audience. While Schiller would associate the dissemination of aesthetic education with the circulation of poetry and plays, Hegel sought to reform Prussia's university system in order to implant a properly systematic understanding of reason in the "universal class" of civil servants.[18] In each case we observe a mode of dissemination in which subject positions (teacher/student, poet/reader, artist/viewer) are fixed and clearly differentiated. And in each case the recipient consumes a set of a priori cognitive lessons, via formal instruction or informal aesthetic experience, in a manner that is seen as preparatory for direct action in the world but necessarily detached from it.

Marx will challenge the assignment of static subject positions, the allocation of expertise, and the bifurcation between theory and praxis that is implicit in this model. He will link the generation of new, critical insight to specific forms of social action oriented toward the transformation of existing political institutions.[19] This marks a key shift, with significant implications for our understanding of autonomy, and the relationship between the transformation of consciousness and creative and political practice. However, the

Marxist legacy in this regard is characterized by a central tension. On the one hand, Marx introduces a new framework within which to understand the nature of human social interaction, oriented around the role of labor as a site at which new forms of learning and self-cultivation can occur. Thus, the breaking down of the autonomy of theory and the "materialization" of transcendent concepts of freedom or justice in actual social practice suggests a situational rather than a universal model of autonomy. One achieves criticality and critical distance *through* shared labor and praxis, rather than treating them solely as a realm of practical error to be corrected by a distanced theory. In his early writings, Marx develops the concept of "social labor" as distinct from the forms of instrumental physical labor associated with industrial or agrarian capitalism. Here labor and language itself function as points of mediation between self and other, and individual and collective, in a manner that has emancipatory implications. Labor, in this view, is cognitively generative (producing new forms of consciousness) and prefigurative (anticipating the possibility of a new social order based on fully realized freedom and equality).[20]

On the other hand, Marx's willingness to attribute some cognitive agency to the working class is tempered by his persistent skepticism regarding their capacity for more advanced forms of thinking (specifically, the development of a holistic account of interlinked systems of political and economic domination, the broader telos of historical transformation, and a general theory of revolutionary change). As I noted above, all of these modes of theoretical insight are, in Marx's view, the unique province of an alienated faction of the bourgeoisie. Rather than this process occurring through the individual's transformation of the natural world, it unfolds as the vanguard theorist extracts value from the previously moribund masses, rendering them politically "productive" as agents of revolution. Thus, a property-based model of autonomy migrates into the Marxist understanding of the masses as what Lenin termed "the bricks of socialism."[21] Here the theorist plays a coordinating and supervisory role in which they employ the physical, insurrectional labor of others to a politically transformative end. This deterministic approach is closely aligned with a hyperbolic account of the various forms of "false consciousness" that prevent the working class from grasping its assigned historical mission, which are used to explain the persistent failure or incompletion of previous attempts at revolutionary change (1848, 1871, the November Revolution in Germany, etc.). In this view, the masses are perennially unprepared for revolution and innately susceptible to forms of ideological manipulation that only the theorist can transcend.

In this context, we can understand the aesthetic as a set of codified values associated with intersubjective experience that seek to produce some mediation between existing forms of human sociality and an improved or ideal form that they might yet attain. In the Enlightenment period, this ideal was embodied in the concept of the aesthetic state (inspired by ancient Greece) in which we would experience an absolute personal autonomy, while at the same time naturally avoiding any action that would impinge on the autonomy of other, equally free, subjects. With the emergence of Marxism and an avant-garde in the nineteenth century, this ideal takes on a new form; now, it is identified with the utopian society that will emerge in the wake of a successful Communist revolution rather than one revived from a dead antiquity. If, in the case of the Enlightenment aesthetic, art's assigned role was to catalyze the forms of advanced thought and behavior necessary to create this new social order, in the avant-garde aesthetic, art's role is to contribute to a broader mosaic of revolutionary thought and action that will precipitate the violent overthrow of the bourgeoisie.

I Too Am a Government

I answered that I too was a government and that I was the sole judge of my painting . . . that I had practiced painting not in order to make art for art's sake, but rather to win my intellectual freedom . . . and that I alone, of all the French artists of my time, had the power to represent and translate in an original way both my personality and my society.
—Gustave Courbet, "Letter to Alfred Bruyas" (December 1854)

"I too am a government" was Gustave Courbet's exasperated response to Napoleon III's director of fine arts, who asked him to temper his transgressive painting style in order to receive the patronage of the French state ("Gustave, put some water in your wine!"). Here Courbet performs his role as the consummate avant-garde artist—supremely confident in his singular capacity to comprehend and mediate the essential nature of the contemporary social order and claiming for himself the absolute freedom that we have identified with the progression of aesthetic autonomy in the modern period. Now, however, the autonomy previously associated with the viewer's or reader's experience of beauty has migrated to the personality of the artist himself (a transposition already anticipated with Hegel's treatment of the philosopher as the living embodiment of speculative thought). This heliocentric orientation is evident in one of Courbet's most famous canvases, *The Artist's Studio* (1855), which portrays "the whole world coming to me to be

painted," as he wrote. Here Courbet, seated at his easel, holds his brush above a scene of his beloved Franche-Comté countryside. The subject matter of Courbet's art is no longer simply the external world but his own exemplary creativity as a symbol and catalyst of societal progress. He locates himself at the center of a universe populated on one side by the figures who fill his compositions (a peddler, a beggar, an unemployed man, a veteran). They are "the other world of everyday life, the masses, wretchedness, poverty, wealth, the exploited and the exploiters."[22] This is the compositional material that he will appropriate and transform through his unique artistic vision. On the other side stand his "shareholders," the patrons, poets, and philosophers who "serve and support" his vision (Baudelaire, Champfleury, Alfred Bruyas, etc.). As Linda Nochlin observes, "Courbet sees himself at once as the earthy, matter-of-fact master-painter . . . and, at the same time, in the iconographic context of the *Studio*, as the Harmonian Leader, the immovable, active, generating center from which the Fourierist implications of the whole work radiate."[23] Nochlin is referring here to philosopher Charles Fourier, a significant influence on Courbet. Fourier argued that the tensions between capital and labor in modern society could be dissolved by the creation of utopian communes, in a process that would hinge on the mediating influence of "artists and scholars."[24] This mediating role is evident in Courbet's canvas, where he serves as the focal point of a social network composed of representatives of the poor and working class (the peddler and beggar), the bourgeoisie (Bruyas, a banker's son), and "talent" (his fellow artists). We see here, as well, the intrinsic ambivalence of the concept of mediation as the egalitarian reconciliation promised by the act of mediation gives way to a process in which the mediator himself assumes a transcendent authority.

In 1825, Saint-Simon first referred to the concept of an avant-garde composed of leading industrialists, scientists, and artists, who would lead society out of the darkness imposed by the "ancient prejudices" of the French ruling class.[25] Artists, as "men of imagination," would play a crucial role in this triumvirate, as Saint-Simon writes, "exercising over society a positive power, a true priestly function, and marching forcefully in the van of all the intellectual faculties, in the epoch of their greatest development!"[26] The belief that the artist, due to his or her ability to visualize the proper future evolution of society, carries a sacred obligation to impart this wisdom to humanity is, as we have seen, typical of the Romantic tradition. Art "manifests . . . the most advanced social tendencies; it is the forerunner and revealer," as Laverdant wrote in 1845.[27] Following the revolutionary ferment of 1848, the language of the avant-garde became more widely mobilized in French political culture,

and journals associated with working-class and socialist parties began to appear under this name for the first time.[28] It was the Paris Commune, however, that definitively shaped our image of the avant-garde as an alliance of renegade artists and intellectuals drawn from the bourgeoisie, and the revolutionary working class, as epitomized by Courbet's central position in the Commune. The reciprocal entwinement of the "two avant-gardes" (artistic and political) in the act of revolution marks the ideal reconciliation (of theory and practice, of mind and body, of artist and worker) that both prefigures and facilitates the practical realization of utopia.[29] Thus, Courbet went from proclaiming himself his own "government," containing within his consciousness the cognitive kernel of an ideal society, to becoming a working member of the Commune's *actual* government, where he served on the Commune Council and directed the Artists Commission, the Parisian Federation of Artists, and the Committee on Archives. It was in this latter capacity that he was involved in the penultimate act of radical negation: the toppling of the Vendôme Column. As Courbet wrote to his father on April 30, 1871, "Paris is truly a paradise; no police, no trickery, no coercion, of any kind; no disputes. Paris goes its own way on greased wheels. All the *corps d'état* have formed federations and control their own affairs. It was I who set the example for that with the artists of all sorts."[30] Here, finally, was the practical realization of a Communist sensus communis, in which individual citizens peacefully coexist, without the need for police, courts, churches, or external coercion of any kind. Schools would admit anyone who sought an education, the artworks of the Louvre were accessible to all, priests were banished, and inefficient and overpaid bureaucrats were replaced by the workers themselves as a natural social harmony pervaded everyday life and eased the logistical operations necessary to sustain the social organism of the Commune. But it could not last. The Communards were so circumspect that they left the assets of the Bank of France untouched, and the National Guard failed to pursue the French Army when it might have been possible to decisively defeat it. Of course, this was not a Communist revolution per se; it was, like the Russian Revolution that would follow more than four decades later, precipitated by widespread disgust at the military and political incompetence of the nation's leadership.[31] In the Marxist tradition, the most important lesson of the Commune was that utopia cannot be realized prematurely; that the nonhierarchical and egalitarian social forms unique to life under Full Communism cannot be allowed to flourish *until* the bourgeois class enemy has been utterly destroyed, in a process that requires iron discipline, military hierarchy, and merciless violence. The fate of the Commune would

play an important role in Marx's elaboration of the concept of the dictatorship of the proletariat, the violent transition phase necessary to accomplish this destruction before utopia would commence. And this would, in turn, inform key aspects of Leninism to which I will return below.

The Wood that Becomes the Violin

The mythos of the avant-garde combines the artist's imaginative capacity to envision humanity's ideal future with the insurgent physical powers of the aggrieved working class to finally bring this vision into practical existence. The fluidity of the term "avant-garde" is key; its association with both vanguard political movements and the most advanced forms of artistic production, carried out in solidarity with the working class. The precise nature of this solidarity constitutes one of the central problematics in the modern avant-garde. Does the artist work with the proletariat? In the service of the proletariat? On behalf of the proletariat? In advance of the proletariat? Each of these formulations suggests a very different orientation to political change and a set of intraclass relationships that vary from subordination to mutual dependence to pedagogical guidance to custodial oversight. At the center of this relationship is a fictive transposition, in which the artist takes on the identity of the worker. This transposition is a product of the symptomatic plasticity of the artistic personality itself. We encounter a key early manifestation of this transposition in Rimbaud's response to the Commune, in which the poet disavowed his own class position to proclaim his enthusiastic identification with the rebellious working class. In a letter to George Izambard in May 1871, Rimbaud declares, "I will be a worker . . . it's this idea that keeps me alive, when my mad fury would have me leap into the midst of Paris' battles—where how many other workers die as I write these words? To work now? Never, never: I'm on strike."[32] As revolution raged in Paris, Rimbaud staged his own personal act of resistance: laying down his tools and refusing to write.

Rimbaud's identification with the workers entailed a deliberate transcendence of the self that was the necessary precondition to becoming what he terms a "seer," able to "define the unknown quality awakening in his era's universal soul."[33] Here Rimbaud reiterates Laverdant's image of the artist as a "forerunner and revealer," defining the poet as "a propagator of progress who renders enormity a norm to be absorbed by everyone." The poet, "unlike everyone else, has developed an already rich soul."[34] This capacity begins with a rigorous inventory of the self. ("The first task of any man who

would be a poet is to know himself completely; he seeks his soul, inspects it, tests it, learns it.") The result is a kind of emptying out of the self that parallels the ontological regression we observed in Schiller's account of aesthetic experience. The "self," grasped from an analytic distance, slips its moorings. "The I," as Rimbaud observed, "is someone else."[35] In this manner, Rimbaud reenacts both the reflective apperception of the Kantian subject and its reinscription in the Odyssean self of bourgeois possessive individualism; free to adopt and abandon versions of the self at will, and to view the world, and the otherness that it harbors, as a reservoir of possibilities to be explored and appropriated. Thus, it is not simply the Communards of Paris with whom Rimbaud will identify, but an entire cast of marginalized social subjects (the criminal, the colonized African, serfs, lepers, etc.).[36] These subaltern figures provide Rimbaud with a locus of identification that allows him to engage in complex forms of rhetorical assault directed at the normative cultural and political values of the bourgeoisie.

Rimbaud's original self is a kind of passive, raw material that he will, through his own imaginative power (and through the ontological fulcrum of the other), transform into an instrument of art. In the letter cited above, Rimbaud continues: "The suffering is tremendous, but one must bear up against it, to be born a poet, and I know that's what I am.... It's wrong to say 'I think': one should say 'I am thought.'... Tough luck to the wood that becomes a violin."[37] Key to this opening up of the self is a conscious "derangement of the senses" that is the necessary precondition for a radical derangement of literary conventions. In her study of Rimbaud, Kristin Ross presents his genre-shattering poetry as constituting a kind of carrier wave for the insurrectional energies of the Commune, preserving and linking them with the subsequent efflorescence of radical art under the surrealists and the situationists, and maintaining a displaced historical continuity as revolutionary praxis was periodically driven underground.[38]

In his poetry, and in his passionate identification with the Communard or the subaltern, Rimbaud acts out the noninstrumentalizing, dialogical openness to the other that is a defining feature of the aesthetic state. But he does so through a form of autonomous artistic subjectivity that carries along with it a set of structural protocols that can reinforce, rather than challenge, monological authority (the compensatory privileging of the artist as the "supreme savant" who measures his genius against the ignorant masses, or who abstracts the singular specificity of the other into a generic placeholder of class victimization with which to batter the reviled bourgeoisie). Here we can observe the characteristic diffraction field of aesthetic autonomy.

On the one hand, it entails a defensive enhancement of the authority of the self in which the poet, alone, possesses a privileged insight into their era's "universal soul," laboriously cultivated in the confines of their own inward consciousness. On the other, the insight thus generated is dedicated to securing the political conditions necessary for the emergence of a very different form of subjectivity—one that is more porous, more open to the reciprocal shaping influence of others, and less consumed by the defensive conviction of its own singular genius. In the tensions between these two modalities lay many of the core contradictions of the modern avant-garde.

As I suggested above, the avant-garde artist claims the absolute freedom and subjective mobility that are central to the discourse of bourgeois aesthetic autonomy while at the same time serving as a vessel through which an exploited otherness is ostensibly given voice. For Rimbaud, this identification with the other serves two related purposes. First, it facilitates a displacement from (or derangement of) the poet's normative self that simultaneously enhances his or her own authority as a seer or savant. And second, it provides a point of rhetorical leverage through which Rimbaud can ventriloquize his own critique of the bourgeoisie, speaking as if he himself were the exploited worker, the reviled criminal, or the oppressed colonial subject. The contradictions of this position for the avant-garde artist are evident, as the self is both disavowed and reaffirmed in its transactions with difference. In prefiguring the potential universality of aesthetic experience, the artistic personality claims a form of transcendence that can easily enough become delectatory rather than critical, leading to a touristic relationship to the world in which otherness, and suffering itself, are reduced to compositional materials. In this case the resulting works may do nothing to alter the social reality that produced this suffering and instead simply enhance the charisma of the artistic personality.[39]

The Commune is significant for my analysis for a second reason. The catastrophic demise of the Commune triggered a reiteration of the cycle of revolutionary failure and aesthetic displacement that we first observed in the aftermath of the 1789 revolution. Where Hegel and Schiller viewed the Terror as evidence of the political immaturity of the French public, the failure of the Commune was seen (by Marx, Lenin, and others) as marking a similar incapacity, as the Communards relied on passion and spontaneity rather than cold-blooded calculation, scientific analysis, and revolutionary discipline (precisely the virtues of the dispassionate and conceptually advanced ruling class identified by Schiller).[40] As a result, the transformative energies of the revolution, squandered in the repressive violence of the

Bloody Week, would be drawn back into the autonomous consciousness of the artist (or theoretical Communist) for safekeeping. Due to the plasticity of the artistic personality, its ability to assimilate other subjectivities while retaining a comprehensive grasp of the "destiny of the human race," the artist was uniquely qualified to receive and preserve these energies until the proper historical moment called for their return to the masses. In this form revolutionary consciousness, like the concept of an aesthetic sensus communis that preceded it, prefigures a future utopia that cannot be realized in practice. This displacement of a critical, revolutionary consciousness expresses itself in the emergence of an incipient formalism in the art of the post-Commune period. The social amnesia of French society during the 1870s and 1880s, as it sought to forget the violence of the Commune and the unresolved class tensions that brought it into view, coincides with the rise of Impressionism. Where Courbet passionately espoused his identification with the working class, the Impressionists would abjure direct political engagement and embrace a radical autonomy that positioned the artist as a detached observer of modern life, a flaneur "botanizing on the asphalt" in Walter Benjamin's memorable phrase.[41] The work of art, freed from the debilitating and fractious struggles of the political sphere, opens a window to an alternative universe of optical sensation and visual pleasure.

Impressionism carries the distinctive double movement of the avant-garde: both critical and exculpatory. On the one hand, as Albert Boime has noted, it covers over the violence of the streets with images of bourgeois recreation (painting the scenes of some of the bloodiest events of the Commune as pastoral parklands and idylls).[42] On the other hand, art historians have sought to redeem Impressionism by arguing that it preserved, even in its sensuality and escapism, a decanted critical intelligence. In this interpretation, Impressionism preserved a residual trace of oppositional consciousness in its transgression of pictorial and perceptual norms. As art historian Paul Wood observes, "It may seem like a long journey from the avant-garde that fights in the streets, or at least throws in its lot with those doing the fighting, to the avant-garde that paints autonomous effects, but after a catastrophe like 1871 it can seem like a journey worth making, if only to keep intact what has survived."[43] In the same essay, Wood identifies the "anarchist" elements in Signac's "new techniques" of painting as "bearing witness" to the "great social process which pits the workers against capital." "The point here," he continues, "is that the radical 'witness' consists *in* the radical techniques."[44] Here the compositional techniques of autonomous art acquire a new form of agency, serving to house and protect a radical intelligence that

is elsewhere repressed. In this dynamic, autonomy emerges again as the protective field needed to shield these fragile loci of experimentation from the pressures of a premature political praxis or the banality of a bourgeois culture that threatens to engulf them. The formalist trajectory that evolves from Impressionism in the late nineteenth century to abstract expressionism and beyond continues to be validated by the implicit claim that ongoing experimentation with the specific stylistic conditions of art constitutes a displaced field of parapolitical critique.

By the early twentieth century, and the period of the Russian Revolution, the discourse of aesthetic autonomy undergoes another cyclical renegotiation. The modes of shock, assault, or transgression become far less oblique (directed toward incremental shifts in pictorial language or representational norms) and more explicit as the two avant-gardes increasingly incline toward one another. This is most evident in the embrace of the Communist Party by the adherents of Dadaism and surrealism, as well as the emergence of Constructivism in the postrevolutionary period. Now the insurrectional ethos previously held in formalist stasis is reactualized in protests, manifestos, performances, and publications in which artistic movements seek to align themselves with ongoing political struggle. Autonomy is no longer secured by the artist's decision to avoid recognizable "social" content or to focus his or her investigations on ostensibly apolitical cognitive and perceptual processes. Rather, the artist will declare him or herself to be "like" a vanguard theorist: a privileged carrier of revolutionary consciousness, dedicated to destroying the bourgeoisie. As I discuss in the following section, this doubling of the figure of the artist-as-revolutionary, or the revolutionary-as-artist, is emblematic. A central feature of this interconnection is the fundamental mobility of revolutionary consciousness itself as something that can be generated and stored, exchanged, and redeemed within a broader mnemonic economy.

The Sovereign Party

The ego, crushed and mangled by Russian autocracy, wreaks its revenge by placing itself, in its own system of thought, on the throne and declaring itself all-powerful.
—Rosa Luxemburg, "Organizational Questions of Russian Social Democracy" (1904)

Rosa Luxemburg's critique of Lenin's model of the vanguard party illustrates the striking correspondence between the compensatory sovereignty of the postsacral bourgeois self, throwing off the shackles of absolutism, and the revolutionary bourgeois intelligentsia. As I have suggested, the demise of

the Paris Commune was understood in the hermeneutic frame already established by the perceived failure of 1789 as evidence of a broader incapacity for emancipatory action. In particular, it seemed to illustrate the inability of the masses, in their quasi-instinctual forms of resistance, to think strategically about their relationship to class domination. For Lenin, this failure demonstrated the absolute necessity that the cognitive leadership of revolution be transferred to a special cadre of vanguard political leaders. These full-time revolutionaries would devote themselves entirely to the science of social and political change, combining an innate propensity for abstract, theoretical analysis with a cold-blooded, quasi-aristocratic capacity for cruelty and violence. This gesture entailed, in turn, the displacement of revolutionary consciousness from the field of praxis to the domain of theory, where it would be cultivated on behalf of a working class as yet unprepared to realize its historical mission. Certainly, the theorist could, and must, learn from actual political practice. However, the masses themselves, as they engaged in struggle, were incapable of generating any independent theoretical insight. Thus, insight is not something that one develops gradually through experiential interaction with the world. Rather, it is understood as a set of axiomatic truths, best revealed and sustained in the form of theory or philosophy and, as a result, transferrable in its totality through a process of directed education or indoctrination. In this process the vanguard theorist emerges as a singularly privileged agent.

The result was a broad rearticulation of the relationship between the professional revolutionary and the working class that further exacerbated the divisions already introduced by Marx between the "theoretical" and "practical" Communist. This shift can be discerned in the wide-ranging debate in revolutionary-era Russia around the question of spontaneity and consciousness. For Lenin, meaningful revolution will occur only when the impulsive energies of the proletariat are harnessed and directed by the strategic intelligence of a vanguard party led by professional revolutionaries. As he writes in *What Is to Be Done?* (1902), "the spontaneous struggle of the proletariat will not become its genuine 'class struggle' until this struggle is led by a strong organization of revolutionaries."[45] Here the masses possess an active bodily agency, grounded in the material immediacy of labor, but are incapable of abstraction or long-term planning. The professional revolutionary, on the other hand, lacks the collective physical power of the masses but does possess a capacity for strategic thinking without which the masses would blunder about blindly. Within this division of labor, the task of the revolutionary is to "expose" the masses to the truth of their oppression in order

to move them from a spontaneous and local consciousness (in which they are concerned only with forms of resistance intended to achieve short-term goals) to a methodical and global vision of revolution, capable of destroying the capitalist system in its entirety.[46]

Notwithstanding a series of revolutionary uprisings during the nineteenth century, the European working class displayed a frustrating indifference to its historical destiny. It was this failure, this incapacity, that necessitated the intervention of a force "brought to them from without," the viral discourse of socialism created by an alienated faction of bourgeois intellectuals ("educated representatives of the propertied classes," as Lenin writes).[47] Here theoretical inquiry is creative and generative, while action is merely iterative, marking the application of ideas already perfected in the consciousness of the professional revolutionary. This is the foundation for the mythos of Lenin as a catalytic authoring force who literally brought the Russian Revolution into existence by his single-minded perseverance and penetrating theoretical insight. We find a vivid expression of this view in Isaak Brodsky's canvas, *Lenin and the Manifestation* (1919; see figure 2.2), produced shortly after Lenin launched his "Monumental Propaganda" program in 1918. The painting portrays the Bolshevik leader sitting in front of a red velvet curtain, which he pulls aside to reveal demonstrators on the streets of St. Petersburg. Lying next to his gesturing hand is a fountain pen and a piece of paper on which Lenin has been writing. The implication is clear, the political actions of the Russian people in overthrowing Tsarist rule were the direct, physical "manifestation" of the revolutionary theories generated within Lenin's own consciousness. The luxurious red curtain, with its overtones of divinity or magisterial power, can equally be read as a theatrical drape being pulled aside to reveal the stage on which the playwright's script is unfolding, or as a curtain concealing a newly finished painting, to be uncovered by the artist for the waiting public. "Look upon that which I have created," the figure of Lenin seems to say.

It is precisely on this question that Rosa Luxemburg challenged Lenin in her 1904 essay on Russian social democracy. As Luxemburg observes, "the most important and profitable changes of the last decade were not 'invented' by any of the movement's leaders [and the] great features of the social democratic tactic of struggle are on the whole not 'invented' [by theorists]: on the contrary, they are the consequence of a continuing series of great creative acts of experimental, often of spontaneous, class struggle."[48]

As noted above, the political activist is charged with awakening the working class to its revolutionary mission by revealing the hidden contradictions

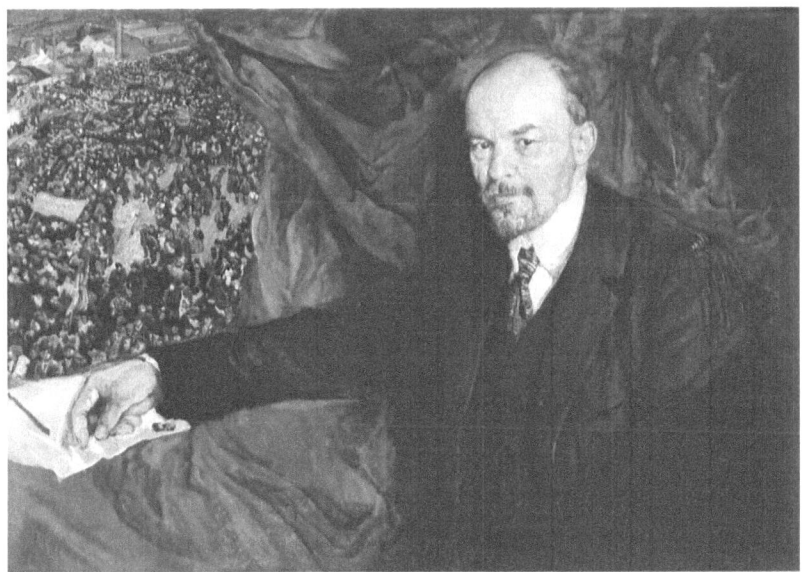

FIGURE 2.2. Isaak Brodsky, *Lenin and the Manifestation* (1919).

of capitalist power and the systemic roots of what are otherwise perceived as merely epiphenomenal forms of injustice, or by working to exaggerate conflict in order to provoke the authorities into a violent response that will further radicalize those members of the working class who become its target. This suggests a key distinction within revolutionary theory. It is not simply the fact that the members of the working class are unaware of their own suffering (or that they do not fully understand its significance), but that their suffering, in its current form, is not yet sufficient to force them to act in a properly revolutionary manner. As a result, the vanguard leader must actually exacerbate their oppression by provoking the ruling class, setting up an escalating cycle of assault and violent counterresponse that will transform working-class consciousness (binding it together, by creating a differentiated class enemy).[49] While these actions may well increase the suffering of the workers here and now, this pain is justified because it will lead to their eventual emancipation. The retribution of the capitalist state becomes the crucible in which their new consciousness will be forged. This dynamic clearly reflects the latent behavioralism of the vanguard personality.

Questions of agency and autonomy are central to the concept of the vanguard party. On one side stands the proletariat, a discrete and relatively

homogeneous entity with identifiable boundaries, which can be mobilized, brought to consciousness, and directed, like a weapon. On the other stands the professional revolutionary, a fully individuated cognitive entrepreneur, who comes from the oppressor class but whose capacity for independent thought regarding the conditions of that oppression has led to the creation of a motivational heuristic system (Marxism) that "opens up for him the widest perspectives, and . . . places at his disposal the mighty force of many millions of workers 'spontaneously' rising for the struggle."[50] The key differentiation between the (collective) proletariat and the (individual) revolutionary is the capacity for "consciousness," which Lenin identifies with a global and strategic understanding of the totality of the capitalist system. This insight can only be achieved through sustained theoretical reflection. While certain advanced elements within the proletariat might be drafted up into the ranks of the professional revolutionary, by virtue of their exemplary initiative, the "science" of socialism remains a uniquely bourgeois invention. Lenin approvingly cites Karl Kautsky on this point, arguing that modern socialism could only have been created by the "bourgeois intelligentsia." "Thus, socialist consciousness is something introduced into the proletarian class struggle from without and not something that arose within it spontaneously."[51] This "scientific" knowledge is necessary, according to Kautsky, in order to "imbue the proletariat with the consciousness of its position and the consciousness of its task. There would be no need for this if consciousness arose of itself from the class struggle."[52] The vanguard party, as Lenin elaborates, must act as a "spirit that not only hovers over the spontaneous movement [of the proletariat], but also raises this movement to the level of its program."[53] Here again we encounter the presentation of the proletariat as incapable of asserting its own independent class identity or consciousness, and dependent instead on the party or revolutionary theorist. The party and the theorist enjoy an absolute immunity from ideological conditioning and possess the intellectual acuity necessary to impose their transformative will on existing political reality, effectively reflecting back to the proletariat a coherent and idealized image of its own revolutionary potential.

Lenin's *What Is to Be Done?*, perhaps his most famous work, constitutes an extended polemic against the principle of "free criticism" then being advocated by the "Workers' Cause" faction, which sought to preserve space for a plurality of tactics within the Russian Social Democratic Labor Party. The key terms in this debate, as noted above, were spontaneity and consciousness. Spontaneity, which Lenin associates specifically with the anarchist and reformist strands of the Russian left, suggests that revolutionary leaders

should let their planning be guided in part by the actions of the proletariat in its unfolding struggle against the Russian state. It implies, moreover, that meaningful insight can be produced *through* their experience of political resistance itself, rather than introduced entirely from "without." In *What Is to Be Done?*, Lenin repeatedly warns of the danger posed by this "new trend" in Russian social democracy, and chastises activists for "bowing to," "slavishly cringing before," and "worshipping" spontaneity.[54] While spontaneity might eventually, with proper cultivation, evolve into "consciousness," it can, on its own, produce only "outbursts of desperation" without theoretical rigor. It is essential, therefore, to maintain a strict hierarchical separation between the two, to prevent spontaneity, in all its physical immediacy, from "overwhelming consciousness."[55] In this manner the discourse of consciousness and spontaneity reproduces the Enlightenment ontology outlined earlier, in which the bourgeois subject possesses a singular capacity to transcend the constraints of the material world, while the working class remain mired in the instinctual immediacy of their bodily experience.

With Lenin, many of the themes I have sketched out above acquire a paradigmatic coherence that will inform the evolution of avant-garde art for the remainder of the twentieth century. The convergence between the personality of the artist and the revolutionary theorist is central to this new discursive system. Both revolution and artistic production were acts of genius requiring an utter disregard for existing values and the creative reinvention of the self in a manner that prefigures, and models, the form of self-transformation toward which the proletariat should aspire. Here revolutionary theory provides a parallel to the displacement of revolutionary cathexis into the "immanent" formal processes of painting or visual art following the Commune. Each function as a reservoir of deactualized energy, as the consciousness of the theorist or artist provides a protected field of radical cognitive experimentation. The artist's canvas preserves the insurrectional energies of the failed Commune in visual form, while vanguard theoretical reflection preserves, in conceptual form, the as-yet unrealized revolutionary consciousness of the proletariat. At the same time, the vanguard theorist exhibits the characteristic combination of a compassionate identification with the suffering of others and an unyielding cognitive sovereignty that we have already encountered in Rimbaud. Thus, the poet will simultaneously collapse himself into the personality of the marginalized other (in order to speak on behalf of their experience of physical and economic deprivation) while also claiming an entirely unique ability to transcend the cognitive limitations of the surrounding social order, including those of the marginalized themselves.

We can observe this same tension in Lenin who, despite being born into economic privilege (his father was made a nobleman for his role as a civil administrator and the family summered in a countryside manor), developed a passionate commitment to relieving the suffering of Russia's poor and working class. At the same time, Lenin was capable of taking on a highly mercenary relationship to Russia's working class. This was the case precisely because he was convinced that he knew, far better than they ever could, what was best for them. This is the foundation of Brodsky's image of Lenin conjuring the revolution into existence through his projective control over the bodies of the Russian working class. Only he possessed the teleological vision necessary to truly liberate them (including from their own ignorance). This was because he had, in effect, absorbed into his own consciousness the most treasured and indispensable feature of their own ontological condition as a class, to be preserved there in the form of revolutionary theory. Thus, while he could express a profound empathy for the plight of the working class, Lenin could also view them as suffering from a fundamental disability that required him to take on a custodial relationship to their well-being.

For Lenin, the failure of existing forms of political change was demonstrated not simply by the object lesson of the Commune but by a whole range of contemporary approaches to political transformation in Russia (identified with the social democrats, Kadets, anarchists, etc.), which entailed some engagement with existing political factions in Russia.[56] This suggests a crucial recoding of the discourse of autonomy, which will now be produced through a form of radical negation based on the total independence of the vanguard party from the corrupting influence of existing political institutions (we must prove that "the entire political system is worthless" as Lenin wrote).[57] As Sergey Nechayev argues in "The Revolutionary Catechism" (1869), a document that exerted a significant influence on Lenin, "The revolutionary . . . has broken all the bonds which tie him to the social order and the civilized world with all its laws, moralities, and customs, and with all its generally accepted conventions."[58] This new discursive system reiterates the characteristically absolute division between "inside" (the revolutionary cell, the party, the domain of political truth) and "outside" (the realm of error and compromised modes of political action), along with a hierarchical ordering based on proximity to this truth. The degree to which this system mimics elements of bourgeois autonomy is evident in Nechayev's writing as well. Thus, the vanguard leader, like the most parsimonious bourgeois *rentier*, must carefully invest the human capital at his command. "All revolutionaries should have under them second or third-degree revolutionaries—i.e.,

comrades who are not completely initiated. These should be regarded as part of the common revolutionary capital placed at his disposal. This capital should, of course, be spent as economically as possible in order to derive from it the greatest possible profit."[59]

The perceived inadequacy of the masses, their failure to fully embrace their historical destiny as the agents of the final revolution, also provided the justification for Lenin's ongoing skepticism regarding the role of democratic processes in a revolutionary movement and, hence, a dramatically expanded role for the dictatorship of the proletariat, in which the conditions of postrevolutionary utopia (democracy, a free press, etc.) are "temporarily" suspended while human nature is expunged of any residual bourgeois tendencies. It is notable here that the concept of the dictatorship of the proletariat only fully emerged in Lenin's writings during the postrevolutionary period. In response to growing calls for the Bolshevik party to implement democratic reforms, Lenin was insistent that the time was not yet right because the proletariat, despite having weathered the crucible of revolution and civil war, was still unprepared to govern itself.[60] Thus, it was necessary to defer, yet again, the final universalization of freedom. Until that time the vanguard party, which had, of course, achieved a fully revolutionary consciousness, would function in a caretaker role. "The proletariat is still so divided, so degraded, and so corrupted in parts," as Lenin wrote in 1920, "that an organization taking in the whole proletariat cannot directly exercise proletarian dictatorship. It can be exercised only by a vanguard that has absorbed the revolutionary energy of the class."[61] If the proletariat was defined by the possession of this advanced form of consciousness or "revolutionary energy," then, for all intents and purposes, the proletariat did not yet exist in postrevolutionary Russia (it had been "de-classed," as Lenin wrote). Here again we encounter the abstraction and displacement of enlightened consciousness (which can be "absorbed," held in a protective stasis, and subsequently returned to the masses) and the deferral of a final, utopic reconciliation, which is a central feature of the longer history of aesthetic autonomy.

Lenin and the Bolshevik "maximalists" were highly resistant to any attempt to create new structures of democratic governance in Russia precisely because they feared that this might erode the party's control.[62] Lenin was able to undermine these calls by championing the individual soviets as the true fountainhead of the worker's political will, but he did so because the Bolsheviks had already established a power base in many of the key soviets. However, Lenin remained quite vague about the long-term role that the soviets might play as part of a more formal democratic system.[63] As historian

John Keep observes, "the new regime based itself in large degree *upon* the soviets, but it was not *of* the soviets."[64] Thus, Lenin believed that the soviets "could certainly strengthen Bolshevik influence over the masses, but equally they might weaken it, by articulating popular dissatisfaction. To avert this, they had to be kept under firm control . . . as instruments of rule rather than sovereign bodies."[65] True autonomy, then, rests solely with the party. From the early debates over workers' autonomy, to the crushing of the Kronstadt rebellion, to the show trials, to the invasion of Hungary and the Prague Spring, the ethos of Bolshevik rule was consistently driven by Lenin's original brand of "hatchet socialism."[66] In every case the argument against the extension of democracy, and in support of further repression, was always the same: the necessity to remain disciplined and mercenary in the face of external threats—civil war, capitalist encirclement, revisionists, internal "class enemies," and so on. And in each case, in each historical moment, the realization of the emancipatory promise of Full Communism is deferred and the party's hold on power becomes ever more unyielding. Of course, anyone who challenges a repressive political system must be prepared to employ instrumental forms of thought and action. But a mode of resistance that is founded on the absolute authority of a sovereign party, and which is so consistently structured through a reified understanding of inside and outside, heretic and true believer, purity and impurity, is destined to devolve into the very thing it seeks to replace.

In his 1906 attack on Russia's Constitutional Democrats, Lenin defined the dictatorship of the proletariat as a system that recognizes "no other authority, no law, no standards, no matter by whom established. Authority—unlimited, outside the law, and based on force in the most direct sense of the word."[67] This sovereign power is not simply directed at Russia's aristocratic and bourgeois classes, which, of course, must be ruthlessly crushed, but also at elements within the working class and petite bourgeoisie, which have been "degraded" by nonrevolutionary theories or by the sheer force of "prejudice, habit and routine, or cowardice."[68] In this view, the Kronstadt sailors, pillars of the October revolution who demanded free elections and free speech, were "undoubtedly more dangerous," in Lenin's view, than the combined forces of the White armies.[69] Thus, Lenin's dictatorship of the proletariat represents a mirror image of the absolutist power against which bourgeois autonomy first sought to contend in its embryonic, Enlightenment form—a force that is wholly self-contained and nonconsensual, able to impose its will unilaterally and to command an immediate and unquestioned subordination. The Marxist tradition, of course, will insist that, far from

challenging this absolutist domination, the bourgeoisie actually reproduced it, behind the ideological cloak provided by liberal concepts of freedom and democracy that it never intended to honor. These concepts can only be actualized through a form of equitable consensual exchange that the capitalist system itself, with its a priori class hierarchies, utterly precludes. In order to create a social world based on universal freedom and noninstrumentalizing interdependence, it is first necessary that society as a whole be subjected to a violent "cleansing" process during which all of the old and alien modes of being are finally and totally expelled, precisely by a force that reproduces their originary form.[70]

For Lenin, bourgeois power will end, as it began, in a violent contest with absolute power. This force will no longer disguise itself in spurious appeals to liberty or democracy, but will be naked and unrestrained, like the "true" power of capitalist militarism that lies just beneath the veneer of bourgeois civility. Only after this homeopathic reversal, of absolute power against absolute power, will human nature finally be purged of its corrupting self-interest, revealing a "New Man" capable for the first time in history of giving authentic and universal expression to concepts such as freedom, democracy, and love. Trotsky captures something of this dynamic in his 1923 essay "Communist Policy toward Art" when he describes the role of art under a fully evolved Communism. Once the "social hatred" necessary to fuel the violence of the dictatorship of the proletariat and bind the proletariat together into a coherent fighting force has burned off, "solidarity will be the basis of society" and "all the emotions which we revolutionists . . . feel apprehensive of naming . . . such as disinterested friendship, love for one's neighbor, [and sympathy] will be the mighty ringing chords of socialist poetry."[71]

Lenin, Chernyshevsky, and the New Man

How they flourish in health and strength! How slender and graceful they are! How full of energy and expression are their features! All of them are joyous and beautiful men and women, living free lives of labor and enjoyment.
—Nikolai G. Chernyshevsky, *A Vital Question: What Is to Be Done?* (1863)

It is notable that the single most influential book for Lenin's development as a revolutionary was not by Marx, Engels, or Herzen. Rather, it was a little-known romance novel written by the philosopher and socialist Nikolai Chernyshevsky while he was imprisoned in the infamous St. Peter and Paul Fortress in 1863. This book, titled *What Is to Be Done?*, provided the

framework for Lenin's reinvention of himself as a revolutionary, and was sufficiently important to him that he appropriated its title for what was, arguably, his own most famous theoretical text. In Chernyshevsky's novel, Lenin discovered a fictional model for the revolutionary self that would pattern the rest of his life, and the broader social imaginary of revolution itself. The novel revolves around the romantic entanglements of Vera Pavlovna as she struggles with an overbearing mother and an arranged marriage, eventually finding happiness after she establishes a sewing commune and discovers true love with a socialist named Alexander Kirsanov. However, the moral center of the novel is provided by the figure of Rakhmetov, who the author introduces in order to underscore the comparatively undeveloped character of the main protagonists. It is precisely in this figure that Lenin finds his paradigm. Rakhmetov (like Lenin) is a noble who disavows his class background and transforms himself, by single-minded discipline, into an avatar of revolution.

The revolutionary, like the poet, must subject the self to a radical derangement. Just as Rimbaud produced this ontological dislocation by identifying with the working class ("I will be a worker!"), Rakhmetov undergoes an even more extreme transposition, literally reshaping his body to take on the physicality of a worker through an organized program of gymnastics and an immersion in various forms of manual labor. As Chernyshevsky describes it:

> He became a plowman, a carpenter, a ferryman, and a workingman—a laborer in every kind of healthy occupation whatever. Once he went the whole length of the Volga, from Dubovka to Ruibinsk, in the capacity of a hurlak [a barge puller] . . . he simply engaged passage as a traveler, and after making friends with the crew, he began to help tow the boat; and at the end of a week he put on the regular harness, as though he had been a genuine laborer. They quickly noticed how powerfully he was towing the boat; they began to put his strength to the test. He out-towed three, even four, of the strongest of his mates.[72]

Rakhmetov will not simply be physically strong, he will become the penultimate version of the worker, the strongest and most proficient imaginable ("it will make me loved and esteemed by the common people"). At the same time, he embraces a frugality in his dress and self-care (notwithstanding his sizable income as an aristocrat) that matches the financial constraints of the working class. "I have no right to spend money of a whim which I need not gratify. . . . I must not eat that which is entirely out of reach of the common people. This is necessary in order that I may feel, though in a very slight

degree, how much harder is the life of the common people than my own. . . . He was always poorly clad . . . he allowed himself no mattress and slept on felt without so much as doubling it up."⁷³ This is a self-imposed poverty that requires Rakhmetov to renounce his own aristocratic class privilege. He will experience, mimetically, both the physical power of the working class and their material suffering and privation. At the same time, he will cultivate his intelligence with a single-minded focus, reading only those works that can provide him with the theoretical tools necessary to launch a revolution. Rakhmetov thus combines, in his own personality, both the physical prowess of the masses (the proletarian body) and the intellectual discipline of the bourgeois or aristocratic class renegade—a perfect Schillerian hybrid. This reinvention of the self requires, in turn, a strict commitment to intersubjective autonomy and sacrifice ("I will not drink a single drop of wine. I will not touch a woman").⁷⁴ Rakhmetov rejects all societal norms and refuses any deep emotional attachment ("Men like me have no right to bind their destiny to that any one whomsoever").⁷⁵ Even pleasurable emotion or sensation is denied to him, all in order to refine his body, mind, and will into a selfless instrument of revolution.

All of this self-denial is necessary in order to usher in a version of life after the revolution (evoked in a series of Vera's dreams) that very much mirrors the paradigm of the aesthetic state introduced in chapter 1. "But here there are no remembrances, no dangers, of want and woe; there are only remembrances of free labor with full satisfaction, of abundance, of good, and of enjoyment. . . . They have all our mental culture together with the physical development of our strong working people. It is comprehensible that their enjoyment, that their pleasure, that their passion, are more lively, keener, wider, and sweeter than with us."⁷⁶ Before we can achieve this Edenic condition, we must first strengthen ourselves to endure the violence and sacrifice that will be required to create a true revolution. In a memorable passage, Rakhmetov hardens his revolutionary resolve by sleeping on a bed of nails. "The back and sides of Rakhmetoff's shirt was covered in blood; there was blood under the bed; the felt on which he slept was covered with blood; in the felt were hundreds of little nails, sticking up about an inch. . . . 'A trial. It was necessary to make it. . . . I know now what I can do.'"⁷⁷

This same commitment to hard-nosed violence is a repeated theme in Lenin's writings and letters. In his *Diary*, Trotsky recalls a conversation with Lenin just before the fall of Kazan in which he complains, "Russians are lazybones, softies. . . . It's a bowl of mush we have, not a dictatorship." Trotsky suggests that it is necessary for the Bolsheviks to form military

units around "a hard revolutionary nuclei which will support iron discipline from within" by shooting deserters and placing armed commissars in charge of Tsarist officers.[78] In 1919, Lenin complains again to Trotsky that "Russians are too kind, they lack the ability to apply determined methods of revolutionary terror."[79] And in a letter to the Bolsheviks of Penza in August 1918, he advises a series of actions intended to send a message to "kulaks" (a somewhat elastic designation meant to identify any peasant wealthy enough to own at least a small amount of land) who were resisting Bolshevik authority: "Hang (and I mean hang so *that people can see*) not less than 100 known kulaks, rich men, bloodsuckers.... Take all their grain away from them.... Identify hostages." In case his directive is not sufficiently clear, Lenin concludes his letter: "P.S. Find tougher people."[80] If you, as a radicalized member of the intelligentsia, allow yourself to feel a sense of emotional connection with others, or to see others as fully human, rather than interchangeable cogs in the unfolding of a revolutionary teleology, you have succumbed to bourgeois sentimentality. Here we encounter a curious inversion of the "incapacity of the masses" thesis that was central to the discourse of Enlightenment aesthetic autonomy. Where Schiller and Kant felt that this incapacity was demonstrated by the tendency of the masses to devolve into violence during a period of revolutionary upheaval, Lenin will associate it with the reluctance of workers to be bloodthirsty *enough* in overthrowing the bourgeoisie.[81]

While the revolutionary may strive to be "like" a worker (Rakhmetov) or to speak on the worker's behalf (Lenin), all too often, the workers themselves seem unable to measure up to the model of revolutionary sacrifice established by the theorist. This frustration continued even after the revolution itself, since the task of expunging counterrevolutionary thought was never ending.[82] Man, as he currently exists, is "a highly awkward creature," as Trotsky observed in 1921. "The question of how to educate and regulate, of how to improve and complete the physical and spiritual construction of man, is a colossal problem which can only be conceived on the basis of Socialism.... To produce a new 'improved version' of man—that is the future task of Communism."[83] The identity of Communism's New Man underwent a series of tactical shifts. During the prerevolutionary period, the New Man took the form of the exemplary revolutionary leader (Rakhmetoff, Nachayev), to be emulated by the proletariat. In this guise the New Man was radically disinterested, or rather, his single, all-consuming "interest" was revolutionary violence, for which he sacrificed all feelings of joy or friendship. Following the revolution, the New Man reemerged as the self-

less, Stakhanovite worker, exhausting himself in the service of the collective. Finally, the New Man was held out as the final telos of the revolution, representing the new form of humanity that will emerge in a fully realized Communist system. No longer driven by capitalist greed, and relieved of the burden of revolutionary emotional "hardness," he will finally indulge his long-repressed desire for conviviality, love, and pleasure without guilt. The parallels with aesthetic experience (which cultivates an ameliorative capacity for "disinterest") are evident in the shared investment in a form of human consciousness in which rapacity and selfishness are replaced by a sense of identification with a collective sensus communis.

For Lenin and Trotsky, this quintessentially aesthetic goal will be achieved through the systematic reeducation of the masses in the principles of socialism. "Millions of years had been needed for the cell to advance to the stage of Homo Sapiens," as Trotsky wrote, "but it took only sixty [since the rise of Marxism] for him to be cleansed of all impurities."[84] With Trotsky's quote we enter another stage in the historical development of the autonomous subject. We began the story of aesthetic autonomy with the inadequacy of existing human consciousness in the postabsolutist era. For Schiller, this inadequacy would be overcome by a process of education designed to produce an "aesthetically tempered man" capable of generating new, consensual norms without devolving into intersubjective violence. As with Kant, this capacity was as yet only possessed by a small number of advanced thinkers and literati. While Lenin and Trotsky's goal was precisely the opposite (the "spiritual construction" of the proletariat required a transformation that would begin by encouraging, rather than overcoming, their tendency toward intersubjective violence), they are equally reliant on the idea that the evolution of humankind would be led by a cadre of exemplary savants, who model, prefigure, or actively accelerate humanity's future cognitive development. Now, however, Enlightenment philosophers and poets, congregating in universities, theaters, and coffeehouses, have been replaced by a political party with direct control over the lives of 120 million Russians. The process of producing an "improved version" of man entailed, then, a strategic recalibration of the liberatory reinvention of the self that was previously performed by the avant-garde artist and the revolutionary theorist (Rimbaud's "unspeakable tortures," Rakhmetov's grueling self-discipline). When applied to the Russian working class, this transformation was no longer self-directed, but rather externally imposed in the interests of revolutionary efficacy or economic productivity.[85]

The Problem of the State

So long as the state exists there is no freedom. When there is freedom, there will be no state.
—V. I. Lenin, *State and Revolution* (1917)

In its original form, the discourse of autonomy carried the redemptive promise that freedom from absolutist domination could lead to the emergence of more just and equitable political structures. It was the task of aesthetic experience to evoke the new, emancipatory forms of social interaction necessary to produce these structures through a process of political transformation that was, itself, both creative and ontologically generative. However, this promise was compromised in its earliest stages by the logic of capitalism, which introduced new forms of structural inequality that could not be resolved without a more fundamental transformation. It was compromised as well by the deliberate uncoupling of the dialectical relationship between speculative aesthetic experience and actual processes of social change, evident in Schiller's work. It is this same disjunction that occurs in the vanguard and avant-garde attacks on the affirmative qualities of aesthetic experience. In this tradition the prefigurative and the exculpatory were irrevocably linked, even as the creative dimension of praxis itself was abandoned. In the Leninist tradition, real change would only occur through a process of violent revolution that would overturn the entire system, creating a tabula rasa on which a new society, and a new form of humanity, could finally flourish in complete autonomy from everything that came before. Until that revolution has occurred, any attempt to develop new political modes that seek to realize, either practically or imaginatively, the promise of an aesthetic sensus communis only encourages the maintenance of the existing system of domination. From this perspective, the problem with the Commune was not simply that the Communards were insufficiently ruthless in their revolutionary strategies, it was also the fact that they indulged in a quasi-utopian institutional practice (introducing new forms of democratic self-governance, etc.) that was, from a Leninist perspective, premature. Instead of reinventing the government of Paris, the Communards should have been focusing all their energies on the "ruthless extermination" of their enemies.[86] For Lenin, it is impossible, or at least highly problematic, for these two modalities—the creation of new, positive, political forms and revolutionary violence and negation—to coexist temporally. They can only be sequential, with one following *after* the other.

As the quote above suggests, Lenin sought to collapse together the state (as a space in which ongoing political differences within a complex social

system might be negotiated) and capitalism. Within this analytic system, the state has only a single purpose: to enforce and legitimate the violence of capitalism by preventing the economic system itself from being openly thematized as a political issue. Since capitalism is the sole cause of all human intersubjective violence, and the state is simply the institutional form taken by capitalism, "politics" as we understand it, will disappear once capitalism is eliminated. As Lenin writes, "with the removal of this chief cause, excesses will inevitably begin to 'wither away.' . . . With their withering away the state will also wither away."[87] Lenin's provocative dissolution of the Constituent Assembly is perhaps the most emblematic expression of his antipathy to the futile "talking shop" of democratic governance. "It is not voting, but civil war that decides *all* serious political problems," as he wrote in 1919.[88] There was no need to worry about the specific social and organizational forms that would follow the chaotic destruction of revolution because by that point, human nature itself would be fundamentally altered. We would no longer need a "state" structure to help adjudicate among competing interests and values in a diverse social system precisely because we would have expunged the single source of all human self-interest: the foreign germ of capitalism.[89] As a result, the institutional apparatus necessary to govern would consist simply of a cadre of low-level civil servants whose job it was to carry out the purely logistical work necessary to actualize the will of the people, which was understood to be uncontentious and self-evident.[90] Nor would we need civil society or a public sphere in which contending political interests and values would be debated because the political, as such, would cease to exist.

Here we can identify another curious parallel between Enlightenment-era and vanguard models of autonomy. Schiller argues that any practical political transformation has to be deferred until humanity's aesthetic "education" has been completed. The prematurity of practice here is based on his belief that existing human consciousness was as-yet unprepared for the freedom entailed by such a transformation (without devolving into violence). While Lenin, like Schiller, sought to exercise a pedagogical authority over the masses, the utopian reconstruction of human consciousness that he sought will only fully express itself *after* the violence of revolution has subsided. Until that point, the repertoire of political practices and experiential modalities necessary to produce revolution must be entirely instrumental, dedicated solely to the violent negation of the existing system. In each case there is a deliberate supersession of the positive, visionary power of political practice itself, which must be deferred until human consciousness is decisively transformed, either by the gradual process of enlightenment (for Schiller)

or the violence of revolution (for Lenin). Only then will the defensive, appropriative autonomy of the revolutionary agent give way to a system in which there are no significant differences to negotiate or transcend. Thus, we achieve a utopic state in which intersubjective violence has ceased to exist precisely because the very categories of "self" and the "other" (as we have previously understood them) have been rendered obsolete by humankind's evolutionary integration into a single, harmonious class.

As this outline suggests, the experience of the dictatorship of the proletariat parallels the role played by the process of aesthetic education for Schiller. Thus, the violent purging of all residual traces of bourgeois subjectivity will produce a fundamental reorientation of the human personality that allows for the emergence of a true, stateless utopia. Even as late as 1940, Max Horkheimer could still confidently predict that "in a new [Communist] society, a constitution will be of no more importance than train schedules and traffic regulations are now."[91] This helps explain Lenin's long-standing suspicion of the decentralized autonomy of the soviets and his rebuffing of the numerous calls for greater democracy that occurred in the postrevolutionary period. A true democracy could only be tolerated *after* the violent interregnum of the dictatorship of the proletariat had passed and the "higher phase" of communism was finally achieved. As Lenin wrote in *State and Revolution*, "only communism makes the state absolutely unnecessary, for there is nobody to be suppressed."[92] In the event, the "higher phase" never came to fruition, and the task of rooting out subversives and "suppressing" residual capitalist impulses among the broader population occupied the entire history of the USSR.

This marks a symptomatic temporal displacement in the discourse of Leninism. On the one hand, we have the contention that the working class is not yet prepared for full political autonomy; on the other hand, we have the insistence that the mediating mechanisms of democratic will formation and civic debate (which might cultivate that capacity) are unnecessary in Soviet society because the party has simply "absorbed" the emancipatory energies of the proletariat. Thus, the party is simultaneously in advance of the proletariat (sustaining a revolutionary consciousness the proletariat has yet to exhibit) and after the proletariat (embodying in its very form the *Sittlichkeit* or ethical community of the actualized Full Communism that is the proletariat's final destiny). In this capacity the party takes on the role of the aesthetic state as the institutional matrix within which any residual tensions between self and other, or individual and collective, are resolved. However, rather than fulfilling this role in a purely symbolic or prefigurative manner,

the party takes on the operational management of an entire country. Thus, the party acts *as if* society had entered the stage of Full Communism in which the democratic mediation of political differences is no longer necessary, even as it continues to exercise an absolute control over every aspect of political expression, on the assumption that Soviet society has not yet achieved its utopic apotheosis. As a result, the state, far from "withering away," is actually enhanced in its day-to-day control over the lives of its subjects, but without even the nominal accountability provided by bourgeois versions of the democratic state. This occurs in Leninism through the uncoupling of politics and administration. As A. J. Polan argues in his book *Lenin and the End of Politics*, "The Bolshevik government delegitimized politics within the citizenry.... What the Bolsheviks could not do was accept a characterization of any political differences as genuine, i.e., an opinion which a person or group had a right to hold and negotiate over as an equal partner in the process of will-formation."[93] Neil Harding reiterates this view, arguing that in "crucial matters of public policy, as Lenin consistently maintained, broad ranging public debate was inherently unlikely to make any significant contribution."[94]

There is, in the concept of the state, a set of questions that remain central but unresolved in the discourse of communism. The question of the state is the question of the political par excellence; it is one of the key spaces within which societies work out the relationship between self and other, private and public, and the individual and the collective. It is also the space in which the transcendent autonomy so central to the avant-garde and vanguard traditions is challenged by the practical realities and transformative potential of a complex social life. One can easily enough be critical of the form taken by the state under capitalism while still realizing that the concept of the state itself poses an essential political question that cannot be ignored. The creative processes required to develop new forms of sociality and social interdependence cannot simply be deferred until the "real" political work of negation and violent revolution has run its course. "Socialist democracy," as Rosa Luxemburg wrote, "is not something that begins only in the promised land after the foundations of socialist economy are created; it does not come as some sort of Christmas present for the worthy people who, in the interim, have loyally supported a handful of socialist dictators."[95] What form should a future society finally take? How do we avoid reproducing the very authoritarian political structures under which we currently suffer, in the struggle to bring it into practical existence? And how might this future society be prefigured, imagined, and practiced here and now? These are not

incidental concerns that will effortlessly resolve themselves in the utopian period that follows the bloody civil war that Lenin viewed as the necessary concomitant of any Communist revolution. Rather, they play a decisive role in the ways in which the existing social order might be transformed. If history teaches us anything, it is that the modality of revolution itself informs the nature of the society that emerges in its wake.

II

NEGATION AND PERFORMATIVITY

3

FROM VANGUARD
TO AVANT-GARDE

Disruption as Punishment and Emancipation

> Painting was an abscess which drained off an evil in me. . . . What I could only have achieved in a social context by throwing a bomb I have tried to express in art.
> —Maurice de Vlaminck, in Jean Leymarie, *Fauvism* (1959)

During the 1920s it became an article of faith, not only in vanguard politics but in avant-garde art, that negation and "social hatred" were the only acceptable modalities of thought and creation during a period of revolutionary ferment. This perspective would exercise a wide-ranging influence on artists across Europe. Its pervasiveness was due in part to the fact that the Bolshevik revolution gave concrete political expression to a set of existing ideas about art and the primacy of negation that extended back to the nineteenth century. We can observe this influence in the near uniformity with which avant-garde artists during the 1910s and 1920s devoted themselves to an unsparing attack on all existing cultural and political values, most especially

those associated with the reviled bourgeoisie and the "European struggle for money."[1] "We must be brave and turn our back on almost everything that until now good Europeans like ourselves have thought precious and indispensable," as Franz Marc wrote in 1911, "if we are ever to escape from the exhaustion of our European bad taste."[2] Giorgio de Chirico expresses a similar spirit of negation in 1913, demanding that we "rid art of everything known that it has contained until the present, every subject, every idea, every thought, every symbol, must be put aside."[3] This tradition reaches its height with the Dadaists. Thus, "everything had to be demolished," according to Marcel Janco, "and would begin again after the tabula rasa. At the Cabaret Voltaire we began by shocking common sense, public opinion, education, institutions, museums, good taste, in short, the whole prevailing order."[4] And Tristan Tzara, in his 1918 Dada manifesto, insists that "morals and logic" serve only the bourgeoisie and the police. In response, artists, like Nachayev in his "Revolutionary Catechism," must steel themselves for "the great spectacle of disaster, conflagration and decomposition." "Let each man proclaim," as Tzara writes, "there is a great negative work of destruction to be accomplished. We must sweep and clean."[5]

Earlier iterations of Dada will often devolve into a quasi-nihilistic absurdism (embodied in Tzara's contention that "Dada means nothing"). The artist, like Rimbaud during the Commune, will go on strike refusing to produce any "positive" content, which would simply be used by the bourgeoisie to paper over its crimes with the veneer of high culture. As a result, objects are created only to be destroyed or rendered useless, as the very principle of utility is attacked as a vestige of bourgeois positivism. Man Ray's *Object to Be Destroyed* (1923) and *Gift* (1921), a flat iron with metal tacks protruding from the ironing surface, are typical examples. In accordance with the exculpatory critique, any positive, utopian, or prefigurative thought or action only serves to reinforce an intolerable status quo. We find a comparable sentiment among the surrealists. In "Revolution Now and Forever" (1925), the Surrealist Group rejects "all accepted law," placing their hope instead in "new, subterranean forces, capable of overthrowing history" (a reference that encompasses both the unconscious and the spirit of Communist revolt). Like Nechayev and Lenin before them, they dedicate themselves without reservation to the necessary violence of revolution: "We should never for a moment worry that this violence could take us by surprise or get out of hand. As far as we are concerned, it could never be enough, whatever happens . . . we believe that bloody revolution is the inevitable vengeance of a spirit humiliated by your doings."[6]

Here we encounter the characteristic doubling and displacement of violent assault, from the vanguard party that seeks to overthrow the capitalist system through direct action to the avant-garde movement that seeks to symbolically "massacre" bourgeois culture and morality. As the surrealist example suggests, the appeal to a principle of a pure, cleansing negation, which abjures any positive, referential linkage to the world as it currently exists, was tempered by the growing identification of artists with the affirmative example embodied by the ethos of Communist revolution and the institutional form of the vanguard party. The relationship between the avant-garde and revolutionary communism was especially pronounced in Germany, due in part to the politicization of many artists during the failed November Revolution. As Richard Hülsenbeck writes, "While Tzara was still writing: *'Dada ne signifie rien'*—in Germany, Dada lost its art for art's sake character with its very first move. Instead of continuing to produce art, Dada . . . went out and found an adversary."[7] In fact, Dada in Berlin found not just an adversary but also a potential ally in its attempted alignment with the Communist struggle against the German bourgeoisie. Thus, Hülsenbeck and Raul Hausmann begin their 1919 manifesto "What Is Dadaism?" with a list of demands that includes "The international revolutionary union of all creative and intellectual men and women on the basis of radical Communism."[8] And in Hülsenbeck's "En Avant Dada" (1920), he reiterates the essential linkage between communism and negation: "the good is for the Dadaist no 'better' than the bad—there is only a simultaneity, in values as in everything else. This simultaneity applied to the economy of facts is communism, a communism, to be sure, which has abandoned the principle of 'making things better' and above all sees its goal in the destruction of everything that has gone bourgeois."[9] John Heartfield, George Grosz, and Erwin Piscator were all members of the German Communist Party (KPD) during the 1920s, even naming their Berlin headquarters the Dadaist Central Union of World Revolution.

While the Dadaists were concerned to proclaim their enthusiastic identification with the Communist cause, the KPD was considerably less interested in being associated with them. There were several reasons for the disinterest, if not outright disdain, of Germany's Communist Party for the Dadaists, but among the most important was the concern within the KPD that the Dadaist tactics of shock and ridicule directed at the bourgeoisie were counterproductive. Instead, they felt that the revolutionary artist must focus on the creation of affirmative images of, and for, the working class. The result was a paradoxical situation in which, even as the USSR was still

supporting experimental art practices under the leadership of Anatoly Lunacharsky, the KPD remained committed to a highly traditional vision of art, due in part to pressure from the Comintern.[10] The KPD was worried that the Dadaist's histrionic embrace of communism would tarnish the Bolshevik brand by associating it with a band of sacrilegious provocateurs. For this reason we find the KPD denouncing such emblematic events as the 1920 International Dada Fair in Berlin and the new theatrical forms developed by Erwin Piscator after he parted ways with the Dadaists. Gertrud Alexander, writing in the KPD journal *Die Rote Fahne*, attacked the works exhibited in the Dada Fair as "tasteless" and "barbaric." For Alexander, the ostensibly scandalous satire of Dada was easily enough assimilated by a complacent bourgeois culture fully prepared to savor its own symbolic immolation. "The bourgeoisie laughs about it," as Alexander writes. "They smell in it the flesh of their own flesh: bourgeois decadence."[11] Even Lu Märten, who wrote to defend the Dadaists in a subsequent issue of the journal, acknowledged the challenge facing the Dadaists in confronting a form of "capitalism that is still willing to see and pay for its own crimes in a mirror and panopticon under the etiquette of art."[12] This observation captures a central tension in the discourse of the avant-garde as it seeks to locate a fulcrum for critique from within the ideological and institutional enclosure of a bourgeois art world that is all too ready to valorize, and commodify, the largely symbolic forms of provocation that the avant-garde typically provides.

For the KPD, the revolutionary artist must abandon satire and instead produce idealized and accessible images of workers and their valiant struggles.[13] While George Grosz initially sought to accommodate himself to the party's demands, even designing posters for use in demonstrations, he eventually grew frustrated with these constraints. By 1928 he would openly condemn a "Hurrah-shouting Bolshevism, which imagines the working man with his hair neatly combed and dressed up in archaic heroic costume."[14] Instead, Grosz advocated an avant-gardist paradigm in which the artist, rather than idealizing the proletariat, would bring the worker into critical awareness of capitalist exploitation. "I absolutely reject the idea that one can only serve the cause of propaganda by producing a one sided, flattering, and false idealization of life.... The task of art is the help the worker understand his exploitation and his suffering, to compel him to acknowledge openly his wretchedness and enslavement, to awaken self-consciousness in him and to inspire him to engage in class warfare."[15] While the KPD would agree that these are essential tasks, it would also insist that only the party was in a position to determine which forms of cultural production were

appropriate at a given moment of revolutionary struggle, and the precise mechanisms (idealism or satire, abstraction or graphic realism) by which workers might be "compelled" to acknowledge their enslavement. Here we see the interference patterns created when two autonomous discursive systems (the vanguard party and the avant-garde movement), each of which claims a proprietary relationship to the consciousness of the working class, come into conflict. The Leninist party demands an absolute and unilateral authority and claims a unique ability to decipher the ideological constraints of capitalist hegemony. It encounters, then, in the avant-garde art movement a system whose claims of sovereignty and critical transcendence are as unyielding as its own. The mandate to harness art to the demands of revolution through images of heroic workers would soon become the order of the day in Russia itself. For his part, Grosz would go from being the KPD's most celebrated artist during the early 1920s to a pariah by the end of the decade, due to his refusal to subordinate his artistic practice to the party's diktats.[16]

The promise of a revolutionary moment, like the period associated with the Bolshevik revolution, is that the vanguard party and the avant-garde art movement will finally become a conjoined force of radical social transformation. In fact, during the 1920s both the Dadaist and surrealist movements would deliberately mimic the institutional protocols of the vanguard party, with formal "congresses," manifestos, and prescribed "lines" on particular political issues. Art, having held its insurrectional potential in the suspensive reserve of formalist experimentation, will finally desublimate this latent political power in modes of provocation intended to openly antagonize the bourgeoisie as a class. This cultural assault will serve as the corollary expression of the party's turn to militant violence in the overthrow of the capitalist system. In this process the political itself will be transformed as society undergoes its final transformation into a universalized aesthetic state. This is the scenario that figures such as Grosz, Piscator, and many other artists in Germany and Russia likely envisioned. The historical record, of course, presents a very different picture, in which the vanguard party and the avant-garde art movement more often conflict with, rather than complement, each other.

For my purposes, the key to understanding the complex interrelationship between the avant-garde and the political vanguard at this time lies not simply in their operational ties (party membership, formal collaboration, etc.), but also in the ways in which artists sought to translate revolutionary precepts into modes of aesthetic production. This question requires a closer examination of the forms of reception that were mobilized in avant-garde

practice. As we have seen with the Dadaists, the avant-garde artist was especially well positioned to impugn the exalted spiritual values that the bourgeoisie had historically associated with fine art. In this manner the artist takes up a critical distance from "art" itself as a valorized category of cultural production. This is the foundation for Hülsenbeck's attack on the exculpatory function of fine art as a "moral safety valve" used to justify bourgeois domination, and the resulting tactic of ridiculing "anything connected with spirit, culture and inwardness" to the (ostensible) consternation of the bourgeois public. But provocation, no matter how gratifying it might be for the artist, has no necessary relationship to either enlightenment or demoralization. In some cases, it might simply strengthen the viewer's resolve to seek refuge in an authoritarian regime dedicated to ridding society of precisely such anarchistic disruptions. And in other cases, as we see with Märten's description of the German bourgeoisie "willing to see and pay for its own crimes in a mirror," provocation can easily enough turn into a form of commodified entertainment or self-affirmation. This represents an inverted, avant-garde version of the exculpatory critique. Rather than the bourgeoisie using beautiful art to indulge in a spurious class transcendence, they use provocative art to exhibit their own self-reflexive openness to critique, and their cultural superiority to philistine elements within the middle class itself.

The Psyche of the Masses

Grosz's reference to "awakening" the worker to "self-consciousness" indicates a significant rearticulation in the rhetoric of the avant-garde as it moves from a paradigm of disruption directed against the bourgeoisie to one intended to bring working-class viewers into full awareness of their revolutionary destiny. Typically, this shift would be linked with the historical transition from a prerevolutionary moment (in which art must remain dedicated to assaulting the still empowered bourgeoisie) to an artistic practice developed in the midst of a revolutionary uprising (which hopes to find its interlocutor in the nascent proletariat). We encounter this shift most fully in the Soviet avant-garde. Thus, the discourse of perceptual assault is characterized by two related, but distinct, modalities: one punitive and one emancipatory. The first entails the deliberate scandalization of an implicitly bourgeois viewer, who will be punished for his or her class identity and made to recognize their criminal complicity with the economic oppression from which they materially benefit. The work of art is experienced as a unilateral assault, and the viewer's subjective agency is meant to be undermined as they recoil

from the uncomfortable truth that has been forced upon them (mirroring the effect of revolutionary violence at the cognitive level). The second variant is concerned with awakening a somnolent, working-class viewer and enhancing (rather than diminishing) their political agency. Here the goal of art's perceptual assault is not to punish or demoralize, but to cultivate a revolutionary consciousness, catalyzing workers to recognize the nature of class oppression (and their own victimization), after which they will align themselves with the revolutionary struggle led by the Communist Party.

Dziga Vertov's "Kino Eye" manifesto from 1926 epitomizes this logic: "We need conscious men, not an unconscious mass, submissive to any passing suggestion. Long live the class consciousness of the healthy, with eyes and ears to see and hear with! . . . We have come to show the world as it is, and to explain to the worker the bourgeois structure of the world. We want to bring clarity into the worker's awareness of the phenomena concerning him and surrounding him."[17] Here we see Vertov struggling to reconcile the violent intentionality of an avant-garde assault originally designed to negate bourgeois consciousness with a more benign, liberatory mode of aesthetic alienation. Sergei Eisenstein, for his part, would dismiss Vertov's cinematic methods (which rely on the self-evident truth of the "Kino Eye") as "artistically useless" and "lacking in metaphorical implication." Instead, Eisenstein will insist on a far more aggressive relationship to the viewer. "In our conception," as he writes in 1925, "a *work of art* . . . is first and foremost *a tractor ploughing over the audience's psyche in a particular class context*" (emphasis in original). Thus, "It is not the Kino Eye that we need but the Kino Fist! Soviet cinema must cut through the skull! It is not 'through the combined vision of millions of eyes that we shall fight the bourgeois world' (Vertov); we'd rapidly give them a million black eyes!"[18] We encounter here a symptomatic slippage between the two modalities outlined above (an avant-garde practice directed against the bourgeois self on the one hand and the proletarian on the other) that will continue to inform the avant-garde tradition throughout the twentieth century.

Notwithstanding the varying forms of affect mobilized in each of these modalities, at the broader level they both mirror Lenin's description of the supervisory role of the party in "directing the thoughts" of the "unconscious" working class toward the recognition of its own oppression. In both the punitive and the emancipatory paradigms, we begin with an artistic practice that takes on a custodial relationship to a viewer who is defined by their cognitive incapacity (not yet aware of the broader social ecology of capitalism and their own relationship to the systematic forms of domination and privilege that

subtend it), and for whom aesthetic experience will precipitate an awakening of critical consciousness (directed toward either their own class privilege or the capitalist system that oppresses them). This latent behavioralism is evident throughout the rhetoric of early Soviet art as it seeks to define its role in conjunction with the operation of the vanguard party.[19] It is especially evident in the critical discourse around the concept of defamiliarization or estrangement (*ostranenie*) in Germany and Russia. The work of the literary theorist Viktor Shklovsky is of central importance in this tradition. In his hallmark essay "Art as Device" (1917), Shklovsky gave a heightened theoretical complexity to questions surrounding the generation of a critical consciousness.[20]

There are several features of Shklovsky's analysis that are of particular importance for my inquiry here. The first is his critique of habitualization. Habitualization refers to our tendency to lose contact with the material specificity of the world and to rely instead on "autonomic" responses to organize our perception of external reality. "Autonomization," Shklovsky writes, "eats away at things, at clothes, at furniture, at our wives, and at our fear of war. If the complex life of many people takes place entirely on the level of the unconscious, then it's as if this life had never been."[21] While Shklovsky's concern was primarily with issues of poetics, his analysis is symptomatic of the broader cultural currents of the revolutionary period and mirrors Lenin's concern with the "habituation" of the working class and petit bourgeois. Here, again, advanced art or poetry can be seen as paralleling the role of the party in revealing to us the existence of hidden structural determinants (of language or of meaning itself), while also catalyzing a revolutionary desire to destroy the existing forms of political domination that depend on these same semantic structures. Habitualization is not simply the plight of a few hidebound and conservative individuals, but has become, in Shklovsky's account, a nearly universal feature of modern life. Art, alone, can remedy this pervasive cognitive incapacity. "The purpose of art, then, is to lead us to a knowledge of a thing through the organ of sight instead of recognition. By 'estranging' objects and complicating form, the device of art makes perception long and 'laborious.' . . . *Art is a mean of experiencing the process of creativity*."[22]

Art, rendered increasingly marginal by the proliferation of mass culture in the early twentieth century, reclaims its purpose as the antidote to precisely those forms of perceptual stasis that have been introduced by the cultural practices that have displaced it. It does so by a deliberate "braking" or slowing of perception. For Shklovsky, the process of aesthetic estrangement

proceeds through a series of metonymic inversions, forms of word play and rhythmic disruptions that have the effect of emphasizing the autonomy of the signifier. While focused on poetic texts, his argument was easily enough extended to the visual arts to account for modes of photographic or cinematic production that "foreground the apparatus" via montage, unusual points of view, and so on. In each case the goal is to draw the viewer's attention to the ways in which the filmic medium itself informs the "truth" that is conveyed to us by the camera. In the process we come to realize that the reality we previously thought to be natural is actually contingent, and susceptible to reconstruction. We become conscious at the same time of our reliance on a set of cognitive structures that have blocked our awareness of the deeper complexity of the experiential world. This outline suggests the potential parallels with a concept of revolutionary consciousness that penetrates beneath the naturalized surface of bourgeois ideology to reveal the hidden system of capitalist domination.

For Shklovsky, the object or work that triggers this insight is "quite unimportant." Instead, what one perceives in advanced art is precisely the act of perception itself, held in stasis so that it can be recognized in the first place. Poetry, or art, reclaim their social relevance not by presenting new political or social "content," but by revealing the preexisting epistemological and semantic system through which meaning itself is created. Poetry for Shklovsky, as for Schiller before him, will return us to a purer or more direct form of consciousness, clearing away the accumulated perceptual debris of past experience and allowing us to encounter the world in its full complexity as if for the very first time. Poetry's destabilizing sensorial assault (a cognate of Eisenstein's "kino fist") triggers an edifying, adaptive response, retraining the mind to be attentive to the actuality of the world. The aesthetic experience generated by these "concussions" will challenge the automatism that is encouraged by ordinary speech or expression, which operate with the perceptual speed, efficacy, and unthinking complicity of advertising.[23] This is the basis for Shklovsky's key distinction between "poetry" and "prose." Prose, the language of daily life and communication, is "economical, easy . . . accurate, and facile."[24] It caters to our naive, "child-like" desire for immediate gratification and for a reassuring fixity of meaning. Crucially, Shklovsky links prose specifically with communal or collective experience. Thus, work songs such as *Dubinushka* help to make the experience of shared labor "automatic" and "unconscious," while poetic expression "deautomatizes" perception and "slows" it down. "The language of poetry is, then, a difficult, roughened, impeded language."[25]

In order to maintain this estrangement, poetic language must periodically draw from the lexicon of prosaic language as existing forms of defamiliarization become "canonized."[26] It is notable that the condition of habitualization that Shklovsky describes is not restricted to our relationship to art or poetry, but also informs our general consciousness of the world. It is equally notable that the solution to this pervasive condition (which entails a fundamental deterioration of our ability to gain meaningful knowledge of the world) lies exclusively with art or poetry. Thus, significant change in the social production of meaning can only occur when the poet or artist intervenes by appropriating denuded, prosaic material and transforming it into a vehicle for a privatized experience of aesthetic alienation. By extension, prosaic language or cultural production is necessarily sterile and uncreative. Prosaic expression is capable only of facilitating the most reductive forms of meaning and communication, reflecting the more general cognitive impairment of the masses, for whom creative agency is foreclosed.

Formalism was not simply an esoteric theory of interest to a handful of poets and intellectuals. By the early 1920s, formalist scholars had taken on key positions in several major state academies in Russia.[27] But this radical experiment was short-lived, and a state-sponsored counterattack began only a short time later. By the early 1930s, formalism, and the broader discourse of formal experimentation in poetry and the visual arts, was increasingly identified with "the dead-end perspective of rootless, bourgeois artists."[28] In 1930 Shklovsky was forced to officially recant ("Formalism has indeed committed a grave error").[29] If the formalists made a "grave error," it was probably their belief, in the early, euphoric, postrevolutionary days, that they were living in the final phase of an accomplished Communist revolution, rather than entering an indefinitely extended dictatorship of the proletariat, during which "experimentation" and "freedom" would not be tolerated. It is one thing to encourage a critical perspective toward all existing systems of meaning when you are seeking to undermine the authority of an existing regime; it is quite another when you are attempting to establish the authority of a new regime on its charred ruins.

People Were Singularly Receptive Then

The future historian will note that during the bloodiest and most brutal revolution, all of Russia was acting.

—Piotr Kogan, "Socialist Theater in the Years of the Revolution" (1919)

For many European artists, the revolutionary upheavals of the 1920s led to the conviction that art must remain autonomous from political resistance, precisely because the political, as embodied by the Communist Party, can exhibit the same instrumentalizing drive that they deplored in the bourgeoisie. Here the autonomy of art is carried forward as a defensive measure against the potential appropriation of art to the demands of political propaganda (Grosz's "Hurrah-shouting Bolshevism"). We can observe, however, a second trajectory in the art of the 1920s in which autonomy, rather than being reinforced (in the defensive autonomy of the avant-garde movement), is renegotiated in a manner that potentially challenges conventional notions of both art and the political. We can identify this tendency in the new forms of theatrical production developed in Germany during the 1920s by figures such as Bertolt Brecht and Erwin Piscator. Brecht and Piscator transformed the conventions of theater, both in terms of its technical development (the use of film projection, new acting techniques, etc.) and in terms of its social architecture, through forms of production involving working-class audiences and participants. This tendency was especially pronounced in Piscator's early work. In 1920 Piscator, along with Hermann Schüller, formed the Proletarian Theater in Berlin. Its six thousand members were drawn primarily from the General Workers Union, the Communist Workers Party, and the Syndicalists.[30] The Proletarian Theater sought to integrate itself with working-class audiences in a variety of ways. Rather than staging its productions in established bourgeois theatrical venues, they were presented in assembly halls and community centers in the working-class neighborhoods of Berlin.[31] Not only did the Proletarian Theater bring its productions directly to working-class audiences, it also solicited suggestions from workers for specific topics to address and sought to involve workers in the creation of the plays. This is an approach that Piscator continued after the dissolution of the Proletarian Theater in 1921 through "Special Sections" composed of younger workers in his subsequent theatrical group the Piscator-Bühne. With as many as sixteen thousand members, these groups developed their own independent productions, with a particular focus on Zeitstücke, or plays that addressed current political events.[32]

We also see Piscator, as well as Brecht, modifying their plays in response to feedback from working-class audiences. Thus, Brecht describes his staging of "preview" performances before audiences of workers or students, in order to solicit their responses. Their suggestions and critiques would then become the basis for further revisions in the play's form. "I am interested in

people's attitudes and opinions," as Brecht writes. "I learn from these discussions.... From what I learned from the audiences that saw it, I rewrote *Mann ist Mann* ten times."[33] While the rhetoric of making strange or defamiliarization persists in both Piscator and Brecht, its specific orientation is quite different from the punishing ethos of Eisenstein's "Kino Fist." In particular, they understand the temporality of disruption in a more complex manner (rather than a singular moment of epiphanic provocation, they argue for an extended process of interpretation and dialogical interaction). Now audiences are "interrupted" (in their immersive surrender to traditional drama) in order to initiate a conversation with them. Here the work of art makes itself at least potentially answerable to viewers, seeking to enhance their reflective agency and becoming reciprocally responsive to their own insights. These are, of course, only partial and exploratory attempts to thematize artistic subjectivity and the creative process in new ways. Both Brecht and Piscator were equally capable of producing more conventional forms of theater with no direct involvement with the audience. However, even at this tentative level, these gestures suggest a significant recoding of the norms of aesthetic autonomy. This challenge unfolds on three, related, levels. First, it occurs in the deliberate thematizing of the autonomy of the artistic self and in the opening up of creative agency to a range of participants and interlocutors. In this view, artistic subjectivity is seen as mobile rather than fixed in the consciousness of a handful of exemplary figures. Here is the way in which Piscator describes this shift in 1920: "This brings the writer face to face with an important task. He too must cease to be the autocrat he has always been in the past, and [he] must learn to push his own ideas and original touches to the back of his mind and concentrate on bringing out the ideas which are alive in the psyche of the masses."[34]

Second, the artwork serves as a locus of intersubjective exchange among a range of different creative agents, rather than the expression of an a priori truth, to be handed over to a receptive audience. Here the compositional structure of the work is not fixed, but open to ongoing transformation and reinvention as a result of these exchanges. Third, and finally, we encounter an opening out of theatrical production from the institutional sphere of bourgeois theater. As I noted above, Piscator's works with the Proletarian Theater were staged in assembly halls and community centers in working-class neighborhoods. Moreover, both Piscator and Brecht sought to incorporate the "prosaic" cultural forms disdained by Shklovsky directly into their plays, including references to sports, mass media, and contemporary political life. The effect was to project onto the stage forms of social interaction

and political critique that rarely appeared in traditional theater. As a critic writing in *Die Rote Fahne* observed in a review of Franz Jung's *Kanakans* in 1921: "What is basically new about this theater is the curious way in which reality and the play merge into one another. You often don't know whether you are in a theater or a public meeting, you feel you ought to intervene and help, or say something. The dividing line between the play and reality gets blurred."[35] We can recognize here an alternative paradigm of artistic production that deviates from the proprietary rhetoric of the avant-garde creator "ploughing over" the viewer's consciousness. Instead, the transformation of consciousness is understood as occurring through a process that is, at least potentially, reciprocal rather than unilateral, as the work of art invites involvement rather than subordination. We encounter here as well an alternative model of political transformation. In the Leninist paradigm, revolutionary struggle must unfold through a hierarchical command structure that can make no concession to demands for democratic consultation, even from members of the working class who are its ostensible beneficiaries. The result is a logic of revolution structured around a binary opposition between the "political" and the "cultural." There is no need for the working class to develop its own cultural expression or generate its own forms of insight independently of the party because the party itself has already absorbed the most meaningful dimension of proletarian consciousness. What we observe in Piscator, and a number of other artists working in Russia and Germany during the 1920s, is the belief that revolution must incorporate both a political *and* a cultural dimension in order to produce and sustain a more just and emancipatory society. And this entails the formation of a culture of creative resistance within the working class itself that is not simply dependent on the wisdom of a radicalized bourgeois intelligentsia.

This aspect of Piscator's work reflects the influence of Alexander Bogdanov, an early member of the Bolshevik party. Bogdanov rejected the authoritarianism of the Leninist vanguard and developed a concept of autonomous, proletarian cultural development that took form as the Prolekult movement. For Lenin, there was no reason for a revolutionary movement to rely on democratic processes and no reason to assume that the working class was capable of generating meaningful insight into the nature of capitalist domination or the means of its overthrow. Nor was there any reason to devote much time to pondering the new social forms that might come into existence after power was seized. Bogdanov, by contrast, argued that forms of political transformation that hope to produce a more equitable social system require a prefigurative dimension, in which some elements of that

future society are cultivated in a speculative or experimental manner. As a result, he was, far more than Lenin, concerned with what would happen the "morning after" the revolution.[36] In this view, the act of resistance is not simply pragmatic, but also has the capacity to transform the consciousness of the agents of resistance themselves, laying the groundwork for the development of alternative social forms that can transcend the limitations of the capitalist lifeworld. There are two related reasons for this. First, it is essential that the actual constituents of revolutionary change see themselves, their own agency and aspirations, reflected in the creation of a new social order. It is precisely this sense of identification that allows for the emergence of the new insights that will be necessary to bring that world into practical existence. These forms of insight (the ability to envision the new social forms that might emerge, and on behalf of which we struggle) cannot be anticipated in advance, but only fully arise through the practice of political transformation itself. Second, any political transformation that depends on an entirely hierarchical organizational structure will inevitably run the risk of bringing into existence a new social order that simply replicates, in modified form, the authoritarianism it sought to displace. For this reason, Bogdanov warned of the dangers of a revolution wholly predicated on the "soldiery influence" of intraclass violence and "personal hatred" that dominated the period of the Russian Civil War. As he wrote, "proletarian culture is basically defined . . . not by destruction but by creativity."[37]

Bogdanov will turn to the concept of culture to elaborate this alternative revolutionary paradigm. For Bogdanov, cultural development—the emergence of new forms of creativity, learning, and sociality—was as essential to the success of a revolution as hard-nosed political calculation. These ideas evolved in Bogdanov's thought in the years following the failure of the 1905 revolution, but he was finally able to give them institutional form after the Bolsheviks took power.[38] Central to the vision of Prolekult was the necessary freedom of culture itself. At its founding conference in 1918 the delegates laid out a number of key principles. Chief among these was the contention that cultural development constituted its own autonomous realm and was just as important as the party itself in realizing the promise of the revolution. The idea of a major institutional structure in Russia that was predicated on the autonomy of the working class, and its ability to develop new forms of cultural expression that might also carry new visions for the future development of Russian society, was anathema to Lenin. The party, and the party alone, was granted the right to imagine the future of Russia and to implement the policies necessary to bring this image into reality. The concept of

an independent proletarian culture brought Bogdanov perilously close to principles of syndicalism and anarchism, which Lenin loathed because they threatened the hierarchical authority of the party and Lenin himself as its leader. With the termination of the Civil War in the early 1920s Lenin was able to pay closer attention to the proliferation of new institutions in the post-1917 period. When he realized how large Prolekult had become, and the extent to which it carried forward Bogdanov's ideas about working-class autonomy, he demanded that it be placed under party control and subordinated to Narkompros (the People's Commissariat for Education). It was eventually eliminated with the transition to Zhadnovian cultural policies in the late 1920s.[39]

The Prolekult movement expanded dramatically during its brief existence. In this respect it mirrors the remarkable outpouring of creative energy among the Russian people following the February Revolution. Viktor Shklovsky captures the utopian spirit of those early days: "Oral delivery, reciting poems on the floor of a factory, a café or a worker's meeting became the only means for disseminating [the artist's] products. . . . No matter what one would set out to do, open a prompter's school for a Red Fleet theater or give a course in the theory of rhythm at a hospital, one was bound to find an audience. People were singularly receptive then."[40] Large segments of the Russian public believed that they were on the cusp of a genuinely new social order defined by freedom and equality, in which they themselves would play a central and formative role. This is what lends such pathos to the widespread enthusiasm at the time for artistic practice among working-class Russians, who glimpsed their own creative potential in the political promise of the revolution. By the early 1920s there were more than 1,300 Prolekult studios and centers located in factories, army barracks, major cities, and provincial centers, with nearly 500,000 active participants drawn from the working class, along with supportive members of the Russian bourgeoisie. The range of Prolekult activities was equally impressive, including studios devoted to drama, literature, visual art, music, and applied arts, as well as more than thirty Prolekult journals. One of the most active areas of Prolekult work was in theater, which drew on a long-established Russian tradition of workers' education.[41]

As with Piscator's Proletarian Theater, a key component of Prolekult involved a commitment to collaborative forms of production, as well as the staging of performances for workers in factory theaters or working-class communities. "The creation of the new proletarian theater," as Platon Kershentsev argued, "needs to start locally, in the districts, because only on

this condition can firm and tight bonds be created among its participants, those familial ties that were unknown in the bourgeois theater."[42] Kershentsev goes on to describe performances that move outside "the four walls of the theater building" entirely. The theater collective will "take its work outside in the streets and squares. It will form small groups of three or five actors who on feast days or in the evenings will go around the city and stage semi-improvised performances in parks and street corners."[43] The interest in developing theater in the context of people's daily lives also implied a willingness to incorporate elements from popular culture that would be familiar to a working-class public. This is evident in the work of Theater of Working-Class Youth (TRAM), which was founded in Leningrad by a railroad worker named Mikhail Sokolovskii. TRAM developed innovative new forms of performance, including living newspapers and plays that synthesized singing, dancing, acrobatics, games, and improvisational forms of composition.[44] The group first emerged in 1925 and subsequently expanded to numerous local chapters in other Russian cities.[45]

By the late 1920s, TRAM's commitment to developing projects that would encourage new forms of working-class culture brought it into direct conflict with the increasingly orthodox orientation of Narkompros. As Lynn Mally notes, in 1927, TRAM was singled out for attack by Robert Pel'she, a leading figure at Narkompros, who "warned that the concept of TRAM 'smelled like syndicalism,' alluding to oppositional tendencies that threatened Communist Party control."[46] This is part of a much broader backlash against the concept of working-class culture that accelerated dramatically during the mid-to-late 1920s. As early as 1921 Shklovsky described the rapid expansion of amateur theater as "a sign of sickness" and "escapism" that has "bred like bacteria" in Russian society.[47] In this view, the Russian working class were guilty of a kind of premature desublimation in which they refused the pressing challenges of postrevolutionary nation-building and instead sought to "dress up and play masquerade" as actors and artists. More precisely, Shklovsky might have said the Russian people were exhibiting a problematic interest in prefigurative forms of aesthetic experience, while shirking the difficult, practical work necessary to "build a new life."[48] This is consistent with Lenin's ongoing skepticism about the capacities of the Russian working class. As early as 1919 he openly declared his rejection of "all kinds of intellectual inventions, all kinds of 'proletarian culture.'" The workers, as he went on, "would like to build a better apparatus for us, but they do not know how. They cannot build one."[49] And in 1921, Lenin would write to Anatoly Lunacharsky, the director of Narkompros: "I advise you to

put all theatres in coffins. Narkompros ought to be concerned with teaching literacy and not with the theatre."[50] In this sense, what Lenin feared in Prolekult was a cultural equivalent to the Kronstadt uprising (which occurred that same year) in which workers and soldiers, the very agents of revolution, challenged the transcendent authority of the party and its increasingly authoritarian control over daily life in Russia. The eventual result, as I have noted, was the wholesale purging of avant-garde tendencies, both formalist and Prolekult, and the imposition of Zhadonvian "socialist realism" in which the prosaic, in its most banal form, was enthroned.

The collaborative ethos of TRAM and Piscator's Proletarian Theater was evident across a broad range of cultural practices during the 1920s and 1930s (many of which were associated with the Popular Front). The Worker's Photography Movement is emblematic. It consisted of local clubs in cities across Czechoslovakia, England, France, Germany, Hungary, the Netherlands, Russia, Spain, and the United States (the Photo League) run by workers with an interest in photography as a tool of political emancipation. As with the performance-based practices outlined above, the Worker's Photography Movement was predicated on the belief that the experiential reality of the working class, grounded in the materiality of labor, was capable of generating valuable forms of insight into the nature of capitalist domination and resistance. Here the perceptions of workers (what Edwin Hoernle called the "Working Man's Eye") were understood to possess unique epistemological qualities, thus challenging the vanguard division between mind and body, theoretical and practical Communist, and consciousness and spontaneity.[51] Similar developments occurred in the realm of graphic art, as evidenced by the work of Taller de Gráfica Popular (TGP) in Mexico City. The TGP was formed in 1937 by artists formerly associated with the League of Revolutionary Writers and Artists, including Leopoldo Méndez, Pablo O'Higgins, and Luis Arenal. During their regular Friday meetings the artists of TGP would sit down with representatives from unions, peasant groups, and student associations who needed graphic imagery for a particular political issue or protest. These discussions would then lead to the creation of images, typically linocuts, which could be produced quickly and at little cost. Since these works were intended to reach a working-class audience, beyond the institutional spaces of the bourgeois art world, the TGP employed vernacular printmaking formats such as flyers (*volantes*) and posters (*carteles*), which could be easily circulated within a given neighborhood. The African American artist Elizabeth Catlett, who worked with the TGP for many years, describes the group's collaborative spirit: "[It was]

collective thinking: it wasn't a cooperative, it was a collective. And it didn't matter how many people worked on something, as long as it came out the best we could make it."[52] The TGP struggled over the years to navigate the complex political currents associated with the increasing conservatism of the Institutional Revolutionary Party, but the initial spirit of the group continued to inspire subsequent generations of Mexican artists, from the Graphic Movement of 1968, which emerged in the wake of the Tlatelolco massacre, to the new forms of street art that emerged in Oaxaca as part of protest movements during the early 2000s.[53]

Anticolonial Performativity

The projects developed as part of the early Prolekult movement are consistent with an often-subterranean tendency that exists both within, and beyond, the European avant-garde tradition. We find a parallel set of cultural practices associated with anticolonial resistance emerging during the same period, as the system of European colonial domination was destabilized by the economic crisis of the Depression, and the social disruptions of the interwar period. Here I want to argue for an underlying affinity between these two bodies of work, which can also reveal important diffraction patterns between the traditions of Marxism and anti-imperialism more generally. These tensions are already apparent in Marx's work. Thus, while Marx was largely supportive of anticolonial struggles framed around experiences of both racial and economic domination, he also viewed them as essentially secondary to the primary field of class struggle on the European continent. Moreover, he perpetuated certain long-standing prejudices regarding the backward nature of existing societies in Africa, Asia, and the Caribbean, which are seen as located outside the broad currents of progressive world history. This accounts for an underlying ambivalence in his analysis of the colonial enterprise. In his writings on British rule in India during the 1850s Marx denounces the violence of British colonialism, but he also praises its ameliorative effects, which have "dissolved" the "semi-barbaric" communities of Indian weavers and spinners through the rationalizing effects of capitalist industrialization. This dissolution, which reflects the protean transformative energies of the European bourgeoisie, has actually played a progressive role in the evolution of these societies. "We must not forget," he writes, "that these idyllic village-communities, inoffensive though they may appear, had always been the solid foundation of Oriental despotism.... We must not forget that this undignified, stagnatory, and vegetative life, that

this passive sort of existence evoked on the other part, in contradistinction, wild, aimless, unbounded forces of destruction and rendered murder itself a religious rite in Hindostan."[54] If history is progressive, and communism itself an inevitable extension of this historical telos, then colonialism can serve to modernize the "despotic" cultures of Asia and elsewhere, hastening them on the road toward eventual world revolution.

This reflects, of course, the ongoing influence of Hegel and his image of world history that evolves along a fixed teleological arc, with Europe at its apogee and "primitive" nations at the margins. Here the non-Western can only ever exist as a particular and derivative instance of a universal dynamic that is first and most fully realized in Western society. It is precisely this perception that Sylvia Wynter challenges in her own critique of European colonialism. In Wynter's analysis the non-Western world, far from being peripheral to the broader currents of modernity is, in fact, at its very center. However, this centrality is consistently disavowed in the traditions of European thought, which envision "Europe" as an autonomous and generative force that emerged out of the "stagnation" of the non-Western world. In fact, the foundations for modern capitalism were not laid in the textile mills of nineteenth-century Manchester, but three centuries before in the plantation "factories" of Asia and the Caribbean and in the slave trade that provided them with free labor. It was here that forms of industrialized agricultural production were first perfected and in which the mechanisms necessary to subjugate the body and psyche of the worker were first developed. It was, as Wynter writes, the "large-scale accumulation of unpaid land, unpaid labor, and overall wealth expropriated by Western Europe from non-European peoples, which was to lay the basis of its global expansion from the fifteenth century onwards."[55] And it was, at the same time, the culturally specific and racialist paradigm of "Man" (the "Single Cultural Norm," as she writes) that emerged out of, and in parallel with, this economic process that serves as the ontological paradigm against which humanity as a whole will be measured (spirit against flesh, civilization against barbarism, white against black). It is this paradigm that will provide the foundation for class-based differentiations that only emerge more fully in the eighteenth and nineteenth centuries. In this respect racial difference, as Wynter argues, is the foundation for, and constitutive of, class difference. Rather than an ancillary form of repression that is the merely epiphenomenal expression of a deeper and unacknowledged mode of class repression, "Black/White identities," as Derrick White argues, "are the 'central inscription and divisions' that generate all other hierarchies within the present episteme. Black skin... serves as

the zero-reference point in the Western social system, because the cultural representation of Blacks function as the ultimate non-norm."[56]

This helps explain the central role played by cultural resistance in Wynter's work—a focus that is also evident in the writing of figures such as C. L. R. James, a major influence on Wynter. Colonial domination is both enforced and legitimated by instrumentalizing the consciousness of the subaltern. As a result, one of the first stages of colonial domination entailed the destruction of existing cultural practices, spiritual traditions, and languages. This accounts for the unique articulation of cultural production within anticolonial resistance, in a manner that is distinct from the traditions of the European avant-garde. Avant-garde artists in Europe had the luxury of critiquing an art-institutional system that was, at least potentially, open and available to them, if they were willing to obey its conventions, and which consciously sought to represent the worldview of a white, bourgeois public of which they themselves were part. It is this broader system of normalized cultural validation that allowed them to perform their own self-expulsion from this same institutional apparatus (Courbet's rejection of the Salon, the Dadaists' attack on "bourgeois" art galleries, etc.) as a transgressive act. This is also what lends many of the gestures of avant-garde provocation their essentially ritualistic quality (the registering of dissent among competing factions within an already privileged class). In the case of colonial resistance, the very production of an autonomous culture, among people who were viewed by their colonizers as subhuman, constitutes an act of resistance. Wynter, in particular, points to the central role played by popular cultural practices in the Caribbean, such as Junkanoo, the ring shout, Voodoo, folk cultures and music, and syncretic forms of Christianity, as a form of anticolonial resistance that unfolds through a process of "indigenization." Central to this was a performative and participatory element that we can also observe in Prolekult practices. As Wynter writes in "Black Metamorphosis," this is exemplified by forms of dance: "Dance as knowledge was a knowledge that could be gained only through praxis, dancing. No one could dance by proxy. This knowledge is the very negation of abstract knowledge. . . . This implies a certain relation to knowledge. One must be possessed by knowledge as by a god, one must participate in knowing. Knowledge is not an accumulation of fixed and permanent truths. Indeed, such truths which presented to be of permanent validity should be guarded against."[57] Where Shklovsky would dismiss "work songs" as the degraded expression of a habituated working class, Wynter views them, in the context of Black cultural expression, as part of a "mechanism of rebellion . . . to be found in the constitution

of an alternative culture." As she writes, "In constituting an other self, an other collective identity, whose coding and signification moved outside the framework of the dominant ideology, the slaves were involved in a long and sustained counter-struggle."[58]

As these examples suggest, we can identify a significant rearticulation of the norms of aesthetic autonomy in the broader history of anticolonial cultural struggle across the global south. As I noted above, the European avant-garde often sought to generate dissent through a symbolic attack on the conventional values of the bourgeois art world. This was intended as a displaced critique of the forms of political domination on which the institutional art world itself depended. In this tradition, critique must remain indirect in order to elude the forms of co-option that would, ostensibly, result from any attempt to align artistic practice more directly with forms of social or political action. We encounter, as well, a tendency in the European avant-garde to dismiss any form of popular culture as inherently corrupt, and therefore incapable of sustaining critical or creative consciousness (a pattern that will be replicated in Adorno's writing). The traditions of anticolonial resistance often emerged in societies less structured through the conventional modernist schism between popular culture and fine art, and less likely to possess the same level of institutional infrastructure devoted to bourgeois high art forms (galleries and museums, concert halls and publishers) that existed in their European metropoles. Rather, we encounter a situation in which popular culture (not yet so thoroughly commodified) still retains a meaningful grounding in the lifeworld of the poor and working class. As a result, it is available to be transformed, and mobilized, in conjunction with political resistance to colonialist domination.

This process is evident in Mahatma Gandhi's cultural activism during the fight for Indian independence. Here Gandhi made use of Indian traditions such as the chakra or spinning wheel and khadi cloth to assemble a set of politically charged symbolic armatures. The domestic spinning of cotton, which was proscribed by the British in order to force India to accept its foreign exports, was a key example. In response, Gandhi sought to literally embody resistance by linking it with the physical performance of spinning cotton (which was required for all members of the Indian National Congress). Here the act of resistance is felt, and practiced, at the bodily level. In this manner Gandhi sought not only to contest British cultural domination, but also to level the class and caste distinctions between elite Congress members and the Indian poor and working class. For Gandhi, the most powerful tools of imperial domination were not economic or military, but cultural, evident

in the tendency of upper-caste Indians to adopt British or European fashion. Thus, the decision to wear simple, white khadi cloth garments constituted a form of sartorial activism that also encouraged trans-caste solidarity.[59] Gandhi himself created a scandal when he wore a simple khadi dhoti for an audience with Queen Mary and King George V at Buckingham Palace in 1931. This performative element is also evident in his various perambulations, most famously the Salt March of 1930 in which he, along with thousands of followers, illegally harvested salt on the coast of the Arabian Sea. It is this same tradition of embodied activism that helped inspire the marches and occupations that occurred in the American South as part of the civil rights movement of the 1960s, such as the influential March from Selma to Montgomery in 1965. We also encounter, within the broader history of anticolonial resistance, a partial movement away from the conventions of the Leninist vanguard, with its normalization of cathartic revolutionary violence. This is evident in Gandhi's commitment to ahimsa or nonviolence, which was inspired in turn by Maori traditions of passive resistance epitomized by the pacificist settlement at Parihaka.[60] Ahimsa would, of course, go on to influence Martin Luther King Jr. and the American civil rights movement as well.

Gandhi's efforts to diminish caste divisions in India, in order to produce a sense of political cohesion in the struggle against British imperialism, encountered significant obstacles. Thus, a number of Congress members objected to the demand of daily spinning, arguing that it was "women's work" and therefore beneath them.[61] And once the wearing of khadi cloth was widely adopted by the country's political elite, a market soon emerged for higher-quality and softer versions of khadi cloth to be worn by upper-caste Indians. Tensions around caste divisions came to a head in Gandhi's Puna Fast of 1932, which he undertook to protest the British government's willingness to provide a separate electorate for lower-caste (Dalit or "Untouchable") Indians, who were almost entirely excluded from political representation in the Indian Congress (a proposal that had overwhelming support among the Dalit themselves). Gandhi's fast was intended to block the implementation of this change, which he feared would allow the British to appear to be benevolent and compromise Indian solidarity within the Swaraj movement. Of course, this "solidarity" was already compromised by the ongoing persistence of caste-based inequality in India. What Gandhi hoped to present as a united and internally coherent Indian nation, struggling for autonomy against a repressive external force, was already riven by internal differentiations, which threatened to disrupt that very coherence. Lower-caste Indians were prevented from working outside a narrowly proscribed set of menial

occupations (often related to sanitation or the handling of waste), denied access to education, segregated in restaurants and schools, and subject to ongoing and routinized humiliation.

While Gandhi (who was from the upper Vaniya caste) would challenge these divisions in his speeches and writing, he was unwilling to take substantive action to eliminate them for fear of alienating his support among upper-caste Hindus. Gandhi's protagonist in the Puna Fast was Bhimrao Ramji (B. R.) Ambedkar, a Dalit, and a leading figure in the movement for Dalit justice. Ambedkar harbored no illusions about the willingness of upper-caste Hindus to extend the promise of Indian independence to the freeing of the Untouchables (who existed in a condition of profound servitude, often as bonded laborers). Facing a potentially violent backlash against already vulnerable Dalits if he continued supporting the British proposal, Ambedkar was forced to back down, but he would later describe Gandhi's Puna Fast as a "foul and filthy act . . . the worst form of coercion against a helpless people."[62] Here an emancipatory notion of "Indian" identity covers over a set of internal contradictions that have existed for centuries. "India," or the concept of India necessary to achieve the political sovereignty (and cohesion) of the Indian nation, is both an empirical and a metaphysical principle, like Hegel's concept of Prussia as the realization of an aesthetic state. Thus, the "universal" notion of India evoked by Gandhi sought, unsuccessfully, to subsume the particularity of lower-caste experience, which serves as the inevitable reminder of its own incompletion. As these examples suggest, Gandhi's symbolic enactment of cross-caste Indian solidarity (in the wearing of khadi cloth, the manual labor of spinning cotton, etc.) was insufficient on its own to challenge such a deeply entrenched hierarchical system. Thus, the prefigurative element in a practice of cultural resistance must be dialogically linked with a commensurate commitment at the tactical level to be truly generative. This same set of tensions, between the pragmatic and prefigurative, will emerge again in art practices during the 1960s.

4

ACTIVISM AND AUTONOMY IN THE 1960S

Compulsory Liberation

There is no possibility of escape.
—Graciela Carnevale, "Project for the Experimental Art Series" (1968)

Let me go, I'm an artist.
—Protester being arrested during a 1968 demonstration at the Museo Nacional de Bellas Artes in Buenos Aires, in Horacio Verbitsky, "Art and Politics" (2004)

As we see with Gandhi, liberation movements are not immune to the problematic transcendence we encounter in the European tradition of political autonomy. The caste-based hierarchies that were repressed in the name of Indian solidarity constitute a metapolitical expression of the binary structure that I introduced earlier in this book as we move from sovereign self to sovereign nation. As I described it, this structure is defined around a set of constitutive oppositions—of spirit and flesh, mind and body, and conscious-

ness and spontaneity, which are mapped onto specific subjects or classes of subjects (men versus women, civilized classes versus the masses, European versus African). In each case the privileged term is associated with the transcendence of the body, the situational, and the spatially proximate by a principle that claims to represent a form of universal consciousness. The "universal" term in each case conceals what is, in fact, a mode of particularity, which defines its universality precisely through the reification of its opposite term: mind or spirit capable of grasping an objective truth versus the body mired in the subjective particularity of the senses, the purity and cultivation of the upper castes versus the impurity and barbarism of the lower castes). Of course, the structures of caste difference in India are clearly distinct from the forms of racial domination that characterized European colonialism. There is, however, an underlying affinity. This affinity is evident as well in the discourse of the Leninist vanguard, even as it dedicates itself to liberating the masses rather than enslaving them. Thus, Lenin's fear of an instinctual working-class spontaneity that threatens to "overwhelm consciousness" will be reiterated more than half a century later in the context of revolutionary struggles in Latin America.[1]

In his pivotal study *Revolution in the Revolution*, Régis Debray drew on his experiences with Ernesto "Che" Guevara in Cuba and Bolivia to codify many of the key tenets of Latin American revolutionary theory during the late 1960s and early 1970s. In it, we can identify the underlying continuities of vanguard political discourse through the later twentieth century. Debray contends that the Cuban revolution introduced an entirely new "problematic" into revolutionary theory. Instead of military action being guided by the leadership of a vanguard party, in Latin America, the guerilla army itself became the locus of a revolutionary consciousness in which the political and the military were conjoined.[2] This consciousness was incubated in a new organizational form first elaborated by Guevara: the *foco* ("focus" or "center"), a small guerilla cell that operated independently. Instead of trying to defend a fixed territory it was mobile and autonomous, freed from the obligation to protect the peasants and workers on whose behalf it waged "total class war."[3] And rather than waiting to act until the "objective" historical conditions necessary for revolution have been achieved, the *foco* will precipitate revolutionary consciousness independently, by engaging in acts of exemplary violence that would inspire the masses. ("The destruction of a troop transport truck . . . is more effective propaganda for the local population than a hundred speeches.")[4] In this manner the normal historical conditions necessary for a fully mature Communist revolution can be short

circuited because, as Guevera insisted, "the insurrection can create them," through the "miraculous" actions of "a small band of men."[5]

The *foco* succeeds because it is not distracted by time-consuming negotiations with the government. Nor does it form tactical alliances with reformists or factions of the bourgeoisie, or work through the compromised mechanisms of electoral politics.[6] In the *foco* all other considerations are secondary to the strategic demands of warfare. We must "cast aside political verbosity," as Debray argues. "No political front, which is basically a deliberative body, can assume leadership of a people's war, only a technically capable executive group, centralized and united."[7] The *focquista* cadres are defined by a splendid autonomy, from normal political systems and discourse, from their class enemies, and even from the masses themselves who are subject to "moral corruption," necessitating that the revolutionary "maintain a certain aloofness."[8] Debray invokes Lenin directly on this point, citing his critique of working-class spontaneity.[9] In fact, the *foco* abandons even the minimal consultative obligations of the Leninist vanguard party in its relationship to the working class.[10] The *focquista* vanguard, in its single-minded commitment to military action, will model a proper revolutionary discipline for emulation by the peasants and working class. In this manner the "small motor" of the *foco* will bring the "large motor" of the masses to political consciousness and "set them in motion." For this process to succeed it is necessary that the masses see the *foco* as "their only interpreter and guide, under penalty of dividing and weakening the people's strength."[11] Debray evokes a kind of revolutionary work ethic in which the exploited, through proximity to the exemplary *foco*, come to realize both the vulnerability of the powerful and the self-sacrifice necessary to overthrow the capitalist system as a whole.

Debray's analysis captures the characteristic vanguardist displacement of the consciousness of the proletariat into the subjectivity of the revolutionary. "If the peasants are skeptical," as he writes, "their confidence in themselves must be restored by imbuing them with revolutionary faith, faith in the revolutionaries that are speaking to them."[12] The forging of this revolutionary consciousness entails a grueling process of self-transformation as the *focquista* cadres struggle together in the countryside. It is here that authentic revolution is born as petit bourgeois intellectuals become hardened guerillas. "These are the militants of our time," Debray declares, "resolute and responsible, each of them knowing the meaning and goal of this armed class struggle through its leaders, fighting like themselves, whom they see daily carrying the same packs on their backs, suffering the same blistered

feet."[13] While the mountains are the locus of authentic revolutionary insight, isolated, pure, and autonomous, the cities are sites of compromise and temptation, "lukewarm incubators" that "make one infantile and bourgeois." Like Rakhmetov and Rimbaud before him, the "guerrillero" must "battle ... himself to overcome his old habits, to erase the marks left on his body by the incubator—his weakness."[14] Through this process, the guerilla will "shed his skin" and undergo a "resurrection."[15]

The durability of the Leninist paradigm of revolutionary action is striking. Nearly fifty years after the Bolsheviks came to power, many of their core beliefs about the cognitive limitations of the "spontaneous" masses and the sovereignty of the revolutionary vanguard remained largely intact. This continuity is paralleled by ongoing developments in artistic practice. During the 1960s, we can observe a growing rapprochement between the rhetoric of the political and the artistic vanguard.[16] Each shares a commitment to the idea of the artist or revolutionary as an exemplar of revolutionary consciousness, who must variously provoke and inspire the masses. This dynamic is evident in a number of artistic practices during the 1960s, but we see it exemplified with particular clarity in Argentine artist Graciela Carnevale's *Acción del Encierro* or "Confinement Action" from 1968. The *Acción del Encierro* was presented as part of the Ciclo de Arte Experimental exhibition in Rosario organized by the Grupo de Arte de Vanguardia.[17] Once audience members assembled in the gallery space for the opening, the artist departed, locking the door behind her. In preparing the space beforehand, Carnevale had covered the glass wall at the front of the gallery with posters, further isolating the visitors. In an interview with historian Fabián Cereijido, Carnevale explained that she hoped to incite a form of "liberating violence" in the participants, who would be forced to act once they realized their plight by breaking the glass of the gallery's front door.[18] This action would have the effect of empowering audience members: moving them from a state of passive acquiescence to conscious action. The act of breaking the glass, and the self-liberation of the audience, had a particular significance in Argentina at the time. Less than two years earlier General Juan Carlos Onganía had taken power in a coup d'etat, overthrowing elected president Arturo Illia. Within a matter of weeks Onganía's Federal Police had ruthlessly suppressed protests at the University of Buenos Aires, beating and jailing professors and students in the notorious "Night of the Long Batons."

For Carnevale, the struggle to break free from physical confinement in the *Acción del Encierro* was presumed to exist in a corollary relationship to the struggle to resist political repression. Moreover, the fact that

this physical confinement was staged in a gallery added a further level of symbolism, to the extent that the subjugated viewers were meant to literally shatter the boundary separating an art-institutional space from the "outside" world. The act of creative destruction has a well-established place in the history of modernism. Typically, this gesture is performed by the artist for the benefit of a viewer, who might be inspired to emulate it at some future point. In Carnevale's case she withdrew from the creative scene in the hope that the audience itself would take action and destroy the window of the gallery. What was the significance of this gesture, in this place and at this time? And what sort of risk did it entail to encourage Argentines to "break free" from their confinement at a historical moment when even the most nominal expression of public dissent could be met with arrest, imprisonment, and even disappearance? The decisive gesture in this work was not the unfulfilled promise of autonomous collective action against the military junta, but the withdrawal of the artist from a scene of transgression that she hoped to precipitate but not share. With this action, Carnevale effectively closed the dialogical circuit between herself and the project's participants. Instead of the artist acting as a surrogate for the viewer, the audience became a surrogate for the artist's own vision of resistance, forced into a symbolic revolutionary event (the breaking of the gallery's glass wall). Carnevale's work demonstrates some of the central themes of post–World War II avant-garde art practice. Certainly, it expresses the movement toward performance and participatory action that was a key component of the period. At the same time, it retains an instrumentalizing attitude toward the viewer, who must be shocked into a cathartic recognition of his or her capacity for resistance and independent action. Thus, while the physical barrier between the art gallery and the world beyond was breached in this project, the social architecture of autonomous artist and dependent viewer remained intact.

It was, of course, not uncommon for Latin American artists to embrace revolutionary political rhetoric at this time. In their famous "Assault Text," delivered to the Argentine museum director Romero Brest in August 1968, Juan Pablo Renzi, Norberto Puzzolo, and Rodolfo Elizalde declare "that the life of 'Che' Guevara and the actions of the French students are greater works of art than most of the rubbish hanging in the thousands of museums throughout the world." "We hope," they continue, "to transform each piece of reality into an artistic object that will penetrate the world's consciousness, revealing the intimate contradictions of this society of classes."[19] Graciela Carnevale also sought to "penetrate the consciousness" and "reveal the contradictions" of class society. In this task she found it necessary to

adopt the *focquista*'s callous disregard for pain and suffering. In her case, the violence of guerrilla warfare is directed not against the military forces of the Onganía dictatorship but against its potential victims: the students, artists, and intellectuals attending the Ciclo de Arte Experimental exhibition in Rosario. This doubling or reiteration of aggression is necessary in order to force her audience members out of their "passivity" and to "provoke [them] into an awareness of the power with which violence is enacted in everyday life." Thus, the "reality of the daily violence in which we are immersed," according to Carnevale, "obliges me to be aggressive, to also exercise a degree of violence.... To that end, I also had to do violence myself, I wanted each audience member to have the experience of being locked in, of discomfort, anxiety and ultimately the sensations of asphyxiation and oppression that go with any act of unexpected violence."[20]

This is consistent with a broader strand of performance-based practice during the 1960s and 1970s that sought to unsettle or assault the viewer, often in quite literal terms. This tendency is exemplified by Vito Acconci's notorious *Seedbed* (1972), in which he masturbated in a small space underneath the floor of the Sonnabend Gallery and engaged in sexual fantasies about the visitors walking above him, which were amplified through a speaker system, or *Claim* (1971), in which he sat blindfolded at the bottom of a staircase holding a crowbar and threatening to kill anyone who approached him. We find parallel examples in the work of the Viennese Actionists, whose masochistic performances evoked the unacknowledged legacy of Nazi violence in Austria. In each case the artist is assumed to be uniquely conscious of the forms of societal cruelty and oppression that their performances mimetically reenact. As Carnevale contends, only the artist can grasp the interconnected totality of violence within society, from the "most subtle and degrading mental coercion from the information media . . . to the most outrageous and scandalous violence exercised over the life of a student."[21] Rather than needlessly exacerbating the anxiety of viewers already on edge after weeks of police brutality, Carnevale's action can be seen as therapeutic in nature. She will administer a kind of homeopathic remedy in which the patient is treated with the diluted version of a substance that would otherwise cause illness. Hence, the "discomfort" created by physical confinement in the gallery will produce a heightened awareness of the far more damaging repression imposed by the Onganía regime. As I already noted, however, this event occurred after protests among Buenos Aires's intelligentsia, most recently the occupation of the University of Buenos Aires, had been cruelly suppressed. If Argentines were "passive," it was not due to a lack of awareness, but rather was the

result of an all too immediate recognition of the violent consequences that would result from any act of resistance on their part.

The *Acción del Encierro* reveals some of the symptomatic linkages that existed between avant-garde art practice and vanguard political movements during the late 1960s, especially as they relate to questions of agency, resistance, and participation. *Focquista* action was Janus-faced. On the one hand they sought to inspire and radicalize the working class through their own exemplary discipline and self-sacrifice, and on the other they sought to ruthlessly attack the military forces of the ruling class. Carnevale collapses together the two modes of *focquista* action (the punitive and the emancipatory) in a manner that was already evident in avant-garde practices during the 1920s. In Carnevale's presentation of the gallerygoer, poised between passivity and freedom, awaiting the artist's intervention in order to raise and direct their consciousness of oppression, we find a parallel to the *focquista*'s struggle to rouse the working class from their torpor and "imbue" them with revolutionary fervor. At the same time, as I noted above, Carnevale displaces the guerilla's characteristic aggression onto her audience members, who become surrogates for the absent agents of repression. This punishing and cathartic attack is not directed at the military and the political elites who led the junta but at those Argentines who have been insufficiently vigorous in their efforts to challenge it. The anxiety, discomfort, and fear evoked in Carnevale's "actors" are the necessary concomitants of advanced art *and* political enlightenment; or rather, the goals of each are blurred. Carnevale offers a coercive model of participatory art, in which "the spectators have no choice; they are obliged, violently, to participate."[22] The *Acción* thus functions as a kind of behavioral experiment in which there are only two possible outcomes: either the participants do nothing, thus confirming their passivity and complicity with power, or they break free and demonstrate their capacity for revolutionary action. They are interpellated as corporeal bodies, trapped or sequestered, placed under inexplicable constraints, and then set "free" to act and be judged. This reduction of agency to a simple act of physical resistance or accommodation (representing the liberation or containment of the participant's "natural impulses") is emblematic. Carnevale's work fails to engage the differentiated subjectivities of those people she chooses to confine. They function instead as representatives of a generic political consciousness, symbolizing the Argentine people as a whole in their opposition to, or complicity with, Onganía's dictatorship.

As I have suggested, the synchronicity between the artist and the revolutionary is a central feature of cultural modernity. It entails, however, a

significant set of displacements. Avant-garde artists, in seeking to assign a role to themselves within revolutionary struggle, identify a parapolitical modality in which forms of artistic reception are assumed to exist in a corollary relationship to forms of political praxis. By the mid-nineteenth century this gesture had taken on its prototypical form, in which the artist seeks to scandalize the bourgeoisie viewer in a kind of psychological warfare. However, during the Russian Revolution, artists who had come of age in the ideological milieu of the early twentieth century avant-garde found themselves confronting a public composed of the newly liberated working class. In negotiating this transformation many artists simply transposed the rhetoric of assault and provocation previously directed toward a bourgeois viewer onto an entirely new audience. The blurring of these two class positions will be a central feature of the avant-garde, and neo-avant-garde, traditions up to the present day. It results in the emergence of a genericized concept of the art-world viewer whose own class position is indeterminate but who possesses attributes of both the working class (a potential capacity for resistance, to be mobilized by the artist) and the bourgeoisie (a complicity with capitalism to be exposed and shamed). Or rather, we might say that the bifurcation between these two forms of political subjectivity is resolved by absorbing the (absent) working-class subject into the consciousness of the bourgeois art viewer. It is this same hybrid subjectivity that we can observe in Carnevale's *Confinement Action*.

A similar pattern occurs in the subject position of the artist in the avant-garde tradition. The revolutionary artist, like the revolutionary theorist, arises from within the bourgeoisie. They each claim, however, to have shed the ideological constraints of their class origin in order to achieve a unique form of cognitive transcendence. It is this transcendent subjectivity, their attainment of a quasi-universal comprehension of the existing political totality, that justifies their custodial relationship to working-class consciousness. And yet they remain, for all that, beneficiaries of their original class background, still dependent on the capitalist division between manual and intellectual labor that valorizes the underlying hierarchical division between theory and practice, mind and body, party and masses. The revolutionary theorist's cognitive transcendence is secured through their dialectical engagement with revolutionary action. In the evolution of the avant-garde, following the political efflorescence of the 1920s, the artist effectively appropriates the class transcendence of the vanguard theorist and transports it into the bourgeoisie art world, where it often functions to reinforce traditional concepts of artistic genius, allowing the artist to retain an ostensibly

privileged knowledge of revolutionary practice, even while having no operational relationship to political resistance itself. In this manner the avant-garde movement carries forward the party form as a saprophytic remainder.

This shift reflects the increasingly attenuated relationship between artistic production and political resistance during the post–World War II period, and the increasingly central role of the institutional art world in contextualizing these practices. While the working class is almost entirely absent from the institutional art world, it retains a ghostly presence in the persistence of an avant-garde paradigm that imagines the bourgeois art viewer as susceptible to radicalization in the first place. In the avant-garde practices that develop in the postrevolutionary period, the artist's assault on the viewer's consciousness is no longer symbiotically linked with the actual process of political resistance. Nor is it addressed to a potentially revolutionary agent (the working class). Instead, the provocation itself becomes the decanted remnant of a future moment of revolutionary political action that can, for now, only take symbolic form in the space of the art world. Here disruption at the level of reception takes on its characteristic contemporary role as the mnemonic placeholder for real political change that is currently foreclosed, to be consumed by bourgeois viewers in a manner that is essentially contemplative. In this respect it comes to occupy a position analogous to the prefigurative status of beauty in the late eighteenth century. In the following section I will explore the ways in which concepts of autonomy are reframed in aesthetic theory during the 1960s. The figure of Theodor Adorno will play a central role here, in providing a theoretical rationale for forms of artistic production that privilege the autonomy of the artist, and the art world as such, from the exigencies of political action. In Adorno's writing we encounter perhaps the most influential rearticulation of aesthetic autonomy since the 1920s, one that continues to exercise a significant influence on contemporary art theory and practice.

Theodor Adorno and the Critique of Action

Works of art take an advance on a praxis that has not yet begun.
—Theodor Adorno, *Aesthetic Theory* (1970)

Where Régis Debray imagined that Che Guevara had devised a new revolutionary theory with the potential to transform global resistance to capitalism, Theodor Adorno argued that the possibility of authentic revolutionary change was entirely "foreclosed," suggesting the fundamentally ambivalent

political nature of the 1960s more generally. As Adorno wrote in *Minima Moralia*, the working class, the "simple folk," who are the ostensible agents of revolution, "surpass anything in the canon of envy and hatefulness displayed by the literati." The "glorification of the splendid underdogs," he continues, "ends up in glorifying the splendid system which made them so."[23] Adorno's pessimistic assessment of the potential of meaningful political change is evident in a dispute with his long-time colleague Herbert Marcuse in 1969. Their disagreement stemmed from Adorno's decision to call the police to break up an occupation of the offices of the Frankfurt Institute led by the Socialist German Student Union (SDS). In February of that year Adorno had written to Marcuse, who was teaching at the University of California, San Diego, to invite him to speak at the Institute. Marcuse, learning of Adorno's decision to call in the police to break up the occupation, wrote to him to express his concern. The key exchange circulates around the relationship between theory and practice. Marcuse writes:

> I would have left them [the protesters] sitting there and left it to somebody else to call the police. I still believe that our cause ... is better taken up by the rebellious students than by the police. ... You know me well enough to know that I reject the unmediated translation of theory into praxis just as emphatically as you do. But I do believe that there are situations, moments, in which theory is pushed on further by praxis—situations and moments in which theory that is kept separate from praxis becomes untrue to itself.[24]

Adorno's response is symptomatic:

> You think that praxis ... is not blocked today; I think differently. I would have to deny everything that I think and know about the objective tendency if I wanted to believe that the student protest movement in Germany had even the tiniest prospect of effecting a social intervention. ... I would ... concede to you that there are moments in which theory is pushed on further by practice. But such a situation neither exists objectively today, nor does the barren and brutal practicism that confronts us here have the slightest thing to do with theory anyhow.[25]

In May 1969, *Der Spiegel* published an interview with Adorno in which he reflected on the incident at the Frankfurt Institute. In the course of the interview the authors press Adorno to explain his refusal to align himself with the student protesters and his decision to turn the police against them. "Critical Theory does not wish to keep conditions as they are," they point

out. "The ... students learned this from you. You, Professor Adorno, now refuse practical action." In response Adorno presents a defense of the necessary autonomy of theory based on its strong correlation with aesthetic activity. As he responds, "I have never offered a model for any kind of action or for some specific campaign. I am a theoretical human being who views theoretical thinking as lying extraordinarily close to his artistic intentions."[26] On the one hand, individual political action (the work of the student protesters, for example) is "predestined to fail," and on the other, theory itself must become art-like, remaining entirely autonomous from the demands of practice and the conformity that is the inevitable consequence of any collective action.[27] It is, ultimately, the sovereignty of theory, and of the theorist's singular consciousness of the world, that must be defended, and that constitutes the most reliable vehicle for the preservation of an authentic revolutionary impulse.

In Adorno's analysis, the protests and demonstrations of the SDS were evidence of the movement's reliance on "actionism," or the naive belief that "if only you change little things here and there, then perhaps everything will be better."[28] "Actionism can essentially be traced back to despair," as Adorno observes, "because people sense how little power they actually have to change society. But I am equally convinced that these individual actions are predestined to fail." It is not action qua action that Adorno rejects, but rather action that operates at the situational or local level. This implies a necessary contrast with a globally coordinated and theoretically informed mode of political resistance that attacks the capitalist system in its entirety, and it is this form of change that is, in Adorno's view, foreclosed. Adorno thus reiterates, in modified form, the Leninist suspicion of "spontaneous" action, unguided by a properly detached theoretical analysis.[29] The student protesters, failing to realize that the current moment "objectively" precludes any possibility of real change, have abandoned themselves to futile gestures of infantile despair. It is notable that Adorno's critique of the protesters reduces their motivations to simple egoism. Thus, he writes, the SDS protesters were "slaves of their own publicity ... who fear being forgotten."[30] The only possible explanation for someone who seeks to link theoretical production with direct action is a deviant impulse toward egotistical self-aggrandizement as they foolishly meddle with forces beyond their understanding. Adorno's rejection of any generative dialectical relationship between theory and praxis is evident in Angela Davis's bemused recollection of a conversation she had with him prior to returning to the United States from her studies in Germany to join the Black Panthers. "He suggested," Davis writes, "that my desire to

work directly in the radical movements of that period was akin to a media studies scholar deciding to become a radio technician."[31]

Not surprisingly, Adorno extended his critique of actionism to artistic groups during the 1960s that challenged the autonomy of contemporary art through activist and performance-based practices (Happenings, Situationism, etc.). For Adorno, these gestures simply "reprise futuristic and Dadaistic actions."[32] He goes on to warn that "the eclipse of art which is being propagated by people who are either just plain thoughtless or resentful of art . . . would play into the hands of conformism."[33] The convergence of art and activism during the 1960s can only be seen by Adorno as marking the absolute destruction of art per se rather than a strategic shift in the structure of aesthetic autonomy.[34] In 1964, Adorno even instituted legal proceedings against members of Subversive Aktion, a Situationist group in Germany (whose membership included Rudi Dutschke) that had posted "wanted" posters featuring Adorno quotations around the University of Frankfurt campus.[35] From Adorno's perspective, the effect of this artistic activism was to encourage the premature desublimation of art's redemptive potential by trying to catalyze, through practical action, the utopia promised by the aesthetic state. Thus, activists who would "do away with art by decree," as a relic of bourgeois ideology, are merely "deluding themselves about the fact that decisive change is foreclosed."[36]

Adorno's analysis of the crucial role played by art, and aesthetic autonomy, in this dynamic is most fully elaborated in his final book, *Aesthetic Theory*. Here he outlines the relationship between art and the "identity thinking" that is endemic to the capitalist system. Identity thinking marks the complete internalization of possessive individualism, which has become so deeply rooted in the human psyche that it saturates virtually every aspect of social life. Even the provisionally autonomous realm of cultural production is not immune to this process, as evidenced by the hegemonic power of the "culture industry" to regulate all forms of human consciousness, resulting in a "total system of delusion."[37] For Adorno, the art object can play a crucial role in subverting this system through an experiential modality that resists the acquisitive consciousness of "identity thinking" by presenting the viewer with an artwork that is opaque and "unintelligible."[38] In this way the viewer's desire for conceptual mastery is thwarted, and they become reflectively aware of the violence with which they try to know and possess the world. The viewer experiences the epistemological resistance posed by the work of art as an assault or "shock."[39] Adorno identifies it specifically with a "prehistoric shudder" that returns the viewer "to the terror of the

primal world" as they come to realize that contemporary society is just as dangerous to us as untamed nature was to primitive man.[40] At the same time this assault carries a redemptive potential. "Momentarily the ego is perfectly able to become aware of the chance it has to leave the realm of self-preservation behind."[41] As a result of this shift, the viewer "loses his footing, as it were, discovering the truth embodied in the aesthetic image has real tangible possibilities."[42] Thus, our "shock" over the artwork's violation of existing compositional norms "becomes horror over the society out which they spring."[43] The "liquidation of ego" that occurs in Adorno's account of aesthetic experience parallels the Enlightenment belief that aesthetic experience facilitates a regression to the presocial core of our being. It is from within this monadic space, and not through the experience of actual intersubjective exchange, that authentic self-transformation must originate. For Adorno, the annihilation of the existing self is a precursor to the therapeutic strengthening of the "weakened" ego structure as the viewer becomes aware of the extent to which his or her own consciousness of the world has been deformed by capitalism.[44]

This therapeutic dismantling of the self is a repeated theme in *Aesthetic Theory*. The work of art "bears no similarity to desire," as Adorno writes. "Rather, it is a memento of the liquidation of the I, which, shaken, perceives its own limitedness and finitude."[45] Here the "bad" autonomy of the bourgeois self, who imposes their norms on the other, becomes the "good" autonomy of the disciplined and critically reflective self, who can freely generate their own norms while also remaining empathetically attuned to the needs of other equally free subjects.[46] This transformation will occur as "the subject, convulsed by art, has real experiences" by which the "subject's petrification in his own subjectivity" is revealed.[47] The artwork becomes a test, then, of the viewer's capacity for self-control and self-regulation (precisely the process first disclosed by the Enlightenment aesthetic in its cultivation of "disinterest"). We can recognize here the underlying continuity between Adorno's critique of bourgeois art audiences and his critique of student protesters during the 1960s. Each group is defined by their lack of self-control and self-criticality, and each is driven by an unreflective "desire" for immediate gratification (of aesthetic pleasure or political transformation). What is required, instead, is the mastering of the body and its errant desires, and their harnessing to a disinterested and disciplined form of cognitive insight that finds its most exemplary expression in the austere rigor of critical theory itself.[48]

The hedonistic bourgeois viewer typically approaches art in search of an ersatz transcendence, as the experience of conventional beauty offers

them a virtual reconciliation of the social and economic antagonisms that surround them in daily life. The avant-garde work of art will deny this false reconciliation, forcing them instead to acknowledge their own class complicity and thereby awakening a dormant super-ego.[49] "Art is practical in the sense that it defines the person who experiences art as a zoon politkon by forcing him to step outside of himself," as Adorno writes, "because it forms and educates consciousness."[50] By denying the viewer the false solace of a reconciliation (between the utopian values associated with art and quotidian existence) that cannot be fully universalized, the artwork offers a painful reminder of bourgeois society's unfulfilled potential. In fact, the nonidentity or opacity of the artwork becomes the penultimate expression of all forms of otherness subjugated by instrumental reason. In this manner art is transformed "into the historical voice of repressed nature, ultimately critical of the principle of the I, that internal agent of repression."[51] The concept of guilt will play a key role here as the viewer is chastised in the aesthetic encounter. As Adorno writes, it is only after the liberation of mankind in a Communist revolution that we will finally be able to "inherit" the "historical legacy" of great works of art "free of all guilt."[52] The work of art itself is, "by definition ... socially culpable," Adorno writes. "But the worthy ones among them try to atone for their guilt."[53]

The very refusal of the work of art to accommodate the viewer's desire to understand it enacts a kind of symbolic resistance against the viewer's own complicit imagination. In this sense it stands in for forms of revolutionary political violence that cannot yet be realized in practical terms. Adorno thus writes of aesthetic shock as the epiphany that occurs as "the sensory apparatus of the individual" is "traumatized by the discovery that the rational [capitalism] is actually irrational."[54] As a result, "what appears in art," as Adorno writes, "is no longer the ideal of harmony or of anything else. Today's art's emancipatory quality rather seems to lie in dissonance and contradiction."[55] This dissonance is registered through what Adorno terms the "objective constitution" of the artwork, which refers to the way in which the "densely organized, flawlessly structured work of art" organizes compositional material.[56] In this view, art uses its own previously transgressive, but now inert, formal traditions as a point of "internal" symbolic resistance against which to assert its own indeterminate nature. For Adorno, this is evident in Schoenberg's "demonic revolt" against "every natural law of music" and Beckett's attempt to "put meaning on trial" in his reinvention of theatrical norms.[57] As he writes, "precisely in his solitariness and isolation the composer carries out social demands; that society itself dwells in

the inmost cells of the self-enclosed technical problems, and he registers its demands all the more legitimately, the less he is prompted from the outside, arbitrarily, and in constraint of the rule of form."[58] Thus, for Adorno, art is able to preserve its unique critical autonomy, and stave off assimilation by the culture industry, by ensuring that its symbolic forward "movement" is produced entirely through its resistance to existing formal conventions that are embodied in the compositional materiality of specific art media rather than through a more direct assault on the structures of capitalist domination. Just as art must remain entirely segregated from the contamination of prosaic or popular culture, so too the intellectual must maintain an "unswerving isolation" from the working class. "All of the humanity of interaction and participation," as he writes, "is the mere mask of the tacit acceptance of inhumanity."[59]

As this outline suggests, for Adorno, avant-garde art only produces a meaningful criticality through its internalized, recursive resistance to the reification of art itself, as its transgressive powers are repeatedly assimilated by the institutions of bourgeois art. This form of co-option, as opposed to the co-option that accompanies art practices produced *outside* the institutional art world (e.g., the "Dadaistic" actions of the 1960s), actually facilitates (rather than forestalls) a unique form of political transcendence and criticality that is unavailable anywhere else in society. It does so because the avant-garde acts out, in mediated form, an essential symbolic process as art-qua-revolution is repeatedly catalyzed, then co-opted, and then launched anew, in a never-ending cycle. In this manner it preserves some trace of the irrepressible desire for a revolutionary transformation that may one day come to pass. Thus, the initial negation of art's autonomy (by an instrumentalizing culture industry) is the necessary precondition for art to produce its revolutionary value (and justify its ongoing existence), as bourgeois assimilation is, ostensibly, turned against itself. This resistance must be "mediated," or acted out in a displaced symbolic form, precisely because of the overdetermination of the current historical moment.[60] The mimetic status of the artwork is essential in this process. Due to the totalized domination of social life, any actual intersubjective exchange will devolve into instrumentalizing violence. In response, aesthetic experience provides the viewer with a facsimile of intersubjective exchange through which they can "practice" a noninstrumentalizing relationship to other subjects or to nature itself. In so doing, it provides a "mimetic vestige" of an "undamaged life."[61]

Notwithstanding his complex account of reception, Adorno remained skeptical that existing artworks could actually precipitate some form of

meaningful ontic disruption. Thus, the true locus of critical insight must remain immanent to the artwork itself. In *Aesthetic Theory*, Adorno will explicitly define the "truth content of art" as "the materialization of the most advanced consciousness."[62] As a result, Adorno will insist that the "understanding" produced by art "must not be located in the subject/viewer" but in the "objective constitution of the artwork itself" as it seeks to "destroy" its "intelligible moment."[63] The work of art can make no reference to, or accommodation for, the responses of actual viewers or readers (who are, after all, the habituated product of a corrupt system). This view is consistent with Adorno's generally pessimistic assessment of existing human consciousness. Confronted with the failure of the proletariat to unite in opposition to fascism and the emergence of a "totalized domination" during the postwar period that made the capitalist, fascist, and Communist systems virtually indistinguishable (at least to Adorno), the capacity for a pure revolutionary consciousness must be transferred to the sequestered imagination of the artist, or theorist, to be held in trust until a more fortuitous historical moment called for its reactualization in practice. As a consequence, the idea that theory or art can identify an actual "addressee" or subject to empower, enlighten, or awaken also vanishes. Political theorist Susan Buck-Morss describes this outlook as constituting a form of Marxism "minus the proletariat."[64] It is in this context that Adorno, in his essay on Paul Valéry, describes the artist as a "deputy" for the masses. The artist is "not simply the individual who produces [the work of art], but rather through his work, through passive activity, he becomes the representation of the subject of society as a whole, that of the entire, undivided humanity, to which Valery's idea of the beautiful appeals . . . in which the whole subject is finally realized."[65] The concept of the "representative subject of all society" refers, of course, to the quasi-Hegelian role assigned to the proletariat in Marxist theory, who come to embody the final reconciliation of self and other as they evolve into a new, "universal" class.[66] As Axel Honneth observes in *The Critique of Power*, "Adorno now attributes to the artist the function of vicariously articulating in his aesthetic work the unreleased potential of the human species."[67] This perspective is not unique to Adorno, but rather represents a general sense of malaise among a generation of Marxist thinkers during the post–World War II period as the revolutionary consciousness previously attributed to the working class, or the Communist Party, migrates into the interior psychic space of the artist or intellectual for safekeeping.[68]

As I suggested above, most viewers will remain immune to the remedial effects of aesthetic experience due to the absolute hegemonic control

exercised by the culture industry. This brings us to a central point of tension in Adorno's aesthetic. On the one hand, the meaning of the work of art must remain entirely immanent, protected from the deformation that would result if it responded (dialogically) to an actual viewer or social context. Thus, the work of art can show no "concern for a viewer, real or ideal, whose reflexes become unimportant." Instead, artworks must be "hermetically closed off and blind" yet, like a Leibnizian monad, "able, in their isolation, to represent the outside world."[69] On the other hand, the only way for the work of art to justify its existence and assuage its guilt is by assaulting and "shocking" a benumbed bourgeois viewer. Far from being indifferent to the viewer, the very structure of the work of art is precisely calibrated to remedy the perceived cognitive incapacity and "ego weakness" of the bourgeoisie as it currently exists. Thus, in *Aesthetic Theory* Adorno describes the essential role of art in "highlighting divergences and antagonisms" and "forcing them into the open" in order to make "arbitration possible." Alternately, the work of art will "throw new light on the familiar, thus meeting the objective need for a change in consciousness that might ultimately lead to a change of reality."[70] But who will be there to witness these various acts of revelation? This position in Adorno's model is vacated and filled, instead, with a hypothetical viewer prepared for the enlightenment promised by the work of art. If "arbitration" and "objective" change are perpetually deferred, then at least the work of art has the consolation of containing, in its internal "formal language," the preconditions for producing a new, critical consciousness able to transcend existing political reality. Until then, it remains the task of the theorist, the only subject currently able to fully grasp the significance of the work of art, to hold open a space of reception and "understanding" that may one day be occupied by a concrete viewer. Here Adorno follows Hegel in asserting that art "nowadays needs philosophy in order to develop its substance."[71]

Autonomy, Transcendence, and Mediation

The concept of transcendence refers to our capacity to rise above a given discursive or cognitive structure—to understand the ways in which our individual actions, thoughts, or experiences are determined (at least in part) by a larger system. In the Kantian lexicon, this crucial political insight can only be obtained through the self-reflective experience of an individual consciousness. Transcendence in this tradition also implies a hierarchical system in which some, more enlightened, individuals are capable of this cognitive leap, while others are not. This is consistent with Adorno's vision of

avant-garde art, and the broader notion of a critical theory that is uniquely aware of its own material grounding in a capitalist system (of which "traditional" theory remains unaware). What Adorno objects to, then, is not the architectonic system of transcendence, the allocation of subject positions, and the appeal to a more objective or "truthful" form of knowledge that is achieved by rising above our sensual embodiment (our "degrading kinship with matter," as Schiller describes it). Rather, he objects to what he perceives as the *false* transcendence of the bourgeoisie, which seeks to cover over its material dependence on the labor of the proletariat by indulging in fantasies of its own autonomous selfhood.

The logical response to this paradigm would seem to entail the search for a more authentic form of transcendence in which reflective knowledge of the world (the kind of knowledge typically achieved via transcendence) is no longer entirely detached from its necessary physical and social mediations, and the self is able to grasp the interdependence of speculative reason and its material determinants (embodied in the class structures, somatic and social forms, ideologies, and political institutions specific to a given historical moment). This linkage was central to the early iteration of Frankfurt School theory, which sought to integrate critical theory with working-class political resistance (evident in Horkheimer's inaugural address of 1931). However, by 1944 and the publication of *Dialectic of Enlightenment*, we encounter a far more pessimistic assessment of the relationship between theory and praxis. In this view, the unforgiving progression of capitalist instrumentality has so corrupted existing material reality that it can no longer provide a meaningful dialectical foil through which abstract thought could be mediated. Here the (speculative) vision of a utopic future society is uncoupled from any reciprocal relationship to the mechanisms of social and political transformation necessary to bring it into practical existence. As a result, Adorno's aesthetic system is predicated on a dematerialized transcendence that is detached from the actuality of political or social experience today (except as a generic field of total instrumentalization, used to justify art's ongoing isolation from praxis). The recalcitrant facticity of the now-profaned material world must instead be subsumed into the resistant "materiality" of artistic media, which carry a residual trace of revolutionary struggle and the suffering of the proletariat it will one day relieve.

Adorno identifies a close correlation between aesthetic autonomy and the concept of mediation, derived from Hegel.[72] For the early Hegel, the self gains insight into its fundamentally decentered condition through its social interaction with other selves via the "media" of language and labor in the

gradual coming to consciousness of Geist. For Adorno, as we have seen, this external mediation (and the progressive historical movement that it implies) is no longer possible. In his writing, mediation describes both an ontology—the repressed but foundational truth of the necessarily "mediated" interdependence of self and other, subject and object—and an epistemological capacity—the ability to comprehend and evoke this repressed ontological condition, now available only through distanced aesthetic contemplation rather than through the gradual evolution of human social practices. It is a mediation, as I have suggested, that is predicated on a core displacement, as the "external" term through which thought might be brought outside itself has no actual autonomy, but rather is a kind of construct, created by thought itself in order to preserve the vestigial trace of an authentically resistant material ground (other concrete selves, or existing political reality as a potential field of creative transformation) that no longer exists. Aesthetic meaning now unfolds, as John Frow writes, entirely within "a closed subjectivity, testifying through its withdrawal from the world to the social pressures forcing this retreat." As a result, for Adorno, "the unresolved antagonisms of reality return in works of art as immanent formal problems."[73] Thus, while Adorno may question the duplicity of bourgeois aesthetic transcendence, he is as fully convinced that he has gained access to the underlying "truth" of social reality by withdrawing into a realm of internalized reflective contemplation as the most ardent Kantian.

How, then, do we differentiate the false transcendence claimed by the bourgeois viewer, who glimpses an unrealizable utopia in the experience of beauty, from the authentic transcendence claimed by the critical theorist, who perceives an unrealizable utopia in the formal tensions of the avant-garde artwork? In Adorno's view, the theorist is able to mobilize an "objective" conceptual system (Marxism) that allows him to recognize the extent to which bourgeois viewers, insulated by their economic privilege from an awareness of the working-class oppression on which their own wealth depends, seek to deny that very dependence in the act of aesthetic transcendence. But Marxism is predicated on the conjunction of theory and an actualized praxis, precisely in order to challenge the tendency of "traditional" theory to lose contact with the material specificity of the world it seeks to comprehend and to universalize the theorist's own class-specific reality. For Adorno, it is precisely this conjunction that is foreclosed due to the totalizing nature of capitalist domination. But this effectively severs the dialectical circuit between the theorist and a concrete reality that he or she might seek to transform. Adorno's judgments about the imposing hegemony

of capitalism are certainly understandable but isolated within the closed, recursive field of an autonomous critical theory, Adorno is also blind to the extent to which his own privilege has conditioned his perception of the nature and necessity of social change itself.

As a result of the cultural capital he possessed as a highly respected bourgeois intellectual, Adorno was able to survive the rise of fascism and the destruction of World War II largely unscathed, even as many of his contemporaries did not. He was able to move, with relative freedom for the time, from one prestigious university post (and one country) to another when danger approached too closely. Here, then, is another form of insulation provided by class status. Adorno was one of the most acute critics of contemporary capitalism in the twentieth century. And yet, in his willingness to disparage all forms of direct action as naive or reactionary, even among those people who were experiencing the violence of the state in a direct and visceral manner, and in his singular concern with the exculpatory ideological benefits that might be accrued by capitalism as a result of this action, it is hard to not recognize the impact of his own cultural and economic status. He seems to have had little awareness of the privilege that would allow him to say to someone with a boot on their neck that they should forgo resistance because it might, eventually, be used to validate a larger system of domination. Rather, his concern is only with a future moment, visible to the theorist alone, at which the denial to capitalism of some situational legitimation here and now might lead to the conditions necessary to foment a real revolution. By extension, he seems unable to recognize the kind of empowerment that arises from the act of challenging repression here and now and, as a result, has little insight into the consciousness-transforming effects that resistance itself can have as a building block for future revolutionary praxis.

Notwithstanding these tensions, at the core of Adorno's work is the vision of a future in which the relationship between self and other is defined by a reflective openness to difference, rather than a repressive drive for mastery.[74] This is, of course, the underlying goal of aesthetic discourse itself over the past two centuries. Adorno's concept of mediation offers a compelling model for how this emancipatory potential might be sustained, but it is not without its own constraints. In particular, by collapsing mediation into a conventional notion of aesthetic transcendence, it effectively curtails precisely that dimension of mediation (the dialectical interaction of self and other, consciousness and lifeworld, or theory and praxis) that can prevent self-reflexivity from devolving into a covert form of solipsism. The result can be, paradoxically enough, an avant-garde aesthetic paradigm based on

a form of selfhood that reinforces, rather than challenges, the sovereignty of the ego. I identified three levels at which Adorno reiterates a conventional paradigm of aesthetic autonomy. The first is in the relationship between the tensions that unfold in the internal, compositional plane of a given work of art and the forms of social or political resistance to which they symbolically refer. The second is in the autonomy of the artist's consciousness as the displaced locus of revolutionary insight and, by extension, in the hierarchical relationship set in place between artist and viewer as a result. And the third is in the separation of both artwork and viewer from the "external" social sphere through the institutional segregation of the art world itself.

I also identified an alternative aesthetic tradition, exemplified by the Prolekult movement and forms of anticolonial cultural resistance, which seeks to understand the epistemologically generative nature of praxis itself. Here we encounter a paradigm of artistic production that explores the potential for creative and self-reflective insight mobilized at each of the levels outlined above (the linkage of artistic production and political action, the thematizing of artistic sovereignty in collaborative modes of production, and the breaking down of the institutional autonomy of the art world). This shift is evident in the commitment to performative and participatory modes of production, from Gandhi's weaving to the collaborative theatrical projects developed by Piscator to the collective graphic art of the TGP. It is evident as well in the complex interrelationship between these practices and the most vital currents of contemporary popular culture (folk cultures for Wynter, the legacy of Posada for the TGP, etc.). Finally, we can observe it in the willingness among many of these practitioners to embrace affirmative forms of meaning (celebrating the survival of modes of cultural expression that are systematically repressed), in contrast to the radical negation of the avant-garde tradition. Combined with an interest in collaborative forms of creativity, this marks the important prefigurative dimension evident in this tradition. We might think of this work as building a "bridge back," as theorist Peter Osborne writes, from the atemporal "now time" of the avant-garde to the "phenomenological structure of the living present" and the complex forms of "practical experience" that unfold within it.[75]

We encounter a parallel expression of this tradition in the writing of the Trinidadian historian and activist C. L. R. James, a contemporary of Adorno's. In fact, James actually met Adorno briefly while both were living in New York City during the early 1940s.[76] It was around this time that the focus of James's research turned increasingly to the generative political role of popular culture, which came to fruition in his book *American Civiliza-*

tion, published in 1950. Even as Adorno was dismissing popular culture as an entirely debased extension of the capitalist culture industry, James was turning to an analysis of blues music, cinema, and other popular forms as incipient expressions of cultural resistance and subaltern creativity. This interest in the emancipatory potential of culture was already evident in James's landmark study of the Haitian Revolution (*Black Jacobins*), which examined the crucial role played by religious and cultural traditions in catalyzing resistance to French colonization (the Bois Caïman ceremony, Vodou, etc.). It is evident as well in James's later works, including *Beyond a Boundary* (1963), a penetrating study of the aesthetic politics of cricket that is simultaneously a memoir and a theoretical analysis of the intersectional effects of racism, class oppression, and colonial domination, which James experienced firsthand. "Cricket," as he writes, "is first and foremost a dramatic spectacle. It belongs with the theater, ballet, opera and the dance."[77] Distinct from Adorno, James also had extensive practical experience as an activist, working closely with the Workers Party in the United States (affiliated with the Fourth International) during the 1950s, and later with Nkrumah in Ghana and the People's National Movement in Trinidad. As a result of this experience, he became increasingly disillusioned with the failure of the Communist Party to substantively address issues of race, and with the destructive hierarchies of party-based vanguardism. "It is absolutely imperative," as he wrote in 1950, "to put an end to the legend of 'the vanguard' which has dominated revolutionary movement for so many decades with such catastrophic results." In place of a political organization defined by a "sharply differentiated" class of intellectuals "who must separate themselves from the working class" because they are "more conscious, more militant and more coherent," James advocated for a form of politics predicated on the "self-movement" of the working class, in which workers and intellectuals learn from each other.[78]

These two paradigms—the conventional avant-gardist orientation we encounter in Adorno's work and what we might term a "dialogical" aesthetic paradigm evident in James's writing, Prolekult, and elsewhere—often coexist in the work of a single artist. Thus, shortly after staging the *Confinement Action* discussed above, Graciela Carnevale participated in the Tucumán Arde project in Rosario. Tucumán Arde ("Tucumán Burning") was developed by the Vanguard Artists Group, a collective of artists and journalists who were seeking to develop "alternative cultural strategies" in Argentina during the 1960s. They undertook extensive research into the experiences of working-class communities in the sugar-producing region of Tucumán

Province, which were suffering under the disastrous economic policies of the Onganía regime. The results of this research were subsequently presented in a provocative "denunciation exhibition" at the headquarters of the Confederacion General de Trabajadores de Los Argentinos in Rosario, which was publicized as the "First Biennial of Avant-Garde Art" (the police closed its Buenos Aires iteration after two days).[79] In Carnevale's work, we can observe the coexistence of both the custodial discourse of the conventional avant-garde (subjecting the viewer to a form of embodied disruption in order to provoke them into political consciousness) and a more dialogical model of production involving consultative interaction with the working class. As I discuss in the following section, we encounter this same duality in the work of Joseph Beuys, another key figure associated with new forms of artistic production during the 1960s.

Joseph Beuys and the Permanent Conference

The only thing would be to abolish the state or make it truly democratic in concept.... The principle of autonomy would be universally accepted in the cultural and democratic spheres, production, consumption and the economic system; the difference being that the democratic forms would then influence everything.
—Frans Haks, "Interview with Joseph Beuys" (1976)

One would be hard pressed to identify an artist more likely to incur Adorno's disdain than Joseph Beuys. While Adorno never wrote about Beuys's work, we can gain some sense of how he might have reacted to it by his comments in *Aesthetic Theory* about the experimental art practices of the 1960s. The fate of all attempts to desublimate art's utopian power prematurely (through political action or by engaging in collective practices that exhibit a prefigurative dimension) is always the same: a miserable co-option that serves only to provide the "culture industry with an excuse for more profit-taking and barbarity."[80] We can assume, then, that Beuys's interest in the creation of alternative institutional forms intended to produce social change would violate Adorno's concept of aesthetic autonomy. Beuys's example is instructive for this discussion precisely because of the complex tension in his own practice between a highly conventional, quasi-romantic notion of the artist (the source of critiques of his "shamanistic" self-fashioning) and his overt commitment to challenging authorial sovereignty in his activist projects. In fact, Beuys's performative staging of himself as a kind of spiritual savant led to a set of tense encounters with US-based feminist artists

during a 1974 trip to New York organized by his dealer Ronald Feldman. As historian Cara Jordan notes, to artists "who valued conversations and dialogue over Beuys's mono-directional lecturing style," he seemed closer to a "Messianic, Christ-like figure" than an ally: "To them, his domineering presence and inability to collaborate with other artists ... confirmed his position in the patriarchal upper echelons of the art world. . . . As Faith Ringgold responded: 'We don't need a leader, Mr. Beuys. If you want to do something, get behind and push.'"[81]

In Beuys's self-conscious performance as theosophical schoolmaster we have, yet again, the image of the artist as deputy or, as Thierry de Duve has it in his obituary of Beuys, the "last proletarian."[82] De Duve identifies Beuys's effort to link artistic production and political transformation with the longer history of the avant-garde, which sought to universalize the values of creative self-actualization embodied by the artistic personality through its rapprochement with a revolutionary vanguard. Here art, or aesthetic experience, functions as the "emancipatory horizon" of society as a whole.

> "Everyone is an artist." Rimbaud already said it and Novalis already thought it long ago. The students of 1968, in Paris, in California, and gathered around Beuys in Dusseldorf, proclaimed it once again and wrote it on the walls. It has never become a reality, at least not in that sense ... the masses don't have the power to actualize this potential because they are oppressed, alienated, and exploited; only those few, whom we stupidly call professional artists, know that in reality their vocation is to incarnate this unactualized potential.[83]

Beuys's death, in de Duve's view, marks the dénouement of the "modern myth" that the forms of freedom, autonomy, and community first evoked in the Enlightenment aesthetic might one day be universalized. Thus, Beuys is the last individual to hold onto the naive belief that there could be any reciprocal relationship between "the hopes and prophecies of the modern cultural field" and "the field of political economy." Once again, the "oppressed, alienated, and exploited" masses have failed to realize their own "unactualized potential," and the last artist who sought to "incarnate" this potential on their behalf has shuffled off this mortal coil.[84] As we will see in chapter 5, the effect of this loss was to trigger another cycle of aesthetic displacement, as the modes of critical consciousness that Beuys, among many other artists during the 1960s, sought to catalyze through the interaction of artistic practice and political resistance were once again returned for safekeeping

to forms of "immanent" critique within the protective enclave of the institutional art world.

The image of the artist as a "supreme savant," in Rimbaud's words, alternately enlightening and provoking the public, came quite naturally to Beuys. Joined with his celebrated production of gallery-based sculptures, drawings, and installations, it identified him fully with the mainstream, market-driven art world. At the same time, his highly conventional artistic persona coexisted with a range of practices that called into question precisely this sort of authorial self-projection—in particular, new forms of para-institutional production at the intersection of art, pedagogy, and activism. The fact that these later projects unfolded with greater or lesser success is less important for my analysis than the fact that through them Beuys was willing to openly thematize issues of authorship and collectivity in the first place, and to place his action-oriented work on a continuum with the rest of his artistic production. This marks a central aporia in de Duve's account. For all his messianic posturing, Beuys did not conceive of himself as a singular exemplar of enlightened consciousness. He never claimed to have "absorbed" the revolutionary awareness of the working class, nor did he view them as incapable of coherent resistance or creativity as a result of their ongoing "exploitation." In Beuys's activist work, the locus of emancipatory political insight is decisively "de-transcendentalized" through the intersubjective exchanges that unfolded in specific concrete actions (the occupation of the Dusseldorf Art Academy, the formation of the Green Party, etc.). Most importantly, he clearly did not share the melancholic belief that "decisive change is foreclosed," which justifies the transposition of artistic and proletarian consciousness in the avant-garde tradition. This is not to discount the critique of Beuys's self-presentation as a kind of condescending paterfamilias, sharing his visionary genius with the public. Rather, we might say that his personality combines attributes of both conventional avant-garde autonomy and the more receptive, dialogical model of selfhood and artistic production that we have already identified in the work of Piscator, the TGP, and Carnevale. In this respect Beuys reflects a set of tensions that were evident more generally in new forms of artistic production during the 1960s.[85]

Beuys referred to these two components of his artistic practice (the production of conventional art objects and performances on the one hand and the creation of para-institutional actions on the other) as "parallel processes." He used the term "permanent conference" to reference the ongoing, discursive nature of the second body of work (public debates, direct engagement with political struggles around education, democracy, and the environment, the

formation of new collectives). It is this later work, specifically, that offers an alternative to Adorno's pessimistic assessment of the critical potential of the general public. As this outline suggests, Beuys placed a great deal of emphasis on the importance of specific forms of direct action and argued that art could play a key role in the process of social change through its ability to transform human consciousness, especially in collective forms of production. His goal was not to destroy art, but to expand and reinvent it (a distinction that Adorno would find difficult to accept). Beuys outlines his vision for this change in a 1978 text for the *Frankfurter Rundschau* ("Appeal for an Alternative"), which served as a kind of manifesto for the Green Party. Here he outlines the necessity for "a NEW STYLE of political work and political organizing" predicated on the unity of "many streams, initiatives, organizations, institutions, etc." acting in "solidarity." He goes on to call for a united front, formed from the feminist movement, the civil rights movements, student demonstrators, environmental activists, and many others, "against the concentrated interests of the powerful."[86]

We might think of Beuys's work as proposing a renegotiation of the norms of aesthetic autonomy that Adorno takes for granted. We can synopsize the broader ideological frame set in place by Adorno's aesthetic in terms of the following, interrelated, claims, which derive from the discourse of aesthetic autonomy. The first claim entails the assumption that no real or substantive political change is possible in the current historical moment. The second claim concerns what Adorno views as the generic incapacity of the public, or "masses," due to the stupefying effects of the culture industry. The third claim involves the notion of the artwork, and the artistic personality itself, as a surrogate or carrier for a form of revolutionary consciousness that the masses are incapable of achieving. And the fourth claim, which flows syllogistically from the preceding three, is the belief that critical insight or revolutionary consciousness must be sequestered in the "immanent" qualities of artistic practice and protected from any reciprocal engagement with the contaminating influence of social or political resistance. Beuys's work will, of course, challenge all of these postulates.

As I noted, while Beuys is certainly associated with conventional art media such as drawing, printmaking, and sculpture, he also saw these practices as existing on a continuum with the creation of new institutional forms and new modes of political action. This is the source of his famous claim in 1969 that "teaching is my greatest work of art" and that "the rest is a waste product, a demonstration." As he continues, "If you want to express yourself you must present something tangible. But after a while this has only the function of

a historic document. Objects aren't very important anymore. I want to get to the origin of matter, to the thought behind it."[87] Beuys's interest in the creation of alternative institutional forms was informed by growing student militancy in West Germany following the police shooting of Benno Ohnesorg during a protest against the visit of the Shah of Iran to Germany in 1967. That same year, Beuys founded the German Students Party in Dusseldorf, followed by the creation of the Organization for Direct Democracy Through Referendum (in 1970), the occupation of the Art Academy in Dusseldorf (in 1971), and the original proposal to establish a new "Free" College in November of that same year, which would eventually become the Free International University for Creativity and Interdisciplinary Research in 1973.[88]

In 1972, Beuys turned his Documenta 5 exhibition into a public forum to advance the ideals of his Organization for Direct Democracy. For one hundred days Beuys organized discussions and debates in the space, focusing on key political issues including women's rights, nuclear energy, unemployment, and institutional racism. By 1980 Beuys was involved with the formation of the Green Party. In fact, where Adorno viewed the SDS and the broader German student movement as naive and even protofascistic, Beuys campaigned together with the SDS's Rudi Dutschke (Adorno's antagonist in Subversive Aktion) for the Green Party in 1979 and, along with several of his students, engaged in his own occupation of the Dusseldorf Art Academy admissions office.[89] What is notable throughout this flurry of institution building is the absence of any static boundaries between art institutions and political institutions. Beuys clearly viewed them as permeable rather than entirely autonomous. In "Appeal for an Alternative," he describes this continuity as representing a form of "alternative life," in which "many people have begun in small zones and special territories" to form a "union of alternative economic and cultural undertakings."[90] The "only chance" for the survival of this "common movement for the alternative" lies in the process of "community and society association."[91] And in a 1971 interview Beuys linked his critique of the Art Academy in Dusseldorf, evident in his acceptance of 142 students who had been denied admission there, to a broader critique of the merely "formal" democracy allowed by the German government. "For this reason, the conception of a new school also includes the goal of conquering purely formal, representative democracy, which does not carry out the statute that 'all power comes from the people.' I want to make such contradictions in our political statutes known so that the majority of the population can one day negotiate and make use of their fundamental rights."[92]

If the first level of Beuys's recoding of aesthetic autonomy involved the expansion of the work of art into a set of multimodal cultural and political actions, the second level involved the reshaping of the artistic personality itself. For Beuys, the artist no longer acts on behalf of an incapable, or hypothetical, public. Rather, the artist works in alliance with the constituents of "alternative life" in an open-ended and improvisational manner. In this process authorship, rather than being the singular possession of the self-identified artist, is mobilized as a site of creative intervention and experimentation. Here it is not a question of disavowing authorship per se but of thematizing it openly as a problematic and a potential. This shift is evident in Beuys's commitment to the expansion of the subject position of "artist," embodied in his description of the "social organism as a work of art," and defined by the belief that "every human being is an artist."[93] Here is yet another iteration of the aesthetic state—a society in which all individuals enjoy the expressive freedom of the artist. For Beuys, this condition, rather than remaining symbolized by the conventional artistic personality, functions instead as the basis for a form of prefigurative social and political reinvention necessary to bring this world into practical existence. Beuys extends this expanded understanding of artistic agency to a deliberate decentering of pedagogical authority. Reflecting on his proposal for a Free International College in Dusseldorf, he writes: "School is universal. That means, on the street—when you talk about these things with people at the grocer's; the school is at the grocer's at that moment. . . . I just want to encourage everyone to take this into their own hands, the educational process. . . . We don't need a brilliant talent somewhere. Precisely the ability that one has at the moment must be put to work."[94]

For Adorno, both of these interventions—the expanded and dematerialized work of art, and the plasticity of the artistic personality—would represent a dangerously premature desublimation of art's critical potential. Artist Terry Atkinson invokes this same threat in a 1995 critique of Beuys, identifying the "foreboding texts of Theodor Adorno" as the necessary "antidote to Beuys' political hubris" (his willingness to engage in a naive actionism entailing prefigurative forms of collective action).[95] Here Adorno's theory, generated in splendid isolation from the turbulence of the street, will provide the intellectual cold water necessary to dampen Beuys's unwarranted political enthusiasm. Benjamin Buchloh, in one of the best-known critiques of Beuys, describes him as a crypto-fascistic "artist-charlatan," whose only goal was a superficial fame via a process of opportunistic self-mythologization.[96] There

is certainly a level of naïveté in many of Beuys's concrete political prescriptions, but that tendency is hardly unique to Beuys. I believe that what was most provocative about Beuys's work for critics such as Buchloh, Atkinson, and many others was his readiness to actualize certain utopic processes in the name of art and his refusal to subordinate his activist artistic work to his production of conventional art objects, effectively suspending the hierarchical ordering of art and direct action on which the discourse of the avant-garde depends for its legitimacy.

If we return to the broader paradigm of aesthetic autonomy outlined by Adorno, we can identify a set of inversions that challenge each of the conditions that Adorno proposes. First, as I have suggested, Beuys believed that meaningful political or social change was, indeed, possible as part of the incipient "common movement for the alternative." Second, Beuys will contest the "incapacity" thesis by developing projects based on the assumption that members of the public are capable of generating competent political judgments and engaging in forms of social praxis that are not doomed to complicity and failure. Third, Beuys will challenge the deputizing function of the artist so essential to Adorno, in which the artist stands as a surrogate for the un-self-conscious proletariat (even as this gesture exists in some tension with his own charismatic self-presentation as an artistic visionary). Finally, Beuys will violate Adorno's strict segregation of aesthetic experience and political praxis through various forms of para-institutional organizing and social sculpture. For Beuys, resistance or action can be both pragmatic and autopoietic, and autonomy, rather than being a fixed or static condition, can fluctuate over time, as moments of partial reconciliation follow on from moments of disruption or agonistic conflict in the unfolding of a given work.

Both Atkinson and Buchloh link Beuys's concept of social sculpture with a kind of delusional egoism or "hubris." In this respect their critiques mirror Adorno's description of the protesting German students who interrupted his classes at the Frankfurt Institute in 1969 as "slaves of their own publicity."[97] Adorno, of course, would insist that "ego weakness" had become pervasive among the general public and was a precursor to fascism (which was fueled by the drive to identify with a strong leader). This concern with "ego weakness" emerges as something of an obsession in *Aesthetic Theory*. Thus, Adorno warns of the "panting politics of the student movement," linking the actualization of politics with the unseemly and uncontrolled expressions of the body surrendering itself to libidinal desire.[98] Elsewhere, he writes that the "recent disruptions by activists are taken straight from the fascist bag of tricks: ego weakness, the inability to sublimate, is being refined as a

higher quality."⁹⁹ We encounter here the ongoing influence within avant-garde discourse of a conventional model of the subject qua ego, who must be brought to internalize a capacity for self-regulation that leaves the underlying structural autonomy of that self unquestioned. We encounter here, as well, the incapacity of the masses thesis, which we have traced from Schiller to Lenin. The masses are simply too febrile, too mired in bodily experience, and too weak and impressionable to sublimate their desire for utopia to the disciplined sacrifice, analytic detachment, and cold-blooded violence necessary for "objective" revolution to occur. Instead, they entertain themselves with spurious displays of pseudo-resistance and are easily lured into the "instantaneous, immediate gratification" provided by desublimated action.¹⁰⁰ This underlying argument has evolved over time into a form of received wisdom. Thus, Ayon Maharaj, in *The Dialectics of Aesthetic Agency*, presents Adorno's analysis as a self-evident truth, contending that "any attempt at revolutionary praxis is always short-circuited by the weak, easily manipulable ego-identities of the would-be revolutionaries." "Any transformation of reality," Maharaj writes, paraphrasing Adorno, "depends on an a priori transformation of consciousness" that can only be brought about by art.¹⁰¹ We are, again, on terrain that is familiar to us from the eighteenth-century discourse of aesthetic autonomy: *any* political action is premature until its agents have first undergone an individuated transformation of consciousness through their encounter with a theoretical text or an avant-garde artwork.

Performativity and Consciousness Raising

While Adorno would disparage the new social movements of the 1960s and 1970s as little more than "noisy optimism," these movements would exercise a profound influence on artistic production, as we have seen with Beuys's activist work. Throughout the 1960s and 1970s there is a generative interconnection between new forms of political resistance and artistic practice. Thus, we see a turn toward performative modes of action in the protests of the Yippie movement (exemplified by Abbie Hoffman's interventions at the New York Stock Exchange in 1967 and the Democratic National Convention in 1968), which exhibit clear affinities with contemporaneous Fluxus performances.¹⁰² We can observe it as well in the Black Panthers, who possessed a sophisticated understanding of the cultural politics of image and performance. This is evident in their self-fashioning (the conscious modeling of an alternative paradigm of militant Black identity via dress and appearance), which employed Afrocentric and urban iconography. There are

clear parallels here to the political symbolism of dress in Gandhi's work with the Indian independence movement. This "visual vocabulary," as Jo-Ann Morgan has described it, is also evident in the work of Emory Douglas, who produced the Panthers' newspaper as the party's "Minister of Culture."[103] Reaching more than 400,000 readers at its height, the newspaper was a crucial element in the Panthers' efforts to intervene in media representations of their actions and beliefs. For the newspaper's illustrations, Douglas developed an inexpensive but highly effective graphic arts style, using markers and pens to evoke the appearance of the revolutionary woodcuts created by groups such as the TGP. In addition, Douglas produced a range of posters and postcards designed to recruit new members and disseminate the Panthers' message in the Black community. This performative sensibility is also evident in Panther actions, such as the occupation of the State Capitol Building in Sacramento, California, in 1967 to protest the Mulford Act. Here a group of thirty party members, carrying pistols and shotguns, entered the Capitol Building to protest a new law that would ban the "open carry" of licensed weapons in California. The law was introduced specifically to prevent the Panther members from engaging in armed "cop-watching" (observing police actions in Black neighborhoods to protect the residents from endemic police violence).

These practices find their parallels in a broad range of artistic production associated with the Black Arts Movement. Emblematic examples include the *Wall of Respect*, a mural created in 1967 by the Organization of Black American Culture, a collective of Black artists based in Chicago.[104] The mural, located in a working-class neighborhood on the city's South Side, features portraits of a cross-section of African American artists, political leaders, and activists, ranging from Nat Turner and W. E. B. Du Bois to Stokely Carmichael, Gwendolyn Brooks, and Ruby Dee. Notably, the *Wall of Respect* includes images of a number of innovative jazz musicians, including Thelonius Monk, Ornette Coleman, and John Coltrane. Their inclusion demonstrates a key point of differentiation from conventional forms of avant-garde aesthetic autonomy. For Adorno, the critical value of Schoenberg's twelve-tone technique lay precisely in its status as an entirely self-referential compositional system, closed off from any contact with the broader field of popular music. The work of figures such as Monk, Coleman, and Coltrane marks an alternative aesthetic paradigm, in which the artist takes on an experimental and dialogical relationship to the conventions of both popular music and the history of jazz itself. Their inclusion, along with portraits of sports stars (Muhammad Ali, Kareem Abdul-Jabbar) and

musicians (Muddy Waters, James Brown, Sarah Vaughan), demonstrates the characteristically fluid boundaries between avant-garde practices and the broader domain of African American culture. As Bracey, Sanchez, and Smethurst argue in *S.O.S. Calling All Black People*, the Black Arts Movement "was a major force in introducing the idea that 'high' art can be popular in form and content and popular culture can be socially and artistically serious." They stress, as well, its emphasis on "performative artistic genres that lent themselves to public performance."[105]

An equally generative site for the reciprocal influence of social change and artistic production occurred in the context of the feminist movement. Here the concept of "consciousness raising" (CR) played a key role. This influence is clear in the work of Judy Chicago and Suzanne Lacy, among many other figures. I already noted the central tension in Beuys's practice between authorial sovereignty (the image of the artist qua visionary that he carefully cultivated) and his interest in collaborative projects developed in conjunction with new social movements associated with environmental activism, participatory democracy, and so on. It was this same tension that informed the critical response of feminist artists to Beuys during his visit to New York in 1974. For feminist artists at the time, it was essential to understand precisely *how* these two registers of meaning (the intersubjective micropolitics of collaborative artistic production and macropolitical issues at stake in broader struggles over sexism) were interrelated. These questions were paramount not simply in feminist art practice but in feminism more generally as new paradigms of resistance were emerging that broke with the masculinist hierarchies of both the Communist vanguard and the artistic avant-garde. It was in this context that the concept of CR took on heightened importance, as it signaled an alternative understanding of how we come to think critically about the nature of oppression. Here insight is generated not through the custodial guidance of a cognitive savant, uniquely able to transcend the disabling constraints of the body, but through a process of collective exchange among those people who have the most immediate cognitive and physical experience of that oppression.

Lacy's early study of psychology at Fresno State College likely influenced her deeper awareness of the complex process by which we come to think and feel differently about the nature of domination. This linkage was further reinforced by her early experiences with Judy Chicago at the Feminist Art Program at Fresno where CR sessions were an integral part of the curriculum,[106] entailing the collective discussion of individual experiences of sexism and sexual violence among women. It emerged as a central processual

aspect of the politicization of women in second-wave feminism. For women who came of age in the late 1950s and 1960s, one of the most debilitating features of patriarchy was its ability to convince them that they themselves were responsible for the routinized harassment, violence, and exploitation that they experienced, rather than it being a structural feature of the society in which they lived. Thus, CR constitutes a deliberate effort to decolonize consciousness, linking their "individual" experience with a broader pattern of organized, patriarchal violence against women that persists to the present day. The result was a politicization of personal experience, which becomes the foundation out of which a broader sense of solidarity and collective empowerment can emerge ("there are no personal solutions," as Carole Hanisch wrote in 1970, "there is only collective action for a collective solution"). Moreover, CR provided a framework for praxis that was grounded in the distinct forms of knowledge generated through the complex interconnection of both bodily and cognitive experience. As Hanisch, a key figure in the evolution of CR, noted in 1970, "I went, and I continue to go, to these meetings because I have gotten a political understanding which all my reading, all my 'political discussions,' all my 'political action,' all my four-odd years in the movement never gave me."[107] We encounter here a process of experiential learning that is antithetical to the vanguardist division between mind and body, consciousness and spontaneity, and theoretical and practical Communist.

An equally formative influence on Lacy's artistic development was provided by Alan Kaprow, who she studied with at Cal Arts. In this respect her work effectively synthesized techniques developed within the feminist movement with the performance-based artistic methodologies pioneered by Kaprow. Many of Lacy's projects since the 1970s have focused on staging dialogues among and between specific communities and groups (often women), related to issues of political repression, sexism, and racism. *Three Weeks in May*, a key work from 1977 focusing on sexual violence in Los Angeles, included CR workshops in which women shared their experiences of rape. Such CR exchanges became a central compositional focus in *Freeze Frame* (1982), a tableau-based work centered around a set of conversations among women from various backgrounds, staged in a furniture store in San Francisco.[108] This same pattern was expanded for *Whisper, the Waves, the Wind* in 1983–1984, which entailed conversations among 150 older women around the experience of aging, set on a beach in La Jolla, California. This project was extended to an even larger scale in *The Crystal Quilt* in Minneapolis (1985–1987), which employed the motif of quilting to present discussions among more than four hundred

older women. During the 1990s, Lacy's tableau-based works expanded to include a series of dialogue-based performances involving young people of color in Oakland who suffered from ongoing police harassment (*Code 33* and *The Roof Is on Fire*). Throughout her career Lacy has remained attentive to the complex intersubjective dynamics set in place between the observer/witness and participant/storyteller in her work.[109] In this respect her efforts to make CR sessions into "public" events, observable by people outside the circle of CR intimacy, are characterized by a symptomatic tension. The concept of CR sought to provide a space within which women could safely share what were often quite traumatic details of their personal lives. As a result, this public dimension is potentially fraught. On the one hand, it can lead to the reduction of CR to a spectacle, in which participants might feel some reluctance to express themselves freely (for this reason Lacy carefully calibrates the spatial proximity of the observer to the participant in these works), but on the other it holds open the possibility that the movement from self to social that occurs in recounting the experience of oppression in a CR exchange can be transmissible, and relevant, to a larger public that has not shared that same experience.

As I noted above, artistic practices developed during the 1960s and 1970s mark the ongoing evolution of the alternative aesthetic paradigm I have traced in previous chapters, associated with anticolonial cultural resistance and the broader currents of participatory action that emerged in the 1920s and 1930s. This evolution is evident in Lacy's work at four interrelated levels. First, and most obviously, we can observe it in her commitment to performative modes of production that challenge conventional authorial sovereignty and encompass the wisdom of the body. As she wrote in 1975, "I believe identity is a dynamic rather than static concept; it is activity (the verb), existing in the *spaces between* bodies, and in the bodies which are themselves dynamic energy relationships. I do not accept the definition of woman as WOMAN (the noun), a person contained in an identity she 'was born with,' nor do I accept the definition of ARTIST as a person who was born into or adopts a role by virtue of certain unique and static characteristics which center around the notions of talent and creativity."[110] Second, it emerges in Lacy's ongoing interest in integrating her projects with forms of popular culture, which provide a point of access for viewers and participants for whom the institutional art world, and its often-esoteric protocols, are unfamiliar (quilting in *The Crystal Quilt*, basketball in *No Blood No Foul*, religious iconography in *The Black Madonna*, etc.). Third, it is evident in the affirmative element of projects that seek to honor, and create solidarity

within, communities who are routinely disparaged or humiliated by the broader society (older women, young people of color, etc.).[111] We encounter this affirmative element in a number of works, including *Ablutions* in 1972, which provided a "healing ceremony" for survivors of sexual assault, and the group conversations among teens in *The Roof Is on Fire* (1993–1994) in which adults were encouraged to learn from the experiences of a population that was widely viewed in the media at the time as immoral and predatory. Finally, Lacy's projects often involve some formal "collaboration with a political organization," as she writes.[112] In the case of the works developed in Oakland, this led to concrete changes in city policies governing the training of police, and *In Mourning and in Rage* forced the city of Los Angeles to introduce an emergency rape hotline and provide funding for neighborhood protection programs. These same factors are evident in a broad range of activist art practices developed during the 1960s and 1970s, which offered a significant alternative to more conventional forms of gallery-based artistic production that continued to flourish during the same period. As I discuss in chapter 5, these two trajectories, and the generative tensions that exist between them, will be renewed during the 1980s and 1990s.

III

AUTONOMY SINCE THE 1980S

> # THE RISE OF THE
> NEO-AVANT-GARDE

The *October* Revolution

Can we write, compose, and make music for an imaginary audience? Or does it all only happen for the art dealer?
—Hugo Ball, diary entry for October 11, 1917, in *Flight Out of Time* (1917)

As I outlined in the previous chapter, Adorno bequeaths to us a model of the avant-garde that reproduces key aspects of the traditional discourse of aesthetic autonomy. This discursive structure was defined through forms of spatial displacement and temporal deferral. At the spatial level we can identify a sequence of iterative structures that are designed to insulate the (implicitly fragile) process of emancipatory insight generation (ostensibly unique to aesthetic experience) from experiential modes that are understood as "external" to art. These unfold through a series of relays from the cognitive (aesthetic experience occurs only in the consciousness of the individual viewer) to the discursive (aesthetic experience can only occur

through an indirect or "mediated" relationship to the world via the artwork-as-semblance) to the institutional (aesthetic experience can only occur in spaces that have been culturally demarcated for the display of "art," such as museums, galleries, or concert halls). This spatial displacement is also reproduced in the compositional structure of the artwork itself, in its production of a virtualized form of resistance (against a reified field of immanent aesthetic conventions), which takes on a metonymic relationship to forms of direct action waged against a reified set of political structures. For Adorno, art employs its own previously transgressive, but now cognitively dormant, formal modes as the point of "internal" resistance against which to assert its own indeterminant nature or nonidentity. Here again we can observe the key binary framing of "inside" and "outside" that is central to the discourse of autonomy more generally. Thus, art's own (exhausted) conventions, now extruded from the work itself in its ongoing evolution, stand in for the "external" coercive force against which the bourgeois subject first burrowed out a resistant shell of autonomous freedom and self-differentiation. In the avant-garde tradition, of course, this coercive external force takes the form of capitalism rather than absolutism, and the rejection of these stylistic norms becomes the symbolic expression of a form of direct political resistance that is not possible in the current historical moment.

At the temporal level deferral, in the Enlightenment aesthetic, occurs through the disjunction between the ideal audience *implied* by aesthetic experience (reflective, critical, capable of self-governance) and the repeated failure of modern art to actually produce this viewer due to the ongoing retardation of social consciousness caused by capitalist mass culture. Here aesthetic experience becomes the carrier for a form of emancipatory consciousness that does not yet exist (aesthetic experience *should* be universal, as Kant writes, but this has not been realized in practice). Until that moment comes, aesthetic experience will remain the singular possession of a small coterie of what Hume called "men of delicate taste," who act as precursors for the new political subject who will eventually emerge from the cumulative process of educational and aesthetic enlightenment. With Schiller the incipience of this moment is lost; aesthetic experience is no longer viewed as conjoined with a broader process of societal progress and enlightenment. This shift is evident in Schiller's concept of the "premature" nature of praxis. Art now takes up its recognizably modern role as the unique embodiment of a form of enlightened consciousness that cannot be realized anywhere else.

With the rapprochement between the political vanguard and the artistic avant-garde during the nineteenth century, the telos of this process shifts

(from the enlightened bourgeois state to Full Communism) but the temporal deferral is sustained, as the work of art speaks to a revolutionary moment that has not yet come to pass, and men of delicate taste are replaced by a revolutionary vanguard. Art can *potentially* be rejoined to praxis now (because Marxism promises to finally universalize freedom), but as a result of the frustration of past revolutionary struggles, art must withdraw into its autonomous shell, acting out the familiar cycle of revolutionary failure and aesthetic displacement that I described in chapter 1. Precisely in protecting itself from co-option by the external world, and by uncoupling so fully the experience of actual social change from its symbolic, compositional enactment, the work of art is able to preserve a (purified) form of revolutionary consciousness, even as it ensures its inability to make it meaningfully accessible to viewers here and now. In this view, the work of art becomes, in critic Hal Foster's words, "a hole in the symbolic order of its time that is not prepared for it, that cannot receive it, at least not immediately, at least not without structural change."[1] Here Foster gives renewed expression to the idea that art's task is to hold the existing social order responsible for its failure to fully realize (via "structural change") the utopia of the aesthetic state. The work of art remains in a holding pattern, waiting for the proper historical moment when it can again open itself to the exigencies of praxis in order to facilitate the full universalization of the aesthetic state. Until that time, art remains "belated," "suspensive," or otherwise temporally discontinuous, pointing the way to a brighter future whose precondition it carries in embryonic form.

This paradigm will remain remarkably durable. In the following section I will trace its evolution since the 1970s. We can begin this exploration with the journal *October*, which played a central role in promoting a rearticulated model of aesthetic autonomy during the 1980s and 1990s. My goal here is not to present a comprehensive account of *October*'s evolution, but rather to focus on the specific ways in which it transformed the discourse of avant-garde aesthetic autonomy. Founded in 1976, the journal was named after the eponymous 1928 film by Sergei Eisenstein, which was commissioned to commemorate the tenth anniversary of the Bolshevik Revolution. The journal thus presents itself as carrying forward, at the level of art criticism, a form of radical consciousness that was already temporally displaced from the form of praxis it sought to honor (by 1928 Stalin had consolidated his control over the Communist Party and Trotsky had already been consigned to internal exile). The journal's editorial staff believed it was uniquely positioned to preserve an authentic kernel of revolutionary insight, rooted in

the traditions of the Russian avant-garde. For *October*, the halcyon postrevolutionary days marked an unprecedented efflorescence of revolutionary creativity that bridged the gap between artistic experimentation and the masses, who were, in the very act of revolution, brought to a heightened level of critical consciousness. This seemed to prove that self-reflexive formal experimentation in art, far from being frivolous, was actually a direct emanation of revolutionary action. "We have named this journal," as they wrote, "in celebration of that moment in our century when revolutionary practice, theoretical inquiry and artistic innovation were joined in a manner exemplary and unique."[2]

In this narrative, the utopian promise of the aesthetic was finally realized in 1917 as the previously discontinuous temporalities of artistic expression, theoretical insight, and revolutionary political action coincided in a mutually enriching, dialogical relationship. But this singular moment of revolutionary truth was, inevitably, followed by failure (the "silence of totalitarian censure" as *October* writes) that necessitated the introjection of that same revolutionary impulse into aesthetic form for safekeeping. For now, as the editors insist, "art begins and ends with a recognition of its conventions."[3] In this familiar scenario, insight and historical progress in art flow not from opposition to an external agent of repression, but from a set of internal constraints (artistic "conventions") that have remained insufficiently clarified at the formal level in past practice, or against which the artist engages in an ongoing struggle or testing. Within the avant-garde system, the specific form taken by the conventionalized other is of far less importance than the simple presence of *some* mode of stylistic or cognitive convention, against which the artist can push (in a 2012 interview, founding editor Rosalind Krauss uses the metaphor of a swimmer "kicking off" against a "rigid surface").[4] Thus, the meaning of the avant-garde gesture lies in the artist's exemplary act of resistance and the ostensibly transformative experience that is made available to the viewer when observing the encounter between reified convention and radical negation that is acted out by a given work.

It was the unique but tragically curtailed moment of creative experimentation associated with figures such as Eisenstein, Tatlin, and Dziga Vertov that *October* dedicated itself to preserving. However, their goal was not merely antiquarian. Rather, *October* sought to assert an intrinsic linkage between art produced during the golden age of the Russian Revolution and specific modes of contemporary artistic production. Thus, in addition to frequent references to the Russian avant-garde, early issues of *October* feature writings by, or about, many of the key artists active in the postmini-

malist period in New York City (Robert Morris, Carl Andre, Richard Serra, and Yvonne Rainer), along with contributions by contemporary theorists such as Jean-François Lyotard and Jacques Derrida.[5] The juxtaposition of these two sources suggests a kind of syllogism, in which continental theory is combined with contemporary art practice to produce a new discursive system capable of carrying forward the revolutionary ethos of the Russian avant-garde. For the *October* generation, "critical theory," as Hal Foster observed, "would be the continuation of the avant-garde by other means," even as the avant-garde was intended as the continuation of revolution by other means.[6] What is especially striking in this configuration is the doubling of the rhetoric of autonomy and displacement. Just as *October* sought to valorize artistic practices that could be viewed as the symbolic expressions of a future revolutionary ethos, it linked the full comprehension of these practices with a set of theoretical sources that also claimed to preserve a subterranean revolutionary impulse. It was, after all, the perceived failure or co-option of 1960s protest movements that necessitated the "long march through the institutions" in which critical theory, infiltrating the protected space of the university, would preserve a residual insurrectional energy whose attempted realization had, once again, proved to be premature.[7]

The particular process by which *October* engaged with the discourse of autonomy was initially informed by Rosalind Krauss's ambivalent relationship to Clement Greenberg. While Krauss began her career as Greenberg's acolyte, she eventually broke with him over what she viewed as his "teleological" orientation to art history. As she notes in a 2013 interview, "[Greenberg's] idea was that art had to end up in a certain place, and if it didn't contribute to that trajectory then he dismissed it."[8] Krauss is referring here to Greenberg's contention that the evolution of the modernist avant-garde had reached an end point with the artist's increasingly self-reflexive engagement with "the ineluctable flatness" of the canvas in postpainterly abstraction. This marked a significant shift from Greenberg's writing during the 1930s, when he argued that the task of the avant-garde, in its ongoing formal evolution, was "to keep culture *moving* in the midst of ideological confusion and violence."[9] Crucially, this "movement" was linked, however tenuously, to the (as yet unrealized) mission of revolutionary socialism.[10] Greenberg's later uncoupling of artistic innovation from revolutionary praxis suggests a degree of complacency about the nature of postwar political life. Krauss, for her part, wanted to keep the dialectical machine in motion (and along with it the implicit linkage between artistic experimentation and some potential, future resistance to political domination). Here Krauss will play Marx

to the late Greenberg's Hegel, for whom the Absolute was finally realized in the modern Prussian state. She will argue, instead, that the internalized tension of art negating its own existing conventions has to be maintained. We find Hal Foster reinforcing this paradigm in a 2013 interview: "That's what bothered us: we construed the aesthetic as a space of resolution—of subjective integration and social consensus—and we wanted to question this conciliatory dimension. Certainly, the art practices that had come to interest us were pledged against this kind of reconciliation."[11]

With this quotation, we return again to the drama of art's premature desublimation, fostered by practices that encourage an affirmative "consensus" rather than a cathartic disruption. The preservation of this symbolic dissensus requires the ongoing identification of new material for art to symbolically "kick off against." In the context of the 1970s and 1980s this will involve, first, a tactical enlargement of art's determinant conventions via Krauss's notion of art's "expanded field." In one of her early essays, this expansion is produced through the characteristically apophatic definition of sculpture as "not-architecture" and "not-landscape."[12] Second, it will involve a further movement outside the (exhausted) formalist parameters of abstract painting through an engagement with various epistemological or cultural "conventions" (eventually including the institutions of the art world itself), most evident in the traditions of postmodernism and institutional critique during the 1980s and 1990s. It is important to note here that Krauss fails to question the underlying hermeneutic system on which Greenbergian formalism was based (the idea that "autonomous" avant-garde art can serve as a placeholder for an unrealizable revolutionary ethos). Rather, she only seeks to extend it beyond Greenberg's premature resolution by justifying the inclusion of postformalist artistic practices that would seem to challenge many of its core assumptions.

The *October* brand achieved its apotheosis during the 1980s with the publication of Krauss's *The Originality of the Avant-Garde* and *The Anti-Aesthetic* anthology, edited by Foster.[13] The essays published in *October* during this period did much to establish the particular relationship between art criticism and critical theory that continues to define academic writing on contemporary art to the present day.[14] It is less a question of specific influences (although these have remained remarkably consistent) than the broader sense of a discipline in crisis and dependent on the insights provided by continental philosophy for new inspiration. Krauss captures this emblematic moment in a 1980 essay that celebrates a new literary paradigm inspired by Barthes and Derrida, in which "the critical text is wrought into

a paraliterary form," dedicated not to revealing layers of meaning but to opening up the play of interpretation.[15] For Krauss the key move, necessary to restore some theoretical gravitas to art criticism, was to transpose the paraliterary as a form of hermeneutic undoing onto the work of visual art, which would constitute a kind of physical embodiment of the poetic text (laying bare the apparatus, making strange, and generally confounding identity, closure, and stasis). In this manner, Krauss replaces Greenberg's essentialist formalism with a formalism that understands art as a broader discursive system (defined by norms of authorship and originality, etc.) and with a self-reflexivity that is produced as artists begin to recognize and deconstruct this system.

The enduring influence of this textual paradigm is evident in Krauss's 2011 book *Under Blue Cup*, in which she acknowledges the central role played by Viktor Shklovsky in her own intellectual development.[16] Here, Krauss expands Greenberg's concept of artistic form to encompass something she terms the "technical support" of art. This includes a much broader range of media than Greenberg would have been willing to countenance, such as James Coleman's use of analog slide projection and audiotape recordings in his installations. Rather than the artist working to refine the immanent conditions of an established art medium such as painting and sculpture, Krauss argues that the artist can, in a manner of speaking, choose which "media" will constitute the determinant material condition against which they will push in defining their art (including such decidedly unartistic media as slide-tape presentations). She relates this concept directly to Shklovsky's notion of art as a "device" intended to lay bare the conventions of "ordinary speech."[17] Notwithstanding Krauss's invocation of Shklovsky, it is clear that we have traveled quite a long way from Sergei Eisenstein threatening to "plough over the viewer's psyche like a tractor" to the genteel self-reflexivity of James Coleman's slide-tape installations. The contemporary artist retains a relationship to this tradition by only the most tenuous of threads. For Shklovsky, of course, the act of "laying bare" entailed a reconstruction of poetics as a form of counterhegemonic denaturalization. This view was based on the assumption that poetic forms have as their job the disruption of normal, and implicitly "autonomized," cognition through the deliberate "impeding" of language (making perception "long and laborious," as Shklovsky writes).[18] Now, visual art would inherit this poetico-critical capacity, and a hidebound Greenbergian formalism would be reinfused with revolutionary vigor.

During the 1980s, this self-reflexive capacity, and the concept that the work of art functions to reveal some hidden ideological truth to the credulous masses,

would migrate beyond the formal constitution of art genres or media and reengage with the world at the level of content. For many *October*-supported artists during this period, the new device to be "laid bare" was identified with the mass media's construction of gender, the truth of the photographic image, or norms of authorship and self-expression in the visual arts. This would prove to be a decisive shift in the evolution of contemporary art and in the discursive structure of aesthetic autonomy. It replaced the idea of a formal art medium (as the resistant field against which the artist works) with the idea of an *ideological* medium defined by a set of reified discursive systems that predetermine the consciousness of individual viewers without their knowledge. This is evident in such prototypical figures as Cindy Sherman (in her exploration of gender and the filmic image), Richard Prince (in his appropriation of advertising imagery), and Sherrie Levine (in works that question gendered norms of authorship).

As this brief account suggests, we can identify an underlying tension in the textual paradigm advanced by *October* between Greenberg's immanent formalism and an approach, inspired by Shklovsky, that encompasses a range of ideological systems beyond the visual arts. For Greenberg as well as Adorno, art is able to preserve its critical autonomy, and stave off assimilation by the culture industry, by ensuring that its symbolic forward "movement" is produced entirely through its resistance to existing formal conventions that are seen as *intrinsic* to art (embodied in the physical or compositional materiality of specific art media). Only in this manner can the necessary autonomy of aesthetic experience be preserved. This paradigm depends, however, on the underlying assumption that there is a fixed and clearly demarcated division between those elements that are safely "inside" and intrinsic to art (form) and those elements that are "outside" and extraneous (content). For Shklovsky, on the other hand, poetry can open itself fully to the incorporation of new, prosaic material. In fact, poetry is utterly dependent on prosaic material to fuel its ongoing evolution as a practice. Shklovsky does not fear that poetry will "lose" its autonomy in this exchange because he no longer defines it as possessing an immanent quality in the first place. Rather, poetry has been reduced to a set of defamiliarizing semantic procedures (rather than fixed compositional or formal properties) with no a priori meaning to be "discovered." For Shklovsky poetry secures its autonomy not simply by repelling nonpoetic material but through its uniquely antithetical relationship to the individual reader's normative perceptions, which will be estranged and transformed in their encounter with the work of art. In this view, the poetic work has no essence to be discovered, no hidden immanent content

to be revealed. Rather, it is founded on an ongoing, and potentially endless, cycle of ontological decentering, restabilization, and renewed disruption. In this respect it acts as a correlate for postmodern concepts of decentered subjectivity that were central to the critical theory that played such an influential role at *October*. The benefit for Krauss is clear; Shklovsky provides a mechanism by which the ongoing movement of the formalist dialectic, prematurely resolved by Greenberg, can be continued indefinitely. Moreover, Shklovsky, in his devotion to a process of perpetual semantic negation, allows her to establish a conceptual bridge between the Russian avant-garde and the "paraliterary" deconstruction of Barthes and Derrida, linking them together as parallel expressions of a common revolutionary ethos.

If Shklovsky's theory provides a way to prolong the dialectic of aesthetic autonomy, by opening art to a whole new range of extra-artistic materials against which it can define itself, it also carries certain risks. Shklovsky was writing during a period of revolutionary upheaval, when advanced art seemed, at least momentarily, to be unifying with revolutionary praxis (the very event that *October* sought to memorialize). As a result, he was not particularly concerned with safeguarding the autonomy of poetry as a placeholder for a revolution yet to be. *October*, however, has demonstrated an ongoing interest in preserving a normative model of aesthetic autonomy, presumably still dependent on the idea that contemporary art retains a displaced, custodial relationship to the revolution after which the journal is named. But this conservatorship requires, in turn, the maintenance of a hermeneutic firewall between the artwork's "internal" and autonomous formal elements and the profane materiality of the external world, which always threatens to co-opt art's unique dissensual power during nonrevolutionary periods. In embracing Shklovsky's expansion of the avant-garde lexicon of reified material beyond Greenberg's immanent formalism (to include various ideological and discursive systems associated with both the institutionalization of art and the broader social world), they threaten to reduce art to a generic form of counterhegemonic critique (something which can be performed with equal efficacy by forms of media activism, cultural studies, etc.).

What is lost here, of course, is the immanent negation that characterized earlier avant-garde movements, whose specific identity as *art* movements was linked to the supersession of a previously credible, but now degraded, artistic form, or to the self-reflexive exploration of ostensibly inherent formal or aesthetic conditions. All that is left to kick off against, in the absence of any immanent aesthetic criteria, are various forms of social or political repression, or in a further refinement of this approach, the institutionally

demarcated space of the art world itself, which functions as a microcosm of this broader, repressive system. But in this case, how do we confidently differentiate contemporary art from a whole range of other cultural practices that also seek to "deconstruct" forms of institutional and discursive domination? In the postmodern, or contemporary, moment how do we determine which norms, conventions, or devices are still sufficiently integral to art itself to *matter* as points of nonidentity or differentiation, without at some point sacrificing the critical autonomy of the artwork itself? This tension is evident in Krauss's own more recent writing. On the one hand, she inveighs against the "meretricious" character of contemporary installation art because it has, ostensibly, sacrificed any dialectical relationship to the art media that inform it, and "wallows" in spurious, nonartistic content.[19] In this view, art can only produce its exemplary form of criticality through a critical engagement with its own, formerly constituent, "technical" modes (in this case, within recognizable art media such as painting and sculpture). On the other hand, Krauss, in *Under Blue Cup*, extends the repertoire of "devices" to be laid bare by art to accommodate elements that are clearly not part of the intrinsic material or formal condition of conventional artworks, including such oddly dissimilar entities as "cars" (for Ed Ruscha) and "photo-journalism" (for Sophie Calle). Here the concept of art as defined via a self-reflexive relationship to a specific set of norms becomes so capacious as to threaten precisely the kind of disordered, nonaesthetic chaos that she finds so "disgusting" in installation art.

The Aesthetics of Deferred Action

The struggle to maintain a logically coherent account of aesthetic autonomy (even as contemporary artistic practices continually push against it) will emerge as an ongoing point of tension in the pages of *October*. In the art of the 1980s and 1990s, this autonomy will be secured in two different ways. In the case of institutional critique practices (Andrea Fraser, Michael Asher, etc.), the artist can be seen as acting out a resistance to something nominally internal to art in the form of the ideological and institutional discourses of the art world itself. And in the case of the "critical" postmodernism famously championed by *October* (Cindy Sherman, Sherrie Levine, Richard Prince, etc.), autonomy is secured by the fact that these works (which engage with extra-artistic ideological formations around gender and identity, as well as art-specific critiques of authorship) are confined to clearly demarcated art exhibition spaces. In each case, the institutional framing is decisive—the fact

that these works were produced and consumed in the context of art museums and commercial art galleries, by audiences which receive the work with all of the evaluative and hermeneutic expectations that this framing implies. The interlocking global network of dealers, critics, collectors, museums, galleries, biennials, investment funds, and public agencies that constitute the contemporary art world plays a central role here as both a constraint (this network always threatens to co-opt or commodify art's critical power) and a potential field of creative resistance.

We find a characteristic expression of this ambivalent relationship in Hal Foster's influential 1994 essay "What's Neo about the Neo-Avant-Garde?" In this essay Foster presents the failure of what he terms the "first" avant-garde (associated with Dada and Constructivism) to help facilitate the destruction of the bourgeois institution of art as the necessary precondition for the emergence of two subsequent "neo-avant-garde" movements, beginning in the late 1950s. Foster identifies the first neo-avant-garde with two related bodies of work. First, he associates it with artworks that reproduced the compositional techniques of the 1920s avant-garde (Rauschenberg's quasi-Dadaistic gestures, monochromatic painting, etc.). Second, he links it with performance-based practices, such as Happenings, staged outside of conventional art spaces, which mimicked the transgressive "melting down" of art-institutional barriers (associated with Constructivism). Foster contends that, in each case, the neo-avant-garde artist sought to invoke the revolutionary ethos of the 1920s by appropriating the rhetoric or formal appearance of the artworks produced in its wake, as if they could conjure a revolutionary moment into existence by simply replicating its affiliated cultural forms. They did so, moreover, without acknowledging the essential legitimating role of the institutional art world in framing and contextualizing these ostensibly radical gestures. Here we can identify the ongoing influence of the discourse of aesthetic autonomy, as Foster's critique hinges on the argument that artists such as Alan Kaprow prematurely desublimated certain affirmative aesthetic elements (nonhierarchical, participatory interaction) that should only be released as part of a genuinely revolutionary movement.

The refusal of the artists associated with the first neo-avant-garde to fully acknowledge the constraints of the institutional art world set the stage for the renewed criticality of a *second* neo-avant-garde, which emerges shortly thereafter. As Foster describes it, the criticality of this second neo-avant-garde is secured by the "deconstructive testing" of the art world itself.[20] Here the failure of the first avant-garde (Dada, etc.) to "destroy the institution of art" is paralleled by the subsequent failure of the first *neo*-avant-garde,

whose effort to recover the traditions of Constructivism or Dadaism during the 1960s merely solidified the ongoing institutionalization of contemporary art. It would be left to a second neo-avant-garde (inaugurated by Daniel Buren, Michael Asher, and Marcel Broodthaers in the late 1960s) to draw the appropriate lessons from the "anarchistic" failure of figures such as Kaprow, who imagined that he could transcend the ideological constraints of the art world simply by operating outside of its physical boundaries. Instead, advanced art must restrict its critical interventions to the institutions of art and to an implicit attack on the hubris and naïveté of the first neo-avant-garde. In this manner, the failure of previous avant-garde movements provided the second neo-avant-garde artist with yet another resistant surface to push off against (thereby deferring yet again art's final reconciliative moment and prolonging its capacity for symbolic negation).

There are clearly two different forms of "failure" at work in Foster's account. The failure of the first avant-garde was the failure of the Bolshevik Revolution to universalize the utopia of Full Communism. The failure of the first neo-avant-garde was simply the failure of any art movement produced in the context of a stable bourgeois culture to forestall co-option by the forces of the market (a criticism that could be equally applied to the works of the second neo-avant-garde). In either case, the result of these two moments of failure was a strategic renegotiation of the boundaries of aesthetic autonomy and a subsequent downgrading of artistic criticality to accommodate the "subtle displacements" and "deconstructive testing" of art-world institutions evident in the work of figures such as Louise Lawler, Silvia Kolbowski, and Christopher Williams during the 1980s.[21] In Foster's analysis, the familiar cycle of revolutionary failure and aesthetic displacement is extended through an additional level of mediation, as the second neo-avant-garde can only negotiate its relationship to the political failure of 1917 indirectly through the subsequent artistic failure of the first neo-avant-garde to reclaim this legacy.

Notwithstanding Foster's analysis, there would seem to be more similarities than differences between the two neo-avant-gardes. In particular, both of these bodies of work are predicated on the underlying assumption that contemporary artistic practice could no longer sustain the kind of reciprocal interaction with processes of political or social transformation that was characteristic of the first avant-garde. And each, in its own way, responds to that absence by developing forms of artistic production that are oriented primarily toward art-world audiences and contexts. By normalizing the institutional art world as the only relevant space within

which avant-garde criticality can be acted out, Foster also naturalizes the art market (the most emblematic feature of art's institutionalized status) as simply another structurally necessary constraint for art to decorously kick off against in elaborating its generative criticality. The rampant commodification of contemporary art may be unfortunate, but it is redeemed by the fact that it allows an "ambitious" art practice to sustain itself (and to produce "new spaces of critical play"). Once artists abandon the naive delusion that they can fundamentally challenge the institutionalization of art and the art market (by aligning themselves with forms of political resistance that might affect a more substantive transformation of the economic system on which the art world depends), or even work meaningfully outside of these institutions, they can devote themselves to devising more realistic and sustainable modes of criticality or negation. The relative criticality of the work of art here and now is of less importance than the autonomous principle of negation that it carries into an uncertain future.

Foster's concept of a "neo" avant-garde represents a significant inflection in the discourse of autonomy as it has evolved since the 1990s. First, it marks a frank admission that advanced art is not simply a placeholder for a revolution yet to be, but that it has also come to depend, for its ongoing survival, on the deferral of the very revolution it ostensibly prefigures. And second, it illustrates an impasse that can be traced back to Krauss's original attempt to move beyond Greenberg, without questioning the underlying discursive system on which Greenberg's formalism was based. As I noted above, the necessary response to revolutionary failure, within the discursive structure of aesthetic autonomy, entails the displacement of a revolutionary consciousness into the personality of the artist and the materiality of the work of art. The capacity for critical negation remains secure in this space precisely because it is encoded in a process of hermeneutic resistance directed against internalized formal or aesthetic norms (which exist in an indirect and highly mediated relationship to the external world). Once we expand the repertoire of oppositional material necessary to define art's criticality to include the totality of the art world, we threaten to weaken art's autonomy and collapse its mediated relationship to the "external" world, which always threatens to subsume it. The art world is far more ambivalently autonomous than the conventions of musical tonality or the formal devices of oil painting. In fact, the institutionalized art world, far from being a protected space, is the key interface between the independent production of art and the degrading world of commerce, publicity, wealth, and privilege against which this autonomous art, ostensibly, contends.

Foster's argument must thus confront the inevitable fact that the second neo-avant-garde is no more able to resist the inexorable forces of institutional co-option than the first neo-avant-garde was. The difference between these two modalities lies in the relative modesty of the second neo avant-garde's critical address. It no longer claims, grandiosely, to break down the barriers between art and life—a strategy that, in Foster's view, reflects a fundamental naïveté about the capacity of art. The primary effect of his recalibrated notion of the avant-garde is to free the artist from the ethical burden of co-option, which assumes that one can actually stand *outside* the co-opting institution in the first place. In Foster's estimation, this position of externality can only lead to the fatal sacrifice of art's critical power to the exigencies of the social world that lies beyond the space of the gallery, as art's desire to align itself with authentic forms of political transformation is, inevitably, disappointed. But how do artworks that decode the conventions of artistic authorship or curatorial ideology represent a "hole in the symbolic order" capable of holding open a promissory space for the world-shattering "structural change" that we associate with revolution? In fact, the simple act of "critiquing" the institutional structures of art, uncoupled from any meaningful attempt to challenge the underlying economic hierarchies on which they are based, is easily enough accommodated by those same institutions. This is evident in the myriad forms of ritualized dissensus that are nurtured in the institutional art world. The artist needs the institution (and specifically, the institution understood as the agent of a coercive, externalized conformity) in order to have something to symbolically rebel against, and the institution needs the artist in order to manifest, in equally symbolic form, the critical self-abnegation that is obligatory for hierarchical, wealth-dominated institutions to retain some legitimacy.

Of course, there is considerable value in this work. I would only question the belief that the institutional art world is any less problematic as a site to develop critique than any other. It would seem self-evident that art institutions as such enjoy no special protection from the mechanisms of political instrumentalization, which can affect gallery-based conceptual interventions just as easily as activist art practices. This instrumentalization may take differing forms in different context, but no institutional site or structure is immune. This level of mutual complicity is not necessarily debilitating, unless your goal is an autonomous art that is defined precisely by its ability to *avoid* the entanglements and compromises that accompany an artistic practice that claims to engage critically with the world beyond the gallery. But, of course, this is the very promise on which *October* was founded and

after which it was named—the ideal of an art practice that could safely preserve, in purified form, a critical intelligence that might yet be reactualized in a moment of revolutionary upheaval that would destroy the hierarchies of wealth and privilege on which the institutional art world itself is founded. Cognizant of this contradiction, Foster, in his "Neo-Avant-Garde" essay, seeks to revise the principle of temporal deferral and revolutionary displacement that is central to the discourse of aesthetic autonomy. In particular, he argues that the neo-avant-garde has effectively detached art from any reciprocal or interdependent relationship to revolution or political change.

Foster develops this argument through a novel psychoanalytic interpretation of the history of the avant-garde.[22] Thus, he identifies the "failure" of the first avant-garde to destroy the institutions of bourgeois art (which is, by extension, the failure of the Russian Revolution to secure the political conditions necessary for this destruction to become universalized) as an initial moment of "trauma," whose symptomatic expression was registered by the subsequent traditions of avant-garde art (the neo-avant-garde) as a "secondary trauma." Consistent with my analysis of the surrogacy of the artist, this argument assumes that the traumatic experience of revolutionary failure in the early twentieth century was transposed to the psyches and imaginations of future avant-garde artists, unborn at the time of the revolution itself. Foster, however, introduces a further modification, which erodes the implicit linkage between the avant-garde as a vessel of revolutionary consciousness and the act of revolution itself. According to Foster, the trauma of the first avant-garde's failure operates through a principle of *Nachträglichkeit* or "deferred action" (associated in the Freudian tradition with a repressed traumatic experience that only manifests itself at a later date). In this analysis, the true criticality (or "full significance") of the first avant-garde was only realized subsequently in the actions of the neo-avant-garde. "Rather than cancel the project of the historical [first] avant-garde," as Foster writes, "might the neo-avant-garde comprehend it for the first time?"[23] In this view, only the neo-avant-garde was able to fully actualize the radical promise that was merely implicit in the first avant-garde. But what is being actualized in the neo-avant-garde? And what promise does it finally realize?

Foster argues that the (second) neo-avant-garde was the first movement to develop a comprehensive critique of art's institutional status, precisely because it was the first movement to understand that the avant-garde itself could be institutionalized. This may well be true, but it entails a crucial elision. The point of an immanent aesthetic criticality (for early Greenberg

and Adorno) was never that it was sufficient in and of itself to redeem art's inevitable complicity with bourgeois domination. This autonomous, internalized criticality was only ever valid if it served as a placeholder for a future revolutionary transformation, or as a mnemonic trace of past moments of revolutionary consciousness that might be reawakened. The single and overriding goal of the first avant-garde's gesture of "institutional critique," whether in Dadaism or Constructivism, was to precipitate the destruction of the bourgeois institution of art, under which creativity and self-expression became the sole province of a privileged class of intellectual producers. Foster, however, wants to extract the gesture of an internalized, art-institutional critique out of the complex historical imbrication of avant-garde art and political resistance during the early twentieth century. In this view, October 1917 was simply the fortuitous historical vehicle for a new form of intra-artistic criticality, whose real significance only became apparent half a century later. Thus, Foster employs the concept of "deferred action" to produce a calculated slippage between political praxis and aesthetic production. In fact, the concept of deferred action is associated with Freud's analysis of the Wolf Man, whose traumatic memory of the primal scene might have been entirely "manufactured." Thus, it is not simply a question of loosening or complicating notions of causality but of calling into question the existence of the "original" trauma itself, which can only ever be "indeterminate" in Freud's account.[24] In this manner, the avant-garde movement, as signifier, is unmoored from its referential source—the Russian Revolution.

With Foster's analysis of the neo-avant-garde, the monadic artwork is now closed off from both a mnemonic relationship to *historical* political praxis (the first avant-garde, now detached from its embeddedness in a revolutionary movement) and a generative or prefigurative relationship to *current* political praxis. The latter is evident in *October*'s long-standing suspicion of socially engaged art produced outside the institutional circuit of the art world, associated most notoriously with the purging of Douglas Crimp from the journal's editorial board in 1990, due to his interest in art associated with AIDS activism.[25] As a result, avant-garde art no longer "moves" (even symbolically) toward some future moment at which theory and practice, or art and politics, will be rejoined in the final utopic synthesis that the Bolshevik Revolution promised but failed to achieve. Nor does it reach out transversally, across existing cultural and political boundaries, to open up new configurations of artistic production attuned to the contemporary moment. Instead, the neo-avant-garde is freed from the burden of both historical validation and existing reality to become a free-floating

source of generic negation that can be directed at virtually any feature of contemporary social or cultural life, so long as this critique is contained by the institutions of the art world. It is defined, as Foster writes, by "a perpetual testing of conventions." Now fully autonomous, the critical energies of the neo-avant-garde can be used to propel art endlessly forward in the absence of the teleological end point toward which the first avant-garde was (fatefully) oriented.[26]

The uncoupling of art and political change (even at the mnemonic or prefigurative level) has significant implications for the validity of the neo-avant-garde paradigm. If the critical power of art is no longer being held in symbolic reserve for some future revolutionary moment, then its only real value lies in the criticality it can induce here and now. Yet precisely this form of actualized criticality is endangered by the multivalent integration of art institutions with existing forms of capitalist domination. As a result, Foster's neo-avant-garde model is based on both a recognition and a disavowal of art's institutional status and the hegemonic economic and political systems on which these institutions depend. On the one hand, the neo-avant-garde requires the existence of conventional art institutions to push off against in order to stage its gesture of critique. But on the other hand, the "conventionality" of the art world, which is produced through its dependence on the market and forms of entrenched economic privilege, cannot be seen as *too* pronounced without acknowledging that these critical interventions are subject to forms of co-option that parallel those imposed on non-art-world-based practices (Beuys's "permanent conference," the activist work documented by Crimp, etc.). As a result, the political imbrication of the art world, its legitimating function relative to the capitalist system as a whole, has to be minimized or diminished. It must be reconstructed as a space of radical experimentation rather than a showroom for a culturally elevated form of conspicuous consumption.

In this manner the art world, and the art market that lies at its center, become both normalized and depoliticized in Foster's account; as inevitable and essential in framing the meaning of art as canvas and paint were for Greenberg. In fact, we often encounter a kind of resigned acceptance of the market among artists and critics associated with *October*. In a 2014 interview, Foster recalls a conversation he had early in his career with artist Barbara Kruger, in which she attempted to allay his concerns about the effect of the art market on the critical mission of avant-garde art. "I was phobic about the market until Barbara Kruger said to me one day, 'There is nothing, not even the lint on your sweater, that's not touched by the market. Get over

it.'"[27] While it is undeniable that the market exercises a pervasive influence on contemporary life, the effect of this observation is to efface the significant distinctions that exist within and across various fields of practice within a market-driven society. The result is to produce a calculated disavowal of the unique forms of complicity that accrue to art practices that seek their primary validation and contextual framing in the institutions of the mainstream art world. Since the contaminating power of the market is, in this view, both pervasive and uniform, there is no reason for us to inquire into the specific effects of commodification on the ostensible criticality of the neo-avant-garde artworks produced in its orbit. But neither is there any reason to assume that the art world is better able to preserve a more substantive form of critique than any other site of cultural production.

Certainly, the constraints of the market, or the larger conjunction of governmental and private sector interests that sustain the international art world, are occasionally acknowledged by *October*'s writers. In fact, we encounter quite robust critiques of the art market among some of the journal's contributors. However, this critique does not extend to the work of the artists who actually exhibit within this circuit, who are regularly valorized in the journal's pages. In this view, as compromised as the institutional art world may be, it is still the only space within which any kind of meaningful critique can be preserved. The same is not true for activist or socially engaged practices that emerged during the 1990s and 2000s, which, in many cases, drew on the alternative aesthetic tradition I have described here.[28] By locating themselves outside conventional museums and galleries, these works as a whole could be accused of abandoning the immanent, resistant "material" against which an authentic avant-garde must define itself. Moreover, they threatened to undermine the central neo-avant-garde contention that it is impossible to sustain a creative and critical art practice beyond the protective enclosure of the institutional art world and in proximity to ongoing forms of social or political resistance. It is inconceivable in this paradigm that artists who work in this manner are engaging with the nature of art practice itself in a meaningful, reflective manner. Like Adorno's protesting students, they can only be seen as acting out an infantile demand for premature desublimation as they "rush" impatiently to realize art's emancipatory potential and instead end by destroying it in its entirety. By the same token, any art practice that chooses to thematize, critically or creatively, the hierarchical status of conventional artistic authorship can only be understood as engaging in the willful destruction of the very concept of the "artist" on behalf of a naive immersion in a "Platonic" collaborative community.[29]

Noncompliant Revolutionary Postconceptualists

Essential to critical thought is an element of exaggeration, of shooting beyond things, of dissociation from the weight of what is factual.

—Theodor Adorno, *Minima Moralia* (1951)

While Foster's framing of the neo-avant-garde relies primarily on psychanalytic sources, Adorno's influence is more overt in the work of his *October* colleague, Benjamin Buchloh. Buchloh retains Adorno's characteristically hyperbolic account of the absolute ideological control exercised by the capitalist culture industry. "We have finally to recognize," he wrote in 2012, "the universal laws of production that have by now permeated every domain of social experience and every fiber of the constitution of the subject."[30] It is axiomatic that this ideological control extends to the working class, which has entirely abandoned its world historical mission. In his writing from the 1980s Buchloh repeatedly invokes Adorno's attack on the "romanticism of blind confidence in the spontaneous power of the proletariat."[31] The only hope for redemption lies, yet again, in the strategic withdrawal of revolutionary consciousness (or an exemplary capacity for critical self-reflexivity, which is its surrogate) into the epistemological mechanisms of contemporary avant-garde art. In his earlier writings Buchloh favored a "demythologizing" approach, evident in a cadre of primarily white, male European artists (Daniel Buren, Marcel Broodthaers, Hans Haacke) who sought to deconstruct the institutional structure of the bourgeois art world. By the late 1990s, the institutional art world had become so irredeemably corrupt, in Buchloh's view, that the act of exposing its spurious "neutrality" could no longer be safely undertaken without the risk of further corruption.[32] As a result, the locus of resistance had to be further displaced, into the consciousness of individual viewers. Here art will model for the viewer a new form of selfhood able to transcend the "systematic destruction of subjectivity" imposed by neoliberal capitalism.[33]

As a result of the monolithic power of the market, this capacity could only be found in a dwindling handful of advanced practitioners, exemplified by Irish artist James Coleman. As referenced above, Coleman employs projected photographs with audio to evoke various social scenarios defined by narrative ambiguity. Coleman's work serves to thematize certain symptomatic tensions within postconceptualist installation art (e.g., the reduction of the viewer to a dehistoricized phenomenological body), while simultaneously staging the necessary disidentity between spectacle and representation, his-

torical past and present moment, and collective and individual subjectivity. Consistent with Adorno's outlook, this work is meant to effect a therapeutic reprogramming of the instrumentalizing bourgeois self. Coleman's work, according to Buchloh, "generates a radical negation of the viewer's restless anticipation of narrative closure," effectively forcing them to abandon proscribed forms of "centered humanist" subjectivity.[34] In this manner, Coleman's work serves to exemplify the critical self-reflexivity that allows avant-garde artworks to function as the "last resistances against the global homogenization generated by spectacle."[35] They serve as fragmentary clues to a future collective emancipation, which can be evoked at the level of allegory but which can never be actualized here and now without "instantly turn[ing] into the most reactionary conviction of nationalism and ethnicism currently played out on the stages of the disintegrated nation-states."[36]

Buchloh's writing on these questions is largely rooted in the conditions of artistic production during the 1990s. We can gain a clearer sense of the ongoing evolution of the neo-avant-garde paradigm in John Roberts's book *Revolutionary Time and the Avant-Garde* (2015). While heavily informed by Adorno, Roberts's analysis of the contemporary avant-garde also exhibits a number of parallels with Foster's concept of a neo-avant-garde. It reflects, as well, a significant rearticulation of the discourse of aesthetic autonomy, which I outlined earlier in this book. The first feature of this discursive system entailed the "incapacity of the masses." We find Roberts reiterating this thesis at several points in his book. As with Adorno, the thesis is justified through a forbidding account of capitalist domination. Thus, according to Roberts, we live in a period of "total control" in which "the effects of class desubjectivization and hypertrophic technological convergence are locked even tighter together [than in the 1990s]." Art itself has barely survived this instrumentalizing onslaught as it struggles to retain its autonomy in "the epoch of its total administration."[37] The masses, for their part, have been subject to a form of ideological regulation that extends to the most basic level as capitalism "invades the body and its neural centers, producing subjects that are compatible with the digital distribution of the sensible."[38] Art, alone, can offer us some hope of breaking through this monolithic field of domination. But any art practice that seeks to critique this totalizing system must begin by refusing to learn from, or communicate with, the public in a reciprocal manner (to "harness" art to "audience requirements" is the way that he describes it). This would entail the necessary subordination of art's critical autonomy because the masses, locked into this system of total control, are only capable of engaging with existing reality when it is reduced to

"predigested themes and expectations."[39] Roberts, again echoing Adorno, insists that in its current state, the general public is capable only of "debased" forms "of communicability or sociability."[40]

While Adorno, especially in his later work, largely focused on art's role as a placeholder for a revolutionary consciousness yet to be, Roberts balances this "promissory" claim with a more detailed analysis of the ways in which art might repair the degraded capacities of existing human selves. In order to effect this transformation, it is necessary for art to avoid any involvement with forms of direct action and to engage, instead, in the "neural re-sculpting" of the masses, thereby awakening them from their ideological stupor and preparing them for eventual activation in revolutionary praxis. For Roberts, this transformation will be effected by "scriptovisual" installation and performance-based art practices (he examines the work of the Art and Language group, Victor Burgin, and the Russian art collective Chto Delat) that "stretch the attentiveness of the spectator in a culture where looking and thinking and experience reduce or expel any connective historical and critical conversation."[41] This "stretching" will occur through the viewer's exposure to contemporary installation art that features complex arrangements of "disparate textual/visual material in an expanded space and through an extended temporal order."[42] As the impaired viewer struggles to impose a "coherent and stable overview" on this sublimely "unmappable" profusion of data, they will eventually achieve a form of attention that "resists [the] distractions of the networked consumer" and facilitates a "judgement of the 'whole work of art' at a glance." It is this judgment—this experience of the work of art as an "open totality"—that exposes the viewer to the revolutionary principle of "nonidentity" safely harbored in the avant-garde work.[43]

This "scriptovisual" orientation is also evident in the projects of Victor Burgin. His early work often took the form of montages, such as *UK-76* (1976), which juxtaposed a photograph of a fatigued female factory worker with a text taken from an Yves St. Laurent advertising campaign. The contrast between these two registers (the banality of quotidian life under capitalism and the glamour world evoked by advertising) was presumably meant to trigger in the viewer a cathartic recognition of the false promises of consumer society and the necessity for systemic change. However, it should be noted here that Roberts's focus is less on the actual objects or physical artworks produced by groups such as Art and Language or artists such as Victor Burgin than on the features of their work that were less accessible to a general audience. This would include the often-abstruse theoretical texts that filled the pages of the eponymous *Art and Language* journal, one of

the group's most widely known manifestations. Thus, Roberts defines the "scriptovisual" as inaugurating "the possibility of a new sociality for art, not on the basis of a program of social intervention, but on the basis of extending the work of reception as a theoretical dialogue. In this the scriptovisual possesses a negating force: it sets out to turn away those who are not willing to engage in the given terms of the theoretical exchange."[44]

Roberts's analysis also conforms to the discourse of aesthetic autonomy in its skepticism regarding existing forms of political practice in what he calls our "Post-Thermidorian" moment, arrested between revolution past and revolution yet to be.[45] This is evident in his reiteration of the familiar vanguardist critique of "spontaneity" and "actionism," which I examined previously. Roberts considers artistic practices that are involved in any way with existing institutional structures (typified for him by "state sponsored eco-plans" or "design projects") as fatally compromised expressions of the neoliberal drive to reduce artists to ineffectual "service providers" (part of capital's "total administration" of art).[46] Even when art bears some correlation with protests or other "political events" (e.g., Occupy Wall Street), it can have "little transformative leverage on the sensible itself," since such practices inevitably "collapse . . . into a spontaneous philosophy of situatedness . . . in which excess is permanently attached to an aestheticized micropolitics of resistance."[47] The "micro" nature of this resistance ensures its inconsequential, easily co-opted nature. We cannot expect to gain any substantive critical insight from "situational" actions, which remain mired in the merely local and pragmatic and fail to provide us with the transfigurative forms of critical consciousness that are only made possible by exposure to advanced art. Moreover, these practices seek to "dissolve representation into pure action," effectively abandoning the mediation necessary to produce a genuine critique.[48]

It is impossible in this view for an artistic practice to generate creative insight into the potential reconstruction of the social or political while also retaining an awareness of art's own compromised status within the institutions of bourgeois power. We might translate this to say, consistent with Adorno, that art *only* produces a meaningful criticality through its internalized, recursive resistance to, or negation of, the reification of art itself, as its proto-revolutionary powers are assimilated and blunted by the institutions of bourgeois art. This form of co-option, as opposed to the co-option that accompanies projects produced outside the institutional art world, actually facilitates (rather than forestalls) a unique form of political transcendence and criticality that is unavailable anywhere else in society. Thus, the initial

negation of art's autonomy (by an instrumentalizing culture industry) is the necessary precondition for art to produce its revolutionary value (and justify its ongoing existence) as bourgeois assimilation is turned against itself. In this process, art retains its critical agency via the catalyzation of an internal reflective operation by which viewers, forced to realize that the ostensible "freedom" of art is illusory, will also come to recognize their own (as yet unacknowledged) enslavement and take action.

The discursive structure of aesthetic autonomy is also evident in the deputizing function that Roberts assigns to the avant-garde. It is, quite literally, the only entity in contemporary society capable of sustaining a meaningful form of critique. As he argues, "It is precisely the refunctioned avant-garde—and the avant-garde alone—that is able to protect autonomy as a social relation."[49] Autonomy as a "social relation" refers to the specific ways in which the avant-garde artwork stages its own exemplary critical distance from the suffocating conformity of hegemonic capitalism. It is, as he writes, the "very site of ideological struggle and critical emergence."[50] By the same token, the artist—in particular, the artist understood as a "non-compliant or revolutionary post-conceptualist"—is viewed as a uniquely privileged vessel of revolutionary consciousness.[51] The artist achieves this status by being "out of joint" with (effectively, autonomous from) the existing order and the current historical moment, standing in explicit opposition to all that is normative and reified in contemporary life (the "dissensual, illicit, [and] heterodox," as Roberts writes, are the unique province of the avant-garde artist).[52] We return here to the concept of art, and the artist, as temporally displaced. Kant spoke of an aesthetic sensus communis as the anticipation of a fully enlightened social order. Hegel saw the artist as the emissary of the unrealized Absolute, while Adorno viewed art as "an advance drawn on a praxis that has not yet begun."[53] Working within this "promissory" temporal economy, Roberts will define the avant-garde as always positioned "in advance of capitalism."[54] In each case, the artist speaks on behalf of a historical moment or social potentiality that has yet to be achieved. At the same time, art is precluded from establishing any reciprocal relationship between this potentiality and the existing social order, due to the "debased" forms of communicability and sociality that are endemic in contemporary society. In order to retain its oracular position in advance of capitalism, the avant-garde must also be temporally displaced from the existing ensemble of social and political structures that prevent the realization of this alternative vision (or which might contribute to its undoing). "There has to be a gap . . . between the time of art's production and reception," as Roberts

claims, "and the actualities of art as a mode of political engagement" in order to preserve the unique "non-identitary" power of the aesthetic.⁵⁵ This gap is also spatial, as the avant-garde can only make contact with the existing social order through the ostensibly protected intermediary institutions of the art world, thereby circumventing art's premature desublimation into praxis.

Where Foster is relatively sanguine about the critical potential of the "institutional art world" as such, Roberts introduces a further subdivision, between the "primary economy" of the institutional art world (defined by sales and commissions) and a "secondary economy," associated with the large number of self-identifying artists who supplement their incomes with other forms of labor.⁵⁶ It is, as he describes it, "that precarious realm of under-monetized and unwaged artistic activity that the majority of artists now operate within."⁵⁷ Here Roberts joins scholars such as Terry Smith in providing a more nuanced account of the complex range of practices developed by artist-run initiatives and cooperatives that are tangential to the dominant institutional art world.⁵⁸ In Roberts's view, the expansion of this "secondary sphere of artistic production" is the natural corollary to the growing domination of the mainstream art world by market interests. It serves, in Roberts's analysis, as a kind of para-institutional space that preserves the emancipatory potential previously associated with the institutional art world more generally, while combining it with a form of economic precarity that has the potential to generate a consciousness among artists of their own incipient "proletarianization."⁵⁹ At the theoretical level, its function is to reproduce the notion of an autonomous sphere of artistic practice that is insulated from the most egregious forms of market exploitation, while also protecting the projects cultivated therein from being "collapsed" into instrumentalized political action or appropriated by the "cultural services industry." In this manner, the art produced within the second economy remains sufficiently proximate to the mainstream art world to retain its locus of critical meaning (it can only produce its critique in the institutional context of the art world more generally), without being contaminated by the vulgar commodification typical of the primary art-world economy.⁶⁰

This proximity is essential because avant-garde art defines its critical agency through the act of challenging the ongoing reification of previous artistic production. Thus, the "out of jointness" of the avant-garde is founded first and foremost on what Roberts terms the "restless, *ever vigilant positioning* of art's critical relationship to its own traditions of intellectual and cultural formation and administration."⁶¹ In this manner the artist's reflective relationship to past artistic practice becomes the prototype for all other

forms of critical *political* insight or resistance. For Roberts, avant-garde art, even in the context of the art world, is only able to generate its full critical power for a brief period during its "initial moment of production." As soon as the work becomes more widely "visible" within the circuits of the "primary" art world, its "critical difference" is effaced. In response, the artist must locate new "non-artistic" material to incorporate into their work in order to produce a revised form of "aesthetic otherness" that is capable of resisting, if only for a moment, the work's inevitable "subsumption" by the "prevailing norms... of the market and intellectual academy." Due to the paradigmatic nature of this aesthetic self-reflexivity, the artist, in the act of retaining a critical awareness of art's cyclical recuperation, also serves as a conduit to the "*universal content* of art in a future post-capitalist world."[62] By calling attention to the process by which art, the singular embodiment of revolutionary hope, is continuously despoiled by bourgeois capitalism, the artist comes to represent not simply him or herself, but rather emerges as the "mediating category" for all possible forms of subjective resistance.[63] As he writes, the "sovereign" artist, as the representative "embodiment of free labor in an alienated world, prefigures a world in which the hierarchical division between productive labor, intellectual labor and manual labor... is dissolved."[64]

In Roberts's account, the avant-garde has come to embody a principle of pure negation or "nonidentity" (he associates it with a whole chain of affiliated terms, such as "non-reconcilability, disaffirmation, distantiation, dissension, subtraction, displacement," etc.).[65] In this manner the "void" of avant-garde art reproduces the mythos of Enlightenment autonomy: a space entirely free of all external determination, allowing for a form of monadic, ex nihilo creation. Roberts's avant-garde is radically autonomous and opposed to all forms of reconstructive insight, temporal continuity, or referentiality. Here again, the perceptual or cultural "rupture" precipitated by avant-garde art serves as a placeholder for forms of actual revolutionary violence. At the same time, the notion that art exists "in advance" of the existing social order implies a generative, imaginary potential that lies beyond the totalizing grip of contemporary capitalism. Roberts's neo-avant-garde preserves this positive, identificatory moment in its linkage to both a "future post-capitalist moment" and to the history of Communist revolution. The act of "keeping faith" with "violence from below" (the necessary metonymic link between the avant-garde and the insurrectional action of the masses) requires a form of semantic and historical reconciliation and referential continuity that violates the avant-garde ethos of "nonidentity." Here, avant-garde criticality is

produced as the artist injects a residual, mnemonic trace of past revolutionary practice into the formal constitution of their work. Thus, the "historical presence" in contemporary avant-garde art of references to the techniques and forms of the early twentieth-century "Soviet and European avant-garde" allows this work to carry with it "the collective memory of the revolutionary Event."[66] It is in this sense that Roberts describes the contemporary avant-garde as "the memory of total revolutionary praxis."[67] The various forms of temporal continuity, prefiguration, and semantic linkage that are disavowed by the avant-garde as an agent of pure negation are resuscitated when the avant-garde is cast as the privileged signifier of a revolutionary consciousness that is manifested in a proximate and accessible historical past, or projected into a utopian future yet to be.

Thus, where Foster reconstructs the avant-garde as the agent of a generic form of cultural critique, with a more or less indiscriminate set of targets, Roberts will insist on the centrality of revolutionary history as a specific referential coordinate for the neo-avant-garde. In fact, Roberts will argue that Foster, in his naturalization of the art market and his abandonment of any semantic correlation between the contemporary neo-avant-garde and past revolution, has effectively depoliticized or "declassed" the avant-garde.[68] Instead, the avant-garde must preserve some hermeneutic linkage not just to "its own (artistic) traditions" but to the "*extra-artistic* conditions of possibility of those traditions" as well.[69] The "extra-artistic conditions" in this case refers to the historico-political forces that framed past moments of revolutionary transformation within which avant-garde art was first incubated (in particular, the reconciliation of art and praxis in the Russian Revolution). According to Roberts, these conditions are referenced as a "memory trace" in the work of figures such as Victor Burgin and groups such as Art and Language or Chto Delat. For Art and Language and Chto Delat, the memory of revolution is preserved in the form of collective modes of production that act as "an allegorical model of workers' self-activity."[70] In fact, "theory" more generally for Roberts is "claimed in the name of working-class struggle and class consciousness."[71]

In each case, these gestures are protected from the risks of co-option and the vicissitudes of "identity" thinking because they operate via a form of allegorical displacement. Thus, the "collaborative, collegiate" nature of Art and Language's work entails no direct interaction with actual members of the working class, but rather evokes an "imagined or remembered . . . working-class (collective) production."[72] Presumably, Roberts is concerned here to avoid what he imagines to be the purely instrumental suturing of art and

praxis that would result from any attempt by the artist to engage with political struggle here and now. Rather, what he has in mind is a metaphysical referential field, defined by the dispersed, inchoate, but still vital "energies" of a revolutionary consciousness that is lodged safely in the past, or projected into an indefinite future. There is no risk here of contamination by "debased forms of communication" (or the "total control" of existing capitalism) because there is no actual interlocutor, whether site, context, or concrete other, to answer back, only a speculative approximation of "total revolutionary praxis" incubated in the consciousness of the Art and Language collective itself. It would be difficult to devise a more explicit restatement of Adorno's central assumption that contemporary art, and theory *as* art, serve as placeholders for a working-class revolutionary consciousness that has yet to come into practical existence.

The final stage of this discursive system is based on the contention that a fully critical knowledge (not just of art but of the entire domain of contemporary political life and its potential transformation) can only be cultivated in the isolated self-consciousness of the individual artist or, in Roberts's account, within the "intra-group" conversations of "revolutionary post-conceptualists" such as Victor Burgin or the members of Art and Language.[73] This insight will subsequently be communicated to the viewer qua "beholder" who comes into contact with the semantically dense aggregations of "semiotic material" produced by these artists, thereby achieving a form of "realized reflexivity."[74] For Roberts, as well as Adorno, avant-garde art can only produce its effects indirectly, through the incremental transformation of individual viewers exposed to various compositional systems ("scriptovisual," performance, and installation-based art for Roberts), which model for the viewer a virtual form of critical self-reflection and therapeutic nonidentity. In each case, this mediated or indirect engagement is necessary because of the overdetermined nature of existing capitalist domination, which makes any genuine political change impossible.

Theory and Praxis 2.0

Roberts will ground his analysis of artistic and political practice in the Hegelian tradition, describing it as a manifestation of the "old problem, in which anarchist impatience in the face of both the fictive and autopoietic demands of art and the gap between the temporality of art praxis and the temporality of political praxis freezes the Absolute."[75] In this view, we must not rush to actualize the ideal social forms that are embodied in art or theory for fear of

either devolving into senseless violence or, in the Marxist tradition, finding that our resistance is all too easily co-opted. Rather, we must delay the (Commune-like) premature desublimation of these ideals, slowly fortifying our capacity for self-discipline, criticality, and "realized reflexivity," until the transformative neural resculpting of the masses has been completed. This accounts for the frequent warnings in Roberts's book regarding the dangers of artistic practices that violate the segregation of autonomous art from political or social action. Here art is accused of "escaping its autonomous condition," "inserting itself *directly* into everyday life," "dissolving itself into everyday life," or "short circuiting the gap" between artistic and political practice.[76] Rather than exhibiting a promiscuous openness to the world, art must "protect its borders of non-compliance and autonomy" from dissolution into the complicit banality of everyday life or the mercenary instrumentality of political praxis.[77] The artist can, and must, open art up to the incorporation of new, "nonartistic" material, but the profane "external" world can make no demands on art in return. Any concession to the imperatives of the nonartistic world will result in the destruction of art itself and, along with it, the slender flame of revolutionary hope that it alone can sustain.

Roberts's model of contemporary society, in which human consciousness is entirely dominated by a process of "hypertrophic technological control," imagines everyday life as a space that is cognitively barren and bereft of creative or transformative potential. The corollary to this belief involves a concept of "political practice" as a realm of purely utilitarian action entailing the routinized application of a set of generative conceptual insights that originate in revolutionary theory. The theory/praxis division is especially crucial for Roberts's analysis. Following Adorno, he sees theoretical and artistic production as intimately linked. Roberts's concept of the neo-avant-garde is, in fact, predicated on the idea that advanced art has taken on a theory-like conceptual orientation.[78] The key role played by theory in Roberts's model of the avant-garde accounts for the unique privilege he assigns to conceptual and postconceptual art practices, which have abandoned any residual, romantic attachment to "painterly sensuousness."[79] This is evident in what he terms the "radical appropriation" of analytic philosophy by Art and Language and the scriptovisual paradigm employed by Victor Burgin. Instead of allowing itself to be weighed down by the recalcitrant materiality of the physical world, avant-garde art must be reinvented as an "eventual process" that operates on a more purely cognitive level. Here art becomes more and more theory-like the further it moves away from embodiment, sensory experience, and the "messy actuality" of praxis and the material world.[80]

Praxis, in Roberts's account, is entirely consumed with the tactical problem of how to produce a "coherent and enforceable position" or a "common space" necessary for the "winning of the general will" to the revolutionary cause.[81] All of these processes require the use of implicitly compromised forms of collective identity as the theoretical Communist seeks to anneal the masses into a coherent, fighting front. As a result, praxis, according to Roberts, can only ever "close down multiple creative options," while avant-garde art is the very quintessence of unconstrained, transfigurative creativity: able to disrupt the "stable" forms of "identification" necessary to produce a "general will" in the first place.[82] In this sense, as well, avant-garde art exists "in advance of class struggle," as Roberts writes. Its function is to preserve the ethos of a future, postrevolutionary moment of collective sociality (symbolized by small cadres of "non-compliant revolutionary conceptualists") that would transcend the ontological limitations of the "coherent" and "common" forms of being necessary to bring this utopian moment into practical existence.[83]

It is fitting that Roberts's penultimate example of contemporary avant-garde practice is the Russian collective, Chto Delat (their name is taken from Lenin's book *What Is to Be Done?*). Given Roberts's insistence that an authentic avant-garde art practice must carry a "memory trace" of revolutionary history, the appeal of Chto Delat is understandable. Formed in St. Petersburg, the epicenter of the 1917 revolution, many of their projects refer to aspects of revolutionary history. In addition, they identify the production of "theory" as a central feature of their artistic output, evident in their creation of a "theoretical newspaper" (*Newspaper of the Engaged Platform*). Moreover, they enthusiastically identify themselves with the traditional avant-garde mission of "question[ing] and destabilize[ing] all existing forms of meaning," including "the very notion of the social, cultural and artistic."[84] Typical projects include the creative reinterpretation of a Brechtian "teaching play" (Brecht's *Lesson on Consent* becomes *Lesson on Dis-Consent*) and a performance in which sandwich board workers were employed to carry boards containing passages from a Brecht poem. The performance ended with the workers reciting each section out loud—a gesture that was intended to register the "depleted pathos of the revolutionary past . . . that new forms of protest aspire to negate," according to Chto Delat.[85]

For Roberts, Chto Delat epitomizes the critical potential of the contemporary avant-garde. In particular, he identifies the group's refusal to develop projects in "alliance with the new cultural services industry" as an "exemplary" expression of their "commitment to the social relation of autonomy

in art."[86] At the same time, he applauds the group for its courageous stand "against the instrumental-activist shift" in contemporary art.[87] However, while the members of Chto Delat may avoid the co-optive snares of the cultural services industry or the "instrumentality of political struggle," they are clearly well integrated into the circuits of the international art world.[88] Their work is held in the permanent collections of the Museum of Modern Art in New York, the Van Abbemuseum in Eindhoven, the Reina Sophia in Madrid, the Centre Pompidou in Paris, and several other internationally renowned museums. Moreover, their projects have been commissioned or curated by the Tate Liverpool, the London Institute of Contemporary Art, and the New Museum in New York, among many others. I do not mention this institutional endorsement because I believe that art-world success invalidates their work, but it does call into question Roberts's contention that Chto Delat has been consigned to a semi-precarious position on the "margins" of the mainstream art world. Is the complicity or compromise entailed in working with the "cultural services industry" (or, for that matter, with specific sites of political activism) of an entirely different order than the complicity entailed in working in conjunction with major art museums or biennals? And what of their willingness, precisely in their capacity *as institutions*, to exploit workers or collaborate with repressive governments (of which the Guggenheim's new museum project in Abu Dhabi is only the most recent example)?

This accounts for a symptomatic tension in Roberts's analysis around his claim that neo-avant-garde artworks produced within the "second economy" have "little or no relationship to the primary economy of art: salerooms, auction houses, museums and large public galleries."[89] As I will discuss in chapter 6, there is clearly a reciprocal interdependence between the forms of real and symbolic capital that circulate within the "primary economy" of the art market and the operations of museums, biennials, and other art-world institutions that are not directly engaged in the buying and selling of artworks. We can identify a second point of tension as well. Thus, while Roberts acknowledges that "second economy" artists might "occasionally show in major public galleries and museums," he insists that "their work and the works' relationships to the social world is not *governed* by this relationship."[90] But how do we reconcile this claim with Roberts's contention that the criticality of this work is produced precisely through its "ever vigilant" foregrounding of the limitations of previous artistic practices (limitations whose existence is only relevant to audiences associated with the mainstream art world)? Even if specific neo-avant-garde works are not "governed" by

the process of direct commodification, they still depend for their meaning on a hermeneutic frame that is determined by art-world norms and values. Further, as the example of Chto Delat suggests, it is not always so easy to identify clear boundaries between the protected sphere of autonomous artistic production Roberts associates with the "second economy" and the surrounding art world. Artists who operate in the second economy are regularly drafted into the mainstream art world. Moreover, while Victor Burgin, to cite another of Roberts's examples, may have never experienced the level of commercial success typical of a figure like Jeff Koons, he still enjoyed a lengthy (and nonprecarious) career as a well-compensated academic, further complicating the model of capitalist commodification on which the concept of a "second economy" depends.[91]

The relative permeability of Roberts's "second economy"—its openness to other domains of culture, art, and institutional power—is evident in many of the projects that he discusses. The situation of Chto Delat is instructive in this regard. In the 2017 iteration of Toronto's "Nuit Blanche," a nightlong cultural festival held during the fall and sponsored by Tourism Toronto, the Toronto Real Estate Board, and the "fast fashion" retailer H&M, among others, Chto Delat presented an "immersive installation" that reflected on the "history and future of revolution." Nuit Blanche, which, according to its website, "attracted an estimated attendance of more than one million people . . . and generated an economic impact of $43 million for Toronto" in 2016, epitomizes the "cultural services industry" that Roberts disdains. While the festival was founded with the goal of exposing a broader public to artists operating outside the cultural mainstream, it is still dependent on a neoliberal paradigm of the "Creative City" that has been widely criticized.[92] To complicate matters further, Chto Delat developed their Nuit Blanche project (*Monument to the Century of Revolutions*) in collaboration with local "artist activist groups touching on issues that address Indigenous peoples, migrant workers, sex workers rights, queer activism, and to revolutions dedicated to the African diaspora."[93] This engagement is consistent with Chto Delat's work in Russia, where they are involved in collaborations with activist groups, including "unions of IT workers" and "educational workers," with the goal of "building a new, engaged public."[94] Of course, by opening their practice to these collaborators, they risk reducing it to a form of "instrumental-activist" art production. Both of these affiliations (their coordination of an activist campaign in Russia and their participation in events such as Nuit Blanche) would seem to disqualify Chto Delat from consideration as an authentic manifestation of avant-garde criticality under

the terms that Roberts proposes. None of this is to invalidate the significance of Chto Delat's work, only to question the absolutist theoretical framing through which Roberts seeks to contextualize it.

For me, the analytic limitations of the avant-garde paradigm of aesthetic autonomy stem from the desire to project onto artistic practices that are, inevitably, constrained by a complex field of social, cultural, and ideological determinants, a kind of aspirational, but ultimately unrealistic, purity. How do we decipher the complex modes of both resistance and ideological manipulation that emerge in contemporary artistic production (socially engaged or otherwise)? I would suggest that it requires a situational analysis of both the immanent forms of power operating at a given site of practice and the artist's strategic, creative, and improvisational response to them. However, the avant-garde discourse of autonomy, with its opposition between a space of pure, critical reflection unconstrained by the forces of cultural or political instrumentalization, and a surrounding realm of habituated "compliance," can foreclose precisely this kind of analysis. If we assume, as Adorno does, that the world as such is beyond redemption, then the failure to fully comprehend the "factual" nature of that world is of little consequence. But if we imagine, as many contemporary artists do, that the potential for meaningful change is not entirely exhausted, then the refusal to explore the materially specific conditions that define both resistance and complicity today is disabling.

Roberts's concept of a second economy is quite useful in capturing the multivalent exchanges that occur in contemporary art, as it traverses a range of institutional and political contexts, constituencies, and discourses. I would contend, however, that it is better understood as a space of exchange and interaction with its own unique constraints, rather than as a sequestered realm that is immune to the co-optive pressures that accrue to other forms of cultural production. For Roberts, of course, the co-option or impurity of neo-avant-garde practice is the necessary precondition for its renewed criticality. But his analysis also depends on the assumption that the particular form of reification imposed on art by the capitalist system is of an altogether different order than the forms of reification that it imposes on other modes of creative production. In this view, while the art world may not be entirely pure, it is less "impure" than any other domain of culture. In addition, Roberts assumes that art's self-reflexive awareness of its own ongoing instrumentalization possesses an exemplary critical value that can serve as a catalytic agent for all other modes of knowledge—or, put another way, that the act of attacking the institutional reification of art specifically carries

some compelling suasive power that could actually sustain a broader revolutionary vision necessary to eventually overthrow the capitalist system. Finally, he assumes that only neo-avant-garde art is capable of maintaining a meaningful level of self-reflexive criticality about its own instrumentalization, while all other forms of knowledge production or sociopolitical praxis are effectively incapable of this self-reflexive insight.

Roberts has very good reasons for remaining suspicious of the ways in which well-intentioned art projects can be appropriated by various state agencies and private institutions. But, as I have suggested, this applies just as much to art galleries and auction houses as it does to the cultural services industries that commission depoliticized participatory art projects, or to the universities that employ "revolutionary conceptualists" such as Victor Burgin. I am not convinced that any one of these sites is intrinsically less complicit, or more critical, than any other (even if the political stakes will vary in each context). At the same time, contemporary artistic practices often circulate within and through all of these sites (as the work of Chto Delat demonstrates). Capitalism is endlessly inventive in extracting value from even the most ostensibly recalcitrant forms of artistic and cultural production, and the exculpatory critique can apply just as easily to artists working with nongovernmental organizations, the "spontaneous interruptions" of Zucotti Park, or the vast exhibition spaces of the Arsenale. The problem for me lies in assuming that the art world, or, in Roberts's case, the art world's adjunctal "second economy," embodies the only space of authentically critical thought currently available to us. This is the epistemological zero-sum game of avant-garde autonomy—the belief that the avant-garde, and the avant-garde "alone," as Roberts writes, is the only engine of authentic "non-compliant" critical insight. As Guy Debord wrote in a letter to sociologist Robert Estivals in 1963, "If [art] really is an avant-garde, it carries in itself the victory *of its criteria of judgement* against the era . . . because the avant-garde exactly represents this era from the point of view of the history that will follow it."[95] Here the avant-garde becomes the quintessential transcendent signifier, the only term not subject to the criteria by which it measures the success or failure of all other systems of thought. In this manner the principle of bourgeois sovereignty, independent from all external determination, is implanted in the persona of the avant-garde artist. It is the tactical recognition and disavowal entailed in the assumption that *this* form of complicity (of art, the artist, and the art world that they inhabit) is uniquely insulated from the full weight of capitalist instrumentality and uniquely open to forms of criticality that are literally

impossible to produce anywhere else in society that is most symptomatic of the avant-garde paradigm.

While I may disagree with aspects of Roberts's analysis, it is hard to imagine a more perspicacious defense of the work of groups and artists such as Chto Delat, Art and Language, and Victor Burgin than the one he provides in *Revolutionary Time*. His book makes a valuable contribution to the ongoing debate over aesthetic autonomy. It also demonstrates the remarkable level of influence that Adorno's concept of the aesthetic, and his particular understanding of the nature of political change, continues to exercise on contemporary art theory more generally.[96] Adorno's enduring appeal is very much understandable. In the face of what appears to be a perennially adaptive capitalist system, and the apparent extinguishing of any coherent opposition to it, he holds out the hope that art can embody a principle of stubborn refusal, and preserve, at least in germinal form, the promise of its eventual overturning. Moreover, one can hardly argue with the contention, fueled by Adorno's profound suspicion of the relentless appropriative powers of the market, that a great deal of contemporary art is openly complicit with forms of economic and institutional domination. And finally, Adorno's skepticism about the viability of a revolutionary consciousness among the broader public is reaffirmed in our own day by the troubling success of neo-nationalist and neo-fascist political movements across Europe and the United States.

At the same time, it is necessary to be explicit about what Roberts is proposing; that a handful of "revolutionary conceptualists" (represented by Victor Burgin, Art and Language, and the Chto Delat collective), by virtue of their self-declaration as artists, and their possession of some historical knowledge of the Soviet avant-garde, have taken possession of an esoteric form of revolutionary truth that is literally unavailable anywhere else in our culture today. Moreover, he contends that they retain their singular possession of this truth precisely by refusing to participate in any concrete forms of political or social resistance through which its value might be tested, challenged, clarified, or elaborated. Rather, they possess this truth precisely *because* of their deliberate disengagement from the practical or creative mechanisms of political transformation as they exist in the current historical moment. Instead, they produce their unique revolutionary insight through a reflexive critique of art's own ongoing institutional appropriation as it flashes up in brief moments of authentic negation before being quickly renormalized. This represents, in condensed form, the belief system that underlies the avant-garde model of aesthetic autonomy: that revolutionary truth must remain separate from any political practice, and

that this truth can only be produced, and sustained, in the consciousness of individual artists. In chapter 6, I will examine a concrete expression of this discursive system in the work of Thomas Hirschhorn. In his *Gramsci Monument* (2013), Hirschhorn will exemplify the process by which the discursive structure of aesthetic autonomy is both challenged and reproduced in contemporary neo-avant-garde art practice.

6

THE HIRSCHHORN MONUMENT
AUTONOMY AS BRAND AND ALIBI

Outsourcing Authenticity

"Autonomy" does not mean self-sufficiency or self-enclosure, "autonomy" is something which stands up by itself, which is sovereign and proud.
—Thomas Hirschhorn in Rosa Birell, "The Headless Artist: An Interview with Thomas Hirschhorn" (2009)

Notwithstanding a series of important shifts that occurred as the discourse of aesthetic autonomy evolved over time (coincident with the rise of the avant-garde/vanguard matrix), the core values that it conveys regarding the status of art, political change, and critical consciousness have remained remarkably consistent. While John Roberts offers one of the most theoretically ambitious rearticulations of these values, they are evident across a range of contemporary artistic, critical, and curatorial practices. Although this situation has begun to change over the past few years, the mainstream art world remains skeptical of any attempt to dissolve the perceived boundaries

between art (or the "aesthetic") and an impure external space, variously defined as the realm of "daily life," "the social," "the political," "ethics," and so on.[1] This is the case even as artistic practices since the 1990s have increasingly challenged many of the conventional mechanisms of spatial displacement and temporal deferral on which this discursive structure depends. While Roberts is critical of Foster's tendency to sunder what he views as the essential referential linkage between the neo-avant-garde and past revolutionary events, he nonetheless shares the belief that the art world as such is the primary space in which authentic critical meaning can be generated. In this view, any effort to work outside its institutional boundaries is futile precisely because there is no relevant audience beyond the art world that is prepared to receive the truth that art alone can provide. As he contends, socially engaged art practice, "for all its refusal to define itself as art (or solely as art), is always invariably being recalled to the 'art world,' so to speak, in order to make its meanings visible."[2] But visible to whom, one might ask? This is the question that was being raised by a growing number of artists and art collectives during the 1990s and 2000s, many of whom remained unconvinced that the institutional art world (even in its "second economy" guise) provided the only legitimate interlocutor for their work.

From this perspective we can understand the move outside the institutional art world not as the expression of an impetuous drive toward premature desublimation, but rather as an attempt to reclaim the creative and critical agency implicit in the act of defining the very nature of that "world" and, with it, the conventions of aesthetic autonomy on which it depends. In this respect I would contend that many of these new art practices mark an exit not from *art* but from the specific forms taken by art within the institutional art world. It is during this period that we begin to observe a growing bifurcation between engaged art practices that have some direct involvement with mechanisms of social and political resistance (e.g., the range of new activist art practices developed in Latin America during the "Pink Tide" period or recent struggles for social justice) and a more visible genre of "relational" or "social" art practice that remained largely integrated with, and responsive to, the discursive protocols and economic subsystems of the art world while periodically locating itself in non-art-world contexts.[3] The decision to stage art projects in spaces outside the museums, galleries, and biennials of the mainstream art world marks a key shift in the evolving discourse of institutional critique practice. By the early 2000s it had become increasingly clear that the "critique" implied by institutional critique was easily enough assimilated by the art-world spaces that were its ostensible target. As a result, the

notion of the institutional art world as the only antagonist against which a neo-avant-garde art practice could define itself was eclipsed by a new strategy in which the artist retained an essential financial grounding in the art world, while outsourcing (at least occasionally) the most visible components of their artistic production to non-art-world sites.

In this manner, artistic practice could still express a nominal critique of the institutional art world by withdrawing from its physical boundaries, even as it remained tightly bound to that world through its economic dependence on the market, as well as its primary orientation toward art-world viewers and audiences. Thus, the transition to a "social" or "relational" art paradigm entailed a two-pronged strategy in which the artist maintains a direct linkage with commercial galleries through the sale of more discrete forms of documentation and ephemera, while at the same time seeking out biennial and foundation commissions to develop highly publicized, site-specific projects, often in contexts intended to foreground racial and class difference. The result was a symbiotic relationship between the artist, the curatorial and economic apparatus of the biennial and art festival circuit, private foundations, and the art market (each of which had its own, often problematic, interest in the signifiers of social authenticity that were made available by artistic projects developed in poor and working-class communities). These commissions allowed the foundations and agencies charged with administering biennials and art festivals to appear to challenge the explicit economic privilege of the art world by supporting projects that evoke a hazily egalitarian engagement with the broader social world, without the risks that would be posed by extended involvement with, or answerability to, the complex political and economic dynamics that are present in these sites. They did so, moreover, in a manner that appeared to eschew the overt commodification of the art market. Given the persistence of the exculpatory critique this strategy was not without some risk. If one moves too fully into the "social," one risks having their work associated with cultural practices (community art, activism, social work, etc.) that are seen as abject in an art-world context and which carry no market value. At the same time, especially in the post-Occupy and post–Arab Spring moment, it became increasingly common for artists to demonstrate some nominal independence from the class privilege of the market-driven art world. The result was a complex process of ideological triangulation necessary to maintain the critical legitimacy of a given body of work (keeping art relevant in a period of political upheaval), while at the same time forestalling the strictures of the exculpatory critique. It is a negotiation that tells us a great deal about the

durability and adaptability of the discourse of aesthetic autonomy, as well as its inevitable limitations.

As I have already suggested, the work of Swiss artist Thomas Hirschhorn is exemplary in this regard.[4] Hirschhorn began his career as a graphic artist. During the 1980s, he worked briefly with the Grapus collective in Paris, which sought to integrate artistic production with political action by developing graphic works for protests and demonstrations. Grapus emerged in the wake of the May 1968 uprising and sought to extend the traditions of street art and graffiti associated with the occupation of the École des Beaux-Arts by students and teachers at that time. These are, of course, precisely the instrumentalized forms of activist culture that Adorno would disparage in his later writings. After working with the Grapus collective, Hirschhorn grew frustrated with the constraints of a practice that required him to subordinate his creative autonomy to any external demand, even if the "client" was a political or social movement. "I wanted to be free," as he observed in a subsequent interview, "I wanted to be the sole author of my work." The only other possible option, to be "the servant of someone else," was intolerable to him.[5] Not surprisingly, Hirschhorn soon gravitated to the contemporary art world, where his unbending commitment to authorial sovereignty would not only be accepted but valorized. In this sense, Hirschhorn's oeuvre perfectly reflects the tensions between the two paradigms I have examined here: a dominant tradition of avant-garde autonomy based on the artist's unconstrained subjective freedom and a subterranean tradition, evident in anticolonial resistance, collective art practices during the 1920s and 1930s, and the social movements of the 1960s, in which the autonomy of the artist and the artwork undergo a creative renegotiation. It is, as I noted, this alternative tradition that emerged once again in new forms of socially engaged art during the 1990s, and it was in opposition to this work that Hirschhorn increasingly came to define his own practice.

Since the early 2000s, Hirschhorn has been associated with a genre of public projects ("Monuments," as well as smaller scale "Kiosks" and "Altars") that are named after specific philosophers, writers, or theorists about whom the artist professes some fascination (he describes himself as a "fan" of philosophy, rather than a knowledgeable interlocutor, reflecting a self-conscious intellectual de-skilling). These are sponsored by prestigious art and civic institutions but often sited in poor and working-class neighborhoods. Thus, the *Deleuze Monument* in 2000 was commissioned as part of Avignon's *La Beauté* exhibition (linked with the designation of Avignon as a UNESCO World Heritage Site) but located in the Cité Champfleury, a "poor

housing estate" outside the city's walls. His *Bataille Monument* of 2002 was funded by documenta but staged in a housing estate in Nordstadt, a "socially deprived area" of Kassel. And the *Spinoza Monument* (2012) was commissioned as part of an international sculpture exhibition but staged in Amsterdam's red-light district.[6] Hirschhorn's Monuments are temporary constructions, often fabricated from "precarious" materials such as plywood, tarps, cardboard, packing tape, and so on. They typically include internet cafes, media centers, workshops, and classes designed primarily to draw in local children. These service-based components are combined with public programming that features various intellectuals talking about the work of the thinker whose ideas inform each configuration of the Monuments series.

Hirschhorn's art-world persona is based primarily on his self-presentation as a "Worker-Soldier artist" who boldly challenges received wisdom and "cautious relativism" with utopic, Beuysian pronouncements ("art is universal!") and public projects that claim to open the typically cloistered experience of contemporary art to a "non-exclusive audience" (coded as poor and working-class people of color in most of his Monument projects).[7] "My work," he argues, "allows itself to fight against the culture of powerlessness, weakness, depression and good conscience."[8] Moreover, Hirschhorn proposes a metaphoric equivalence between the impoverished materials he employs and the "non-exclusive" viewers he is engaging with his work: "I do not want to intimidate nor to exclude by working with precious, selected, valued, specific art materials. I want to include the public with and through my work, and the materials I am working with are tools to include and not to exclude."[9] At the same time that Hirschhorn presents his use of quotidian materials as a "political choice," he also maintains a highly lucrative commodity-based practice, with his works circulating widely through the global art market.[10] Notably, these works are often composed of the same self-consciously degraded materials that he uses for his Altars, Kiosks, and Monuments (plastic, cardboard, etc.). However, even the most mundane of these constructions are carefully signed and numbered in limited editions. A few typical examples will suffice to suggest the range of this work: a handmade lighter in an edition of fifty (composed of cardboard, foil, plastic, and tape) from his *Musée Précaire Albinet* project was valued by Sotheby's at $15,000–$20,000 in 2016, while an orange armband (cardboard, red paper, and cellophane) inscribed with the phrase "Energy Yes, Quality No!" and helpfully numbered in an edition of two was valued by Sotheby's at more than $10,000. This does not include the myriad of more complex photo collages, nail and wire constructions, wall and floor sculptures, and so on

that Hirschhorn produces and sells through his various international dealers for far higher sums. This is, of course, the characteristic alchemy of the art market, which can turn impoverished materials and crudely fabricated objects ("Quality No!") into valuable artworks worth tens of thousands of dollars, precisely because they are referentially linked with the authoring personality of a famous artist.

This suggests one of the central tactical shifts that occurred in the post-institutional critique moment, as the art market itself was effectively depoliticized. Hirschhorn, for his part, is adamant that he has no interest in institutional critique, and even claims to be unaware of the key artists associated with it.[11] He has also sought, like Foster, to normalize the art market as an essential, if not benign, aspect of contemporary artistic practice. In a 2008 essay, "Doing Art Politically: What Does This Mean?," this occurs through a symptomatic inversion of Jean-Luc Godard's famous distinction between making "political films" and "making films politically."[12] Godard, of course, was referring to forms of cinema that sought to operate outside the dominant commercial film market and instead were circulated through alternative networks associated with activist groups and university film societies. Hirschhorn appropriates Godard's distinction in order to differentiate his work from what he views as the abject tradition of "activist" art practice, which seeks to operate beyond the mainstream art market. As he writes: "Doing art politically does not mean working for or against the market. The question is much more about understanding the market as part of the artist's reality and about working in this reality."[13] He concludes by arguing that "only through autonomy and independence can art maintain itself beyond the laws of the market. Only a direct and affirmed confrontation with the reality of the market... makes it possible to resist and go beyond the market pressure and as an artist, I cannot become dependent." By this logic, it is only by acceding to the demands of the art market and by producing works that will effectively sustain a system of commodity production predicated on the taste patterns of wealthy collectors that Hirschhorn can ensure his own "autonomy" and independence.

As I noted, Hirschhorn frames his compositional reliance on packing tape, mailing tubes, silver paper, photocopies, and so on as a bold rejection of "arty" high-quality materials, and as an explicit invitation to nonexclusive viewers who, he imagines, would be less "intimidated" by "materials that are in everyday use."[14] It is instructive to compare this interpretation with the analysis of Hirschhorn's formal methodology by sympathetic critics. Roberts focuses specifically on the art-world reception of Hirschhorn's

work, arguing that his use of "non-artistic" materials produces an "emaciated spectator." In this interpretation, Hirschhorn's ramshackle aesthetic deprives the art-world viewer of the (false) reconciliation provided by the beautiful, well-crafted object, thereby revealing the "poverty" of the public sphere in which he locates his work.[15] Foster, echoing Hirschhorn, describes a kind of syntagmatic relationship between the artist's use of "precarious" physical materials and the degraded living conditions of the "precariat" in whose communities he locates his work.[16] In this manner Hirschhorn's crude materials, rather than marking an opening to "non-exclusive" viewers who might otherwise be "intimidated" by fine art, become signifiers of the poverty of their own lives, intelligible only to the exclusive audience of the art world.

The effect of these formal choices, according to Foster, is to question the manner in which capitalism's "perilous and privative effects" are produced and, by extension, to "implicate the authority that imposes this revocable tolerance."[17] Foster extends this series of transpositions (impoverished materials in art represent the impoverished existence of the working class) by identifying Hirschhorn himself as a surrogate for the immiserated working-class subject. Thus, in his art practice Hirschhorn "crosses over into the precarious," acting out "his own state of emergency" through an "actual sharing in the conditions of social risk lived by a precariat in a particular situation." "To this end," Foster argues, "Hirschhorn sometimes takes up the guise of the squatter."[18] Hirschhorn corroborates this equivalence, writing, "I have to risk myself, that is the beauty in precariousness," thus drawing an implicit parallel between the labor involved in developing his public art commissions and the "risk" of unemployment, poverty, homelessness, and hunger suffered by the actual members of the precariat.[19] The problematic network of projections, transpositions, and elisions evident in Hirschhorn's relationship to precarity is consistent with the discourse of aesthetic autonomy and the notion of the artist as deputy that I outlined earlier.

The appeal of Hirschhorn's work for critics such as Roberts and Foster is clear. By providing them with a distinctive formal apparatus to interpret (spatially overloaded installations, a deliberate disregard for conventional compositional purity, the use of symbolic, arte povera–type materials), he can be seen as maintaining the necessary mediatory distance between art and the "social." In this manner, the key locus of critical and semantic meaning in his work is effectively separated from his interactions with the "non-exclusive" class or race of others who inhabit his projects. Rather, these encounters are always refracted, and made significant, through a displaced formal language in which cardboard mailing tubes and plastic tarps serve as

aestheticized signifiers of what Benjamin Buchloh terms the "most abject everyday" environment of "low-income housing projects."[20] This is a language, as I noted, that is primarily intelligible *as critique* to the "exclusive" audience of the art world itself. Bits of cardboard and unfinished plywood thus mirror the precarious material existence of the poor people into whose lives and communities Hirschhorn's work is inserted. The result is a hermeneutic and economic relay in which cardboard serves as a site of unilinear exchange between the "social" realm of lived poverty (the sphere of "total alienation and reification" in Buchloh's words) and the institutional art market, into which Hirschhorn's precarious objects are destined to pass.[21] On one side of this relay, crude cardboard and packing-tape constructions signify the impoverished living conditions of the poor, and on the other side they are linked referentially to the authoring personality of the artist, whose creative autonomy justifies their heightened economic value.

Art Undamaged by Praxis

Buchloh: One might still misunderstand you and argue that you benevolently overlook the actual conditions of total alienation and reification that govern the everyday life of the Turkish working class in Germany.... What do you say to such critics?
Hirschhorn: Nothing is impossible with art. Nothing.
—Benjamin H. D. Buchloh, "An Interview with Thomas Hirschhorn" (2005)

Hirschhorn is, of course, fully cognizant of the manifold ethical and creative dilemmas that are raised by the gesture of a white, male European artist, operating at the highest levels of institutional and economic privilege, working in impoverished communities, and selling artifacts intended to embody that impoverishment for obscene amounts of money. Thus, a central feature of his artistic practice has entailed a carefully calibrated process of discursive self-fashioning (of his own work and of his personality as an artist) intended to "wrest interpretive power from critics and art historians" (he dismisses art criticism in general as "skeptical" and "negative").[22] We might say, in fact, that the most symptomatic aspect of Hirschhorn's work entails his own highly self-conscious staging of himself *as* an artist through numerous interviews, manifestos, personal statements, and other written materials in which he attempts to frame the critical relevance of his own work. One of the chief goals of this process has been to preemptively immunize his work from various forms of critique. In particular, Hirschhorn is concerned to overcome the provisions of the exculpatory critique. With the emergence of

new forms of socially engaged and community-based art during the 1990s, the exculpatory critique, rearticulated by Adorno during the 1960s, takes on a renewed significance. As I have argued, these forms of art emerge in the writing of a number of critics as one of the primary foils against which an authentic neo-avant-garde art practice must differentiate itself.[23] This critique unfolded along two axes. First was the contention that art practices that engage with forms of political or social resistance will inevitably be instrumentalized or subjected to stultifying forms of consensus. The second line of critique reiterated Adorno's contention that social or political action, by producing some positive transformation at the situational level, merely served to legitimate the broader system of capitalist oppression by demonstrating that progressive change is possible here and now, without "total revolution." While these criticisms were certainly apropos in many cases (there are plenty of problematic activist and community-based practices in the world), they also tended to be applied in an indiscriminate manner to virtually any artistic project developed through some form of collaborative production, or which was involved in processes of social change or political resistance.

For this reason, Hirschhorn's work, in its reliance on specific forms of social organization that are common in the field of community art (workshops, collectively produced newspapers, free libraries, classes for children, etc.), is especially vulnerable to this critique. Moreover, Hirschhorn's own statements about the nature of his work evoke precisely the jubilant, prefigurative qualities that Adorno associated with the premature desublimation of art's utopic power: "I speak of the *Gramsci Monument* as a paradise where members of this community—without understanding, without knowing each other, both together and alone—share the space of their lives, their happiness, and their failures, thereby creating and exploring new forms of living, new forms of thinking and another form of reality."[24] Thus, Hirschhorn has to tread a very narrow path, between engaging with non-art-world ("nonexclusive") communities and sites in order to optimize the social authenticity (and "newness") of his practice, while at the same time minimizing his own reciprocal answerability for the actual effects that his presence has on these communities. This has necessitated a compensatory valorization, and even exaggeration, of his own autonomy. We might say, in fact, that as artists rooted in the evaluative horizons of the neo-avant-garde feel compelled to move beyond the protective enclosure of the art world, they find it increasingly necessary to foreground, at the rhetorical level, their own steadfast allegiance to the concept of aesthetic autonomy that this move threatens to undermine.

Hirschhorn produces this claim at two different levels. First, he defines the autonomy of his artistic practice through a series of apophatic negations, describing his work as a form of "pure art" that avoids the compromises that accompany the adjacent cultural practices that it so clearly resembles, in its focus on workshops, lectures, media labs, and a whole proto-educational apparatus imbedded in poor or working-class neighborhoods.[25] As he insists, "I never use the terms 'educational art' or 'community art,' and my work has never had anything to do with 'relational aesthetics.'"[26] Elsewhere he is adamant that his work not be confused with "social work" or "participatory" art: "I want to work out an alternative to this lazy, lousy 'democratic' and demagogic term 'Participation.' I am not for 'Participative-art,' it's so stupid because every old painting makes you more 'participating' than today's 'Participative-art,' because first of all real participation is the participation of thinking! Participation is only another word for 'Consumption'!"[27] Here, "participation" becomes the kitsch-like counterpoint to the forms of "thinking" mobilized by his own art practice, which has more in common with avant-garde painting than such devalued genres as "community art" or "social work." These reviled practices are assumed to rely on a set of condescending beliefs about the artist's (or social worker's) superior moral and intellectual capacity, as they seek to repair the social and personal shortcomings of the disempowered. For his part, Hirschhorn will invert this dynamic, claiming that it is *he* who actually needs the "help" of the poor and working-class communities in which he locates his work: "This work cannot be done without the help of the inhabitants because I—the artist—am not the one who claims to be helping, who wants to 'help' or furthermore who 'knows' how to help; on the contrary, the inhabitants are the ones helping the work."[28]

We have, of course, several decades of critical thought across a range of different disciplines and fields dedicated to exposing the problematic nature of this kind of patronizing altruism. Moreover, there have been innumerable critiques of the ethical equivocations of certain forms of community art and social work, dating back to the 1970s and beyond. In fact, this set of concerns has been repeated so often that it has become a kind of received wisdom within the art world. Nonetheless, Hirschhorn presents the claim that he does not seek to "help" others as a radical departure from the normative conditions of contemporary artistic practices that operate in poor and working-class settings. In this sense, Hirschhorn employs generic notions of "social work" or "community art," not in order to shed any light on the specific conditions of these practices, but rather to provide a suitably

reified foil that will allow him to demonstrate the exemplary originality of his own approach to producing art in disenfranchised communities. In this manner Hirschhorn seeks to indemnify his own, "pure" mode of artistic production from contamination by other, presumably impure, cultural practices. Rather, his own approach must be understood as sui generis, having originated entirely from within the artist's unique consciousness of art and the social world.

Hirschhorn foregrounds the autonomy of his work more directly as well through a series of deliberately hyperbolic claims. "I believe that art is universal," as he writes, "and I believe art must be something completely autonomous . . . and autonomous could be another word for the Absolute or for Beauty."[29] Elsewhere he contends, "I believe in Universality and in the universal power of art to transform each human being. Other words for 'Universality' are 'Equality,' the 'Non-Exclusive Audience,' 'Truth,' 'The One World' or 'Justice.'"[30] Universality is, of course, the telos of all aesthetic thought—the final realization of the ideal form of social harmony that is, as yet, only anticipated in the aesthetic encounter. Here the prefigurative power of the aesthetic (the promise that the leisure and self-cultivation currently enjoyed by the bourgeoisie will, one day, be available to all) is reconfigured as an imminent possibility that merely needs to be acted out with sufficient conviction by the artist (who stands, again, as its representative agent). It is notable that Hirschhorn openly embraces concepts that have been widely discredited or challenged (the idea of beauty, for example, as a form of experiential knowledge that transcends its material and contextual framing) by precisely the forms of critical theory he claims to admire.

Notwithstanding the logical inconsistency of Hirschhorn's statements, his willingness to evoke many of the core values of the Enlightenment aesthetic is significant. It reflects a recognition that something fundamental has begun to shift in the nature of contemporary art practice as it seeks to move beyond the often-ritualistic forms of critique that are regularly deployed in the institutional art world. Instead, his observations point, at least intuitively, to some of the crucial questions raised by the possible actualization of art's generative potential. As he argues, "I cannot understand the skeptical, the disappointed, the resigned, the cynical, the critical."[31] The fact that theorists and historians as astute as Buchloh and Foster, who have built their careers as advocates for the avant-garde's unique "critical" power will, in a manner of speaking, suspend disbelief when it comes to Hirschhorn's work (embracing modes of practice, and rhetorical statements, that they would have previously disdained in the work of figures such as Beuys) suggests

that this paradigm shift is being registered at the highest levels of the art critical establishment. It also suggests Hirschhorn's particular value in the mainstream art world as a figure who challenges the constraints of the existing neo-avant-garde while remaining sufficiently grounded in its core values (and institutional allegiances) to ensure that this challenge remains relatively superficial.

We can gain some sense of these limitations in Hirschhorn's account of the autonomy of the artistic personality itself, which is especially evident in the writing associated with *Gramsci Monument* (2013), the last in his series of Monument projects and one of the most celebrated public art projects of the past decade. *Gramsci Monument* involved the construction of a set of temporary plywood structures near Forest Houses, a public-housing project in the South Bronx, an area that has suffered from high rates of poverty and crime for decades. It featured the typical array of educational and community services encountered in Hirschhorn's other monuments (a theater, daily newspaper, radio station, children's art classes, library, workshops, and a café). The various structures became the site for a ten-week-long series of lectures, performances, exhibitions, and readings by an impressive roster of intellectual celebrities (Gayatri Spivak, Chantal Mouffe, Toni Negri, Okwui Enwezor, etc.). *Gramsci Monument* was funded by a range of international art foundations, public agencies, and collectors, including the Dia Foundation for the Arts (the primary commissioning agency), the Andy Warhol Foundation for the Arts, a Swiss pharmaceutical heiress and Museum of Modern Art trustee named Maja Oeri, Pro Helvetia (a Swiss government art and culture agency), the Swiss Arts Council, the New York Department of Cultural Affairs, and several other public and private foundations.[32]

Projects that are virtually identical to *Gramsci Monument* (aside from the presence of celebrity intellectuals) are undertaken every summer in many parts of New York City, with community centers providing free art classes, poetry readings, computer labs, and other resources to children. These programs seldom merit a feature article in the *New Yorker*, ongoing coverage in the *New York Times*, or the financial support of such an illustrious group of international funders and patrons. Hirschhorn's project received so much attention for two related reasons. First, it was judged to be media-worthy because of his own social capital as an internationally famous artist who chose to work in a space seen as peripheral to the mainstream New York art world (that spatial dislocation in itself commanded a certain level of interest from the press). The second reason has to do with the specific way in which Hirschhorn framed the cross-class (and cross-race) exchanges that are a

typical feature of projects of this nature. In particular, it was Hirschhorn's claim to have somehow bypassed the problematics of class and race difference at work in community art practice, while at the same time infusing the exchanges that took place between the largely white, upper- and middle-class members of the art world drawn to Forest Houses and the local residents with a latent, utopic dimension. The project's art-world resonance was also heightened by Hirschhorn's symptomatic linkage of advanced art and critical theory. If, as John Roberts contends, the use of theory by groups such as Art and Language was always undertaken "in the name of the working class," Hirschhorn will place theory in direct physical proximity to the poor and working class, who will be brought onto the scene of its potential consumption via various forms of social provision, primarily directed at children. He will, in this way, evoke the key moment toward which the entire history of the avant-garde has been drawn, when the revolutionary truth for so long sequestered in vanguard theory is finally transmitted to the masses to be actualized in practice.

The project received a remarkable level of coverage, not just in the art press but from the mainstream media as well, almost all of which was laudatory. *New Yorker* art critic Peter Schjeldahl praised it as "this year's most captivating new artwork."[33] At *Gramsci Monument*, as Schjeldahl observed, "Nobody counts as special, except everybody." His idyllic meditations on the *Monument* are typical of much of the coverage the project the received: "At the Monument, I felt safely remote from the current art world's baleful pressures of ravening money and pandering institutions. The democracy of the place, leveling the artist with the kids asplash in the wading pool, brought tones of Walt Whitman to mind."[34] This image of *Gramsci Monument* as facilitating the utopic intermingling of people across divides of class, race, and ethnicity is a common feature in much of the publicity for the project. Thus, Dia curator Yasmil Raymond contends that Hirschhorn's work proposes "a new type of spectator, a body comprising individuals from different if not opposing economic and cultural stratas," assembled together in a kind of prefigurative aesthetic state in order to "protest the boundaries of exclusivity that have limited the experience of art to an affluent minority."[35] And Tracie Morris, who participated in a poetry reading at the *Monument*, praises Hirschhorn's "sincere fellowship," which drew together "grown ladies from the Forest Houses tenant's association . . . the hip hop kids . . . the culturally distant adventurers who back-packed up to the Bronx . . . and the moneyed cognoscenti attempting to blend."[36] Schjeldahl's comment above perfectly captures the appeal of Hirschhorn's work in the mainstream art

world. *Gramsci Monument* allowed him to indulge in forms of affect that appeared to "level" or transcend the class and race differences that would normally exist between the "moneyed cognoscenti" of the art world and the poor and working-class residents of Forest Houses, intuiting in the process an anticipatory sensus communis. "No privilege, no autocracy of any kind, is tolerated where taste rules and the realm of aesthetic semblance extends its sway," as Schiller wrote two centuries before.[37]

This aesthetic transcendence is, of course, forbidden by the terms of avant-garde aesthetic discourse as marking a moment of premature desublimation (art's role is to remind us of our class privilege, not to allow us to imaginatively escape it). However, Hirschhorn's careful staging of his work as the expression of a "pure" artistic impulse untroubled by the tensions that accompany other modes of cross-class experience (social work, community art) allowed Schjeldahl to suspend his default skepticism ("on three visits, my cynical antennae scanned in vain for hints of do-good condescension," as he writes). *Gramsci Monument* thus offered the jaded denizens of the art world a few weeks to rub shoulders with the poor and working class in a joyous space of splashing children, art classes, and high theory lectures, where they could, for a moment, feel liberated from the "baleful" influence of money that otherwise dominates their daily interactions. This is a key elision, as Schjeldahl's experience of *Gramsci Monument* allowed him to separate himself (in his professional capacity and class identity) from the economic complicity of the art world of which he is a part. Hirschhorn, of course, seeks the same absolution. As a result, he is unlikely to question the underlying relationship *between* the art world "awash in money" (of which he is a significant beneficiary) and the picturesque poverty on display in his Monuments.

Hirschhorn's tactical invocation of autonomy is repeated in his arguments about the artistic personality. In his writings for *Gramsci Monument*, Hirschhorn outlines what he describes as a "new kind of authorship": "This means that me, the artist, am the author of the 'Gramsci Monument,' I am entirely and completely the author, regarding everything about my work. As author, in Unshared Authorship, I don't share the responsibility of my work nor my own understanding of it, that's why [I use] the term: 'Unshared.'"[38] He goes on to state that "'Unshared Responsibility' . . . allows [*sic*] to take responsibility for what I am not responsible for." While Hirschhorn's phrasing is sometimes cryptic, the general orientation of this concept is consistent with his tendency to emphasize his own untrammeled creative freedom as an artist. In a 2004 interview he argues, "I want to act freely in my practice and

with what is my own. I do not have to communicate, to explain, to justify, to argue for my work."[39] Cognizant that his conceptualization of authorship as a form of absolute sovereignty might appear "offensive," Hirschhorn is quick to extend this possessive autonomy to the poor and working-class community members who "help" him realize his artistic vision ("the Other" in his formulation): "But I am not the only author! Because the Other, the one who takes the responsibility of the work also, is—equally—author. The Other can be author, completely and entirely, in his/her understanding of the work and regarding everything about the work. 'Unshared' stands for clearness, for a decision, for the 'non-exclusive,' for the opening toward 'co-existence.'"[40] It is revealing that Hirschhorn presents his model of creative, intersubjective experience as a variety of contract law. In "Unshared Authorship," two wholly autonomous selves enter into a negotiated relationship from a position of (ostensibly) horizontal "equality," each in pursuit of his or her own rational self-interest and each refusing to share "responsibility" for the outcome or obligation to the other. Hirschhorn imagines this form of "co-existence" as an antidote to the intersubjective messiness entailed in any form of "community" or "shared responsibility" based on reciprocal interdependence. For Hirschhorn, as the examples of community art and social work have shown, our well-intentioned desire to empathize with or attempt to "know" the other, to ameliorate their suffering, or make ourselves subjectively vulnerable to their existence will only ever lead to a patronizing form of altruism (Schjeldahl's "do-gooder condescension"). The only way to avoid this dismal fate is to rigidify the boundaries of the self and withdraw into a monadic self-sufficiency (epitomized in his case by a concept of artistic autonomy) in which we each claim absolute sovereignty over our respective "work." By extension, we must assume that the other's self in this dynamic is equally impermeable and consummated entirely in the expression of its own singular authorship.

This accounts for a curious, quasi-authoritarian undertone in descriptions of the project, around Hirschhorn's managerial relationship with the Forest Houses tenants who were employed in building and staffing the Monument. Dia curator Raymond provides a set of revealing vignettes, describing Hirschhorn as "zigzagging between his roles as artist and laborer, instilling a distinct atmosphere of comradery while also achieving productivity and a sense of mutual accountability.... Braving challenges of organization and punctuality, Hirschhorn's rationale of presence and production began to materialize into a work ethic: the process of production of a work of art demands complete commitment."[41] One gains a sense here of Hirschhorn

as a demanding but ultimately benevolent boss who inspires dedication by his own paradigmatic self-sacrifice, struggling to instill a sense of "punctuality" and a proper "work ethic" in his charges. All that is missing in this description is a reference to art's ability to cultivate a heightened level of self-esteem in Forest Houses residents to return us to the most problematic traditions of neoliberal community art practice.[42] Here the poor and working class will be lifted out of their self-imposed inertia through exposure to the artist—an exemplary, self-actualizing individual.

Hirschhorn's drive to complete the construction of the *Monument* in his desired time frame led, eventually, to moments of tension. Raymond describes one encounter when the local residents, working in the pouring rain, confronted Hirschhorn about their desire to take a break: "the collective sentiment was that the rain had become too much. . . . The crew gathered under the blue tarp where the portable table saw was stationed. Hirschhorn was reluctant about missing a day of work because of rain. Walter, one of the senior members of the group, said aloud what they were all feeling: 'Thomas, you don't love us. You only love your work.' . . . He had spoken the truth . . . [but] we found ourselves smiling, because they had understood a devotion and stubbornness that made Hirschhorn an artist."[43] In this interpretation, Hirschhorn's manifest indifference to the well-being of his employees is recast as the redemptive expression of the artist's absolute autonomy. This is not something to abjure, but rather a model from which the "precariat" of Forest Houses might gain inspiration. Clyde Thompson, who helped facilitate the employment of Forest Houses residents for Dia, makes precisely this point in an interview with assistant curator Kelly Kivland: "The genius of the project is that it tapped and motivated a lot of people who were not working. . . . When they started working, I see cats walking with purpose, you know? 'Hey Clyde! How you doing?' They got on their red Gramsci shirts. They're going to the store to get lunch, and they're rushing to be back to the job on time, because Thomas had these expectations."[44] Thompson goes on to praise Hirschhorn more explicitly: "His passion, his will to move something, is so powerful. When we're talking to the kids about Thomas we say, 'All you have to have is something that y'all love like that.' Everybody should have something that they care about, like how Thomas cared about that project. And then, having it supported. . . . The kids needed to see that. . . . Everyone is feeling this energy from one person with an idea and a vision."[45]

This sentiment is hard to argue with; the decision to define one's life through a passionate commitment to a higher purpose, artistic or otherwise, is

admirable. Even more valuable, as Thompson would no doubt agree, would be a social system in which the possibility of nurturing such a passion, as well as the ability to see it "supported," was available to all the residents of Forest Houses, not just famous artists like Hirschhorn. Needless to say, this is not a challenge that an artist of Hirschhorn's stature faces, as his "passion" has been institutionally and economically validated for many years and at levels of support that would be inconceivable for the residents of Forest Houses. But this transformation, the transformation that would universalize the expressive autonomy and privilege of the artist and lead to the creation of a world in which the children of Forest Houses had access to the resources necessary to enjoy those same opportunities, is precluded in the neo-avant-garde paradigm. Rather, art's role is precisely to remind us of the *impossibility* (or at least the prematurity) of this kind of systematic change. Hirschhorn's work gestures toward praxis, in its deployment of prefigurative forms of social interaction (which so entranced art critics) and in its tactical mimicry of adjacent forms of activist or community-based art production that would seek to contribute to the practical and partial realization of this ideal here and now. However, this gesture must remain entirely symbolic.

Hirschhorn centered the *Monument* around Antonio Gramsci, a Marxist theorist who sought to foreground the insurrectional potential of the working class, but at the same time, he did nothing to link the creative unfolding of the project with a recognition of the specific effects of hegemonic power on the lives of Forest Houses residents, or the specific forms of resistance that have been acted out within the community, now or in the past. Rather, his focus was on the creation of a festive, celebratory atmosphere of children's art classes and poetry readings (which served the interests of the project's funders), overlaid with a set of lectures intended to bring various forms of vanguard theory into spatial proximity to a working-class neighborhood. Here, "theory" (a force that was literally "brought from outside") served to represent the forms of systematic critique necessary to insulate Hirschhorn from the charge that he was simply trying to create the spectacle of a naively affirmative, micro-utopia in a working-class housing development. But this theory must, by necessity, be held apart from any practical application in the Forest Houses community itself, in order to avoid the perception that Hirschhorn believes real political change is actually possible. As a result of the epistemological vacuum created between these two blocked potentials (*Gramsci Monument* as either naively affirmative or overtly activist), the most powerful message to emerge from the project came via Hirschhorn's own un-self-conscious projection of artistic sovereignty as a paradigm of

aspirational selfhood, which can easily enough conform to existing conservative beliefs that the suffering of the poor could be overcome by a process of personal transformation.

It is hard to imagine that Hirschhorn would have sought to encourage a narrative in which the only thing preventing the young people of Forest Houses from escaping their economic precarity is an absence of passion, or an insufficient level of hardnosed, artistic self-interest. At the very least, however, he seems to have been remarkably unaware of how his own performance of exemplary "sovereignty" would be understood and made use of in the context of the Forest Houses community. In this view, Hirschhorn will infuse the Forest Houses tenants with a sense of his extraordinary "will" and his radical autonomy ("you don't love us, you only love your work"), in which everything, including intersubjective generosity or care, is sacrificed in pursuit of a higher goal, which is the work of art. It is not surprising that the members of the Forest Houses community would do whatever they could to extract some value from *Gramsci Monument* and their improbable encounter with an internationally famous artist. What is surprising is the way in which Hirschhorn chose to make use of their generous invitation to enter this community, given the long and tortured history of efforts to infuse poor people with a properly entrepreneurial sensibility in order to overcome their ostensibly self-imposed deprivation. Hirschhorn often speaks in praise of the necessary "headlessness" of his practice ("I can't think too much about what I'm doing"), but here, certainly, is a point at which some degree of critical self-reflection on his part would have been salutary.[46]

Hirschhorn operates, then, as if his own class privilege, and his own whiteness, were invisible.[47] And to him at least, they are. As we have already seen, the avant-garde artist often presumes to speak on behalf of a universal political potential or a category of otherness (the proletariat, the disempowered subaltern for Rimbaud, etc.), in a manner in which their own subjectivity and agency is simultaneously effaced and profoundly enhanced. This is precisely the claim made by the alienated bourgeoisie who constituted the original cadres of both the artistic avant-garde and the political vanguard. Although Hal Foster was willing to transpose Hirschhorn's identity with that of a homeless squatter, Hirschhorn himself is too astute to make these claims on his own behalf. He nonetheless retains the implicit belief that his own privilege can be conjured away through a simple process of rhetorical disavowal, even as its concrete, operational effects are evident in the managerial role he so naturally assumed in relationship to the labor of Forest Houses working-class residents. The residents (many of whom were

unemployed) were participating in the building of *Gramsci Monument* because Hirschhorn was paying them through the largesse of the Dia Foundation and the project's other funders. Nonetheless, he imagines that their interactions were conducted under the guise of some sort of egalitarian horizontality in which their involvement stemmed entirely from their shared devotion to a work of art that was, ultimately, his alone. This accounts for Hirschhorn's remarkable disingenuousness, even in the context of a relationship of direct wage labor. As Yasmil Rayond recalled: "Thomas said: 'It's true. I do care very much about my work, but I care about you, too. I am not the boss, and you are not my employees. I am the artist, and you are helping me.'" Of course, Hirschhorn was, quite literally, their boss. His obfuscation of this managerial relationship is symptomatic. In the incident described above, he is paying the Forest Houses residents for their labor, pushing them to work in inclement conditions and haranguing them when he believes their work isn't adequate, but he is *not* their "boss." Rather, they are simply two free agents, who have agreed to work together toward a common goal (the practical realization of Hirschhorn's own artistic vision). Here the privilege of whiteness, which claims to transcend the specificity of race, makes common cause with the class transcendence claimed by the bourgeois artist.

He Doesn't Want Anything to Interfere with His Monument

With Hirschhorn's unshared authorship, we return, once again, to the origins of Enlightenment autonomy and the crucial interconnection between aesthetic autonomy and possessive individualism. The self, for Hirschhorn, is implicitly appropriative. The only way that intersubjective exchange can unfold safely is to bracket any form of interaction that implies reciprocal obligation or answerability to the other (which can only ever lead to the condescension of the social worker trying to "rehabilitate" the disenfranchised).[48] Here the work of art becomes an essential mediating device that allows self and other to interact indirectly without fear of instrumentalization ("by taking responsibility for the work," as Hirschhorn writes, rather than each other). What preserves the ostensible purity of Hirschhorn's art is precisely his willingness to disavow his answerability to the other here and now, behind the mantle of "unshared authorship," and instead to engage with them through their shared subordination to the task of helping him make *his* art, which calls upon each of them for absolute "commitment." We can detect here an echo of Adorno's concept of the art object as the necessary physical mediator between subjects not yet prepared for direct intersubjective exchange.

Hirschhorn has no interest in "helping" the other. His sole concern is with realizing his own artistic project (and, in effect, helping himself). In this endeavor, the other (the residents of the "precarious" poor and working-class communities in which he sites his work) might be drawn along by his charismatic energy or might determine that their own interests can be served by contributing to the realization of his vision. But that is a determination that is based entirely on their own assessment of the relative value of an exchange in which their interlocutor has already declared that he is unwilling to consider their own well-being.

In Hirschhorn's model, both the artist and the community member retain an entirely exclusive relationship to the project itself. At the same time, only one of these actors occupies a position of institutional, cultural, and economic privilege that will allow him to accrue any significant financial benefit from this exchange (future commissions, enhanced sales of his "precarious" artworks, professional advancement for the curatorial staff associated with a given work, salutary publicity for the sponsoring foundations, etc.). Thus, the ostensible "equality" that characterizes Hirschhorn's unshared authorship is belied by very real differences in power and agency. This does not invalidate his work, but it does raise some questions about the ways in which Hirschhorn frames his interactions with the Forest Houses residents. The paradoxical effect of Hirschhorn's "unshared authorship" is to invert the altruistic dynamic that he disparages in community art and social work. The residents, having been assured that Hirschhorn has no interest whatsoever in helping them, nonetheless agree to *help him* realize his own artistic project (and enhance his own symbolic capital), generously offering their time, physical presence, and understanding: "I tell them, 'This is not to serve your community, per se, but it is to serve art, and my reasons for wanting to do these things are purely personal artistic reasons. . . . My goal or my dream is not so much about changing the situation of the people who help me, but about showing the power of art to make people think about issues they otherwise wouldn't have thought about.'"[49] Of course, the "help" that these communities provide is not limited to their participation but is also made possible by their very existence as signifiers of a "precarious existence" and "street credibility" (the term appears repeatedly in Hirschhorn's notes), which he seeks to foreground thematically, and materially benefit from, in his work.[50] They serve, simultaneously, as the physical and cognitive labor necessary to construct and staff the project and as a semantic material to be deployed within the broader conceptual field of Hirschhorn's artistic practice (a function that is evident in the treatment of precarity as

a formal device by critics such as Buchloh and Foster and in the physical composition of his own artworks). In this manner their social authenticity, as symbols of class and racial difference that hold a particular fascination within the institutional art world, is quite literally monetized.

We can identify a symptomatic tension around unshared authorship in Hirschhorn's description of his meetings with potential community hosts for his project. In one of his "Debrief" notes, following a meeting with Diane Herbert and Clyde Thompson of the Southeast Bronx Neighborhood Center, Hirschhorn proudly claims: "I made no concession in anything," by which he means he refused to concede that the project could or should "benefit" their community in any way. "The meeting with Diane Herbert and Clyde Thompson was good, they are very concerned by 'what is the benefit for the community' . . . it was a frank discussion, I refused to 'sell' (their term) my project to them, I told them that I am not a social worker or an artist who serves de [*sic*] community—I tried to tell them that I have only to serve the art, they understand that—it was a nice moment—the fragile beginning of a real dialogue between equal human beings."[51] It would seem self-evident that no matter how adamant Hirschhorn was about refusing to "serve the community," he was clearly positioned in these exchanges as someone with access to a level of resources and media attention that are quite rare for public-housing communities (including paid construction and security jobs, the provision of computer labs, summer art classes for kids, etc.). For Hirschhorn, this exchange represented "the fragile beginning of a real dialogue," in which his transcendent love of art convinced the residents that he had also transcended his own class and race privilege. But another interpretation is possible. This may also be the point in the conversation at which the residents realized that in order to gain access to the very tangible benefits offered by Hirschhorn (to a chronically deprived community), they would need to indulge his particular mode of romantic self-presentation. They may have reached an implicit, and quite pragmatic, understanding that Hirschhorn would continue to make whatever rhetorical pronouncements he felt necessary to justify his work while they would do what they could to make use of the resources and "help" he could provide. Tenant Association president Erik Farmer, who played a crucial role as Hirschhorn's go-between with the Forest Houses community, says as much in a New York City Housing Authority press release from May 15, 2013, stating: "*Gramsci Monument* is going to be something very different that the community has never seen before . . . I think that it will bring the community together. It will bring jobs and teach residents about art, something that the commu-

nity is not used to."⁵² This is, of course, precisely the reviled language of the community art tradition that Hirschhorn is so anxious to distance himself from. In another interview Farmer is quite explicit about the gap that exists between Hirschhorn's presentation of *Gramsci Monument* and his own understanding, arguing that for Hirschhorn, "this is a work of art. For me, it's a man-made community center. And if it changes something here, even slightly, well, you know, that's going in the right direction."⁵³ Changing things "even slightly" is, of course, the catalyst for the exculpatory critique, but so long as Hirschhorn himself does not openly admit to this intention, his own ideological autonomy is preserved (even if it is precisely what his "collaborators" hope to achieve).

The incommensurability between Hirschhorn's image of the infectious aesthetic transcendence evoked by his "pure art" and the pragmatic calculations of public-housing residents attempting to reap what benefit they can from the fortuitous presence in their community of an international art star, and the media trailing in his wake, is at the core of this project. For Hirschhorn, his exchange with Herbert and Thompson was the very embodiment of an aesthetic sensus communis (a "real dialogue between equal human beings"). It is telling that this utopic exchange occurs precisely at the moment when Hirschhorn imagines the public-housing residents are absolving him of both his whiteness and his own class identity (i.e., not equating him with a patronizing bourgeois social worker or community artist who has come to "help" them). The fact that Hirschhorn is unable to see the complicated position he has placed Herbert and Thompson in, by dangling much-needed material resources before them while simultaneously refusing any transactional obligation to them for the benefits he will in turn accrue through their involvement (including the symbolic capital or "street credibility" he will extract from their community), is symptomatic of his un-self-conscious privilege. It suggests, moreover, a degree of willful self-deception regarding the practical questions the Forest Houses representatives had to consider before giving him access to their community. I think it is more accurate to understand the disjunction between Hirschhorn's and Farmer's understanding of *Gramsci Monument* as marking the thin membrane of irreconcilability that Hirschhorn feels he must maintain, between his understanding and that of the other, between theory and practice, and between art and life, in order to preserve the essential critical and aesthetic power of his work. It constitutes the "gap," as John Roberts might contend, "between the time of art's production . . . and the actualities of art as a mode of political engagement."⁵⁴

The benefit of all this tacit rhetorical coding for Hirschhorn is clear enough. By making a point of repeatedly declaring his autonomy, he gives himself plausible deniability to argue that his work has eluded the various ethical snares of community art and social work, and thus represents something entirely "new" as a form of artistic practice (a persistent theme in his interviews about the work, and a key factor in its intellectual marketability as art). The concept of "unshared authorship" allows Hirschhorn to insulate himself from the questions that might be raised by using Forest Houses residents as the compositional material for a project that can do a great deal to enhance the prestige of both Hirschhorn and the art institutions affiliated with his work, but which may do relatively little to enhance the long-term well-being of the communities in which he works. The residents have, after all, freely agreed to their participation in the project, and should have no unrealistic expectations about the benefits it might provide or the costs it might entail. Of course, this rhetorical egalitarianism is founded on a socioeconomic dynamic in which an artist commanding a sizable budget (by the standards of public-housing project communities), an international network of prestigious academics and artists, and the capacity to generate extraordinary levels of media attention has chosen to work in a community that suffers from chronic unemployment, homelessness, and violence.[55] At the same time, the South Bronx is facing the early stages of gentrification, with the opening of artisanal coffee shops, boutiques, craft breweries, and, of course, art galleries, leading to fears of displacement (a process that *Gramsci Monument* itself might easily have encouraged). This is the "precarious" reality into which the media frenzy of *Gramsci Monument* descended for ten weeks in the summer of 2013. Simply stating emphatically that he has no interest in "helping" the residents of Forest Houses does nothing whatsoever to alleviate the ethical ambiguities raised by Hirschhorn's presence in their community. This does not mean that many Forest Houses residents did not benefit from the project (at the very least, it provided several residents with paid employment for ten weeks, and the children of Forest Houses had access to much-needed computers and art classes). There was clearly a great deal of enthusiasm for the project, precisely because of the benefits it did provide. It does, however, call into question Hirschhorn's strenuous effort to differentiate his project from abject forms of community art or social work and their accompanying ethical compromises.

It is instructive here to outline a more precise analysis of Hirschhorn's artistic self-fashioning by considering the complexities imbedded in his concept of "help." We can identify at least three variations of help or assistance

that are mobilized in his work. First, we can understand help in terms of the monetary and institutional resources that Hirschhorn can provide to the communities (for salaries, art classes, computers, internet access, libraries, food, etc.). This is likely the form of "help" that was of most interest to the public-housing communities that Hirschhorn sought to enter. The second modality of "help" relates to the idea of the artist, or social worker, seeking to "improve" or uplift the consciousness of the poor. In this view, the root cause of poverty is not material deprivation, systemic racism, or structural unemployment but rather a lack of self-esteem or personal discipline. This is likely the specific form of "help" that Hirschhorn was most concerned to disavow, but it remains nonetheless as a persistent undercurrent of the project (as evidenced by the appeals to "punctuality" and the image of the hardworking artist as an exemplar for children). The final modality of help entails the attempt to produce some positive, long-term change, however modest, in the material condition of a given community through direct political or social action. This, of course, is precluded by the terms of the exculpatory critique, and Hirschhorn is scrupulous about disavowing any claim that his work could have a lasting effect on the Forest Houses community (even as the residents might have hoped otherwise).

As I pointed out above, Hirschhorn argues that the privilege of "unshared authorship" is not unique to the artist. Rather, he extends it to his *Gramsci Monument* collaborators as well, writing that "the Other, the one who takes the responsibility of the work also, is—equally—author . . . in his/her understanding of the work and regarding everything about the work."[56] It is equally clear, however, that the authorship function exercised by Hirschhorn is of an entirely different order than the authorship enjoyed by the residents of Forest Houses. While they are free to "take responsibility" for the work, and to project their own unique interpretive "understanding" on to it, the "form" of the work itself belongs exclusively to Hirschhorn. In fact, long before Hirschhorn selected Forest Houses as the location for his project (out of the forty-six public-housing sites he visited), he was already conceptualizing its structure, lining up speakers, and determining the programming. This is consistent with Hirschhorn's notion of the artist as a "form-giver" (form, in this case, referring to the design of the physical structures, the events, and, crucially, the time frame of the project itself). This "form," as Hirschhorn writes, is "the most important thing." It is "something coming from myself, from my own, something that I am the only one to see and perceive as logic, something that only I can work out and can give."[57]

Based on firsthand accounts of the project, there appears to have been a curious transposition at work in *Gramsci Monument*, in which Hirschhorn himself came to replace Gramsci as the embodiment of enlightened consciousness, self-discipline, and commitment to be emulated by the local residents. Here, again, is the essential core of conventional aesthetic autonomy that underlies Hirschhorn's practice: a position of inviolable creative agency that extends from the wading pools and art classes of Forest Houses to the showrooms of Gladstone Gallery. It is precisely the "form" of *Gramsci Monument*, in Hirschhorn's view, that constitutes its exemplary value as an entirely "new" artistic practice: "The 'Gramsci-Monument' is a Form, it is a new Monument Form. It is a new Monument because of its Dedication, it is new because of its Location, it is new because of its Duration and it is new because of its Outcome. Everything related to it and coming from it is new and is—above all—'Form.' The 'Gramsci-Monument' is a tribute to Form and my answer to the question: What is Form?"[58] The residents, for their part, might exercise their "unshared authorship" in *Gramsci Monument* by "having fun," "hanging out," feeling implicated," "making encounters," "enjoying the artwork," and perhaps even "thinking of Gramsci's contribution to the thinking of today," according to Hirschhorn.[59] These are all potentially valuable experiences, but they are clearly of a different order than the sui generis form-giving power of the artist, who creates the behavioral apparatus in which all of these (quasi-utopian) experiential modes might be played out. The Forest Houses residents can be physically present, they can attend lectures and readings, take art classes, provide the "street credibility" necessary to authenticate Hirschhorn's practice, and even build (and dismantle) the physical structure itself, but they are precluded from playing any role in conceptualizing the project itself or changing its form or orientation over time. Instead, they are called upon to make themselves available, physically and cognitively, to be worked upon by an event matrix set in place by the artist; this is the extent of their agency, and their autonomy, in Hirschhorn's model of "unshared authorship."

We can observe here a residual trace of the avant-garde separation between mind and body, between the artist/theorist, who possesses a unique capacity for complex conceptualization, and the masses, who are only allowed to engage in physical and cognitive interactions that unfold within a contextual field defined a priori by the conceptualizing mind. This does not mean that many residents did not make use of the project in their own highly creative ways (by serving as DJs, performers, etc.). There was even a small time slot set aside for events "suggested" by residents and organized

"with the help of the artist" ("Running Event"). However, it was clear, at least to the Forest Houses community, that Hirschhorn's ownership of the project was uncompromising and absolute. As resident and *Gramsci* staffer Dannion Jordan notes in an interview:

> [Hirschhorn] doesn't want anything to interfere with his monument.... Whether it's rain, Dia, NYCHA, he doesn't want anything to interfere with his project. If you're not interfering with his project, everything's good.
>
> What happens if you interfere?
>
> [*Laughs*] He gets crazy, starts screaming, using his fingers [*jabs his finger*] and everything.[60]

Here the ontic core of possessive individualism that lies at the heart of the avant-garde paradigm reappears. "I am doing it," as Hirschhorn writes of *Gramsci Monument*, "because I authorize myself to do it."[61] Hirschhorn associates his autonomous, form-giving authority with his ability to determine the precise duration of *Gramsci Monument*. This is a crucial assertion, with broader significance for my analysis. One of the results of efforts by mainstream artists and art institutions to lay some claim to new forms of collaborative or participatory art has been a tactical shift in the constitution of autonomy itself. We have moved from a model of spatial autonomy, in which art preserves its independent criticality by remaining sheltered in museums and galleries, to a model of temporal autonomy, in which the artist preserves his or her critical independence by retaining mastery over the unfolding of a given project through time. Here the artist alone determines the moment of both origination and cessation and the complex choreographic markers that structure the processual rhythms (of creativity, of incipient resistance, of reinvention or reorientation) set in motion by their work. In the absence of the institutional and spatial boundaries of the museum or gallery, time becomes one of the primary "forms" through which the artist exercises his or her autonomy. It is the realm of expectation and disappointment, realization and deferral, and completion and incompletion.

The orientation to time in the structuring of *Gramsci Monument* is symptomatic. It was exhaustively event driven rather than process driven, combining elements of a museum education program, a community art project, and a biennial (complete with its own "pavilions"). Daily activities included poetry readings, art classes, seminars with critical theory luminaries, performances, field trips, and so on. This is museum time, institutional time, predicated on planned events and scheduled, highly programmatic,

activities, and largely resistant to the improvisational emergence of new critical insight or the unforeseen social energies and antagonisms that can be generated by a messy, complex, creatively staged collaborative interaction. This is not to ignore the good intentions of either Hirschhorn or the Dia curatorial staff who brought the *Monument* into existence, but it is important to be realistic about the material and ideological constraints that they operate under and how these constraints work to privilege specific types of art practice and specific artists. In particular, art institutions and funders tend to prioritize projects that are relatively short term, that have a clear and predictable starting and ending point, and that are highly mediagenic and can be well documented in a way that appears to illustrate the production of certain positive social effects or forms of "outreach" (notwithstanding Hirschhorn's own claims to the contrary). This set of biases necessarily excludes projects that evolve in a sustained dialogical and tactical relationship to processes of resistance or transformation, which may not be documentable in the same manner, and which are not so easily containerized in terms of their spatial or temporal boundaries. These projects might also piss some people off, which is something that most art foundations have no interest in doing. As a result, the mainstreaming of "social art" practice has tended to encourage a form of art that can often be relatively superficial, press friendly, unsustainable, and disconnected from the temporal and cultural complexities of change or resistance.

The Aesthetics of Disappointment

Hirschhorn's work, with its persistent valorization of theory and philosophy (defined by Monuments and Altars to famous thinkers), fits comfortably within the avant-garde tradition that I have examined previously. Here, "art" and "theory" function as interdependent forms of revolutionary consciousness, held in trust on behalf of a working class not yet prepared to actualize their truths. This history gives *Gramsci Monument* an additional pathos. Notwithstanding the persistent foregrounding of Gramsci in the project (extending to an on-site library housing his slippers, comb, wallet, and other artifacts from his life), "theory" functioned primarily as an intellectual consumable to be delivered to the local residents through lectures, plays, and other conventional pedagogical forms. Hirschhorn's presentation of Gramsci reflects an underlying notion of theory as transparent and immediate: requiring merely the presence of an authoritative figure to communicate its truths. In an alternate iteration of this project, "theory" might have

been introduced in a way that illuminated Gramsci's relevance for the Forest Houses community at a deeper, experiential, and cognitive level. This is a neighborhood, after all, that is facing rising rents due to incipient gentrification, pressure by the NYCHA to force out residents on public assistance, and significant levels of police corruption and violence.[62] This makes it all the more poignant to read the following transcription in one of Hirschhorn's "debriefing" notes, from a conversation with public-housing residents on June 17, 2012: "Fairness: Help us!" "Young men: Rent Increasing!" "Help," of course, is precisely what Hirschhorn is unwilling to provide, for fear of compromising the purity of his artistic vision and the sovereignty of his "unshared" authorship. Needless to say, art is not capable of solving these problems, but neither does it have to refuse to acknowledge their existence in the discursive unfolding of a given project. But this, in turn, would require at least a provisional "reconciliation" of theory and praxis (as articulated in and through the specific political conditions of Forest Houses today) that is foreclosed for Hirschhorn. In the final analysis, the theoretical insight that is ostensibly at the core of *Gramsci Monument* must remain "undamaged" by praxis, as Adorno would say.

The question of praxis returns us to Hirschhorn's sovereign relationship to temporality. This attitude is clearly evident in his insistence on the "time-limited" nature of *Gramsci Monument*.[63] For Hirschhorn, the purity and "newness" of *Gramsci Monument*, and his own critical autonomy as an artist, rests on his singular ability to prescribe its temporal limits and to refuse any responsibility for the actual effect the work might have on the Forest Houses community "after" the project is completed. As Hirschhorn contends, all that can remain in Forest Houses following his departure are "thoughts and reflections," as the actualization of theory in praxis is deferred, yet again, for another day. In an interview conducted about a year after the closure of *Gramsci Monument*, Hirschhorn was informed that many Forest Houses residents lamented the loss of the resources provided by the project and struggled to find a way to sustain its energies without the institutional connections and prestige that Hirschhorn enjoys. His response is symptomatic: "I am happy to learn that residents want the Monument back, because this means that the project was not a failure. But I had been, since the very beginning, clear to everybody that *Gramsci Monument* is a new kind of Monument, and it's a new form of art—concerning its dedication, its location, its output and its duration. . . . It's not a Monument which understands eternity as a question of time; it's a Monument which understands eternity as 'here' and as 'now.'"[64]

The temporality of *Gramsci Monument* was determined a priori by Hirschhorn and was entirely independent of the emergence of any unforeseen points of transformative potential (shifts in consciousness, new modalities of resistance, opportunities for scalar expansion or continuity, etc.) that might have unfolded in the situational context of Forest Houses. The effect of this temporal sovereignty on the community itself is apparent in the following observations. The first was made during the project's ten-week run by Philippe Vergne, the then-director of the Dia Art Foundation: "The seminars on Saturdays are packed. There are people coming every day: that's a sign that the residents are interested in the project. I remember I was there one morning just before it opened to the public and a group of kids was running toward the monument, screaming, 'The monument is about to open. Let's go to the computer room!' There is ownership. The *Gramsci Monument* is part of Forest Houses; it's part of their lives."[65] Here we have the essence of *Gramsci Monument* as it was publicized by the sponsoring funders and presented in sympathetic press and media accounts, and foundation annual reports. It was a site of remarkable cultural energy and exchange located in the midst of a public-housing project, characterized by euphoric children expressing a sense of "ownership" over the resources provided by Hirschhorn's largesse and the unexpected opportunities they opened up. The second observation comes from Susie Farmer (the mother of Erik Farmer, Hirschhorn's chief contact at Forest Houses), who, like Hirschhorn himself, was interviewed about a year after *Gramsci Monument* was removed. Here she describes the disappointment and frustration of young children in the Forest Houses community who, for a brief period of time, had access to art classes, computer labs, and an engaged and supportive staff, and who kept wondering when it would all return.

> WHITNEY KIMBALL: I remember the last time I talked to you, you were telling me about kids who were getting really inspired by the art there. Have you seen that [enthusiasm] grow at all over the year? [Last year, Susie had told me a story about a little boy who'd been particularly inspired by the *Monument* and had been thinking about going into an art program because of it.]
>
> SUSIE FARMER: No. And one little boy who we particularly thought would be very good [with art], I don't even know if he's going to school now like we'd encouraged him to do. The children are asking every day if it's going to come back. No, they're not going to come back. It was a one-time thing. Every day they had something to look

forward to. They would get up early and come to the monument. It was something they never had in their area before, and they may never have it again.[66]

Erik Farmer himself corroborates this view, noting in the same article that "Everyone keeps asking me 'Is it going to come back this year, is it going to come back?' I had to tell them, nope, that was it, not again this year. So there's nothing for the kids to do now, they're really bored. You can see how nobody's out here, when the monument was here last year, it was full of people outside." Here is another image of *Gramsci Monument*, after the "experiential intoxication" generated by attentive media, visiting city officials, art-world crowds, famous academics, and enthusiastic art teachers and poets, had subsided.[67] The experience of children is not incidental here. As Lex Brown, who was employed to run the art class program at *Gramsci Monument*, notes, "the vast majority of the people who came to *Gramsci Monument* were the kids of Forest Houses." They were drawn, as Brown notes, because the *Monument* provided "a safe, outdoor place where the kids could socialize, create, and play without being graded or creatively limited."[68] They were also attracted by the presence of food. Brown notes that the Gramsci Bar, despite being run as a "microbusiness," sought to provide snacks for the kids ("some of them were really hungry"), and Raymond notes that the children also frequented the Gramsci Library, not to gaze upon Gramsci's slippers but because the library offered free apples.[69]

Of course, Hirschhorn has a strong incentive for disavowing any concern with the longer-term consequences of his presence at Forest Houses. If he professed some interest in helping to produce any practical transformation in the social life of the community, Hirschhorn would, as I have noted, be vulnerable to the exculpatory critique. From this perspective, any more concrete change he might have been able to facilitate (e.g., helping to create the infrastructure necessary for art classes to continue beyond the project's ten-week end point, setting aside some of his budget for free meals for children, giving each of the children a piece of his own work that could be auctioned, etc.) would have been offset by the (presumed) ability of local governments to use this improvement as an excuse for their own inaction. In this manner *Gramsci Monument* can be seen as offering an indirect critique of the failure of existing public agencies to fulfill their own obligation to support the Forest Houses residents, invoking what Hirschhorn obliquely terms the "non-necessity of the world as it is."[70] For Hirschhorn, art's function is to provide a brief, symbolic anticipation of a different world, a world in which

"Equality" and "Truth" and even "Beauty" are more than hollow platitudes, by evoking the *possibility* of concrete change or political empowerment (in *Gramsci Monument* via the staged consumption of Marxist theory) but never seeking to realize it. If the aftereffect of this approach is some level of disillusionment that the unprecedented outpouring of resources and media attention devoted to the Forest Houses community had been abruptly withdrawn, it is preferable to the unlikely scenario in which the state could point to some more concrete improvement in the community to excuse its own inaction. As I suggested, one can hardly expect Hirschhorn, or any artist, to resolve the economic crisis of the working class in the South Bronx. But one can ask what it means for an artist to offer the hope of something different from "the world as it is," while using the frustration and disappointment produced by its failed realization to demonstrate his unwillingness to indulge in the premature reconciliation of art and practical action. Here the people of Forest Houses—their kindled enthusiasm, their aroused hopes, their participatory involvement—become the medium for a critical gesture intended primarily for art-world consumption.

As this outline suggests, while Hirschhorn deliberately sites his work in spaces outside of the institutional art world, his practice is still largely conditioned by the underlying protocols of the gallery and museum. As a result, it is characterized by a fundamental duplicity, in which the bodies and personalities of the Forest Houses tenants are engaged in the practical task of building and staffing his project, while also serving as signifiers of precarity in a composition that is intended to represent certain conceptual tensions around the emancipatory potential of aesthetic experience and revolutionary theory (a semantic frame that is likely of little concern to the tenants themselves). As Benjamin Buchloh contends, *Gramsci Monument* sought to evoke both the "utopian desire" for a revolutionary cathexis, in which the working class is unified through theoretical insight, and a "dystopian" recognition of the present impossibility of precisely such a reconciliation.[71] This is a disjunctive experience that is uniquely suited to the sensibilities of art-world viewers, steeped in the history of the avant-garde and prepared to savor the "tragicomic" expression of its continued failure. In this second capacity the tenants of Forest Houses are no longer discrete human subjects, with unique histories and desires, hopes and insights, but simply symbols (of the "precariat" or the absent class agent of revolution long foretold by the emissaries of the avant-garde), to be held in a resonant semantic suspension with signifiers of revolutionary theory represented by Gramsci's writings and personal effects.

Hirschhorn demonstrates an impressive level of sophistication in maintaining a precisely calibrated relationship between the institutional art world and "off-shore" sites such as Forest Houses, where the symbolic materials necessary to validate the radical newness of his work can be found and extracted. Regardless of how sensitively Hirschhorn handled the negotiations with Forest Houses tenants necessary to accomplish the work's physical production, this second phase, in which they serve as a symbolic resource for the creation of a coded message directed at an art-world audience, is unavoidably reductive and instrumentalizing. One can certainly understand the perception that no meaningful political transformation is possible in the current moment and that all attempts to produce change here and now are premature. This is, after all, the justification for art's claim to preserve a form of revolutionary consciousness by challenging the immanent formal or institutional constraints of art itself. However, the dynamics of an artistic practice predicated on this belief change dramatically when it is demonstrated through the reduction of actual human selves to compositional elements in a social tableau designed to symbolize this prematurity for the economically privileged.

CONCLUSION
AESTHETICS BEYOND SEMBLANCE

As I have noted, Hirschhorn's decision to center one of his Monuments on the legacy of Antonio Gramsci evokes the early twentieth-century mythos in which the political vanguard finally unites with the artistic avant-garde. What is most symptomatic about *Gramsci Monument*, then, is Hirschhorn's complex relationship to praxis and to the process of actualizing the lessons of vanguard theory in the creative, experiential work of resistance itself. By invoking Gramsci, Hirschhorn is compelled to come to terms with the failure of the revolutionary transformation that Gramsci himself dedicated his life to securing. In Hirschhorn's attempt to address these questions we can observe some of the central transformations that have occurred in the discourse of the neo-avant-garde over the past two decades. Hirschhorn's work also helps us identify the ongoing interference patterns produced in the relationship between Enlightenment and avant-garde paradigms of aesthetic autonomy. Hirschhorn chose, quite deliberately, to move outside the

economically privileged sphere of the institutional art world and to work through a site that is defined by distinct forms of repression and inequality based on class and race. This movement beyond the art world is a response to the inevitable co-option of institutional critique practices by galleries, museums, and biennials. Hirschhorn made this move under the guise of a quasi-utopian set of claims about the unique power of art to break down "exclusivity" and transcend the class and racial privilege that is epitomized by the art world itself. This is the same image that is evoked by the Dia Art Foundation's director Philippe Vergne in the project catalog: "*Gramsci Monument* was the ideal institution. It was an institution as sculpture, an institution without institutional orthodoxy, where everybody—residents, donors, neighbors, passersby, museum directors—was treated with the same level of attention and care."[1]

Vergne's description returns us to the promise of the aesthetic state in which everyone "is a free citizen, having equal rights with the noblest."[2] This has been, of course, the promise of the aesthetic since Schiller first identified art's unique capacity to reconcile the "civilized" classes and the "masses" in the transcendent experience of beauty. In Hirschhorn's case, however, this prefigurative potential is not simply evoked through the semblance of aesthetic play in the consciousness of the individual viewer. Rather, Hirschhorn sought to actualize this aesthetic transcendence in real time, in the space of Forest Houses. Hirschhorn knew that in making these claims he faced a complex set of ideological forces associated with the avant-garde critique of Enlightenment aesthetic autonomy. In particular, he had to avoid the perception that this gesture was intended to foreground a naively affirmative dimension of aesthetic experience. He also had to come to terms with Foster's critique of Kaprow and the traditions of the first neo-avant-garde, which assumed that one could overcome the elitism of the art world simply by locating works beyond the walls of the gallery. Hirschhorn attempted to indemnify himself from these critiques in three ways. First, he sought to foreground his own radical autonomy and lack of reciprocal obligation to the Forest Houses community through a contractual paradigm of selfhood in which Hirschhorn and the residents interrelate entirely through the mediating structure of his own art project. This was a paradigm in which both Hirschhorn and the residents were assigned a set of fixed and hierarchical roles. Second, he sought to preserve the criticality of his work by taking up an antagonistic relationship to forms of participatory or community-based art practice, thus replicating the second

neo-avant-garde's recursive critique of the first neo-avant-garde's premature desublimation of art's critical potential. And third, Hirschhorn sought to secure the critical legitimacy of his work through the inclusion of Gramsci.

Gramsci's presence, or the aura of Gramsci's revolutionary theory, is the crucial symbolic element that prevents this work from lapsing into stereotypical community-based or participatory art by inserting signifiers of Marxist theory into the project's spatial field. Gramsci becomes, then, a placeholder for a form of admonitory revolutionary consciousness, reminding us that the only authentic mode of political transformation must entail an absolute overturning of the capitalist system. For Gramsci to play this legitimating role, however, his insights, his presence, must, by necessity, remain spectral and de-realized. In this capacity, Gramsci's slogans can be emblazoned on the walls of the housing development, his personal artifacts can be displayed in an altar, and academics can present his theories in public lectures. However, Hirschhorn can do nothing to creatively mediate the relationship *between* Gramsci's theory and the experiential lifeworld of Forest Houses through a learning process in which he might come to understand the salient forms of repression that its residents face, as well as the modes of resistance they have practiced now and in the past. This would have entailed an experience of intersubjective openness, and a possible renegotiation of both the "formal" nature of the project and the respective roles played by Hirschhorn and the residents, which is antithetical to the concept of authorial autonomy on which his self-image as an artist depends. It would entail, as well, a willingness to allow the specificity of the site (and the complex cultural and political heritage of South Bronx) to exercise a reciprocal influence on Hirschhorn's own consciousness of the work. He was never prepared to accept what Gramsci understood as the necessarily dialogical relationship between the "democratic philosopher" and the "cultural environment he is proposing to modify." Here the environment "reacts back on the philosopher and imposes on him a continual process of self-criticism" in which his own understanding is enriched, even as his intellectual sovereignty is called into question.[3]

This absence is all the more striking because Gramsci exemplifies an alternative tendency within early twentieth-century Marxist thought, which sought to challenge the cognitive hierarchy of the vanguard party. I have already discussed this tradition in the work of Aleksandr Bogdanov, to whom Gramsci is often compared. As I have noted, Lenin viewed the working class as incapable of meaningful intellectual development and utterly dependent on the bourgeois theorist to guide and facilitate their emancipation. Gramsci,

by contrast, contended that the "subaltern" classes were capable of achieving critical insight into the nature of oppression and the processes of resistance, through the development of their own autonomous culture, rooted in the work of "organic intellectuals" arising from within the proletariat itself.[4] Gramsci is, of course, also associated with an analysis of the operations of hegemonic forms of capitalist domination. However, if Hirschhorn had linked *Gramsci Monument* with a concrete and probing inquiry into the specific forms of capitalist hegemony operative at Forest Houses, he would risk violating the symbolic, suspensive status of theory itself during a period in which its desublimation into action is, ostensibly, premature. He would, then, open himself to the same accusations of hubris and naïveté that *October* directed at Joseph Beuys. It is this complex ideological field that Hirschhorn seeks to transcend by invoking an unreconstructed notion of aesthetic "autonomy" and artistic "purity," thereby relieving himself from any teleological responsibility for the long-term consequences of his project. In this manner he can circumvent the perception that he is seeking to simply "help" the residents of Forest Houses in a condescending manner, while at the same time avoiding the risks involved in having his artistic practice entangled with complex processes of resistance or direct action, which might compromise its reception within the institutional art world. This last point is essential, since it is toward the institutional art world that his work is inevitably oriented.

As a result, Gramsci comes to function in Hirschhorn's work as another compositional element rather than a potential to be actualized in practice. In preserving the suspensive discursive structure of avant-garde aesthetic autonomy Hirschhorn also carries forward the formalist methodology that comes along with it. Hirschhorn does, of course, engage in direct interactions with the residents of Forest Houses, but he is careful to differentiate their activities as participants from his own "form-giving" creativity, which is entirely autonomous from them and legible primarily in an art-world context. This does not render the remarkable forms of interaction and creativity that unfolded among the residents of Forest Houses irrelevant. Clearly something transformative occurred in the poetry sessions and dance performances, the children's art classes and field trips, the local radio station and the newspaper. The children of Forest Houses in particular were able to glimpse for a brief period of time the kinds of cultural opportunities that are provided as a matter of course in middle-class school districts across the country. One can hardly question the value of this experience, even for a short period. Nor can one doubt Hirschhorn's sincerity in bringing it about. However, it

is also reasonable to ask about the specific ways in which Hirschhorn made use of this community, and the forms of both creative and critical insight that might have been generated with it. No matter how far this potential might have evolved, Hirschhorn was never prepared to open the underlying structure of the project so that it might sustain itself and have a life beyond his own form-giving authority.

The fact that the residents were left with the sense that, in the absence of Hirschhorn himself, nothing else was possible is a testament to the singular authority he took over the project as a nexus of actual and potential creativity (it was, finally, "his" work alone). Hirschhorn's response when confronted with these concerns is simply to reiterate his own autonomy and the novelty of his own artistic practice (*"Gramsci Monument* is a new form of art. . . . It is time-limited"). Here semblance, the necessary segregation of aesthetic experience from praxis, takes on a new form as an imposed ephemerality. Moreover, while the residents could perform their creativity for visiting art-world audiences, this creativity was never understood as having a proper place in the gallery or museum itself. Rather, *Gramsci Monument* provided a way for the institutional art world to safely consume "nonexclusive" forms of creativity, to valorize them in order to assert its own institutional relevance, while at the same time ensuring that this valorization was always mediated through the personality of a "legitimate" artist. These are, of course, not simply the constraints of *Gramsci Monument*. They are generic to the discourse of avant-garde aesthetic autonomy, and they reflect both the potentials and the limits of this paradigm. They also reflect, as I have argued here, a set of tensions inherited from the earliest stages of the modern aesthetic.

Autonomy is not an ontological condition of the artwork itself, to be preserved or abandoned through an act of individual creative will. Clearly, works that are ostensibly "autonomous" always bear some reciprocal relationship to the social or political world in which they are imbedded (through the mediation of the market, through their reception by concrete viewers, and through their position within the larger institutional and discursive system of the art world). By the same token, works that have, ostensibly, "collapsed" aesthetic experience into the political always retain a mediated relationship to praxis or action. Autonomy, and the particular way in which it is structured in a given work or by a given artist, is better understood as marking a set of historically contingent claims about the nature of political change itself. What forms of change are meaningful, and what forms of change are inconsequential? Do the resources necessary for meaningful

change exist here and now, or do they survive only as a mnemonic trace from an idealized past, or the wish image of an uncertain future? In this book I have identified two responses to this question within the long trajectory of modernism and the avant-garde. My primary focus has been on the processes of displacement and deferral associated with the belief that revolutionary change is premature and must be held in reserve through forms of symbolic resistance that are immanent to the work of art or the institutional art world. This represents a central strand within the history of the modern avant-garde that continues to inform our understanding of the potential of contemporary art. It remains, like the background radiation of the Big Bang, in a set of preconscious norms and values that structure our understanding of even the most ostensibly apolitical forms of artistic production. My goal has not been to invalidate this tradition, but rather to clarify the underlying, and often implicit, political claims on which it depends. At the same time, I have identified an alternative, and often subterranean, tendency with its own constraints and potentials. Here the artist seeks to transform and expand the mediatory relationship between art, praxis, and daily life. This is a lineage that runs from the para-institutional practices of the Paris Commune to the countercultural work of the Indian Independence movement, and from the innovations of Prolekult theater collectives to forms of cultural and artistic production inspired by the emergence of new social movements during the 1960s. Here artistic production emerges in a dialogical relationship with social and political resistance, under the assumption that the form taken by political transformation plays a central role in determining the kind of society that will emerge in its wake. This requires, in turn, a notion of political change that can account for the crucial role played by speculative, creative, and prefigurative experience in the act of resistance.

It is this same vision that has energized a broad range of socially engaged art practice over the past thirty years, as the neo-avant-garde consensus that first took shape in the 1970s has begun to unravel under the pressure of another moment of historical transformation, uniquely its own, but also informed by the past. In this new body of work we find an increasing number of artists and collectives who are not only willing to move beyond the physical boundaries of the institutional art world, but to challenge its underlying ideological constraints as well. We also encounter a decisive movement beyond the Eurocentric parameters of the conventional avant-garde tradition I have examined in this study. Examples range from the escrache tradition in Argentina, which was developed in conjunction with attempts to bring the perpetrators of past political violence to justice, to the Rojava Film Commune

in North Syria, to the "Lava la Bandera" actions in Peru that helped drive Alberto Fujimori from power, to the innovative street performances of Iranian artists, in which they deliberately transgress regulations that forbid women from singing and dancing in public. In all of these cases, critical meaning is produced not through the reflexive negation of art's own institutional status but through forms of resistance directed against existing modes of social and political domination. In this process the social architecture of aesthetic autonomy itself is openly thematized as a field of critical and creative investigation, in a manner that resonates with the alternative artistic tradition I have described here. If the first phase of aesthetic autonomy was associated with an image of bourgeois revolution that was fulfilled by 1789, the second phase was centered on a Communist mythos that reached its apotheosis in 1917. The third, and current, phase is defined precisely by the loss of a fixed referent and the search for a new paradigm of political transformation that might transcend the limitations of the previous two. At the beginning of this book, I described a crucial point of transition as early forms of political autonomy were translated into a bourgeois idiom that informed the subsequent evolution of modern concepts of the aesthetic. All too often in this tradition we encounter the perception that freedom from external constraint can only be secured by claiming sovereignty over others. I also identified an alternative, and often liminal, movement in which autonomy itself is openly thematized in a manner that has creative and emancipatory potential. This process is evident in hundreds of engaged art practices over the past three decades as they seek to facilitate a vision of the future in which the relationship between self and other is defined by a reflective openness to difference rather than a repressive drive for mastery. In a companion book, *Beyond the Sovereign Self*, I will provide a detailed analysis of this tradition, offering an alternative theoretical paradigm that can account for the unique aesthetic qualities mobilized by this body of work.

NOTES

Introduction

1 See https://theautonomyproject.org/, accessed June 22, 2022. The Autonomy Project was launched on April 19, 2010, and featured a series of seminars and two summer schools, as well as a "newspaper" publication, all available online. Supporters included the Dutch Art Institute, the Grizedale Art Centre, John Moores University, Lectoraat Kunst en Publiek Ruimte, Platform Moderne Kunst, the University of Hildesheim, and the Van Abbemuseum. The events were organized by John Byrne (John Moores University), Steven ten Thije (Van Abbemuseum), and Clare Butcher (independent curator).
2 See https://theautonomyproject.org/.
3 See https://theautonomyproject.org/autonomy_symposium.
4 Lütticken, "Three Autonomies and More," 38.
5 Ahlers, "The Puzzling Spectrum," 45.
6 Rancière, "Aesthetic Revolution."
7 Roberts, *Revolutionary Time*, 54.
8 Brown, *Autonomy*, 37, 180.

9. Rancière, *Aisthesis*; Hirschhorn, "Tribute to Form," 52; Bishop, "Another Turn," 22.
10. Léger, *Brave New Avant-Garde*; Rasmussen, *After the Great Refusal*; Roberts, *Revolutionary Time and the Avant-Garde*.
11. See, for example, Budgen et al., *Lenin Reloaded*.
12. Žižek, "Repeating Lenin."
13. Badiou, "Destruction, Negation, and Subtraction."
14. Bensaïd, *Think Again*, 105.
15. See, for example, the benchmark Mei Moses Index, accessed June 22, 2022, https://www.sothebys.com/en/the-sothebys-mei-moses-indices. Total sales of contemporary art were almost $3 billion in 2022.
16. Burgos and Ismail, "New York Apartments Top Gold."
17. Paumgarten, "Dealer's Hand," 78.
18. The term "autopoiesis" was introduced by the Chilean biologists Humberto Maturana and Francisco Varela in 1972 to describe self-regulating natural systems. See Maturana and Varela, *Autopoiesis*.
19. Badiou, "Fifteen Theses."
20. See Schulte-Sasse et al., *Theory as Practice*, 153.
21. Schiller, *Aesthetic Education*, 33.
22. Schiller, *Aesthetic Education*, 27.
23. Rosemont, *What Is Surrealism?*, 76.
24. Bernstein, *The Fate of Art*; Rancière, *The Politics of Aesthetics*; Bennett, *Pragmatist Aesthetics*; Bertram, *Art as Human Practice*.
25. Jameson, *The Political Unconscious*, 42.
26. See Hess, *Reconstituting the Body Politic*, 49–50.
27. For a detailed discussion of the "ontological rehabilitation" of the arts in the German Enlightenment, see Buchenau, *The Founding of Aesthetics*.
28. Courbet, *Letters of Gustave Courbet*, 116.
29. Here we encounter the characteristic slippage in Schiller's account between the artist, operating in the realm of semblance, imposing their will on passive compositional material, and the "statesman artist," who works in the realm of the actual but ultimately depends on the same instrumentalizing orientation. See Redfield, "Aesthetics, Sovereignty, Biopower."
30. Gorky, *Untimely Thoughts*, 89.
31. Jelinek, *This Is Not Art*, frontispiece.

1. Freedom and Sovereignty

1. Schneewind, *Invention of Autonomy*, 4–8.
2. Macpherson, *Political Theory of Possessive Individualism*.
3. Shapiro, *Evolution of Rights*, 53.

4 Barrell, "Public Prospect and Private View," 49.
5 Wynter, "Unsettling the Coloniality of Being," 277.
6 Eze, *Race and the Enlightenment*, 55.
7 Wynter, "Counterdoctrine of Jamesian Poesis," 67.
8 Wynter, "Counterdoctrine of Jamesian Poesis," 67.
9 See James, *Black Jacobins*.
10 For example, Rousseau, *The Social Contract*.
11 Muthu, *Enlightenment against Empire*, 137.
12 Schulte-Sasse et al., *Theory as Practice*, 153.
13 Cited by Egbert, "Idea of 'Avant-Garde,'" 343.
14 Kant, *Political Writings*, 54.
15 Schiller, *Aesthetic Education*, 219.
16 Woodmansee, *The Author, Art, and the Market*, 62.
17 Woodmansee, *The Author, Art, and the Market*, 78.
18 Woodmansee, *The Author, Art, and the Market*, 72, 78.
19 Schiller, *Aesthetic Education*, 163.
20 Schiller, *Aesthetic Education*, 45.
21 The "natural character of man," as Schiller observes, is "selfish and violent" and aims "at the destruction of society rather than its preservation." Schiller, *Aesthetic Education*, 15.
22 See Ginsborg, "Lawfulness without a Law."
23 Kant, *Critique of Judgment*, 33, 63.
24 Schiller, *Aesthetic Education*, 163.
25 "The psyche of the listener or spectator must remain completely free and inviolate. It must go forth from the magic circle of the artist pure and perfect as it came from the hands of the Creator." Schiller, *Aesthetic Education*, 157.
26 Schiller warns of an "impetuous" artistic instinct that "hurls itself directly upon present-day reality and upon the life of action, and undertakes to fashion anew the formless material presented by the moral world." Schiller, *Aesthetic Education*, 59.
27 Schiller, *Aesthetic Education*, 137.
28 Schiller, *Aesthetic Education*, 197.
29 Schiller, *Aesthetic Education*, 151.
30 Schiller, *Medicine, Psychology and Literature*, 262–63.
31 Germana, *The Anxiety of Autonomy*, 11.
32 Schiller, *Aesthetic Education*, 193.
33 Chuh, *The Difference Aesthetics Makes*, 26.
34 "I had not been in Europe two years," he wrote in 1953, "before I came to the conclusion that European civilization as it then existed was doomed." James, *Mariners, Renegades and Castaways*, 154.
35 Wilder, *Freedom Time*, 52.

36 Wilder, *Freedom Time*, 67.
37 Muthu, *Enlightenment against Empire*, 1.
38 Muthu, *Enlightenment against Empire*, 74.
39 Muthu, *Enlightenment against Empire*, 15.
40 Muthu, *Enlightenment against Empire*, 24.
41 Muthu, *Enlightenment against Empire*, 247.
42 Muthu, *Enlightenment against Empire*, 67.
43 Muthu, *Enlightenment against Empire*, 229.
44 See Zukert, *Herder's Naturalist Aesthetics*.
45 Muthu, *Enlightenment against Empire*, 253.
46 Babeuf, "Babeuf's Defense," 56.
47 Habermas, "From Kant to Hegel."
48 Chytry, *The Aesthetic State*.
49 On the correlation between Geist and Kantian sensus communis, see Wendland and Winkler, "Hegel's Critique of Kant."
50 Chytry, *The Aesthetic State*, 23–33. This is consistent with the Hellenism of Winckelman, Schelling, Hölderlin, and Schiller, who viewed ancient Greece as an ideal example of the reconciliation of the individual and a collective cultural ethos, as embodied in the "complete freedom" of the Athenian state under Pericles.
51 Chytry, *The Aesthetic State*, 184. The centrality of the aesthetic as a paradigm for the political reinvention of modern life is evident in the *Systemprogram* (1796), a kind of manifesto of German Idealism written by Hegel but influenced by Schelling and Hölderlin, which defines the "highest act of reason, the one through which it encompasses all ideas," as an "aesthetic act." Bernstein, *Classic and Romantic German Aesthetics*, 186. During the 1790s Hegel would even form a "league of beauty" that sought to bring the Athenian ideal to life in contemporary Germany through a transformation of philosophy and literature (Chytry, *The Aesthetic State*, 121).
52 Hegel, *Philosophy of Right*, 178.
53 Knox, *Hegel's Aesthetics*, 31.
54 While the Greeks enjoyed a "beautiful, happy liberty," it was based on a false unification of the particular and the universal. See Avineri, *Hegel's Theory of Modern State*, 112.
55 Hegel would identify the constitutional monarchies of Wurtenburg, Bavaria, and Prussia in particular as exemplars. Terry Pinkard notes Hegel's contention, in his inaugural lecture in 1818, that "the cultivation and the flowering of the *sciences* is here one of the essential *moments* itself in the *life of the state*; at this university... *philosophy*, the *focal point* of all cultivation of the spirit, of all science and truth, must find its place and its principal furtherance." Pinkard, *Hegel*, 430.
56 Hegel, *Philosophy of Right*, 176.
57 Chytry, *The Aesthetic State*, 198.

58 "Philosophy to be sure reaches the highest level, but it brings only, as it were, a fragment of man to this point. Art brings *the whole man,* as he is, to that point, namely to a knowledge of the highest of all, and on this rests the eternal difference and the miracle of art." Schelling, "System of Transcendental Idealism," 113.

59 The estates include the "immediate" agricultural class of landowners and the "reflecting" or formal business class, as well as the civil servants of the state bureaucracy. Hegel will contend that the land-owning members of the "Agricultural Estate" are "particularly fitted for political position and significance in that [their] capital is independent alike of the state's capital, the uncertainty of business, the quest for profit, and any sort of fluctuation in possessions. It is likewise independent of favor, whether from the executive or the mob." Hegel, *Philosophy of Right*, 199.

60 Hegel, *Philosophy of Right*, 179.

61 Hegel describes the monarch "as that to which the ultimate decision belongs." Hegel, *Philosophy of Right*, 195.

62 Hegel, *Philosophy of Right*, 178.

63 Comay analyzes the complex symbolic role played by the French Revolution for Hegel in *Mourning Sickness*.

64 Hegel, *Philosophy of Right*, 22. See also Comay, "Dead Right."

65 "So opposed to the sovereignty of the monarch, the sovereignty of the people is one of the confused notions based on the wild idea of the 'people.' Taken without its monarch and the articulation of the whole which is the indispensable and direct concomitant of monarchy, the people is a formless mass and no longer a state." Hegel, *Philosophy of Right*, 183.

66 "Unlike the monarch [the public] has no criterion of discrimination, nor has it the ability to extract the substantive element it contains and raise it to precise knowledge. . . . Thus, to be independent of public opinion is the first formal condition of achieving anything great or rational where in life or in science." Hegel, *Philosophy of Right*, 204–5.

67 See Woodmansee, *The Author, Art and Market*, 29.

68 Hegel, *Philosophy of Right*, 200. As he writes, "if 'people' means a particular section of the citizens, then it means precisely that section which does *not* know what it wills" (196).

69 Kant, *Anthropology from a Pragmatic Point of View*, 36.

70 Hegel, *Philosophy of Right*, 131.

71 Hegel, *Philosophy of Right*, 150.

72 Hegel, *Philosophy of Right*, 278.

73 Hegel, *Philosophy of Right*. See also Buck-Morss, *Hegel, Haiti and Universal History*.

74 Hegel, *The Philosophy of History*, 91. "In Negro life the characteristic point is that consciousness has not yet attained . . . so that the knowledge of an absolute Being, an Other and a Higher than his individual self, is entirely wanting." Hegel, *Philosophy of Right*, 93.

75 Hegel, *Philosophy of Right*, 279.
76 Hegel, *Philosophy of Right*, 288–89.
77 Knox, *Hegel's Aesthetics*, 356.
78 Knox, *Hegel's Aesthetics*, 11.
79 Knox, *Hegel's Aesthetics*, 54.
80 Pinkard, *Hegel*, 92.
81 Chytry, *The Aesthetic State*, 217.
82 Woodmansee, *The Author, Art and Market*, 74.
83 Goethe cited by Hegel in *Philosophy of Right*, 204.
84 Hegel, *Philosophy of Right*, 197.
85 "The rabble seek only diversion and beautiful works of art are passed by with indifference" as Moritz wrote in 1788. Woodmansee, *The Author, Art and Market*, 34.

2. Communism and the Aesthetic State

1 Poggioli, *The Theory of the Avant-Garde*, 9.
2 Harrison and Wood, *Art in Theory 1900–1990*, 259.
3 Livingstone and Benton, *Karl Marx*, 141.
4 Ollman, *Social and Sexual Revolution*, 67. See also Draper, *The Dictatorship of the Proletariat*.
5 Ollman, *Social and Sexual Revolution*, 95.
6 Ollman, *Social and Sexual Revolution*, 79.
7 If one person inadvertently does harm to another, he or she will be so overcome with remorse that the ostensible "victim" will see it as his or her task to alleviate the transgressor's lacerating guilt rather than seek their punishment. Marx and Engels, *The Holy Family*, 239. See also Lenin, "The Transition from Capitalism to Communism," in *State and Revolution*, chap. V.
8 Robert Tucker, in his essay "The Cunning of Reason," describes the "latent metaphysical character" that Marx assigns to the classes. Thus, the capitalist is "an anonymous, world-historical individual," as Tucker writes: "He is no one particular flesh-and-person, such as Alexander or Caesar in Hegel's philosophy, but simply anyone who fits into the role of capitalist. He is, as Marx in one place refers to him, 'Monsieur Capitalist,' the embodiment of a world-historical principle: 'As a capitalist, he is merely capital personified.'" Tucker, "The Cunning of Reason," 282.
9 Levin, *Marx, Engels and Liberal Democracy*, 83.
10 Marx, "Critique of Hegel's Philosophy of Right."
11 As Schiller writes, "the majority of men are far too wearied and exhausted by the struggle for existence to gird themselves for a new and harder struggle against error." Schiller, *Aesthetic Education*, 51.
12 Levin, *Marx, Engels and Liberal Democracy*, 153.

13 Levin, *Marx, Engels and Liberal Democracy*, 71.
14 Levin, *Marx, Engels and Liberal Democracy*, 70.
15 These terms are taken from *The German Ideology*. See Avineri, *Social and Political Thought*, 95.
16 Sartre, *The Communists and Peace*, 130.
17 Kevin Anderson addresses Lenin's tendency to "transcendentalize" the Party in *Lenin, Hegel and Western Marxism*, 167–69.
18 Pinkard, *Hegel*, 609.
19 This attitude is epitomized by the famous eleventh *Thesis on Feuerbach*: "Philosophers have hitherto only *interpreted* the world in various ways; the point is to *change* it." https://www.marxists.org/archive/marx/works/1845/theses/index.htm, accessed June 22, 2022.
20 I will explore these questions more fully in a forthcoming companion book, *Beyond the Sovereign Self*.
21 Liebman, *Leninism under Lenin*, 222.
22 Letter to Champfleury (November–December 1854) in Courbet, *Letters of Gustave Courbet*, 131.
23 Nochlin, *Realism*, 130.
24 Fourier, "The Phalanstery."
25 Harrison and Wood, *Art in Theory 1815–1900*, 39.
26 Egbert, "Idea of 'Avant-Garde,'" 343.
27 Poggioli, *The Theory of the Avant-Garde*, 9.
28 Egbert, *Social Radicalism and the Arts*, 122–23.
29 On the "two avant-gardes," see Poggioli, *The Theory of the Avant-Garde*, 8–12.
30 Letter from Courbet to his father, May 1871. See Larkin, "Courbet and the Commune," 257.
31 As Marx wrote in 1881: "apart from the fact that this was merely the rising of a city under exceptional conditions, the majority of the Commune was in no wise socialist, nor could it be." Schulkind, *Paris Commune*, 245.
32 Letter to George Izambard (Charleville, May 13, 1871), in Rimbaud, *Rimbaud Complete*, 369.
33 Letter to George Izambard (Charleville, May 13, 1871), in Rimbaud, *Rimbaud Complete*, 369.
34 "The Poet . . . undergoes unspeakable tortures that require complete faith and superhuman strength, rendering him the ultimate invalid among men, the master criminal, the first among the damned—and the supreme Savant!" Letter to Paul Demeny (May 15, 1871), in Rimbaud, *Rimbaud Complete*, 372.
35 Letter to George Izambard (Charleville, May 13, 1871), in Rimbaud, *Rimbaud Complete*, 369.
36 Ross, *Communal Luxury*, 66–67.
37 Letter to George Izambard (Charleville, May 13, 1871), in Rimbaud, *Rimbaud Complete*, 369.

38 Ross, *Communal Luxury*.
39 One thinks here of Ai Wei Wei's controversial decision to have himself photographed in the posture of Alyn Kurdi, the Syrian refugee child who drowned in the Mediterranean in September 2015.
40 See Marx, *The Civil War in France*, 67, and Trotsky, *Leon Trotsky on the Paris Commune*, 53.
41 Benjamin, *Charles Baudelaire*, 36.
42 Boime, *Art and the French Commune*.
43 Wood, "The Avant-Garde and the Paris Commune," 120.
44 Wood, "The Avant-Garde and the Paris Commune," 129. For an extended analysis of the constitutive tension between the political and the artistic in Impressionism, see Clark, *The Painting of Modern Life*.
45 Lenin, *What Is to Be Done?*, 132.
46 Lenin, *What Is to Be Done?*, 55.
47 Lenin, *What Is to Be Done?*, 31.
48 Hudis and Anderson, *The Rosa Luxemburg Reader*, 255.
49 See Figes, *A People's Tragedy*, 129.
50 Lenin, *What Is to Be Done?*, 49.
51 Lenin, *What Is to Be Done?*, 40.
52 Lenin, *What Is to Be Done?*, 40.
53 Lenin, *What Is to Be Done?*, 52.
54 Lenin, *What Is to Be Done?*, 39, 34, 53.
55 Lenin, *What Is to Be Done?*, 31.
56 This purism is also evident in the "social fascism" policy that emerged in the KPD during the late 1920s and 1930s, and which contributed to the success of the Nazi Party. The social fascism line was developed by the Comintern in 1924, under the assumption that international capitalism was entering a calamitous "third period" of imminent collapse. Under pressure from the Comintern, the KPD rejected any alliances with the Socialist Democratic Party (SPD), whose policies were equated with those of the Nazis. See the "Resolution on Fascism Adopted by the Fifth Comintern Congress," in Degras, *The Communist International*, 138.
57 Lenin, *What Is to Be Done?*, 85.
58 Nechayev, "The Revolutionary Catechism," 3.
59 Nechayev, "The Revolutionary Catechism," 4.
60 Harding, *Leninism*, 154.
61 Lenin, "The Trade Unions," 23.
62 This tension, between authoritarianism and hierarchy within the party leadership, and the innate desire for open, democratic processes among the Russian people, was evident in Bolshevik rule from its earliest stages. As historian John Keep notes, "Many trade-unionists could not see why rights which they had

won in struggle against employers should now be surrendered to organs of the new [Bolshevik] state." Keep, *The Debate on Soviet Power*, 15. See also Aves, *Workers against Lenin*.

63 As A. J. Polan notes, "What is perhaps interesting is that Lenin's view of the soviet as a governmental form was hardly more positive than his view of parliaments.... What is clearly absent from Lenin, even more than from the Menshevik account, is any conception of the soviets as the actual institutional structure of a post-revolutionary state." Polan, *Lenin and the End of Politics*, 150–51.

64 Keep, *The Debate on Soviet Power*, 22–23.

65 Keep, *The Debate on Soviet Power*, 22–23.

66 Radkey, *The Sickle under the Hammer*, 5.

67 Lenin, "A Contribution to the History," 50.

68 Lenin, "A Contribution to the History," 52.

69 Hosking, *Rulers and Victims*, 91.

70 As Lenin wrote to Joseph Stalin in November 1922, "We will cleanse Russia for a long time to come." Volkogonov, *Lenin*, 269.

71 Trotsky, "Communist Policy toward Art."

72 Chernyshevsky, *A Vital Question*, 276.

73 Chernyshevsky, *A Vital Question*, 214.

74 Chernyshevsky, *A Vital Question*, 212.

75 Chernyshevsky, *A Vital Question*, 220.

76 Chernyshevsky, *A Vital Question*, 386.

77 Chernyshevsky, *A Vital Question*, 219.

78 Volkogonov, *Lenin*, 260. See also Zarudnaya, *Trotsky's Diary in Exile*, 82.

79 Volkogonov, *Lenin*, 203.

80 Volkogonov, *Lenin*, 70. In "How to Organize Competition" (December 1917), Lenin advises: "In one place half a score of rich, a dozen rogues, half a dozen workers who shirk their work ... will be put in prison. In another place ... one out of every ten idlers will be shot on the spot." https://www.marxists.org/archive/lenin/works/1917/dec/25.htm, accessed June 22, 2022.

81 We can observe a similar embrace of extreme violence in Nechayev's "Revolutionary Catechism." Echoing Trotsky's concept of "social hatred," Nechayev defines the revolutionary in the following terms: "All the gentle and enervating sentiments of kinship, love, friendship, gratitude, and even honor, must be suppressed in him and give place to the cold and single-minded passion for revolution.... He knows only one science: the science of destruction." Nechayev, "The Revolutionary Catechism," 1.

82 In his struggle against "Oblomovism," or workplace idlers, Lenin turned as early as 1919 to the principles of Taylorism and Scientific Management. See Brunnbauer, "The League of Time."

83 Figes, *A People's Tragedy*, 734.

84 Cited by Cheng, *Creating the "New Man,"* 3.

85 Viktor Shklovsky captures this tension in a 1922 essay. "At first, they believed that their formula didn't conflict with life, that the mainspring of life was the 'spontaneous activity of the masses,' but regulated by their formula. And now their words lie in Russia like so many defunct rhinoceroses and mammoths." Shklovsky, *A Sentimental Journey*, 189.

86 Lenin, "Lessons of the Commune," 476.

87 Lenin, "The Transition from Capitalism to Communism." There is a significant literature devoted to the "withering away of the state" in the Marxist tradition. See Surin, "Withering Away of the State."

88 Lenin, "The Tasks of the Third International," 509. Lenin dismisses democratic processes as a "talking shop" in, among other places, "Revolutionary Office Routine," 62.

89 As Neil Harding observes in his study of Lenin, "where there were no classes there could be no politics." Harding, *Leninism*, 167.

90 See Polan's discussion of *State and Revolution* in *Lenin and the End of Politics*, 13–15.

91 Horkheimer, "The Authoritarian State," 105.

92 As Lenin wrote in *State and Revolution*, "only communism makes the state absolutely unnecessary, for there is nobody to be suppressed." Lenin, "The Transition from Capitalism to Communism."

93 Polan, *Lenin and the End of Politics*, 77.

94 Harding, *Leninism*, 153.

95 Luxemburg, "Organizational Questions," 308.

3. From Vanguard to Avant-Garde

1 Goddard, *Savage Tales*, 82.

2 Goldwater, *Primitivism in Modern Art*, 127.

3 de Chirico, "On Mystery and Creation," 9.

4 Janco, "Dada at Two Speeds," 36.

5 Tzara, "Dada Manifesto," 19.

6 Rosemont, "*La Revolution Surréaliste*, no. 5," 77.

7 Hülsenbeck, "Dada Forward," 48.

8 Lippard, *Dadas on Art*, 48.

9 Lippard, *Dadas on Art*, 49.

10 This period coincided with Lenin's efforts to open channels of communication with the West, prior to the launching of the New Economic Policy in 1921. The Bolsheviks were anxious to overcome reporting in the Western media that they were destroying art treasures from the Tsarist past, so any affiliation with a Dada movement that proclaimed its desire to trash the entirety of Germany's cultural heritage was perceived as problematic. McCloskey, *George Grosz*, 86.

11 McCloskey, *George Grosz*, 80–81.
12 McCloskey, *George Grosz*, 83.
13 McCloskey, *George Grosz*, 84.
14 Flavell, *George Grosz*, 312.
15 Flavell, *George Grosz*, 312.
16 McCloskey, *George Grosz*, 136, 137.
17 Michelson, *Kino Eye*, 66, 73.
18 Eisenstein, "The Problem of the Materialist Approach to Form," 62 (emphasis in original), 64.
19 In a 1919 manifesto, Vladimir Tatlin defines the artist as an "Initiative Individual" who "collects the energy of the collective." Tatlin, "The Initiative Individual," 309.
20 See Ehrlich, *Russian Formalism*, 78.
21 Shklovsky, "Art as Device," 5.
22 Shklovsky, "Art as Device," 6; emphasis in original.
23 Shklovsky, "Art as Device," 14.
24 Shklovsky, "Art as Device," 13.
25 Shklovsky, "Art as Device," 13–14. Shklovsky's analysis is striking because *Dubinushka* was frequently sung by protesting workers during the 1905 revolution.
26 Ehrlich, *Russian Formalism*, 260.
27 Ehrlich, *Russian Formalism*, 85.
28 Ehrlich, *Russian Formalism*, 106. See Kemény, "Photomontage as a Weapon in Class Struggle," 205.
29 Ehrlich, *Russian Formalism*, 136.
30 Piscator, *The Political Theater*, 27, 50.
31 See Loup, "The Theatrical Productions of Erwin Piscator," 46.
32 See Piscator, *The Political Theater*, 165–73.
33 Brecht, *Brecht on Theatre*, 80.
34 Piscator, *The Political Theater*, 46–47.
35 From *Die Rote Fahne* review of Jung's *Kanakans* (April 12, 1921), in Piscator, *The Political Theater*, 54.
36 Sochor, *Revolution and Culture*, 78.
37 Sochor, *Revolution and Culture*, 18.
38 On the history of Prolekult, see Mally, *Culture of the Future*.
39 On the demise of Prolekult, see Mally, *Culture of the Future*, 195–229.
40 Ehrlich, *Russian Formalism*, 48.
41 Mally, *Revolutionary Acts*, 26–28.
42 Aquilina, *Amateur and Proletarian Theater*, 77.
43 Aquilina, *Amateur and Proletarian Theater*, 79–80.

44 Mally, *Revolutionary Acts*, 109–45.
45 Although it was affiliated with Komsomol rather than Prolekult (which was brought under direct party control in 1920), TRAM carried forward the participatory and experimental spirit of Prolekult theater.
46 Mally, *Revolutionary Acts*, 129.
47 Aquilina, *Amateur and Proletarian Theater*, 59.
48 Aquilina, *Amateur and Proletarian Theater*, 58.
49 Sochor, *Revolution and Culture*, 170.
50 Russell, *Russian Drama*, 27.
51 Mellor, *Germany*, 47.
52 Herzog, *Elizabeth Catlett*, 94.
53 ASARO et al., *Getting Up for the People*.
54 Marx, "The British Rule in India," 5.
55 Wynter, "Unsettling the Coloniality of Being," 17.
56 White, "Black Metamorphosis," 139.
57 Wynter, "Black Metamorphosis," 546.
58 Wynter, "Black Metamorphosis," 410.
59 Gonsalvez, *Khadi*, 108.
60 See Hohaia et al., *Parihaka*.
61 Gonsalvez, *Khadi*, 113.
62 Vundru, *Ambedkar, Gandhi and Patel*, 34.

4. Activism and Autonomy in the 1960s

1 See Kester, "The Sound of Breaking Glass."
2 Debray, *Revolution in the Revolution*, 107.
3 Debray, *Revolution in the Revolution*, 65.
4 Debray, *Revolution in the Revolution*, 53–54.
5 Guevara, *Guerrilla Warfare*, 14.
6 "In the new context of struggle to the death, there is no place for spurious solutions ... there is no middle way." Debray, *Revolution in the Revolution*, 106.
7 Debray, *Revolution in the Revolution*, 112, 86.
8 Debray, *Revolution in the Revolution*, 43.
9 Debray, *Revolution in the Revolution*, 39.
10 The *foco*'s reliance on volunteerism and exemplary violence was questioned at the time by figures such as Abraham Guillén in his book *Estrategia de la Guerrilla Urbana*.
11 Debray, *Revolution in the Revolution*, 109. See also 84.
12 Debray, *Revolution in the Revolution*, 47.
13 Debray, *Revolution in the Revolution*, 113.
14 Debray, *Revolution in the Revolution*, 71.

15 Debray, *Revolution in the Revolution*, 112.
16 In 1965 we find Argentine artist Ricardo Carreira reiterating Rimbaud's identification with working-class insurrection, sublimated through his artistic production: "I paint this way because I can't join the shooting in Santo Domingo." Longoni, "'Vanguard' and 'Revolution,'" 66.
17 For a broader context, see Giunta, *Avant-Garde, Internationalism and Politics*.
18 Cereijido, "Assured Pasts," 67. As Cereijido notes: "It was 1968 and as the Tucuman Arde action was taking shape, [Carnevale] presented *Encierro*, the piece documented in the photograph that I saw in Kassel. For this piece she told me in the interview, it was her intention to induce the people into exemplary 'liberating violence.' The liberating violence was spiked by some elements of screwball comedy. The exterior wall and the door of the gallery were made of glass. Once the people were inside, Carnevale locked the door from outside. The glass was covered with posters that the trapped public (most of them students) proceeded to remove. Then a group attempted to take apart the hinges. A man that was passing by, seeing the desperation in some of the faces inside, broke the glass wall to let them out. At this point an artist friend who was inside as a mole, disappointed by the actions of the rescuer, hit him with an umbrella. There was pushing and shoving, angry insults and the noise of broken glass. It happened to be October ninth, the first anniversary of Che's assassination in Bolivia and the police were particularly alert. Soon a police battalion intervened and closed down the exhibit."
19 Katzenstein, *Listen, Here, Now!*, 295. In 1969, Luis Camnitzer argued that there was a "high density of aesthetic content" in the work of "certain guerilla groups, especially the Tupamaros and other urban groups." Camnitzer, "Contemporary Colonial Art," 229.
20 This and the above quotations are from Carnevale, "Project for the Experimental Art Series," 299.
21 Katzenstein, *Listen, Here, Now!*, 299.
22 Katzenstein, *Listen, Here, Now!*, 299.
23 Adorno, *Minima Moralia*, 28.
24 Adorno and Marcuse, "Correspondence," 125. I discuss this exchange in Kester, "Noisy Optimism."
25 Adorno and Marcuse, "Correspondence," 131.
26 See Richter and Adorno, "Who's Afraid of the Ivory Tower?," 15.
27 Adorno warns of the "compulsive pressure to deliver oneself, to join in," which he associates with the SDS. Richter and Adorno, "Who's Afraid of the Ivory Tower?," 15.
28 Richter and Adorno, "Who's Afraid of the Ivory Tower?," 17.
29 In Detlev Claussen's biography of Adorno he cites Adorno's comments on Lenin and Marx from a 1956 conversation with Horkheimer: "I always wanted to produce a theory that would be faithful to Marx, Engels and Lenin. . . . Marx was too harmless; he probably imagined quite naïvely that human beings are basically the

same in all essentials and will remain so. . . . The idea that human beings are the products of society down to their innermost core is an idea that he would have rejected as milieu theory. Lenin was the first person to assert this." Claussen, *Theodor W. Adorno*, 233.

30 Richter and Adorno, "Who's Afraid of the Ivory Tower?," 18. For a detailed account of Adorno's interactions with the SDS, see Wiggershaus, *The Frankfurt School*, 627–36.

31 Abromeit and Cobb, *Herbert Marcuse*, 43–50.

32 Adorno, *Aesthetic Theory*, 441.

33 Adorno, *Aesthetic Theory*, 440.

34 Adorno, *Aesthetic Theory*, 356.

35 See Wiggershaus, *The Frankfurt School*, 618.

36 Adorno, *Aesthetic Theory*, 356.

37 Wolin, "Utopia, Mimesis, and Reconciliation," 33–49.

38 Adorno, "Commitment," 180.

39 Adorno, *Aesthetic Theory*, 125.

40 Adorno, *Aesthetic Theory*, 118.

41 Adorno, *Aesthetic Theory*, 348.

42 Adorno, *Aesthetic Theory*, 347.

43 Buck-Morss, *The Origin of Negative Dialectics*, 40.

44 Adorno, *Aesthetic Theory*, 347.

45 This text is from the Robert Hullot-Kentor translation of *Aesthetic Theory*, which, in some cases, gives a more accurate rendering of the original. Adorno, *Aesthetic Theory* (Hullot-Kentor), 245.

46 This is the precondition for a "good universality that doesn't leave the particular out," as Adorno writes in "The Artist as Deputy," 100.

47 Adorno, *Aesthetic Theory* (Hullot-Kentor), 269.

48 Thus, the "people" are driven primarily by their desire for "even the most fleeting gratification . . . [and] force their eyes shut, and voice approval, in a kind of self-loathing, for what is meted out to them." Adorno, "Culture Industry Reconsidered," 12.

49 Adorno, *Aesthetic Theory*, 62.

50 Adorno, *Aesthetic Theory*, 345.

51 Adorno, *Aesthetic Theory* (Hullot-Kentor), 245–46.

52 Adorno, *Aesthetic Theory*, 60.

53 Adorno, *Aesthetic Theory*, 333.

54 Adorno, *Aesthetic Theory*, 440.

55 Adorno, *Aesthetic Theory*, 24.

56 Adorno, "The Artist as Deputy," 107.

57 Buck-Morss, *The Origin of Negative Dialectics*, 45; Adorno, *Aesthetic Theory*, 220.

58 Buck-Morss, *The Origin of Negative Dialectics*, 35.

59 Adorno, *Minima Moralia*, 26.
60 "If art were to raise its voice in direct protest against society's tightly woven mesh, it would surely get caught in it." Adorno, *Aesthetic Theory*, 194.
61 Adorno, *Aesthetic Theory*, 171.
62 Adorno, *Aesthetic Theory*, 247.
63 Adorno, *Aesthetic Theory*, 476.
64 Buck-Morss, *The Origin of Negative Dialectics*, 24–42.
65 Adorno, "The Artist as Deputy," 107.
66 This parallels Georg Lukács's distinction between the "empirical" and the "imputed" consciousness of the proletariat, with the artist taking on the role previously assigned to the revolutionary vanguard ("the Party is assigned the sublime role of bearer of the class consciousness of the proletariat and the conscience of its historical vocation"). Lukács, *History and Class Consciousness*, 41.
67 Honneth, *The Critique of Power*, 67.
68 See Dubiel, *Theory and Politics*, 100–104.
69 This quotation and the previous quotation are from Adorno, *Aesthetic Theory*, 136, 257.
70 Adorno, *Aesthetic Theory*, 272, 345.
71 Adorno, *Aesthetic Theory*, 135. "Critique," as Adorno writes, "interprets the spirit of works of art on the basis of the configurations in them. . . . That is why criticism is an essential and necessary component of art works" (131).
72 See Frow, "Mediation and Metaphor," 61.
73 Frow, "Mediation and Metaphor," 61, 60.
74 As Margherita Tonon has pointed out, "mediation" is not reciprocal for Adorno. "The 'object' can do without the subject but not the other way around." Tonon, "Theory and the Object," 191.
75 Osborne, *The Politics of Time*, 156, 152.
76 For a detailed analysis of the linkage between Adorno and James, see Castellano, *Art Activism*, 107–38.
77 James, "What Is Art?," 196.
78 James, *State Capitalism and World Revolution*, 98; James and Lee, *Facing Reality*, 92.
79 See Kalyva, "The Rhetoric of Disobedience."
80 Adorno, *Aesthetic Theory*, 441.
81 Jordan, "Joseph Beuys and Feminism," 145, 150.
82 de Duve, "Joseph Beuys."
83 de Duve, "Joseph Beuys," 55.
84 de Duve, "Joseph Beuys," 55.
85 For a symptomatic expression of this moment, see Terry Smith's 1976 essay "Without Revolutionary Theory." In the conclusion he asks "How do we begin to develop a revolutionary theory for cultural action? It has to be . . . grounded

in action. It has to explicitly embody the stage we are at in developing our social bases, not merely reflect bourgeois art (in the form of 'anti-art')." Smith, "Without Revolutionary Theory . . . ," 136.

86 Beuys, "Appeal for an Alternative," 752–53.

87 Sharp, "An Interview with Joseph Beuys," 85. See also Jordan, "Joseph Beuys and Social Sculpture."

88 Stachelhaus, *Joseph Beuys*, provides a useful overview of his organizational and activist work during this period. Also see Mesch, *Joseph Beuys*.

89 See Matthew Biro's discussion of Beuys's occupation of the Düsseldorf Academy of Art in "The Art of Joseph Beuys."

90 Beuys, "Appeal for an Alternative," 753.

91 Beuys, "Appeal for an Alternative," 753.

92 Gotz et al., *Joseph Beuys*, 231. Beuys was reacting to the close control that the German government exercised over admissions to the art school.

93 Beuys, "Every Man an Artist," 194.

94 Beuys, "Every Man an Artist," 195.

95 Atkinson, "Beuyspeak," 175.

96 Buchloh, "Twilight of the Idol."

97 Richter and Adorno, "Who's Afraid of the Ivory Tower?," 18.

98 Adorno, *Aesthetic Theory*, 441.

99 Adorno, *Aesthetic Theory*, 356.

100 Adorno, *Aesthetic Theory*, 441.

101 Maharaj, *The Dialectics of Aesthetic Agency*, 160.

102 See Lavazzi, "Punching the Line."

103 Morgan, *The Black Arts Movement*, 118.

104 Alkalimat et al., *The Wall of Respect*.

105 Bracey et al., *S.O.S. Calling All Black People*, 9, 6.

106 Lacy discusses this history in a 1990 interview in the Smithsonian Archives of American Art. Roth, "Oral History Interview."

107 Hanisch, "The Personal Is Political."

108 See Santone, "The Feminist Consciousness Raising Circle."

109 Santone, "The Feminist Consciousness Raising Circle," 56.

110 Irish, *Suzanne Lacy*, 49.

111 Lacy describes these as "mythic or celebratory events." Irish, *Suzanne Lacy*, 97.

112 Irish, *Suzanne Lacy*, 73.

5. The Rise of the Neo-Avant-Garde

1 Foster, "What's Neo," 29.

2 "About OCTOBER," 4.

3 "About OCTOBER," 4.

4 Bois, "Interview with Rosalind Krauss."
5 Lyotard, "Preliminary Notes"; Derrida, "Parergon."
6 Bollen, "Interview with Hal Foster."
7 German student activist Rudi Dutschke coined this term in 1967, evoking the Communist "Long March" through China under Mao.
8 Plante, "The Real Thing."
9 Greenberg, "Avant-Garde and Kitsch," 5.
10 Greenberg, "Avant-Garde and Kitsch," 21.
11 Elkins and Montgomery, *Beyond the Aesthetic*, 26.
12 Krauss, "Sculpture in the Expanded Field."
13 Krauss, *The Originality of the Avant-Garde*; Foster, *Anti-Aesthetic*.
14 We can gain some indication of *October*'s canonical ambitions in the 2004 publication of an art history textbook by several of the journal's leading editors. Titled *Art since 1900*, it sought to provide "the most comprehensive critical history of art in the twentieth and twenty-first centuries ever published." The book's approach very much reflects the central role assigned by *October* to the conventions of aesthetic autonomy in the avant-garde. As Steve Edwards notes in a trenchant review, for the authors "every attempt [by contemporary artists] to resurrect art without the (political) self-critique of autonomy entails a reactionary retreat." See Edwards, "October's Tomb."
15 Krauss, "Poststructuralism and the 'Paraliterary,'" 40.
16 Krauss, *Under Blue Cup*.
17 Bois, "Interview with Rosalind Krauss."
18 Shklovsky, *Theory of Prose*, 5.
19 Plante, "The Real Thing."
20 Foster, "What's Neo," 25.
21 "Our present is bereft of this sense of imminent revolution. . . . As a result, contemporary artists concerned to develop the institutional analysis of the second neo-avant-garde have moved away from grand *oppositions* to subtle *displacements*." Foster, "What's Neo," 25–26 (emphasis in original).
22 Foster, "What's Neo," 29.
23 Foster, "What's Neo," 16.
24 For an analysis of the "manufactured" character of trauma in deferred action, see Laplanche and Pontalis, *Language of Psychoanalysis*, 111–14.
25 Crimp's special issue on AIDS activism appeared in Winter 1987 (#43). Crimp discusses the journal's response in a 2008 interview. Danbolt, "Front Room–Back Room."
26 Foster, "What's Neo," 18.
27 Bollen, "Interview with Hal Foster."
28 Kester, *The One and the Many*.

29 Bishop, "The Social Turn," 183. Here Bishop argues that socially engaged art practices abandon all aesthetic criteria and instead subsume art into a set of "ethical" concerns associated with fashionable forms of "identity politics . . . and an inflexible mode of political correctness." An authentic art, on the other hand, disdains the parochial constraints of "ethics" and instead subjects the viewer to various forms of perceptual assault intended to inculcate a therapeutic sense of cognitive indeterminance. It is worth noting the extent to which Bishop's attack on "identity politics" and "political correctness" mirrors, consciously or not, the rhetoric of neoconservativism in the United States during this period. These terms served as coded references to artistic practices developed specifically by artists of color and are linked with a conservative backlash against the perceived erosion of proper aesthetic criteria resulting from the emergence of art practices concerned with challenging the normative whiteness of the institutional art world.

30 Buchloh, "Farewell to an Identity," 261.

31 Buchloh, *Formalism and Historicity*, 290, 324.

32 Buchloh, *Formalism and Historicity*, 100.

33 Buchloh, *Neo-Avantgarde and Culture Industry*, x.

34 Baker, *James Coleman*, 96.

35 Baker, *James Coleman*, 104, 100.

36 Baker, *James Coleman*, 99.

37 Roberts, *Revolutionary Time and the Avant-Garde*, 221, 121.

38 Roberts, *Revolutionary Time and the Avant-Garde*, 223.

39 Roberts, *Revolutionary Time and the Avant-Garde*, 55.

40 Roberts, *Revolutionary Time and the Avant-Garde*, 86.

41 Roberts, *Revolutionary Time and the Avant-Garde*, 115.

42 Roberts, *Revolutionary Time and the Avant-Garde*, 113.

43 Roberts, *Revolutionary Time and the Avant-Garde*, 113.

44 Roberts, *Revolutionary Time and the Avant-Garde*, 152. This self-referential quality is evident in the gallery-based work of Art and Language as well. It is typified by *Index 01* (1972) at Documenta, which consisted of a set of filing cabinets filled with their own written texts and conversations; effectively consecrating the aesthetic value of the collective's "intra-group dialogues."

45 Roberts, *Revolutionary Time and the Avant-Garde*, 223.

46 Roberts, *Revolutionary Time and the Avant-Garde*, 28, 32.

47 Roberts, *Revolutionary Time and the Avant-Garde*, 247. "Nowhere," Roberts insists, "is art able to provide a stable space or point of identification for collective politics from below" (217).

48 Roberts, *Revolutionary Time and the Avant-Garde*, 210.

49 Roberts, *Revolutionary Time and the Avant-Garde*, 184.

50 Roberts, *Revolutionary Time and the Avant-Garde*, 200.

51 Roberts, *Revolutionary Time and the Avant-Garde*, 228.

52 Roberts, *Revolutionary Time and the Avant-Garde*, 117.
53 Adorno, *Aesthetic Theory*, 123.
54 Roberts, *Revolutionary Time and the Avant-Garde*, 219.
55 Roberts, *Revolutionary Time and the Avant-Garde*, 258.
56 Roberts, *Revolutionary Time and the Avant-Garde*, 22–23.
57 Roberts, *Revolutionary Time and the Avant-Garde*, 7.
58 See Smith, *Art to Come*.
59 Roberts, *Revolutionary Time and the Avant-Garde*, 28.
60 Roberts, *Revolutionary Time and the Avant-Garde*, 24.
61 Roberts, *Revolutionary Time and the Avant-Garde*, 54.
62 Roberts, *Revolutionary Time and the Avant-Garde*, 62.
63 Roberts, *Revolutionary Time and the Avant-Garde*, 90.
64 Roberts, *Revolutionary Time and the Avant-Garde*, 117.
65 Roberts, *Revolutionary Time and the Avant-Garde*, 56.
66 Roberts, *Revolutionary Time and the Avant-Garde*, 67.
67 Roberts, *Revolutionary Time and the Avant-Garde*, 156.
68 Roberts, *Revolutionary Time and the Avant-Garde*, 89.
69 Roberts, *Revolutionary Time and the Avant-Garde*, 58.
70 Roberts, *Revolutionary Time and the Avant-Garde*, 151.
71 Roberts, *Revolutionary Time and the Avant-Garde*, 141, 142.
72 Roberts, *Revolutionary Time and the Avant-Garde*, 150.
73 Roberts, *Revolutionary Time and the Avant-Garde*, 228.
74 Roberts, *Revolutionary Time and the Avant-Garde*, 93.
75 Roberts, *Revolutionary Time and the Avant-Garde*, 211.
76 Roberts, *Revolutionary Time and the Avant-Garde*, 103, 257.
77 Roberts, *Revolutionary Time and the Avant-Garde*, 195.
78 Art must be "theoretically driven," as he writes. Roberts, *Revolutionary Time and the Avant-Garde*, 3, 228.
79 Roberts, *Revolutionary Time and the Avant-Garde*, 68. This is evident in what he terms the "radical appropriation" of analytic philosophy by Art and Language and the emergence of a "scriptovisual" paradigm in the work of Victor Burgin.
80 Roberts, *Revolutionary Time and the Avant-Garde*, 218.
81 Roberts, *Revolutionary Time and the Avant-Garde*, 218.
82 Roberts, *Revolutionary Time and the Avant-Garde*, 217–18.
83 Roberts, *Revolutionary Time and the Avant-Garde*, 210, 247.
84 Roberts, *Revolutionary Time and the Avant-Garde*, 177.
85 Chto Delat, "Why Brecht?"
86 Roberts, *Revolutionary Time and the Avant-Garde*, 193.
87 Roberts, *Revolutionary Time and the Avant-Garde*, 178.
88 Roberts, *Revolutionary Time and the Avant-Garde*, 220.

89 Roberts, *Revolutionary Time and the Avant-Garde*, 191.
90 Roberts, *Revolutionary Time and the Avant-Garde*, 22.
91 Burgin was Professor Emeritus of the History of Consciousness at UC Santa Cruz, the Robert Gwathmey Chair in Art and Architecture at the Cooper Union in New York, and the Millard Professor of Fine Art at Goldsmiths College, University of London.
92 Sandals, "10 Thoughts."
93 City of Toronto website, "Nuit Blanche Toronto," https://nbto.com/program/art-projects/curated-exhibitions/century-of-revolutions.html, accessed June 22, 2022.
94 Chto Delat, "Rosa's House of Culture."
95 Rasmussen, "The Self-Destruction of the Avant-Garde," 124.
96 See, for example, Bosteels, *Philosophies of Defeat*.

6. The Hirschhorn Monument

1 Greg Sholette examines some of the contradictions that have emerged as mainstream art institutions have sought to embrace various forms of "social" art practice in recent years in *The Art of Activism*.
2 Roberts, *Revolutionary Time and the Avant-Garde*, 71.
3 See, for example, Kelley and Kester, *Collective Situations*; Castellano, "Decentering the Genealogies of Art Activism."
4 A collection of his writings published by MIT Press was coedited by Hal Foster. Benjamin Buchloh coedited a Phaidon monograph on his work, and the journal has featured several interviews and essays on his work over the years.
5 Artspace Editors, "Quality, No! Energy, Yes!"
6 See Dezeuze, *Thomas Hirschhorn*.
7 Lee and Foster, *Critical Laboratory*, xii, xiii.
8 Thomas Hirschhorn quoted in Garrett, "Philosophical Battery."
9 Garrett, "Philosophical Battery."
10 Artspace Editors, "Quality, No! Energy, Yes!"
11 Lee and Foster, *Critical Laboratory*, 330.
12 Hirschhorn, "Doing Art Politically."
13 Hirschhorn, "Doing Art Politically."
14 Schmelzer, "Thomas Hirschhorn on *Cavemanman*."
15 Roberts, *Revolutionary Time and the Avant-Garde*, 208.
16 Foster, "Towards a Grammar of Emergency."
17 Foster, "Towards a Grammar of Emergency," 114, 108.
18 Foster, "Towards a Grammar of Emergency," 117.
19 Foster, "Towards a Grammar of Emergency," 107–8.
20 Buchloh, "Detritus and Decrepitude," 48.

21 Buchloh, "An Interview with Thomas Hirschhorn," 87.
22 Lee and Foster, *Critical Laboratory*, xiii.
23 Bishop, "The Social Turn"; Rasmussen, "A Note on Socially Engaged Art Criticism."
24 Hirschhorn, "What I Learned," 447.
25 "Ask the artist to describe his piece . . . and he will tell you that it was 'pure art.'" Rose, "Monumental Endeavor," 226.
26 Lee and Foster, *Critical Laboratory*, 377.
27 Bishop, *Artificial Hells*, 264. Also see Schjeldahl, "House Philosopher," 76 ("this is no social-work experiment, but 'pure art'").
28 Lee and Foster, *Critical Laboratory*, 300.
29 Lee and Foster, *Critical Laboratory*, 319, 325.
30 Birrell, "The Headless Artist."
31 Hirschhorn, *Gramsci Monument*, 54.
32 For a relatively small investment, by the standards of the international art world (the total budget was around $500,000), *Gramsci Monument* generated a great deal of highly beneficial publicity for the agencies involved. The two Dia staff members who played a lead role in the project (director Philippe Vergne and curator Yasmil Raymond) went on to prestigious positions (Vergne is now director of the Museum of Contemporary Art in Los Angeles and Raymond is a curator at the Museum of Modern Art in New York), due in no small part to the successful reception of the *Gramsci Monument* commission.
33 Schjeldahl, "House Philosopher," 76.
34 Schjeldahl, "House Philosopher," 77.
35 Raymond, "Desegregating the Experience of Art"; Hirschhorn, *Gramsci Monument*, 17.
36 Morris, "On Embodying," 323. As Marcella Paradise, the chief librarian for *Gramsci Monument*, observed: "Whites saw that they could walk through a Black community and not have anything to fear. Whoever thought that you would see whites in and out of the projects?" (304).
37 Schiller, *Aesthetic Education*, 217.
38 Hirschhorn, *Gramsci Monument*, 54.
39 Garrett, "Philosophical Battery."
40 Hirschhorn, *Gramsci Monument*, 54.
41 Raymond, "Desegregating the Experience of Art," 24.
42 See Kester, "Evangelical Aesthetics."
43 Raymond, "Desegregating the Experience of Art," 25.
44 Hirschhorn, *Gramsci Monument*, 445.
45 Hirschhorn, *Gramsci Monument*, 445.
46 Birrell, "The Headless Artist."

47 A New York–based blogger named Susan Bernofsky posted this revealing observation about Hirschhorn following a trip to *Gramsci Monument*: "At one point I heard Hirschhorn regaling an audience with a story of how the NYPD arrived one evening in an armed posse, saying that leaving the monument up overnight violated some law; they were intending to dismantle it. Hirschhorn talked them down with John Wayne–style bravura. And to hear him tell it, he seems to think his local collaborators might have done the same if they only had the self-confidence. I'm thinking his collaborators must have neglected to initiate him into the finer points of police/community relations in the Bronx (either that or he wasn't listening)." See Bernofsky, "Hirschhorn on Robert Walser."

48 Lee and Foster, *Critical Laboratory*, 340.

49 Kennedy, "Bringing Art and Change to Bronx."

50 In this process, Hirschhorn made use of "social workers" from youth centers, senior centers, and community development corporations in New York City to provide him with access to residents who had, as he described it, "street credibility." In particular, they had to have sufficient "charisma" and "authority" in the community to help defuse any suspicion from the residents regarding Hirschhorn's presence in their housing complexes. See the "Debrief" documents in the "FIELDWORK" section of the *Gramsci Monument* archival site, http://www.diaart.net/gramsci-monument/page50.html, accessed June 22, 2022.

51 *Gramsci Monument* archival site, http://www.diaart.net/gramsci-monument/page50.html, accessed June 22, 2022.

52 New York City Housing Authority, "Forest Houses Residents to Help Build New Art Monument," press release, May 15, 2013, https://www1.nyc.gov/site/nycha/about/press/pr-2013/nycha-forest-houses-residents-to-help-build-new-art-monument.page.

53 As Farmer remarks: "There's nothing cultural here at all. It's like we're in a box here, in this neighborhood. . . . This is kind of like the world coming to us for a little while." Kennedy, "Bringing Art and Change to Bronx."

54 Roberts, *Revolutionary Time*, 258.

55 In 2016, the 42nd Precinct, where Forest Houses is located, experienced 489 assaults, 321 robberies, thirty-seven rapes, and eight murders. And the Forest Houses school district (district number 9) has the highest percentage of homeless students in New York City's thirty-two districts.

56 Hirschhorn, *Gramsci Monument*, 54.

57 Hirschhorn, *Gramsci Monument*, 52.

58 Hirschhorn, *Gramsci Monument*, 52.

59 Lookofsky, "Thomas Hirschhorn's Project in the Projects."

60 These quotes are from a *Gramsci Monument* documentary produced by Art21 (episode 221, May 22, 2015), http://magazine.art21.org/2015/05/22/perspectives-from-the-gramsci-monument/#.XN2sG9NKhTY.

61 Hirschhorn, *Gramsci Monument*, 52.
62 Including notorious arrest quotas in the 42nd Precinct. See King, "Soul Snatchers."
63 Kimball, "How Do People Feel."
64 Kimball, "How Do People Feel."
65 Schmelzer, "The Momentary Monument."
66 Kimball, "How Do People Feel."
67 Raymond, "Desegregating the Experience of Art," 25.
68 L. Brown, "Monument Time," 231.
69 Raymond, "Ambassador's Notes," 257.
70 Kimball, "How Do People Feel." Critic Ben Davis makes a similar argument in a review for *ArtInfo*. See Davis, "Thomas Hirschhorn's 'Gramsci Monument.'"
71 Buchloh, "Precarious Publics," 436–37.

Conclusion

1 Vergne, "A Monument as a Garden," 453.
2 Schiller, *Aesthetic Education*, 219.
3 Gramsci, *Prison Notebooks*, 350.
4 In 1919, Gramsci cofounded the journal *L'Ordine Nuovo* to support the cultural development of the Italian working class and a "School of Culture and Propaganda," which was directly modeled after Prolekult organizations in Russia. See Sochor, "Was Bogdanov Russia's Answer to Gramsci?"

WORKS CITED

"About OCTOBER." *October* 1 (Spring 1976): 3–5.
Abromeit, John, and Mark W. Cobb, eds. *Herbert Marcuse: A Critical Reader*. London: Routledge, 2003.
Adorno, Theodor. *Aesthetic Theory*. Edited by Gretel Adorno and Rolf Tiedemann. Translated by C. Lenhardt. London: Routledge, 1984.
Adorno, Theodor. *Aesthetic Theory*. Edited by Gretel Adorno and Rolf Tiedemann. Translated, edited, and with an introduction by Robert Hullot-Kentor. Minneapolis: University of Minnesota Press, 1997.
Adorno, Theodor. "The Artist as Deputy." In *Notes to Literature*, vol. 1, translated by Shierry Weber Nicholsen, 98–108. New York: Columbia University Press, 1991.
Adorno, Theodor. "Commitment." In *Aesthetics and Politics: Debates between Bloch, Lukács, Brecht, Benjamin and Adorno*, translated and edited by Ronald Taylor, 177–95. London: Verso, 1977.
Adorno, Theodor. "Culture Industry Reconsidered." Translated by Anson G. Rabinbach. *New German Critique* 6 (Fall 1975): 12–19.
Adorno, Theodor. *Minima Moralia: Reflections from a Damaged Life*. Translated by E. F. N. Jephcott. London: Verso, 1984.

Adorno, Theodor, and Herbert Marcuse. "Correspondence on the German Student Movement." *New Left Review* 233 (January–February 1999): 123–26.

Ahlers, Jesse. "The Puzzling Spectrum between Art and Life." In *The Autonomy Project: Newspaper #3, At Work*, 44–47. Eindhoven: Onomatopee, 2012. https://theautonomyproject.org/newspapers.

Alkalimat, Abdul, Rebecca Zorach, and Romi Crawford, eds. *The Wall of Respect: Public Art and Black Liberation in 1960s Chicago*. Evanston, IL: Northwestern University Press, 2017.

Anderson, Kevin. *Lenin, Hegel and Western Marxism: A Critical Study*. Urbana: University of Illinois Press, 1995.

Aquilina, Stefan, ed. *Amateur and Proletarian Theater in Post-Revolutionary Russia: Primary Sources*. London: Methuen Drama, 2021.

Artspace Editors. "Quality, No! Energy, Yes! Thomas Hirschhorn on Why Confrontation Is Key When Making Art for the Public." Artspace, November 18, 2016. https://www.artspace.com/magazine/art_101/book_report/phaidon-thomas-hirschhorn-interview-54368.

ASARO, Mike Graham de la Rosa, and Suzanne M. Schadl, eds. *Getting Up for the People: The Visual Revolution of ASAR-Oaxaca*. Oakland, CA: PM Press, 2014.

Atkinson, Terry. "Beuyspeak." In *Joseph Beuys: Diverging Critiques*, edited by David Thistlewood, 162–81. Liverpool: Tate Gallery, 1995.

Aves, Jonathan. *Workers against Lenin: Labor Protest and the Bolshevik Dictatorship, 1920–22*. London: Bloomsbury, 1996.

Avineri, Shlomo. *Hegel's Theory of the Modern State*. Cambridge: Cambridge University Press, 1974.

Avineri, Shlomo. *The Social and Political Thought of Karl Marx*. Cambridge: Cambridge University Press, 1988.

Babeuf, François-Noël. "Babeuf's Defense from the Trial at Vendôme, February–May 1797" (1797). In *Socialist Thought: A Documentary History*, edited by Albert Fried and Ronald Sanders, 56–71. Chicago: Aldine, 1964.

Badiou, Alain. "Destruction, Negation, Subtraction: On Pier Paolo Pasolini." Art Center College of Design in Pasadena, California, February 6, 2007. http://www.lacan.com/badpas.htm.

Badiou, Alain. "Fifteen Theses on Contemporary Art." Lecture at the Drawing Center (New York City), December 4, 2003. https://www.lacan.com/issue22.php.

Baker, George, ed. *James Coleman*. Cambridge, MA: MIT Press, 2003.

Ball, Hugo. Diary entry for October 11, 1917. In *Flight Out of Time: A Dada Diary by Hugo Ball*, edited by John Elderfield, translated by Ann Raimes, 98. Berkeley: University of California Press, 1996.

Barrell, John. "The Public Prospect and the Private View: The Politics of Taste in Eighteenth-Century Britain." In *Reading Landscape: Country-City-Capital*, edited by Simon Pugh, 41–61. Manchester: Manchester University Press, 1990.

Benjamin, Walter. *Charles Baudelaire: Lyric Poet in the Era of High Capitalism*. London: Verso, 1983.

Bennett, Jill. *Pragmatist Aesthetics: Events, Affects and Art after 9.11*. London: I. B. Tauris, 2012.

Bensaïd, Daniel. "Alain Badiou and the Miracle of the Event." In *Think Again: Alain Badiou and the Future of Philosophy*, edited by Peter Hallward, 94–105. London: Continuum, 2004.

Bernofsky, Susan. "Thomas Hirschhorn on Robert Walser." *Translationista*, September 10, 2013. http://translationista.com/2013/09/thomas-hirschhorn-on-robert-walser.html.

Bernstein, J. M., ed. *Classic and Romantic German Aesthetics*. Cambridge: Cambridge University Press, 2003.

Bernstein, J. M. *The Fate of Art: Aesthetic Alienation from Kant to Derrida to Adorno*. University Park: Pennsylvania State University Press, 1992.

Bertram, Georg W. *Art as Human Practice*. Translated by Nathan Ross. London: Bloomsbury, 2019.

Beuys, Joseph. "Appeal for an Alternative" (originally published in the *Frankfurter Rundschau* on December 23, 1978). In *Theories and Documents of Contemporary Art: A Sourcebook of Artists' Writings*, edited by Kristine Stiles and Peter Selz, 2nd ed. revised and expanded by Kristine Stiles, 752–53. Berkeley: University of California Press, 2012.

Beuys, Joseph. "Every Man an Artist: Talks at Documenta 5" (1972). Translated by Clara Bodenmann-Ritter. In *Joseph Beuys: The Reader*, edited by Claudia Mesch and Viola Michely, 189–97. Cambridge, MA: MIT Press, 2007.

Biro, Matthew. "The Art of Joseph Beuys." *Journal of the International Institute* 2, no. 2 (Winter 1995). http://quod.lib.umich.edu/j/jii/4750978.0002.203/--arts-of-joseph-beuys?rgn=main;view=fulltext.

Birrell, Rosa. "The Headless Artist: An Interview with Thomas Hirschhorn." *Art and Research: A Journal of Ideas, Contexts and Methods* 3, no. 1 (Winter 2009–2010). http://www.artandresearch.org.uk/v3n1/pdfs/hirschhorn2.pdf.

Bishop, Claire. "Another Turn." *Artforum International* 44, no. 9 (May 2006): 22–23.

Bishop, Claire. *Artificial Hells*. London: Verso, 2012.

Bishop, Claire. "The Social Turn: Collaboration and Its Discontents." *Artforum International* 44, no. 6 (February 2006): 178–83.

Boime, Albert. *Art and the French Commune: Imagining Paris after War and Revolution*. Princeton, NJ: Princeton University Press, 1997.

Bois, Yve-Alain. "Interview with Rosalind Krauss." *Brooklyn Rail*, February 1, 2012. http://www.brooklynrail.org/2012/02/art/rosalind-krauss-with-yve-alain-bois.

Bollen, Christopher. "Interview with Hal Foster." *Interview*, December 5, 2014. https://www.interviewmagazine.com/art/hal-foster-the-insiders.

Bosteels, Bruno. *Philosophies of Defeat: The Jargon of Finitude*. London: Verso, 2019.

Bracey, John H., Sonia Sanchez, and James Smethurst, eds. *S.O.S. Calling All Black People: A Black Arts Movement Reader*. Amherst: University of Massachusetts Press, 2014.

Brecht, Bertolt. *Brecht on Theatre: The Development of an Aesthetic*. Edited and translated by John Willett. New York: Hill and Wang, 1964.

Brown, Lex. "Monument Time." In *Gramsci Monument*, edited by Stephen Hoban, Yasmil Raymond, and Kelly Kivland, 230–33. New York: Dia Art Foundation, 2013.

Brown, Nicholas. *Autonomy: The Social Ontology of Art under Capitalism*. Durham, NC: Duke University Press, 2019.

Brunnbauer, Ulf. "The League of Time: Problems of Making a Soviet Working Class in the 1920s." *Russian History* 27, no. 4 (Winter 2000): 461–95.

Buchenau, Stefanie. *The Founding of Aesthetics in the German Enlightenment*. Cambridge: Cambridge University Press, 2013.

Buchloh, Benjamin H. D. "Detritus and Decrepitude: The Sculpture of Thomas Hirschhorn." *Oxford Art Journal* 24, no. 2 (2001): 43–56.

Buchloh, Benjamin H. D. "Farewell to an Identity." *Artforum International* (December 2012): 252–63.

Buchloh, Benjamin H. D. *Formalism and Historicity: Models and Methods in Twentieth-Century Art*. Cambridge, MA: MIT Press, 2015.

Buchloh, Benjamin H. D. "An Interview with Thomas Hirschhorn." *October* 113 (Summer 2005): 77–100.

Buchloh, Benjamin H. D. *Neo-Avantgarde and Culture Industry: Essays on European and American Art from 1955–1975*. Cambridge, MA: MIT Press, 2001.

Buchloh, Benjamin H. D. "Precarious Publics and the Public Precariat: Thomas Hirschhorn's Gramsci Monument." In *Gramsci Monument*, edited by Stephen Hoban, Yasmil Raymond, and Kelly Kivland, 436–37. New York: Dia Art Foundation, 2013.

Buchloh, Benjamin H. D. "Twilight of the Idol: Preliminary Notes for a Critique." *Artforum International* 18, no. 5 (January 1980): 5–43.

Buck-Morss, Susan. *Hegel, Haiti and Universal History*. Pittsburgh, PA: University of Pittsburgh Press, 2009.

Buck-Morss, Susan. *The Origin of Negative Dialectics: Theodor W. Adorno, Walter Benjamin, and the Frankfurt Institute*. New York: Free Press, 1977.

Budgen, Sebastian, Stathis Kouvelakis, and Slavoj Žižek, eds. *Lenin Reloaded: Toward a Politics of Truth*. Durham, NC: Duke University Press, 2007.

Burgos, Jonathan, and Netty Ismail. "New York Apartments Top Gold as Stores of Wealth Says Fink." *Bloomberg News*, April 20, 2015. http://www.bloomberg.com/news/articles/2015-04-21/new-york-apartments-art-top-gold-as-stores-of-wealth-says-fink.

Camnitzer, Luis. "Contemporary Colonial Art." In *Conceptual Art: A Critical Anthology*, edited by Alexander Alberro and Blake Stimson, 224–31. Cambridge, MA: MIT Press, 1999.

Carnevale, Graciela. "Project for the Experimental Art Series" (1968). In *Listen, Here, Now! Argentine Art of the 1960s: Writings of the Avant-Garde*, edited by Ines Katzenstein, 229–301. New York: Museum of Modern Art, 2004.

Castellano, Carlos Garrido. *Art Activism for an Anti-Colonial Future*. Albany: State University of New York Press, 2021.

Castellano, Carlos Garrido, ed. "Decentering the Genealogies of Art Activism." Special issue, *Third Text* 34, no. 4–5 (2020).

Cereijido, Fabián. "Assured Pasts or Gambled Futures: Contrasting Approaches to Context in Selected 20th Century Mexican and Argentine Art Practices." PhD diss., University of California, San Diego, 2010.

Cheng, Yinghong. *Creating the "New Man": From Enlightenment Ideals to Socialist Realities*. Honolulu: University of Hawai'i Press, 2009.

Chernyshevsky, Nikolai G. *A Vital Question: What Is to Be Done?* Translated by Nathan Haskell Doyle and S. S. Skidelsky. New York: Thomas Y. Crowell, 1886.

Chto Delat. "#11: Why Brecht?" Accessed June 22, 2022. https://chtodelat.org/category/b8-newspapers/12-63/.

Chto Delat. "Rosa's House of Culture." Accessed October 6, 2022. https://chtodelat.org/category/c215-embodied-projects/.

Chuh, Kandice. *The Difference Aesthetics Makes*. Durham, NC: Duke University Press, 2019.

Chytry, Joseph. *The Aesthetic State: A Quest in Modern German Thought*. Berkeley: University of California Press, 1989.

Clark, T. J. *The Painting of Modern Life: Paris in the Art of Manet and His Followers*. New York: Knopf, 1985.

Claussen, Detlev. *Theodor W. Adorno: One Last Genius*. Translated by Rodney Livingston. Cambridge, MA: Harvard Belknap Press, 2008.

Comay, Rebecca. "Dead Right: Hegel and the Terror." *South Atlantic Quarterly* 103, no. 2–3 (Spring–Summer 2004): 375–94.

Comay, Rebecca. *Mourning Sickness: Hegel and the French Revolution*. Stanford, CA: Stanford University Press, 2011.

Courbet, Gustave. *Letters of Gustave Courbet*. Translated by Petra ten-Doesschate Chu. Chicago: University of Chicago Press, 1992.

Courbet, Gustave. "Letter to Alfred Bruyas." In *Letters of Gustave Courbet*, translated by Petra ten-Doesschate Chu, 416–18. Chicago: University of Chicago Press, 1992.

Danbolt, Mathias. "Front Room–Back Room: An Interview with Douglas Crimp." *Trikster* no. 2 (2008). http://trikster.net/2/crimp/4.html.

Davis, Ben. "Thomas Hirschhorn's 'Gramsci Monument' Transcends Its Own Conceit." ArtInfo, September 5, 2013. https://gladstonegallery.com/sites/default/files/TH_ArtInfo_Sept13_e.pdf.

Debray, Régis. *Revolution in the Revolution*. Translated by Bobbye Ortiz. New York: Grove Press, 1967.

de Chirico, Giorgio. "On Mystery and Creation." In *Dadas on Art*, edited by Lucy R. Lippard, 9. Englewood Cliffs, NJ: Prentice-Hall, 1971.

de Duve, Thierry. "Joseph Beuys, or the Last of the Proletarians." *October* 45 (Summer 1988): 47–62.

Degras, Jane, ed. *The Communist International: Documents*, vol. 2, *1923–1928*. London: Frank Cass, 1971.

Derrida, Jacques. "Parergon." *October* 9 (Summer 1979): 3–14.

Dezeuze, Anna. *Thomas Hirschhorn: Deleuze Monument*. Cambridge, MA: MIT Press, 2014.

Draper, Hal. *The Dictatorship of the Proletariat from Marx to Lenin*. New York: Monthly Review Press, 1987.

Dubiel, Helmut. *Theory and Politics: Studies in the Development of Critical Theory*. Translated by Benjamin Gregg. Cambridge, MA: MIT Press, 1985.

Edwards, Steve. "October's Tomb." *Radical Philosophy* 138 (July/August 2006): 43–46.

Egbert, Donald D. "The Idea of 'Avant-Garde' in Art and Politics." *American Historical Review* 73, no. 2 (December 1967): 339–66.

Egbert, Donald Drew. *Social Radicalism and the Arts: Western Europe*. New York: Alfred Knopf, 1970.

Ehrlich, Victor. *Russian Formalism: History-Doctrine*. New Haven, CT: Yale University Press, 1981.

Eisenstein, Sergei. "The Problem of the Materialist Approach to Form." In *The Eisenstein Reader*, edited by Richard Taylor, 59–64. London: BFI, 1998.

Elkins, James, and Harper Montgomery, eds. *Beyond the Aesthetic and the Anti-Aesthetic*. University Park: Pennsylvania State University Press, 2013.

Eze, Emmanuel Chukwudi. *Race and the Enlightenment: A Reader*. Oxford: Blackwell, 1997.

Figes, Orlando. *A People's Tragedy: The Russian Revolution*. New York: Viking, 1997.

Flavell, Mary Kay. *George Grosz, a Biography*. New Haven, CT: Yale University Press, 1988.

Foster, Hal, ed. *Anti-Aesthetic: Essays on Postmodern Culture*. Seattle: Bay Press, 1983.

Foster, Hal. "Towards a Grammar of Emergency." *New Left Review* 68 (March–April 2011): 105–18.

Foster, Hal. "What's Neo about the Neo-Avant-Garde?" *October* 70 (Autumn 1994): 5–32.

Fourier, Charles. "The Phalanstery" (1850). Accessed June 22, 2022. https://www.marxists.org/reference/archive/fourier/works/ch27.htm.

Frow, John. "Mediation and Metaphor: Adorno and the Sociology of Art." *Clio* 12, no. 1 (Fall 1982): 57–66.

Garrett, Craig. "Philosophical Battery: Thomas Hirschhorn." *Flash Art* no. 238 (October 2004). https://www.papercoffin.com/writing/articles/hirschhorn.html.

Germana, Nicholas A. *The Anxiety of Autonomy and the Aesthetics of German Orientalism*. Rochester, NY: Camden House, 2017.

Ginsborg, Hannah. "Lawfulness without a Law: Kant on the Free Play of Imagination and Understanding." *Philosophical Topics* 25, no. 1 (Spring 1997): 37–82.

Giunta, Andrea. *Avant-Garde, Internationalism and Politics: Argentine Art in the 1960s*. Durham, NC: Duke University Press, 2007.

Goddard, Linda. *Savage Tales: The Writings of Paul Gauguin*. New Haven, CT: Yale University Press, 2019.

Goldwater, Robert. *Primitivism in Modern Art*. Cambridge, MA: Harvard University Press, 1986.

Gonsalvez, Peter. *Khadi: Gandhi's Mega Symbol of Subversion*. New Delhi: Sage Press, 2012.

Gorky, Maxim. "For the Attention of the Workers" (November 10, 1917). In *Untimely Thoughts: Essays on Revolution, Culture and the Bolsheviks 1917–1918*, 87–89. New Haven, CT: Yale University Press, 1995.

Gotz, Adriani, Winfried Konnertz, and Thomas Karin. *Joseph Beuys: Life and Works*. New York: Barron's Educational Series, 1979.

Gramsci, Antonio. *Selections from the Prison Notebooks*. Edited and translated by Quinin Hoare and Geoffrey Nowell Smith. New York: International Publishers, 1971.

Greenberg, Clement. "Avant-Garde and Kitsch." In *Art and Culture: Critical Essays*, 3–21. Boston: Beacon Press, 1961.

Guevara, Che. *Guerrilla Warfare*. Lincoln: University of Nebraska Press, 1985.

Guillén, Abraham. *Estrategia de la Guerrilla Urbana*. Montivideo: Manueles de Pueblo, 1966.

Habermas, Jürgen. "From Kant to Hegel and Back Again—The Move towards Detranscendentalization." *European Journal of Philosophy* 7, no. 2 (1999): 129–57.

Haks, Frans. "Interview with Joseph Beuys" (1976). In *Joseph Beuys: Diverging Critiques*, edited by David Thistlewood, 36–40. Liverpool: Tate Gallery, 1995.

Hanisch, Carol. "The Personal Is Political." Accessed June 22, 2022. http://www.carolhanisch.org/CHwritings/PIP.html.

Harding, Neil. *Leninism*. Durham, NC: Duke University Press, 1996.

Harrison, Charles, and Paul Wood, eds. *Art in Theory 1900–1990: An Anthology of Changing Ideas*. Oxford: Blackwell, 1993.

Harrison, Charles, and Paul Wood, eds., with Paul Gaiger. *Art in Theory 1815–1900: An Anthology of Changing Ideas*. Oxford: Blackwell, 1998.

Hegel, G. W. F. *The Philosophy of History*. Translated by J. H. Clarke. New York: Dover, 1956.

Hegel, G. W. F. *Philosophy of Right*. Translated with notes by T. M. Knox. London: Oxford University Press, 1967.

Herzog, Melanie Anne. *Elizabeth Catlett: An American Artist in Mexico*. Seattle: University of Washington Press, 2000.

Hess, Jonathan M. *Reconstituting the Body Politic: Enlightenment, Public Culture and the Invention of Autonomy*. Detroit, MI: Wayne State University Press, 1999.

Hirschhorn, Thomas. "Doing Art Politically: What Does This Mean?" (2008). http://www.thomashirschhorn.com/doing-art-politically-what-does-this-mean/.

Hirschhorn, Thomas. "Tribute to Form." In *Gramsci Monument*, edited by Stephen Hoban, Yasmil Raymond, and Kelly Kivland, 52–53. New York: Dia Art Foundation, 2013.

Hirschhorn, Thomas. "Unshared Authorship." In *Gramsci Monument*, edited by Stephen Hoban, Yasmil Raymond, and Kelly Kivland, 54–55. New York: Dia Art Foundation, 2013.

Hirschhorn, Thomas. "What I Learned from the Gramsci Monument." In *Gramsci Monument*, edited by Stephen Hoban, Yasmil Raymond, and Kelly Kivland, 446–51. New York: Dia Art Foundation, 2013.

Hohaia, Te Miringa, Gregory O'Brien, and Lara Strongman, eds. *Parihaka: The Art of Passive Resistance*. Wellington, New Zealand: City Gallery, Wellington/Victoria University Press/Parihaka Pā Trustees, 2001.

Honneth, Axel. *The Critique of Power: Reflective Stages in a Critical Social Theory*. Cambridge, MA: MIT Press, 1991.

Horkheimer, Max. "The Authoritarian State." In *The Essential Frankfurt School Reader*, edited by Andrew Arato and Eike Gebhardt, 95–117. New York: Continuum, 1985.

Hosking, Geoffrey. *Rulers and Victims: The Russians in the Soviet Union*. Cambridge, MA: Harvard University Press, 2009.

Hudis, Peter, and Kevin B. Anderson, eds. *The Rosa Luxemburg Reader*. New York: Monthly Review Press, 2004.

Hülsenbeck, Richard. "Dada Forward." In *Dadas on Art*, edited by Lucy R. Lippard, 45–56. Englewood Cliffs, NJ: Prentice-Hall, 1971.

Irish, Sharon. *Suzanne Lacy: Spaces Between*. Minneapolis: University of Minnesota Press, 2010.

James, C. L. R. *The Black Jacobins: Toussaint L'Ouverture and the San Domingo Revolution*. New York: Vintage, 1989.

James, C. L. R. *Mariners, Renegades and Castaways: The Story of Herman Melville and the World We Live In*. Hanover, NH: University Press of New England, 2001.

James, C. L. R. *State Capitalism and World Revolution*. Chicago: PM Press, 2013.

James, C. L. R. "What Is Art?" In *Beyond a Boundary*, 195–211. Durham, NC: Duke University Press, 2013.

James, C. L. R., and Grace Lee, with the collaboration of Cornelius Castoriadis. *Facing Reality*. Detroit, MI: Bewick Editions, 1958.

Jameson, Fredric. *The Political Unconscious: Narrative as a Socially Symbolic Act*. Ithaca, NY: Cornell University Press, 1981.

Janco, Marcel. "Dada at Two Speeds." In *Dadas on Art*, edited by Lucy R. Lippard, 35–38. Englewood Cliffs, NJ: Prentice-Hall, 1971.

Jaurès, Jean. "Yesterday and Tomorrow." In *The Paris Commune: The View from the Left*, edited and introduction by Eugene Schulkind, 259–63. London: Jonathan Cape, 1972.

Jelinek, Alana. *This Is Not Art: Activism and Other "Not Art."* London: I. B. Tauris, 2013.

Jordan, Cara M. "Joseph Beuys and Feminism in the United States: Social Sculpture Meets Consciousness Raising." In *The Art of Direct Action: Social Sculpture and Beyond*, edited by Karen van den Berg, Cara M. Jordan, and Philipp Kleinmichel, 135–78. Berlin: Sternberg Press, 2019.

Jordan, Cara M. "Joseph Beuys and Social Sculpture in the United States." PhD diss., City University of New York Graduate Center, 2017.

Kalyva, Eve. "The Rhetoric of Disobedience: Art and Power in Latin America." *Latin American Research Review* 51, no. 2 (2016): 46–66.

Kant, Immanuel. *Anthropology from a Pragmatic Point of View*. Translated and edited by Robert B. Louden, with an introduction by Manfred Kuehn. Cambridge: Cambridge University Press, 2006.

Kant, Immanuel. *Critique of Judgment*. Translated with an introduction by Werner S. Pluhar. Indianapolis, IN: Hackett, 1987.

Kant, Immanuel. *Political Writings*. Edited by Hans Reiss. Translated by H. B. Nisbet. Cambridge: Cambridge University Press, 1991.

Katzenstein, Inés, ed. *Listen, Here, Now! Argentine Art of the 1960s: Writings of the Avant-Garde*. New York: Museum of Modern Art, 2004.

Keep, John L. H., ed. and trans. *The Debate on Soviet Power: Minutes of the All-Russian Central Executive Committee of the Soviets, Second Convocation, October 1917–January 1918*. Oxford: Clarendon Press, 1979.

Kelley, Bill, Jr., and Grant Kester, eds. *Collective Situations: Readings in Contemporary Latin American Art 1995–2010*. Durham, NC: Duke University Press, 2017.

Kemény, Alfred. "Photomontage as a Weapon in Class Struggle." In *Photography in the Modern Era: European Documents and Critical Writings 1913–1940*, edited by Christopher Phillips, 204–6. New York: Metropolitan Museum of Art, 1989.

Kennedy, Randy. "Bringing Art and Change to Bronx." *New York Times*, June 27, 2013. http://www.nytimes.com/2013/06/30/arts/design/thomas-hirschhorn-picks-bronx-development-as-art-site.html.

Kester, Grant. "Evangelical Aesthetics: Conversion and Empowerment in Contemporary Art." *Afterimage* 22, no. 6 (January 1995): 5–11.

Kester, Grant. "The Noisy Optimism of Immediate Action: Theory, Practice and Pedagogy in Contemporary Art." *Art Journal* 71, no. 2 (Summer 2012): 86–99.

Kester, Grant. *The One and the Many: Contemporary Collaborative Art in a Global Context*. Durham, NC: Duke University Press, 2017.

Kester, Grant. "The Sound of Breaking Glass Part 1: Spontaneity and Consciousness in Revolutionary Theory." *e-flux journal* no. 30 (December 2011). https://www.e-flux.com/journal/30/68167/the-sound-of-breaking-glass-part-i-spontaneity-and-consciousness-in-revolutionary-theory/.

Kimball, Whitney. "How Do People Feel about the *Gramsci Monument* One Year Later?" *Art F City*, August 20, 2014. http://artfcity.com/2014/08/20/how-do-people-feel-about-the-gramsci-monument-one-year-later/.

King, Shaun. "Soul Snatchers: How the NYPD's 42nd Precinct . . . Conspired to Destroy Black and Brown Lives." Medium, August 21, 2017. https://medium.com/blacklivesmatter/soul-snatchers-how-the-nypds-42nd-precinct-the-bronx-da-s-office-and-the-city-of-new-york-7454a5a43924.

Knox, T. M., trans. *Hegel's Aesthetics: Lectures on Fine Art*. Vol. 1. Oxford: Clarendon Press, 1988.

Kogan, Piotr. "Socialist Theater in the Years of the Revolution." In *Amateur and Proletarian Theater in Post-Revolutionary Russia: Primary Sources*, edited by Stefan Aquilina, 50–55. London: Methuen Drama, 2021.

Krauss, Rosalind. *The Originality of the Avant-Garde and Other Modernist Myths*. Cambridge, MA: MIT Press, 1985.

Krauss, Rosalind. "Poststructuralism and the 'Paraliterary.'" *October* 13 (Summer 1980): 36–40.

Krauss, Rosalind. "Sculpture in the Expanded Field." *October* 8 (Spring 1979): 30–44.

Krauss, Rosalind. *Under Blue Cup*. Cambridge, MA: MIT Press, 2011.

Laplanche, J., and J. B. Pontalis. *The Language of Psychoanalysis*. Translated by Donald Nicholson-Smith. New York: W. W. Norton, 1967.

Larkin, Oliver. "Courbet and the Commune." *Science and Society* 5, no. 3 (Summer 1941): 255–59.

Lavazzi, Tom. "Punching the Line: Fluxus, Yippie, and the 1968 DNC." *Rhizome* no. 9 (Fall 2004). http://www.rhizomes.net/issue9/lavazzi.htm.

Lee, Lisa, and Hal Foster, eds. *Critical Laboratory: The Writings of Thomas Hirschhorn*. Cambridge, MA: MIT Press, 2013.

Léger, Marc James. *Brave New Avant-Garde: Essays on Contemporary Art and Politics*. London: Zero Books, 2012.

Lenin, V. I. "A Contribution to the History of the Question of the Dictatorship: A Note" (1920). In *Collected Works*, vol. 31, 340–61. 4th English ed. Moscow: Progress Publishers, 1965. https://www.marxists.org/archive/lenin/works/1920/oct/20.htm.

Lenin, V. I. "Lessons of the Commune" (1908). In *Collected Works*, vol. 13, 475–78. Moscow: Progress Publishers, 1972. https://www.marxists.org/archive/lenin/works/1908/mar/23.htm.

Lenin, V. I. "Revolutionary Office Routine and Revolutionary Action" (1905). In *Collected Works*, vol. 10, 62–65. Moscow: Progress Publishers, 1965. https://www.marxists.org/archive/lenin/works/1905/nov/20.htm.

Lenin, V. I. *The State and Revolution* (1917). Accessed June 22, 2022. https://www.marxists.org/archive/lenin/works/1917/staterev/ch05.htm#s4.

Lenin, V. I. "The Tasks of the Third International" (1919). In *Collected Works*, vol. 29, 494–512. 4th English ed. Moscow: Progress Publishers, 1972. https://www.marxists.org/archive/lenin/works/1919/jul/14.htm.

Lenin, V. I. "The Trade Unions, the Present Situation and Trotsky's Mistakes" (1920). In *Collected Works*, vol. 32, 19–42. 1st English ed. Moscow: Progress Publishers, 1965. https://www.marxists.org/archive/lenin/works/1920/dec/30.htm.

Lenin, V. I. *What Is to Be Done? Burning Questions of Our Movement*. New York: International Publishers, 1978.

Levin, Michael. *Marx, Engels and Liberal Democracy*. London: Palgrave Macmillan, 1989.

Leymarie, Jean. *Fauvism: A Biographical and Critical Study*. Translated by James Emmons. New York: Skira, 1959.

Liebman, Marcel. *Leninism under Lenin*. Translated by Brian Pearce. London: Merlin Press, 1975.

Lippard, Lucy R., ed. *Dadas on Art*. Englewood Cliffs, NJ: Prentice-Hall, 1971.

Livingstone, Rodney, and Gregor Benton, trans. *Karl Marx: Early Writings*. Harmondsworth, UK: Penguin Books, 1975.

Longoni, Ana. "'Vanguard' and 'Revolution,' Key Concepts in Argentine Art during the 1960s and '70s." *Brumaria* no. 8 (Spring 2007): 66–72.

Lookofsky, Sarah. "Thomas Hirschhorn's Project in the Projects." *Dis Magazine* (2013). http://dismagazine.com/disillusioned/47438/thomas-hirschhorn-on-his-project-in-the-projects/.

Loup, Alfred Joseph, III. "The Theatrical Productions of Erwin Piscator in Weimar Germany: 1920–1931." PhD diss., Louisiana State University, 1972.

Lukács, Georg. *History and Class Consciousness*. Translated by Rodney Livingstone. Cambridge, MA: MIT Press, 1983.

Lütticken, Sven. "Three Autonomies and More." In *The Autonomy Project: Newspaper #1, Positioning*, 32–39. Eindhoven: Onomatopee, 2010. https://theautonomy project.org/newspapers.

Luxemburg, Rosa. "Organizational Questions of Russian Social Democracy." In *The Rosa Luxemburg Reader*, edited by Peter Hudis and Kevin B. Anderson, 248–65. New York: Monthly Review Press, 2004.

Lyotard, Jean-François. "Preliminary Notes on the Pragmatic of Works: Daniel Buren." *October* 10 (Autumn 1979): 59–67.

Macpherson, C. B. *The Political Theory of Possessive Individualism: Hobbes to Locke*. Oxford: Oxford University Press, 2011.

Maharaj, Ayon. *The Dialectics of Aesthetic Agency: Revaluating German Aesthetics from Kant to Adorno*. London: Bloomsbury, 2013.

Mally, Lynn. *Culture of the Future: The Prolekult Movement in Revolutionary Russia*. Berkeley: University of California Press, 1990.

Mally, Lynn. *Revolutionary Acts, 1917–1938*. Ithaca, NY: Cornell University Press, 2000.

Marx, Karl. "The British Rule in India." *New York Herald Tribune*, June 10, 1853. https://www.marxists.org/archive/marx/works/1853/06/25.htm.

Marx, Karl. "Critique of Hegel's Philosophy of Right." In *Karl Marx: Early Writings*, translated by Rodney Livingstone and Gregor Benton, 243–58. Harmondsworth, UK: Penguin, 1975.

Marx, Karl. "The Paris Commune." In *The Civil War in France: Address of the General Council of the International Working-Men's Association* (pamphlet). London: Edward Truelove, 1871. https://www.marxists.org/archive/marx/works/1871/civil-war-france/ch05.htm.

Marx, Karl, and Friedrich Engels. *The Holy Family, or Critique of Critical Critique*. Translated by R. Dixon. Moscow: Foreign Languages Publishing House, 1956.

Maturana, Humberto R., and Francisco J. Varela. *Autopoiesis and Cognition: The Realization of the Living*. Boston: D. Reidel, 1980.

McCloskey, Barbara. *George Grosz and the Communist Party: Art and Radicalism in Crisis 1918–1936*. Princeton, NJ: Princeton University Press, 1997.

Mellor, David, ed. *Germany: The New Photography, 1927–1933*. London: Arts Council of Great Britain, 1978.

Mesch, Claudia. *Joseph Beuys*. London: Reaktion Books, 2017.

Michelson, Annette, ed. *Kino Eye: The Writings of Dziga Vertoz*. Translated by Kevin O'Brien. Berkeley: University of California Press, 1984.

Morgan, Jo-Ann. *The Black Arts Movement and the Black Panther Party in American Visual Culture*. London: Routledge, 2019.

Morris, Tracie D. "On Embodying." In *Gramsci Monument*, edited by Stephen Hoban, Yasmil Raymond, and Kelly Kivland, 321–25. New York: Dia Art Foundation, 2013.

Muthu, Sankar. *Enlightenment against Empire*. Princeton, NJ: Princeton University Press, 2003.

Nechayev, Sergey. "The Revolutionary Catechism" (1869). http://www.marxists.org/subject/anarchism/nechayev/catechism.htm.

Nochlin, Linda. *Realism*. London: Penguin, 1971.

Ollman, Bertell. *Social and Sexual Revolution: Essays on Marx and Reich*. Boston: South End Press, 1979.

Osborne, Peter. *The Politics of Time: Modernity and Avant-Garde*. London: Verso, 2011.

Paumgarten, Nick. "Dealer's Hand: Why Are So Many People Paying So Much Money for Art? Ask David Zwirner." *New Yorker*, December 2, 2013. https://www.new yorker.com/magazine/2013/12/02/dealers-hand.

Pinkard, Terry. *Hegel: A Biography*. Cambridge: Cambridge University Press, 2000.

Piscator, Erwin. *The Political Theater*. Translated by Hugh Rorrison. New York: Avon Books, 1978.

Plante, David. "The Real Thing: An Interview with Rosalind E. Krauss." *artcritical: the on-line magazine of art and ideas*, August 30, 2013. https://artcritical.com/2013/08/30/rosalind-krauss-interview/.

Poggioli, Renato. *The Theory of the Avant-Garde*. Translated by Gerald Fitzgerald. Cambridge, MA: Belknap Press of Harvard University Press, 1968.

Polan, A. J. *Lenin and the End of Politics*. Berkeley: University of California Press, 1984.

Radkey, Oliver Henry. *The Sickle under the Hammer: The Russian Socialist Revolutionaries in the Early Months of Soviet Rule*. New York: Columbia University Press, 1963.

Rancière, Jacques. "The Aesthetic Revolution and Its Outcomes." *New Left Review* 14 (March–April 2002): 133–51.

Rancière, Jacques. *Aisthesis: Scenes from the Aesthetic Regime of Art*. London: Verso, 2013.

Rancière, Jacques. *The Politics of Aesthetics*. Translated by Gabriel Rockhill. London: Bloomsbury, 2004.

Rasmussen, Mikkel Bolt. *After the Great Refusal: Essays on Contemporary Art, Its Contradictions and Difficulties*. London: Zero Books, 2018.

Rasmussen, Mikkel Bolt. "A Note on Socially Engaged Art Criticism." *FIELD: A Journal of Socially Engaged Art Criticism* no. 6 (Winter 2017). http://field-journal.com/issue-6/a-note-on-socially-engaged-art-criticism.

Rasmussen, Mikkel Bolt. "The Self-Destruction of the Avant-Garde." In *The Idea of the Avant-garde and What It Means Today*, edited by Marc James Léger, 121–30. Manchester: Manchester University Press, 2014.

Raymond, Yasmil. "Ambassador's Notes. In *Gramsci Monument*, edited by Stephen Hoban, Yasmil Raymond, and Kelly Kivland, 254–58. New York: Dia Art Foundation, 2013.

Raymond, Yasmil. "Desegregating the Experience of Art: A User's Guide to Gramsci Monument." In *Gramsci Monument*, edited by Stephen Hoban, Yasmil Raymond, and Kelly Kivland, 10–27. New York: Dia Art Foundation, 2013.

Redfield, Marc. "Aesthetics, Sovereignty, Biopower: From Schiller's *Über die ästhetische Erziehung des Menschen* to Goethe's *Unterhaltungen deutscher Ausgewanderten*." In *Romanticism and Biopolitics*, edited by Alastair Hunt and Matthias Rudolf. Romantic Circles Praxis Series, December 2012. https://romantic-circles.org/praxis/biopolitics/HTML/praxis.2012.redfield.

Richter, Gerhard, and Theodor W. Adorno. "Who's Afraid of the Ivory Tower? A Conversation with Theodor W. Adorno." *Monatshefte* 94, no. 1 (Spring 2002): 10–23.

Rimbaud, Arthur. *Rimbaud Complete*. Vol. 2: *The Letters*. Translated, edited, and with an introduction by Wyatt Mason. New York: Modern Library, 2002.

Roberts, John. *Revolutionary Time and the Avant-Garde*. New York: Verso, 2015.

Rose, Julian. "Monumental Endeavor: Thomas Hirschhorn's Gramsci Monument." *Artforum International* 52, no. 3 (November 2013). https://www.artforum.com/print/201309/monumental-endeavor-thomas-hirschhorn-s-gramsci-monument-43522.

Rosemont, Franklin, ed. "*La Revolution Surréaliste* no. 5 (1925)." In *What Is Surrealism? Selected Writings of Andre Breton*, 69–76. New York: Pathfinder Press, 1978.

Ross, Kristin. *Communal Luxury: The Political Imaginary of the Paris Commune*. London: Verso, 2015.

Roth, Moira. "Oral History Interview with Suzanne Lacy, March 16–September 27, 1990." https://www.aaa.si.edu/collections/interviews/oral-history-interview-suzanne-lacy-12940.

Rousseau, Jean-Jacques. "Deputies or Representatives" (1762). In *The Social Contract*, translated by G. D. H. Cole, book III, section 15. Accessed June 22, 2022. https://www.marxists.org/reference/subject/economics/rousseau/social-contract/.

Rousseau, Jean-Jacques. "Discourse on Political Economy" (1758). In *Creating the "New Man": From Enlightenment Ideals to Socialist Realities*, edited by Yinghong Cheng, 13. Honolulu: University of Hawai'i Press, 2009.

Russell, Robert. *Russian Drama of the Revolutionary Period*. London: Macmillan, 1988.

Sandals, Leah. "10 Thoughts on Why Nuit Blanche Has Triumphed—and Tanked—across Canada." *Canadian Art*, September 25, 2014. https://canadianart.ca/features/nuit-blanche-canada/.

Santone, Jessica. "The Feminist Consciousness Raising Circle as Pedagogical Form in Suzanne Lacy and Julia London's *Freeze Frame* (1982)." RACAR*: Revue d'art Canadienne/Canadian Art Review* 46, no. 1 (2021): 44–58.

Sartre, Jean-Paul. *The Communists and Peace, with a Reply to Claude Lefort*. New York: George Braziller, 1968.

Schelling, F. W. J. "System of Transcendental Idealism." In *German Aesthetic and Literary Criticism: Kant, Fichte, Schelling, Schopenhauer, Hegel*, vol. 1, edited by David Simpson, 111–16. Cambridge: Cambridge University Press, 1984.

Schiller, Friedrich. *Letters on the Aesthetic Education of Man*. Translated and edited by Elizabeth M. Wilkinson and L. A. Willoughby. Oxford: Oxford University Press, 1987.

Schiller, Friedrich. *Medicine, Psychology and Literature*. Translated and edited by Kenneth Dewhurst and Nigel Reeves. Berkeley: University of California Press, 1978.

Schjeldahl, Peter. "House Philosopher: Thomas Hirschhorn and the 'Gramsci Monument.'" *New Yorker*, July 29, 2013. https://www.newyorker.com/magazine/2013/07/29/house-philosopher.

Schmelzer, Paul. "Interview: Thomas Hirschhorn on *Cavemanman*." *Sightlines*, November 6, 2006. https://walkerart.org/magazine/audio-blog-thomas-hirschhorn.

Schmelzer, Paul. "The Momentary Monument: Philippe Vergne on Thomas Hirschhorn's Ode to Gramsci." *Walker Art Museum Magazine*, September 12, 2013.

http://www.walkerart.org/magazine/2013/philippe-vergne-interview-hirschhorn-gramsci.

Schneewind, J. B. *The Invention of Autonomy: A History of Modern Moral Philosophy.* Cambridge: Cambridge University Press, 1998.

Schulkind, Eugene, ed. *The Paris Commune: The View from the Left.* London: Jonathan Cape, 1972.

Schulte-Sasse, Jochen, Haynes Horne, Andreas Michel, Elizabeth Mittman, Assenka Oksiloff, Lisa C. Roetzel, and Mary Strand, eds. *Theory as Practice: A Critical Anthology of Early German Romantic Writers.* Minneapolis: University of Minnesota Press, 1997.

Shapiro, Ian. *The Evolution of Rights in Liberal Theory.* Cambridge: Cambridge University Press, 1986.

Sharp, Willoughby. "An Interview with Joseph Beuys." *Artforum International* 8, no. 4 (December 1969): 40–47.

Shklovsky, Viktor. "Art as Device." In *Theory of Prose*, translated by Benjamin Sher, 1–14. Champaign, IL: Dalkey Archive Press, 1991.

Shklovsky, Viktor. *A Sentimental Journey: Memoirs 1917–1922.* Normal, IL: Dalkey Archive Press, 2004.

Sholette, Greg. *The Art of Activism and the Activism of Art.* London: Lund Humphries, 2022.

Smith, Terry. *Art to Come: Histories of Contemporary Art.* Durham, NC: Duke University Press, 2019.

Smith, Terry. "Without Revolutionary Theory . . ." *Studio International* 191, no. 980 (March–April 1976): 134–36.

Sochor, Zenovia A. *Revolution and Culture: The Bogdanov-Lenin Controversy.* Ithaca, NY: Cornell University Press, 1988.

Sochor, Zenovia A. "Was Bogdanov Russia's Answer to Gramsci?" *Studies in Soviet Thought* 22, no. 1 (February 1981): 59–81.

Spivak, Gayatri Chakravorty. "1996: Foucault and Najibullah." In *Other Asias*, 132–60. London: Wiley, 2003.

Stachelhaus, Heiner. *Joseph Beuys.* Translated by David Britt. New York: Abbeville Press, 1987.

Surin, Kenneth. "Marxism(s) and 'The Withering Away of the State.'" *Social Text* no. 27 (1990): 35–54.

Tatlin, Vladimir. "The Initiative Individual" (1919). In *Art in Theory 1900–1990: An Anthology of Changing Ideas*, edited by Charles Harrison and Paul Wood, 309. Oxford: Blackwell, 1993.

Tonon, Margherita. "Theory and the Object: Making Sense of the Concept of Mediation." *International Journal of Philosophical Studies* 21, no. 2 (2013): 184–203.

Trotsky, Leon. "Communist Policy toward Art" (1923). https://www.marxists.org/archive/trotsky/1923/art/tia23.htm.

Trotsky, Leon. *Leon Trotsky on the Paris Commune.* New York: Pathfinder Press, 1987.

Tucker, Robert C. "The Cunning of Reason in Hegel and Marx." *The Review of Politics* 18, no. 3 (July 1956): 269–95.

Tzara, Tristan. "Dada Manifesto." In *Dadas on Art*, edited by Lucy R. Lippard, 13–20. Englewood Cliffs, NJ: Prentice-Hall, 1971.

Verbitsky, Horacio. "Art and Politics." In *Listen, Here, Now! Argentine Art of the 1960s: Writings of the Avant-Garde*, edited by Inés Katzenstein, 296–97. New York: Museum of Modern Art, 2004.

Vergne, Philippe. "A Monument as a Garden." In *Gramsci Monument*, edited by Stephen Hoban, Yasmil Raymond, and Kelly Kivland, 452–55. New York: Dia Art Foundation, 2013.

Volkogonov, Dmitri. *Lenin: A New Biography*. New York: Free Press, 1994.

Vundru, Raja Sekhar. *Ambedkar, Gandhi and Patel: The Making of India's Electoral System*. London: Bloomsbury, 2017.

Wendland, Aaron James, and Rafael Winkler. "Hegel's Critique of Kant." *South African Journal of Philosophy* 34, no. 1 (2015): 129–42.

White, Derrick. "Black Metamorphosis: A Prelude to Sylvia Wynter's Theory of the Human." *The CLR James Journal* 16, no. 1 (Spring 2010): 127–48.

Wiggershaus, Rolf. *The Frankfurt School: Its History, Theories and Political Significance*. Translated by Michael Robertson. Cambridge: Polity Press, 1995.

Wilder, Gary. *Freedom Time: Négritude, Decolonization, and the Future of the World*. Durham, NC: Duke University Press, 2015.

Wolin, Richard. "Utopia, Mimesis, and Reconciliation: A Redemptive Critique of Adorno's Aesthetic." *Representations* no. 32 (Autumn 1990): 33–49.

Wood, Paul. "The Avant-Garde and the Paris Commune." In *The Challenge of the Avant-Garde*, edited by Paul Wood, 113–36. New Haven, CT, and London: Yale University Press and Open University, 1999.

Woodmansee, Martha. *The Author, Art, and the Market: Rereading the History of Aesthetics*. New York: Columbia University Press, 1994.

Wynter, Sylvia. "Black Metamorphosis: New Natives in a New World." Unpublished manuscript, 1977–1982. https://monoskop.org/log/?p=22948.

Wynter, Sylvia. "The Counterdoctrine of Jamesian Poesis." In *C. L. R. James's Caribbean*, edited by Paget Henry and Paul Buhle, 63–91. Durham, NC: Duke University Press, 1992.

Wynter, Sylvia. "Unsettling the Coloniality of Being/Power/Truth/Freedom: Towards the Human, after Man, Its Overrepresentation—An Argument." CR: *The New Centennial Review* 3, no. 3 (Fall 2003): 257–337.

Zarudnaya, Elena, trans. *Trotsky's Diary in Exile: 1935*. London: Faber and Faber, 1958.

Žižek. Slavoj. "Repeating Lenin" (2001). https://www.lacan.com/replenin.htm.

Zukert, Rachel. *Herder's Naturalist Aesthetics*. Cambridge: Cambridge University Press, 2019.

INDEX

Abdul-Jabbar, Kareem, 138–39
Ablutions (Lacy), 142
absolute sovereignty: artists' demand for, 9; Badiou's discussion of, 6–7
absolutism: aesthetic autonomy and decline of, 19–25, 37; Prussian State and, 41
Acción del Encierro ("Confinement Action") (Carnevale), 111–16, 129
Acconci, Vito, 113
actionism, 167; Adorno's critique of, 118–24; Beuys's support for, 135
activism: artistic production and, 137–42, 160; art's convergence with, 119–20; in Bueys's work, 132–37; cultural activism, 105–7
Adorno, Theodor, 2, 11, 14; on aesthetic autonomy, 119–24, 130, 135–36, 152, 178–79; on art and praxis, 119–24, 167; on avant-garde, 119–24, 145–48, 163–65; on critical thought, 163, 233n71; critique of action and, 116–24; exculpatory critique and, 188; on experimental art, 130, 135–36; on Lenin and Marx, 231n29; on mediation, 125–26, 233n74; on music, 138; popular culture dismissed by, 127–29, 133; on survival, 127, 176; on transcendence, 124–30, 135–36
advertising, scriptovisual incorporation of, 165–66
aesthetically tempered man, Schiller's concept of, 30–31
aesthetic autonomy: Adorno's analysis of art and, 119–24, 130, 135–36; artist's authority and, 4; avant-garde and, 4–8, 12, 165–71, 175–79, 212–18; Beuys and, 133–37; class divisions and, 54–57; contemporary art and, 164–65; deferred

aesthetic autonomy (continued)
 action and, 154-62; development of, 2;
 disappointment aesthetics and, 206-11;
 discursive structure of, 13, 45-47, 145-
 46, 167-71; Hirschhorn's artistic practice
 and, 187-98, 216-18; mediation and,
 126-30; neo-avant-garde and, 157-62;
 origins of, 19-24; outsourcing of authen-
 ticity and, 180-87; Paris Commune and,
 60-64; political transformation and,
 4-5, 26-30; possessive individualism
 and, 198-206; rearticulation of, 48-53;
 state imposition of, 77-82
aesthetics: as alibi and prefiguration, 25-28;
 avant-garde rejection of, 49-53; from
 below, 32-37; challenge to capitalism
 and, 10; definitions of, 3; of disappoint-
 ment, 206-11; social architecture of, 11;
 temporal deferral and, 29-30, 80-82,
 146-47; as with and against Enlighten-
 ment, 36-37
aesthetic state: communism and, 48-82;
 Hegel's critique of, 39-41; Hirschhorn's
 Gramsci Monument and failure of, 213-
 18; Marx's discussion of, 50-53, 57; Schil-
 ler's concept of, 25-28, 32-33
Aesthetic Theory (Adorno), 119, 123-24, 130,
 136-37
aesthetic transcendence, avant-garde repu-
 diation of, 5
*After the Great Refusal: Essays on Contem-
 porary Art* (Rasmussen), 5
agency: artistic personality and, 7-8; cultural
 difference as precondition for, 36-37;
 participatory art and reduction of, 115;
 revolutionary vanguards and, 67-73;
 transformation of nature through, 25
AIDS activism, art and, 160
Alexander, Gertrud, 88
Ali, Muhammad, 138-39
altruism, Hirschhorn's work and, 189-90
Ambedkar, Bhimrao Ramji, 107
American Civilization (James), 128
Andre, Carl, 149
Andy Warhol Foundation for the Arts, 191
The Anti-Aesthetic (Krauss), 150-51
anticolonial resistance: aesthetic autonomy
 and, 4-5; avant-garde performativity
 and, 102-7; popular culture and, 128-30;
 praxis and, 128
anti-imperialism: Enlightenment in context
 of, 34-37; Hegel and, 45, 103, 223n74;
 Marxism and, 102-7
"Appeal for an Alternative" (Beuys), 133
Arenal, Luis, 101
Argentina, artistic revolutionary vanguard
 in, 111-16, 129-30, 231n16
art: activism's convergence with, 119-24;
 Adorno's analysis of, 119-24, 167; cul-
 tural production and role of, 88-90;
 discursive structure of, 45-47, 145-46,
 167-71; Krauss's technical support of,
 151; philosophy and, 40-47, 223n58; po-
 litical resistance and, 95; Schiller's dis-
 cussion of, 28-29, 42, 221n26
Art and Language group, 165-66, 170, 172,
 178, 192
Art and Language (journal), 165-66
"Art as Device" (Shklovsky), 92-94, 151
artistic personality: agency and, 7-8;
 Hirschhorn on autonomy of, 191-98;
 modernization and, 37
artistic practices: Beuys's discussion of,
 132-37; engaged *vs.* relational practices,
 181-87; Hegel on evolution of, 43-45;
 of Hirschhorn, 187-98; institutional
 critique movement and, 182-87; out-
 sourcing of authenticity and, 181-87;
 political transformation and, 10, 111-16,
 131-37; praxis and, 187-98; production
 and reception of, 167-71; revolution-
 ary vanguard and, 5-6, 111-16, 166-67;
 Roberts's Post-Thermidorian perspective
 on, 166; segregation of art and politics
 and, 172-79, 216-18; social movements
 and, 137-42
Asher, Michael, 154, 156
"Assault Text" (Renzi, Puzzolo, and Eli-
 zalde), 112-13
Athenian state, Hegel's critique of, 39-41,
 222n51
Atkinson, Terry, 135-36
authenticity, aesthetic autonomy and out-
 sourcing of, 180-87
authorial sovereignty: aesthetic autonomy
 and, 4; autonomy and reconstitution of,

23–24; Beuys's projects and, 130–31, 139; contemporary art and, 183–87; performative production and, 141
authoritarianism: Bolshevism and, 72–73, 226n62; Hirschhorn's Monument projects and, 194–98
autonomy: aesthetics and, 11–12; artistic practices and, 172–79; contemporary art and, 1–3; critical postmodernism and, 154–55; decline of absolutism and rise of, 19–25, 37; as defensive measure, 95; government and, 57–60; of guerrilla cells, 109–11; historical phases of, 8; Impressionism and, 63–64; Marxist theory and, 11–12, 50–53; revolutionary vanguards in Russia and, 67–73; socialism and, 53–57; state and role of, 77–82; transcendence and, 124–30. *See also* aesthetic autonomy
Autonomy: The Social Ontology of Art under Capitalism (Brown), 2
Autonomy Project, 1–2
avant-garde: Adorno's critique of, 119–24, 145–46; aesthetic autonomy and, 4–8, 12, 165–71, 212–18; anticolonial performativity and, 102–7, 128; Beuys and, 131–37; Black American culture and, 138–39; Bolshevism and, 13–14, 85–86; colonial resistance and, 104–7; creative consciousness and, 105–6; disruption and emancipation and, 85–90; fluidity of, 60–64; Foster on failure of, 155; government and, 57–60; Hegel and prehistory of, 37–40; instrumentalization of the viewer and, 112–16; Marxist theory and, 10; *October*'s coverage of, 148–54; Paris Commune and, 59; revolutionary vanguard and, 5–8, 69–73, 114–16; Roberts on capitalism and, 167–71; working class and, 90–94. *See also* neo-avant-garde

Babeuf, François-Noël, 37
Badiou, Alain, 6–8
barbarity, rejection of Enlightenment discourse on, 35
Barthes, Roland, 150–51
Bataille Monument (Hirschhorn), 184

Baudelaire, Charles, 49
beauty: Adorno's critique of, 120–21; aesthetic experience of, 49
Bensaïd, Daniel, 6
Bernofsky, Susan, 240n47
Beuys, Joseph, 130–37, 139; Hirschhorn compared with, 183–84, 215
Beyond a Boundary (James), 129
Bishop, Claire, 236n29
Black American artists, social movements and, 138–42
Black Arts Movement, 138–39
"Black Metamorphosis" (Wynter), 104
Black Panthers, 118–19, 137–38
body: Adorno on mastering of, 120; aesthetics and role of, 32; avant-garde separation of mind and, 203–6
Bogdanov, Alexander, 97–102, 215–16
Boime, Albert, 63
Bolshevism, 147; antidemocratic resistance of, 71–73; art and, 85–86, 160–62; avant-garde and, 13–14, 69–73, 156
bourgeois aesthetics: Adorno's critique of, 119–24; autonomy and, 53–57; avant-garde and, 60–64, 86–90, 159; Dadaism and, 87–90; perceptual assault discourse and, 90–94; persistence of inequality and, 25–28; political autonomy and emergence of, 20–24; revolutionary vanguard and, 67–73, 115–16; transcendence and, 125–26
Bracey, John H., 139
Brave New Avant-Garde (Léger), 5
Brecht, Bertolt, 95–102, 173
Brest, Romero, 112–13
Breton, André, 9
Brodsky, Isaak, 66, *67*, 70
Broodthaers, Marcel, 156, 163
Brooks, Gwendolyn, 138
Brown, James, 139
Brown, Lex, 209
Brown, Nicholas, 2
Buchloh, Benjamin, 14, 135–36, 163–71, 187, 190, 210–11, 238n4
Buck-Morss, Susan, 123
Buren, Daniel, 156, 163
Bürger, August, 28
Burgin, Victor, 165–66, 170, 172, 175, 178

Calle, Sophie, 154
capitalism: Adorno's view of, 126–29, 163–64; art as site of, 2, 6–8; avant-garde and, 6–8, 167–79, 215–18; colonialism and, 103–7; disappearance of kinship and, 9–10; Marxist view of, 10, 224n8; Roberts's analysis of, 164–65, 177–79; state enforcement of, 77–82
Carmichael, Stokely, 138
Carnevale, Graciela, 108, 111–16, 129–30, 132
Carreira, Ricardo, 231n16
caste hierarchies, Indian nationalism and, 106–9. *See also* class hierarchies
Catlett, Elizabeth, 101–2
Centre Pompidou (Paris), 174
Cereijido, Fabián, 111, 231n18
Chernyshevsky, Nikolai, 73–77
Chicago, Judy, 139–40
Chto Delat collective, 165, 170, 173–78
Chuh, Kandice, 33–34
Chytry, Joseph, 39
Ciclo de Arte Experimental exhibition, 111, 113
civil rights movement, embodied activism in, 105
Claim (Acconci), 113
class hierarchies: Adorno's theories in context of, 127–30; aesthetically tempered man and, 31–32; aesthetic experience and, 3, 54–57; artistic production and, 114–16; caste system in India and, 105–7; community art and, 199–206; creative consciousness and, 101, 108–9; *foco/foquista* (guerrilla cells) and, 109–11, 114–16; German literature and, 28; Hegel's modern state and, 42–45; Hirschhorn's artistic practice and foregrounding of, 182–87, 192–98, 213–18; individualism and, 22; Marxist theory and, 52–53; philosophy and, 3, 54–57; revolutionary action and, 64–73; vernacular culture and, 49–53
Claussen, Detlev, 231n29
cognitive agency: aesthetic knowledge and, 3–4, 36–37; avant-garde and, 7–8; Marxist theory and, 56–57, 214–18; postabsolutist reconstruction of, 19; revolutionary vanguard and, 115–16; transcendence and, 124–30

Coleman, James, 151, 163–64
Coleman, Ornette, 138
collaborative projects: instrumentalization of, 175–76; sovereign self and, 139; unshared authorship and, 203–6
colonialism: anti-imperialist Enlightenment discourse on, 34–35; capitalism and, 103–7; class structure and, 32; Enlightenment and, 12; Hegel's defense of, 43–45; legacy of, 34; property-based models and rise of, 21–23; theology and, 22
Coltrane, John, 138
Comintern, 226n56
communism: anticolonial resistance and failure of, 129; art and, 95–102; avant-garde embrace of, 64; role of state in, 81–82
Communist League, 53
The Communist Manifesto (Marx), 53
Communist Workers Party (Germany), 95
community art: Hirschhorn and, 188–98, 213–18; possessive individualism *vs.* aesthetic autonomy in, 198–206
Confederacion General de Trabajadores de Los Argentinos, 130
consciousness raising, aesthetic autonomy and, 139–42
Constitutional Democrats (Russia), 72
constitutional monarchies, Hegel's discussion of, 41, 222n55, 223nn65–66
Constructivism, 64, 155–56, 160
contemporary art: challenges to autonomy of, 1–3, 119; installation art, 165–66; Krauss's discussion of, 150–52; monetization of, 6–7; political and social transformation and, 156–57; Robert's analysis of, 164–65; Russian Revolution and, 148–49; second economy concept and, 176–79
co-option: ethical burden of, 158; second economy concept and, 176–79
Courbert, Gustave, 12, 49, 57–60, 63
creative consciousness: Adorno's assessment of, 123–24; artistic practices and, 172–79; artists' sovereignty and, 4, 7, 13, 28; avant-garde appropriation of, 90–91, 105–6; Beuys's view of, 132–37; class hierarchies and, 89, 101, 108–9; colonial instrumentalizaton of, 104; Geist and,

39, 42–45; habitualization and, 8, 92–94; Hirschhorn's *Gramsci Monument* and, 215–18; political transformation and, 8, 11–14, 77–79; of proletariat, 96–98; resistance and, 98; temporal deferral and, 29

creative destruction, artistic revolutionary vanguard and, 111–16

cricket, aesthetic politics of, 129

Crimp, Douglas, 160–61

critical consciousness: aesthetic awakening of, 92; art's relationship to, 168–71; Hirschhorn's *Gramsci Monument* and, 207–11; Marxist displacement of, 54–55; philosophy and, 44–45; revolution's impact on, 110–11, 148

critical theory: Adorno and, 124–25; avant-garde and, 170–71; Hirschhorn's art and, 192; *October* (journal) and, 149, 153–54

critique of action, Adorno and, 116–24

Critique of Judgment (Kant), 29–30

The Critique of Power (Honneth), 123

cross-class experience, in Hirschhorn's work, 193–98

The Crystal Quilt (Lacy), 140–41

Cuban revolution, 109–10

cultural pluralism, Enlightenment aesthetics and, 34–37

cultural production: anticolonial resistance and, 102–7; art in context of, 8–9; Indian activism and, 105–7; instrumentalization of, 2, 6–8, 123–24; revolution and, 98–99

cultural resistance, colonialism and, 103–7

cultural services industry, Roberts's critique of, 175–79

Dadaism, 49–50, 64, 86–90, 155–56, 160

Dalits activism (India), 106–7

dance, as cultural resistance, 104–5

Davis, Angela, 118–19

Debord, Guy, 177

Debray, Régis, 109–10, 116

de Chirico, George, 86

deconstructive testing, neo-avant-garde and, 155–56, 163

de Duve, Thierry, 131–32

Dee, Ruby, 138

defamiliarization discourse, 92–94

deferred action, neo-avant-garde and, 154–62

Deleuze Monument (Hirschhorn), 183–84

democracy: aesthetic state and, 32–33; Hegel's discussion of, 41–45; Lenin's distrust of, 71–73, 97

demythologization, Buchloh's perspective on, 163–71

Derrida, Jacques, 149–51

Der Spiegel, 1969 interview with Adorno, 117

Dia Foundation for the Arts, 191–92, 194, 198, 208, 239n32

Dialectic of Enlightenment (Horkheimer and Adorno), 125

The Dialectics of Aesthetic Agency (Maharaj), 137

Diderot, Denis, 34–35

Die Rote Fahne (journal), 88, 97

The Difference Aesthetics Makes (Chuh), 33–34

disappointment, aesthetics of, 206–11

discursive structure, aesthetic autonomy and, 13, 45–47, 145–46, 167–71

disruption, as punishment and emancipation, 85–90

Documenta 5 exhibition (Beuys), 134

"Doing Art Politically: What Does This Mean?" (Hirschhorn), 185

Douglas, Emory, 138

Dubinushka (work song), 93

Du Bois, W. E. B., 138

Duchamp, Marcel, 6

Dusseldorf Art Academy, student occupation of, 134

Dutschke, Rudi, 134

École des Beaux-Arts, student occupation of, 183

economic inequality, autonomy and persistence of, 25–28

ego weakness, Adorno's concern with, 136–37

Einfühling, Herder's concept of empathy as, 36

Eisenstein, Sergei, 91–92, 96, 147–48, 151

Elizalde, Rodolfo, 112–13

emancipation: aesthetic state and, 32–33; disruption as, 85–91

emotion, Schiller on reason and, 30–32

empathy, Herder's *Einfühling*, 36
En avant Dada (Hulsenbeck), 49–50, 87
Encierro (Carnavale), 231n18
Engels, Friedrich, 54
Enlightenment: aesthetics discourse in, 3–5, 11–13, 26–27, 33–35, 120; autonomy and, 8; avant-garde reproduction of, 169–71; Hirschhorn's invocation of, 190–98, 213–18; Marxist break with, 52–53; postcolonial recovery and reinvention of, 34–37; secular humanism and, 23
Enlightenment against Empire (Muthu), 34
Enwezor, Okwui, 191
estates, Hegel's division of, 41, 223n59
Estivals, Robert, 177
Eurocentrism: avant-garde rejection of, 85–86; in Hegel's work, 43; Marx and, 102–3; noble savage ethos and attack on, 35
evolution, secular humanism and, 23
exculpatory critique, Hirschhorn and, 187–98, 209–11

Farmer, Erik, 200–206, 208–9
Farmer, Susie, 208–9
Feldman, Ronald, 131
feminism, conscious raising and, 139–42
feminist artists, Beuys and, 130–31, 139
Feminist Art Program, 139–40
Fichte, Johann Gottlieb, 45
film, politics and, 185
financialization of contemporary art, 2, 6–8, 154–55; institutional critique movement and, 182–87
"First Biennial of Avant-Garde Art" (Argentina), 130
foco/foquista (guerrilla cells), 109–14, 230n10
Forest Houses project, *Gramsci Monument* at, 188–98, 200–218
formalism, 94
Foster, Hal, 14, 147, 149–51, 155–62, 170, 181, 185–86, 190, 197
foundational support: artistic practices and, 182–87; Hirschhorn's artistic projects, 191–98
Frankfurt Institute, 117–18, 136
Frankfurt School theory, 125
Fraser, Andrea, 154

freedom: autonomy as, 12, 13–14; Hegel's modern state and, 42–45
Free International University for Creativity and Interdisciplinary Research, 134–35
Freeze Frame (Lacy), 140
French Revolution: failure of, 62–64; Hegel's response to, 41–42, 46–47; Schiller's critique of, 13, 29, 46–47
Freud, Sigmund, 160
Frow, John, 126
Fujimori, Alberto, 218

Gandhi, Mahatma, 105–7, 128, 138
Geist, Hegel's concept of, 39; absolutism and, 41; aesthetic autonomy and mediation and, 125–26; modern state and, 42–45
gender, in contemporary art, 152
General Workers Union (Germany), 95
Germana, Nicholas, 32
German Communist Party (KPD), 87–90
German Idealism, 222n51
German Students Party, 134, 136
German Worker's Educational Association, 53
Germany: defamiliarization discourse in, 92–94; Hegel's analysis of, 41–45; theatrical production in, 95–102
Gift (Man Ray), 86
Godard, Jean-Luc, 185
Goethe, Johann Wolfgang von, 46
Gorky, Maxim, 14
government, aesthetic autonomy and, 57–60
Gramsci, Antonio, 196–98, 206, 212, 214–18, 241n4
Gramsci Monument (Hirschhorn event), 14–15, 188–89, 191–218; beneficial publicity of, 239n32; police presence at, 240n47, 240n55; social workers' involvement in, 188–98, 240n50
graphic art, avant-garde in, 101–2
Grapus collective, 183
Greece as an aesthetic state, Hegel's concept of, 39–41, 43, 222n50
Greenberg, Clement, 149–53, 157, 159–61
Green Party (Germany), 133–34
Grosz, George, 87–90
Grotius, Hugo, 20
Grupo de Arte de Vanguardia, 111

guerrilla groups, as revolutionary vanguard, 109–11, 114–16, 231n19
Guevara, Ernesto "Che," 109–10, 112–13, 116
guilt, Adorno on art and, 121

Haacke, Hans, 163
Habermas, Jürgen, 38–39
habitualization, Shklovsky's critique of, 92–94
Haitian Revolution, 129
Haks, Frans, 130
Hallward, Peter, 6
Hanisch, Carole, 140
hatchet socialism, 72
Hausmann, Raul, 87
Heartfield, John, 87
Hegel, G. W. F., 12; on art and Absolute, 167; Marx on, 50–51, 53; on mediation and aesthetic autonomy, 125–26; prehistory of avant-garde and, 37–40; on Prussian State, 40–43, 150
help, Hirschhorn's rejection of, 202–11, 215
Herbert, Diane, 200–206
Herder, Johann Gottfried, 34–36
hierarchical systems: aesthetic state and, 32–33; autonomy's dependence on, 22
Hirschhorn, Thomas, 2, 14–15; aesthetics of disappointment and, 206–11; artistic practice of, 187–98; failure of revolutionary transformation and work of, 212–18; Monuments work of, 180, 183–87; possessive individualism vs. aesthetic autonomy in work of, 198–206
Histoire des Indes (Diderot), 34
history, aesthetics as placeholder in, 36–37
Hobbes, Thomas, 20
Hoernle, Edwin, 101
Hoffman, Abbie, 137
Hölderlin, Frierich, 40, 222n51
Honneth, Axel, 123–24
Horkheimer, Max, 80, 231n29
Hülsenbeck, Richard, 49–50, 87, 90
Hume, David, 146

ideological medium, art and, 152
Illia, Arturo, 111
immanent formalism, 149, 152–54, 159–60
Impressionism, 63–64

incapacity of masses thesis, 32–33, 62, 65–66, 76; Adorno on, 124, 133, 136–37; art as remedy for, 91–92; Beuys's challenge to thesis of, 136–37; *Gramsci Monument* and, 214–18; Hegel on, 46; Kant and, 76; Roberts's discussion of, 164–65; Schiller on, 13, 36, 46, 76
India: caste hierarchies in, 106–9; cultural activism in, 105–7; independence movement in, 14, 105–7, 138, 217; Marx on British rule in, 102–3
indigenization, colonial resistance and, 104–7
individual will, Hobbes's concept of, 20
inequality: autonomy and persistence of, 25–28; Hegel's modern state and persistence of, 42–45
In Mourning and in Rage (Lacy), 142
institutional critique movement, 150, 154–62; creative agency and, 181–87; demythologization perspective and, 163–64
Institutional Revolutionary Parti (PRI) (Mexico), 102
instrumentalization of art: avant-garde and, 112–16; Chto Delat collective and, 174; contemporary art and, 156–57, 164–65; institutional critique movement and, 157–62; market forces and, 2, 6–8, 15, 123–24, 154–55; necessity for, 166–67; primary and secondary economy and, 174–75
International Working Men's Association, 53
intersubjective experience: aesthetics and openness of, 20, 27; Hegel on, 39–40; self-transformation and, 30; theater and, 96–102; violence and, 33
In the Time of Harmony (Signac), 51–52
Iran, artistic practices as resistance in, 218
Izambard, George, 60

James, C. L. R., 14, 34, 104, 128–29
Jameson, Fredric, 10–11
Janco, Marcel, 86
Jaurès, Jean, 48
jazz music, aesthetic autonomy and, 138–39
Jelinek, Alana, 15
Jordan, Cara, 131
Jordan, Dannion, 205
Jung, Franz, 97
justice, autonomy discourse and, 23–25

Kanakans (Jung), 97
Kant, Immanuel, 12; on aesthetic experience, 29–30, 40–41; critique of self-interest by, 26; Hegel on, 38–40; on human nature, 27; secular paradigm in, 45; on social order and collective education, 28; sovereign self in philosophy of, 38; transcendence and individual consciousness and, 124–25
Kaprow, Alan, 140, 155–56
Kautsky, Karl, 68
Keep, John, 72, 226n62
Kershentsev, Platon, 99–100
Kimball, Whitney, 208–9
King, Martin Luther, Jr., 105
"Kino Eye" manifesto, 91–92, 96
kinship, disappearance of, 9–10
Kivland, Kelly, 195
Kogan, Piotr, 94
Kolbowski, Silvia, 156
Koons, Jeff, 175
Krauss, Rosalind, 148–54, 157
Kronstadt Uprising, 72, 101
Kruger, Barbara, 161–62

La Beauté exhibition (Hirschhorn), 183–84
Lacy, Suzanne, 139–41
Latin America, revolutionary vanguards in, 109–16
"Lava la Bandera" actions (Peru), 218
Laverdant, Gabriel-Désiré, 49, 58–59, 60
Lawler, Louise, 156
League of Revolutionary Writers and Artists, 101–2
Lectures on Aesthetics (Hegel), 40
Lectures on Fine Art (Hegel), 44–45
Léger, Marc James, 5–6
Lenin, Vladimir, 6, 56; Chernyshevsky and, 73–77; commitment to violence of, 75–77, 227n81; distrust of democracy by, 71–73, 97, 214–15; revolutionary vanguard and, 64–73, 111; state control and autonomy and, 77–82, 98–99
Lenin and the End of Politics (Polan), 81
Lenin and the Manifestation (Brodsky), 66, 67
Letters on the Advancement of Humanity (Herder), 35
Letters on the Aesthetic Education of Man (Schiller), 9, 28–29, 31–32
Levine, Sherrie, 152, 154
Leymarie, Jean, 85
liberating violence, Carnevale's concept of, 111–16, 129–30, 231n18
liberation movements, political autonomy and, 108–9
literature: critical text paradigm in, 150–51; emancipatory potential of, 10–11; populist forms of, 28, 42
Locke, John, 20
Lom d'Arce, Louis-Armand de, 35
London Institute of Contemporary Art, 174
L'Ordine Nuovo (journal), 241n4
L'Ouverture, Toussaint, 35
Lukács, Georg, 233n66
Lunacharsky, Anatoly, 88, 100–101
Lütticken, Sven, 2
Luxemburg, Rosa, 64–65, 66–69, 81
Lyotard, Jean-François, 149

Maharaj, Ayon, 137
Mally, Lynn, 100
Manet, Edouard, 49
Man Ray, 86
Marc, Franz, 86
Marcuse, Herbert, 117
market forces: avant-garde and, 156; Beuys's work and, 132; depoliticization of, 185–87; institutional critique movement and, 182–87; instrumentalization of contemporary art and, 2, 6–8, 123–24; limits of possessive individualism and, 25–26; neo-avant-garde acceptance of, 157, 161–62; Prussian State and, 41; Schiller's discussion of, 9
Märten, Lu, 88, 90
Marx, Karl: aesthetic state and theories of, 50–53; anticolonialism and, 102–7; avant-garde and, 149–50; critique of Hegel by, 43, 50–51, 53; on philosophy and class, 54–57
Marxist theory: Adorno and, 123–24, 126–27; avant-garde and, 50–51; capitalism and, 10; community and participatory art and, 214–18; Paris Commune and, 59–60; praxis and, 172–79

mass culture: art marginalization and, 92–94; contemporary art and, 151–52; experimental art and, 148–54
mastery, autonomy as, 12
media coverage, of Hirschhorn's *Gramsci Monument*, 191–92
mediation, transcendence and, 124–30, 233n74
Méndez, Leopoldo, 101
Mexico, avant-garde in, 101–2
Millet, Jean-Francois, 49
Minima Moralia (Adorno), 117
modernization: autonomy source and, 25–28; Hegel's modern state and, 42–45; human personality and impact of, 37; utilitarianism and, 9
Monk, Thelonius, 138
Montaigne, Michel de, 34–35
moral instruction, art and, 11–12
morality, subordination principle as basis for, 19–20
Morgan, Jo-Ann, 138
Moritz, Karl, 11
Morris, Robert, 149
Morris, Tracie, 192
Mouffe, Chantal, 191
Musée Précaire Albinet project (Hirschhorn), 184–85
Museum of Modern Art (New York), 174
Muthu, Sankar, 34–35

Nachayev, Sergey, 86
Nachträglichkeit (deferred action), 159
Narkompros (People's Commissariat for Education), 99–101
Nazi Party, 226n56
Nechayev, Sergey, 70–71, 227n81
negation: of absolutism, 25; avant-garde and principle of, 5, 7–8, 169–71; capitalism and, 26; communism and, 86–90; neo-avant-garde and, 157, 160–61; thought and creativity linked to, 85–90
Negri, Toni, 191
Négritude, aesthetic paradigm for, 34
neo-avant-garde: Adorno's influence on, 163; deferred action aesthetics and, 154–62; influences on, 155; institutional critique movement and, 181–87; *October* (journal) and, 145–54; postconceptualist art and, 163–71; rise of, 14–15, 145–79; theory and praxis in, 171–79
neoliberal institutions: demythologization perspective and, 163–64; instrumentalization of contemporary art and, 2, 6–8, 15, 123–24; revolutionary violence and arrest of, 5–8
New Economic Policy (Russia), 228n19
New Museum (New York), 174
Newspaper of the Engaged Platform (Chto Delat), 173
New York Department of Cultural Affairs, 191
New Yorker (magazine), 191–92
"Night of the Long Batons" (Argentina), 111
Nkrumah, Kwame, 129
noble savage ethos, anti-imperialist source and, 35
Nochlin, Linda, 58
nonviolence, cultural activism and, 105–7
norms: aesthetic state and, 32–33; self-governance and, 12–13
"Nuit Blanche" exhibit (Toronto), 175

Object to Be Destroyed (Man Ray), 86
October (journal), 14, 147–55, 215; deferred action aesthetics in, 154–55, 158–62
Oeri, Maja, 191
O'Higgins, Pablo, 101
Ohnesorg, Benno, 134
Ollman, Bertell, 51
Onganía, Juan Carlos, 111, 113, 130
Organization for Direct Democracy Through Referendum, 134
Organization of Black American Culture, 138
The Originality of the Avant-Garde (Krauss), 150–51
Osborne, Peter, 128
otherness: Adorno on self in relation to, 127–28; aesthetic transformation of, 26–27; in Hirschhorn's projects, 194–98; self as negation of, 23–25

Paris Commune, 59–60, 217; Rimbaud and, 60–64
participatory art: coercive model of, 111–16; Hirschhorn's rejection of, 189–98
patriarchy, feminist experience of, 140

Pel'she, Robert, 100
People's National Movement (Trinidad), 129
perceptual assault discourse, 90–94
performance-based artistic practice: Adorno's critique of, 119; assault of viewers in, 113–16; Beuys's experiments in, 131–37; Lacy's work with, 140–41; neo-avant-garde and, 155; postconceptualism and, 165
performative autonomy, 2; anticolonialism and, 104–7; consciousness raising and, 137–42; cultural production and, 128–30
permanent conference, Beuys's concept of, 130–37, 139, 162
Peru, artistic practices as resistance in, 218
Phenomenology of Spirit (Hegel), 40
philosophy: class and, 54–57; discursive structure of, 45–47; Hegel on necessity of, 40–45; Marx on, 53
Philosophy of Right (Hegel), 42–43
photography: Coleman's postconceptualist art, 151, 163–71; scriptovisual installations, 165–66
Piscator, Erwin, 87–89, 95–99, 128, 132
Piscator-Bühne theater group, 95
Pissarro, Camille, 49
play drive, Schiller's concept of, 31, 50
poetry, Shklovsky's discussion of, 93–94, 152–53
Polan, A. J., 81
political artist, Schiller's concept of, 14
The Political Unconscious (Jameson), 10–11
political transformation: Adorno's critique of action and, 116–24; aesthetic autonomy and, 4–5, 26–30, 46–47; aesthetic state and, 32–33; artistic production and, 10, 111–16, 131–37, 167–71; avant-garde and, 5–6, 114–16; Beuys's involvement in, 132–37; community and participatory art and, 214–18; contemporary art and, 156–57; neo-avant-garde and, 161–62; Paris Commune and failure of, 62–64; possessive individualism and, 33–37; Roberts's Post-Thermidorian perspective on, 166; in Russia, 70–73; Schiller's critique of, 29–31; theory/praxis division in art and, 172–79
popular culture: anticolonial resistance and, 128–29; avant-garde dismissal of, 105

Popular Front, 101
populism, Schiller's critique of, 28, 42, 46–47
possessive individualism: aesthetic autonomy and, 198–206; emergence of, 21–23; limitations of, 25–26; philosophy and, 44–45; political transformation and, 33–37
postconceptualist art, noncompliant revolution and, 163–71
postminimalism, 148–49
postmodernism, 150, 154–55
poverty, Hegel on abolition of, 42–43
praxis: Adorno's critique of action and, 117–24; aesthetics of disappointment and, 207–11; artistic production and, 11, 115–16, 147, 187–98; avant-garde as memory of, 170–71, 173; consciousness raising and, 140; dance and, 104; historical political praxis, 160; Leninist tradition and, 78; Marxism on theory and, 55–56, 65, 126–27; neo-avant-garde and, 171–79; revolutionary praxis, 61, 153; Schiller's premature praxis, 46, 64, 146–47; segregation of art and politics and, 172–79, 216–18; theory and, 171–79
primary economy, artistic production and, 174–75
Prince, Richard, 152, 154
Pro Helvetia, 191
Prolekult movement, 14, 97–102, 104, 128
Proletarian Theater (Berlin), 95–97, 100–102
proletariat: Adorno's perspective on, 124, 133, 136–37, 163–64; aesthetics and, 54–57, 79–82, 233n66; as revolutionary vanguard, 65–73. *See also* working class
property-based models, autonomy and, 21–24
Prussian state, Hegel's critique of, 40–43, 150
public: art as deputy for, 123–24; incapacity for collective action of, 46–47; Schiller's aesthetic state and, 32–37, 50
public opinion: Hegel's criticism of, 42–47; perceived incapacity of, 46–47, 223n65
public projects, Hirschhorn's association with, 183–87
Pufendorf, Samuel von, 21
Puna Fast (India), 106–7
punitive paradigm, disruption as, 85–91
Puzzolo, Norberto, 112–13

race: colonialism and, 23–24, 103–4; community art and, 199–206; Hegel's discussion of, 45, 103, 223n74; Hirschhorn's artistic practice and foregrounding of, 182–87, 192–98, 213–18, 239n36; Marx and, 102–3
Rainer, Yvonne, 149
Rancière, Jacques, 2
Rasmussen, Mikkel Bolt, 5
Raymond, Yasmil, 192, 194–95, 198, 209, 239n32
reason: political systems based on, 22–23; relationality of, 36; Schiller on emotion and, 30–32
Reformation, autonomy and decline of, 19
Reina Sophia (Madrid), 174
relational paradigm, artistic practice and, 181–87
religion: anticolonial resistance and, 129; Hegel on philosophy and, 44–45
religious theology, hierarchy in, 22
Renzi, Juan Pablo, 112–13
resistance: Adorno on mediation of, 122–24; art as separate from, 95; Bogdanov's view of, 97–98; Frankfurt School theory of, 125
revolutionary conceptualists, Robert's concept of, 178–79
"The Revolutionary Catechism" (Nechayev), 70–71, 86
Revolutionary Time and the Avant-Garde (Roberts), 5, 164–65, 178–79
revolutionary transformation: Adorno's critique of action and, 116–24, 163–64; aesthetic autonomy and, 4–6; artistic practices and, 5–6, 111–16, 166–67; avant-garde and, 4–6, 13–14, 48–53; avant-garde as memory of, 170–71, 173; Bogdanov's view of, 97–99; failure of, 212–18; in Latin America, 109–16; Leninist paradigm of, 111; neo-avant-garde and, 157–62; *October*'s coverage of, 147–54; Paris Commune and, 62–64; praxis and, 173–79; working class mobilization, 64–73
Revolution in the Revolution (Debray), 109
"Revolution Now and Forever" (Surrealist Group), 86

Rimbaud, Arthur, 49, 60–64, 69, 86, 132, 231n16
Ringgold, Faith, 131
Roberts, John, 2, 5, 14, 164–81, 185–86, 192, 201
Rojava Film Commune (Syria), 217–18
The Roof Is on Fire (Lacy), 142
Ross, Kristin, 61
Rousseau, Jean-Jacques, 28, 34
Ruscha, Ed, 154
Russian Revolution of 1917: aesthetic autonomy and, 14, 64, 66–73; avant-garde in, 115–16, 148–49, 159–62
Russian Social Democratic Labor Party, 68–69

Saint-Simon, Henri de, 26, 58–59
Salt March (India), 105
Sanchez, Sonia, 139
Sartre, Jean-Paul, 54–55
Schelling, Friedrich Wilhelm Joseph von, 40–41, 222n51
Schiller, Friedrich: aesthetically tempered man concept of, 30–31, 221n21; on aesthetic experience, 1–2, 9, 11–12, 14, 25, 220n29; aesthetic state concept of, 25–28, 32–33, 40–41; on art and literature, 28–29, 42, 221n26; critique of self-interest by, 26–27; Hegel's Geist and work of, 39–40; on political transformation, 79; premature praxis concept of, 46, 64, 146–47; primacy of classical culture for, 36; secular paradigm in, 45
Schjeldahl, Peter, 192–94
Schneewind, J. B., 19–20
Schoenberg, Arnold, 138
Schüller, Hermann, 95
scriptovisual installations, 165–66, 172
second economy, neo-avant-garde and, 174–75
secular humanism: emergence of, 23–24; Hegel's version of, 45
Seedbed (Acconci), 113
self-governance, autonomy and, 12–14, 20
self-interest: Kant's critique of, 26; Schiller's critique of, 26
self-transformation, Adorno's discussion of, 120

Senghofd, Léopold, 34
sensus communis: avant-garde and, 49; government and, 59–60; Hegel's Geist and, 39–41; Kant's discussion of, 167; Marxist view of, 50–52; philosophy and, 44–45; populist literature and, 28; Schiller and, 27–28
Serra, Richard, 149
Sherman, Cindy, 152, 154
Shklovsky, Viktor, 92–94, 96–97, 99, 151–53, 228n85
Signac, Paul, 51
slavery: anti-imperialist Enlightenment discourse on, 34–35; capitalism and, 103–7; Hegel's rejection of, 40; property-based models and rise of, 21
Smethurst, James, 139
Smith, Terry, 233n85
social fascism, 226n56
socialism: autonomy and, 53–57; avant-garde and, 149–50; revolutionary vanguard and, 69–73
Socialist German Student Union (SDS), 117–18, 134
socialist realism, Lenin's imposition of, 101
social reality: aesthetic autonomy and, 46–47; Marxist view of, 51–52
social work: artistic production and, 137–42, 160, 181–87, 236n29; contemporary art and, 156–57; in Hirschhorn's projects, 188–98
Sokolovskii, Mikhail, 100
somatic conditioning, aesthetics and, 37
Sonnabend Gallery, 113
S.O.S. Calling All Black People (Bracey, Sanchez, and Smethurst), 139
sovereign self: Adorno on otherness and mediation of, 127–28; aesthetic autonomy and, 60–64, 198–206; collaborative projects and, 139; cultural difference as precondition for, 36–37; debate over autonomy and, 20–24; Hegel and concept of, 38–40; Hirschhorn and, 207–11; Hirschhorn's invocation of, 213–18; instrumentalization of human and natural world and, 23–24; social marginalization and, 60–61; vanguard party model and, 64–73

sovereignty, autonomy as, 13–14
speculative consciousness, reason and emotion and, 32
Spinoza Monument (Hirschhorn), 184
Spivak, Gayatri Chakravorty, 32–37, 191
sports stars, artistic production inclusion of, 138–39
Stalin, Joseph, 147
state: aesthetic state concept, 25–28, 32–33, 38–40; autonomy and role of, 77–82, 177–79; harmonious existence and, 51–52; Hegel on development of, 40–41
State and Revolution (Lenin), 80
Stittlichkeit (Hegel's ethical community), 40
student militancy: Beuys and, 134; Hirschhorn and, 183–87
Sturm und Drang movement, 28
subjectivity: autonomy and transformation of, 38–40; postconceptualist art and, 163–64
surrealism, 64, 86–90
Surrealist Group, 86–87
Swiss Arts Council, 191
Syndicalists (Germany), 95, 99
Systemprogram, German Idealism's concept of, 222n51

Taller de Gráfica Popular (TGP), 101, 128, 132
Tate Liverpool, 174
Tatlin, Vladimir, 148
teaching, Beuys on, 133–35
temporal deferral: aesthetics of, 154–62; Enlightenment aesthetic and, 146–47; in *Gramsci Monument* project, 205–7; Leninist discourse and, 80–82; Schiller's concept of, 29–30
theater, defensive autonomy and, 95–102
Theater of Working-Class Youth (TRAM), 100–102, 230n45
theory: aesthetics of disappointment and, 206–11; neo-avant-garde and, 171–79; political action vs., 118–24; praxis vs., 55–56, 65, 171–79, 196–98
Thesis on Feuerbach (Marx), 225n19
Thompson, Clyde, 195–96, 200–206
Three Weeks in May (Lacy), 140
Tonon, Margherita, 233n74

transcendence: autonomy and mediation and, 124–30; community art and unshared authorship and, 199–206
Trotsky, Leon, 75–77, 147
Tucker, Robert, 22n8
Tucumán Arde project (Vanguard Artists Group), 129–30
Turner, Nat, 138
Turpitudes Sociales (Pissarro), 49
Tzara, Tristan, 86

UK-76 (Burgin), 165–66
Under Blue Cup (Krauss), 151, 154
Union of Soviet Socialist Republics (USSR): art under, 87–88, 92; defamiliarization discourse in, 92–94
universality, Hirschhorn's artistic practice and, 190–98
unshared authorship, community art and, 199–206
utopian potential of aesthetic: Adorno on, 119–21, 130; artistic freedom and, 4, 9, 11–12, 147; bourgeois liberalism and, 27–28, 80, 126; class and racial transcendence and, 15; emancipation and, 3–4, 10, 12–13; exculpatory critique and, 188; Geist of Hegel and, 51; Hirschhorn's *Gramsci Monument* and, 206–11, 213–18; inadequacy of the masses paradigm and, 71, 79, 137; Marxism and, 57; Paris Commune and, 58–60; philosophy and, 44–45; Prolekult movement and, 99; revolution and, 148–54; sensus communis and, 63; surrealism and, 86

Valéry, Paul, 123
Van Abbemuseum (Netherlands), 174
Vanguard Artists Group, 129–30
vanguard revolutionaries: avant-garde and, 85–90; Dadaism and, 89–90; Lenin's advocacy of, 65–73
Vaughan, Sarah, 139
Vendôme Column, 59
Vergne, Phillippe, 208, 213, 239n32

Vertov, Dziga, 91–92, 148
Viennese Actionists, 113
violence: Adorno on art as, 121–24; by guerrilla cells, 109–11; Lenin's commitment to, 75–77
violent destruction, Marxist valorization of, 50

Wall of Respect (Black Panther mural), 138
Waters, Muddy, 139
"What Is Dadaism?" (Hülsenbeck and Hausmann), 87
What Is to Be Done? (Chernyshevsky), 73–77
What Is to Be Done? (Lenin), 65, 68–69, 173
"What's Neo about the Neo-Avant-Garde?" (Foster), 155–62
Whisper, the Waves, the Wind (Lacy), 140–41
White, Derrick, 103–4
Wilder, Gary, 34
Williams, Christopher, 156
Wolf Man, Freud's analysis of, 160
Wood, Paul, 63
Workers Party (US), 129
Worker's Photography Movement, 101
working class: Adorno's discussion of, 117; aesthetics and, 54–57; artistic production and, 115–16, 192–98; autonomy of, 55–57; avant-garde and, 49; Enlightenment view of, 23, 31–32; Frankfurt School theory of political resistance and, 125; German avant-garde and, 90–94; indifference of, 66; Kant's view of, 42; Lenin and, 70–73; Marxism and, 50–57; Prolekult movement and autonomy of, 97–102; revolutionary vanguard and, 65–73; Rimbaud's identification with, 60–61. *See also* proletariat
Wynter, Sylvia, 22–23, 103–5

Yippie movement, 137

Žižek, Slavoj, 5–6
Zwirner, David, 7